The canonicity of Vermeer's oeuvre was originally established within the general framework of modernist aesthetics. The specific concepts guiding critics were developed in the context of a reappraisal of Dutch painting in the nineteenth century, particularly in Germany and France. In this study, Christiane Hertel interprets the suppositions underlying Vermeer's canonization and also addresses the critical problem of locating his paintings in history. Based on current as well as historical discussions of a theory of aesthetic reception, her book makes a contribution to the self-definition of the discipline of art history.

Vermeer

Vermeer

Reception and Interpretation

Christiane Hertel
Bryn Mawr College

CAMBRIDGE
UNIVERSITY PRESS

Published by the Press Syndicate of the University of Cambridge
The Pitt Building, Trumpington Street, Cambridge CB2 1RP
40 West 20th Street, New York, NY 10011-4211, USA
10 Stamford Road, Oakleigh, Melbourne 3166, Australia

First published 1996

Printed in the United States of America

Library of Congress Cataloging–in–Publication Data
Hertel, Christiane, 1958–
 Vermeer : reception and interpretation / Christiane Hertel.
 p. cm.
 Includes bibliographical references.
 ISBN 0-521-55020-3
 1. Vermeer, Johannes, 1632–1675—Criticism and interpretation. I. Vermeer,
Johannes, 1632–1675. II. Title
ND653. V5H47 1996 95-26526
759.9492—dc20 CIP

Publication of this book has been aided by a grant from
the Millard Meiss Publication Fund of the College Art Association.

MM

A catalog record for this book is available from the British Library.

ISBN 0-521-55020-3 Hardback

Pages ix and x constitute a continuation of the copyright page.

Contents

meinem Jay

List of Illustrations

Photo Credits

Alinari/Art Resource, New York: figs. 32, 38

Jörg P. Anders, Berlin: Pls. III, IV; figs. 7, 8, 11, 52

Bayrische Staatsgemäldesammlungen, Munich: fig. 46

Bryn Mawr College: figs. 9 (from Schmidt 1923, fig. 63), 10 (from exhib. cat. Berlin 1983), 34, 35, 36 (from Ripa 1971, reprint), 42 (from Ripa 1970, reprint), 43 (from Ripa 1971, reprint), 53

Bryn Mawr College, Mariam Coffin Canaday Library: figs. 22, 23; rare book room: fig. 37

Bryn Mawr College, Thomas Art and Architecture Library: figs. 19 (from Henkel and Schöne 1967, no. 1361), 20 (from Ripa 1971, reprint), 25, 30, 31

Martin Bühler, Öffentliche Kunstsammlung, Basel: fig. 18

Isabella Stewart Gardner Museum, Boston: fig. 15

Gemäldegalerie Alte Meister, Dresden: fig. 26

Heartfield-Archiv, Berlin: fig. 4

Koninklijke Musea voor Schone Kunsten van België/Musées Royaux des Beaux-Arts de Belgique: figs. 45, 51

Kunsthistorisches Museum, Vienna: Pl. VII

Hugo Maertens, Bruges: fig. 47

Mauritshuis, The Hague: Pls. V, VI; fig. 12

Museumsfoto: B. P. Keiser: Pls. I, II

The National Gallery, London: fig. 13

Sydney W. Newbery, London: fig. 1

Edward Peterson, Jr.: fig. 2

Museo del Prado, Madrid: fig. 39

Stedelijk Prentenkabinet, Antwerp: fig. 48

Statens Museum for Kunst, Copenhagen: fig. 14

Elke Walford, Hamburg: fig. 5

Westfälisches Landesmuseum für Kunst- und Kulturgeschichte, Münster: fig. 54

Copyrights

Acknowledgments

The project of writing this book began in 1985 when I reviewed, on the occasion of what in German is aptly called the "Rigorosum" (Ph.D. oral exams), Norman Bryson's *Vision and Painting* and stumbled over his presentation of Vermeer as a modern painter, a self-conscious semiotician, even an ironist. This interpretation of Vermeer struck me as a challenge which subsequently engaged me for the next decade. Now that *Vermeer: Reception and Interpretation* is completed, thanks are due to many individuals and several institutions.

First I wish to thank my husband, Jay Baker, who accompanied me through all the phases of writing this book; I know that without his love, encouragement, and criticism I could not have written it.

Very special thanks go also to my colleagues at Bryn Mawr College, David Cast, Dale Kinney, Steven Z. Levine, and Gridley McKim-Smith who, apart from passing on numerous bibliographic references and other Vermeeriana over the years, offered advice and quite varied and valuable criticism of my lectures on Vermeer and then of the final draft of my manuscript.

Three graduate seminars at Bryn Mawr stand out for helping me deal with problems I address here. Thus I owe much to the participants in "Vermeer" (1989), "German Aesthetics and Art Criticism" (1993), and "Allegory" (1995).

A number of grants facilitated my research: an ACLS Grant-in-Aid (1988), the Bryn Mawr College Junior Faculty Leave (1992–3), and an NEH Summer Grant (1995). I thank these institutions and the individuals who sat on their grants award committees for their confidence in my research project.

Several scholars gave me the opportunity to lecture on my Vermeer studies. For this opportunity I wish to thank in particular Andreas Haus, Jane Hutchison, Cynthia Lawrence, and Kathryn Crawford Luber.

Among the many individuals – scholars, artists, curators, and librarians – who helped me over the years with their advice, criticism, and interest in my work on Vermeer, I wish to mention here Celeste Brusati, Charles A. Burke, Albert Cook, George Deem, Wayne Franits, Barbara Haeger, Konrad Hoffmann, Eileen Markson, Charles Talbot, and Leslie Topp. I am very grateful to them for everything they have done to further my work.

Thanks to a Millard Meiss Grant from the CAA and a generous publication grant from Bryn Mawr College the illustration of my text was made possible in its present form. I also wish to thank Mary Campo at Bryn Mawr for her sovereign management of everything having to do with the illustrations.

Finally I turn to those three women who in the most literal sense made this book happen. I am most grateful to Beatrice Rehl, my editor at Cambridge University Press, for her essential interest in my manuscript and her encouragement in

all phases of its publication, to the copyeditor, who prefers anonymity, for her rigor and understanding, and to Jo Ellen Ackerman for seeing the book so competently and patiently through its production.

<div align="right">

Christiane Hertel
Innsbruck, January 17, 1996.

</div>

Vermeer

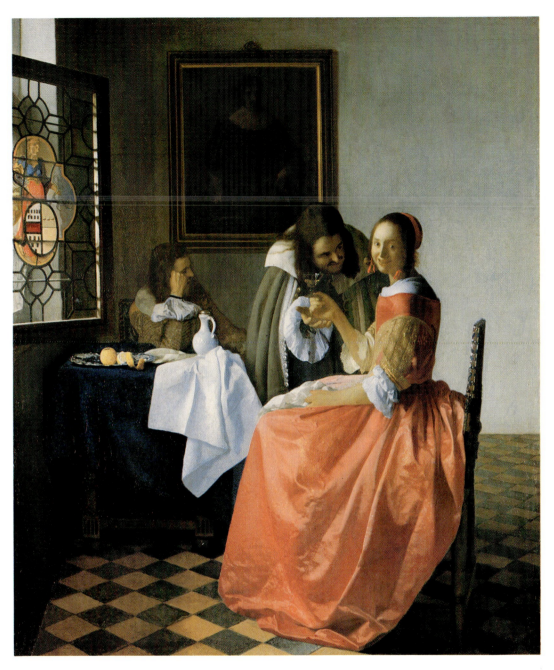

I. Jan Vermeer, *The Girl with the Wine Glass*, c. 1659–60, oil on canvas, 78 x 67 cm, Herzog Anton Ulrich-Museum, Brunswick.

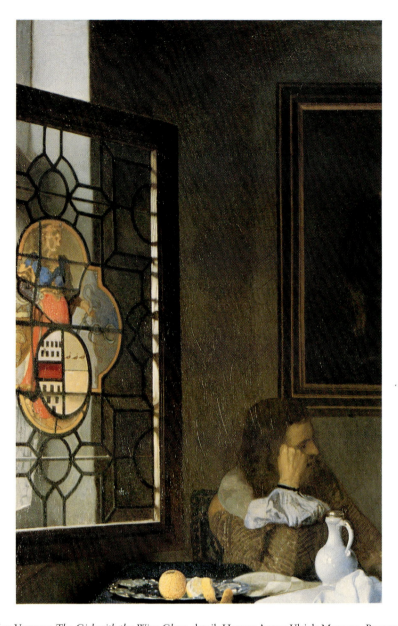

II. Jan Vermeer, *The Girl with the Wine Glass*, detail. Herzog Anton Ulrich-Museum, Brunswick.

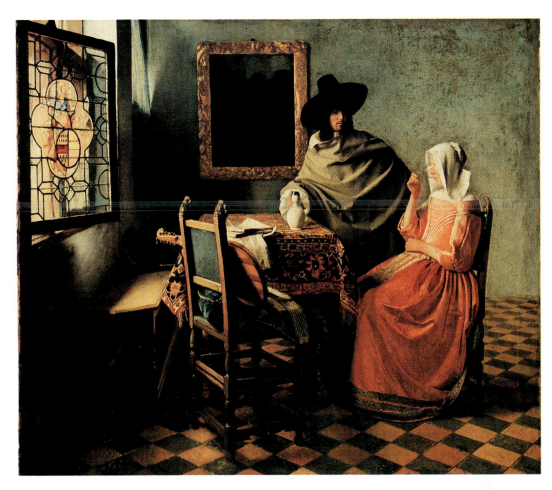

III. Jan Vermeer, *The Glass of Wine,* c. 1658–60, oil on canvas, 65 x 77 cm, Staatliche Museen zu Berlin, Preußischer Kulturbesitz, Gemäldegalerie.

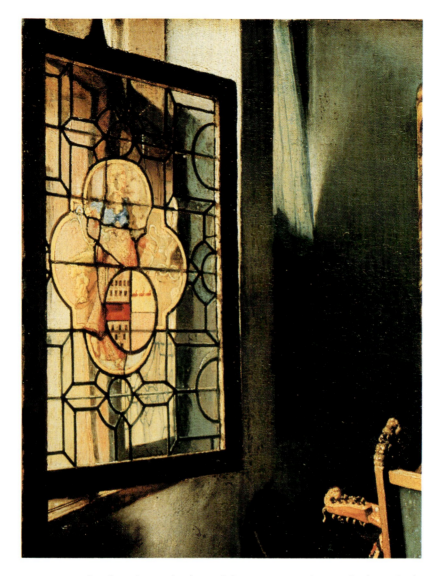

IV. Jan Vermeer, *The Glass of Wine*, detail. Staatliche Museen zu Berlin, Preußischer Kulturbesitz, Gemäldegalerie.

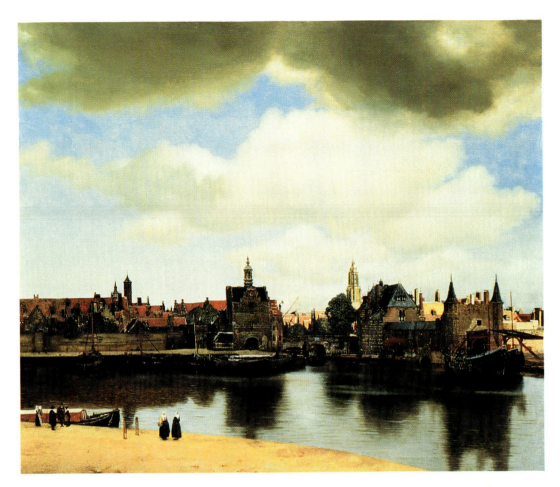

V. Jan Vermeer, *View of Delft,* c. 1660–1, oil on canvas, 98 x 117.5 cm, Mauritshuis, The Hague.

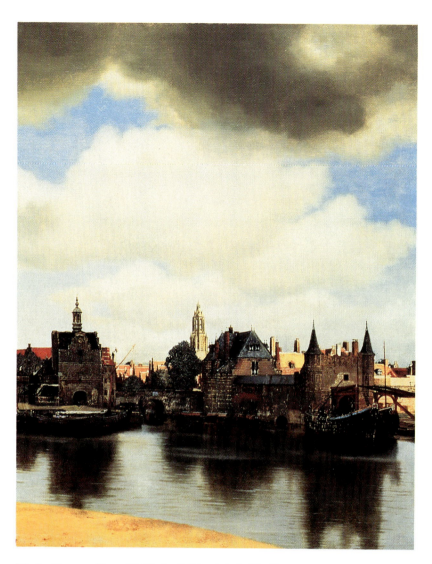

VI. Jan Vermeer, *View of Delft*, detail. Mauritshuis, The Hague.

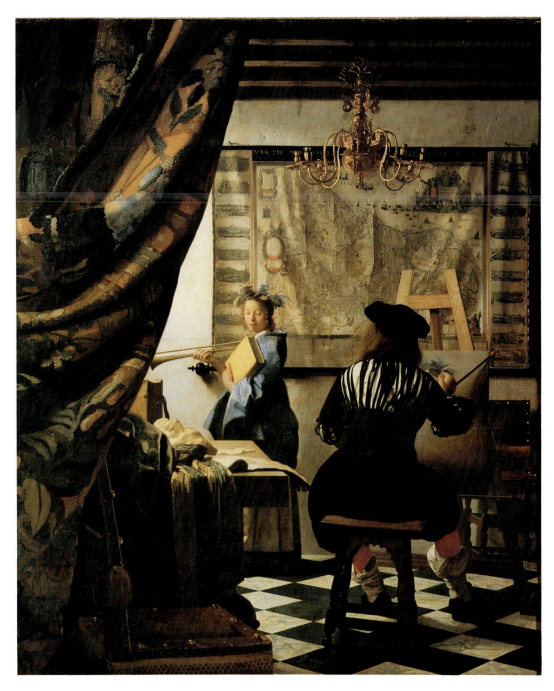

VII. Jan Vermeer, *The Art of Painting*, c. 1666–7, oil on canvas, 130 x 110 cm, Kunsthistorisches Museum, Vienna.

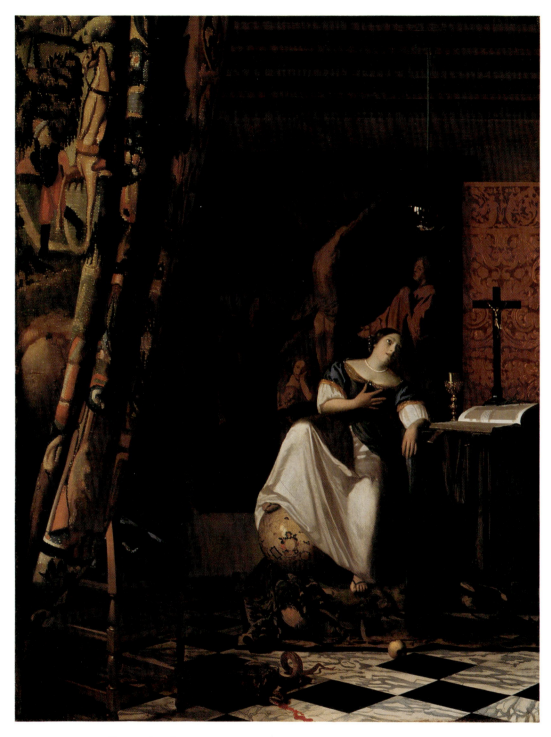

VIII. Jan Vermeer, *Allegory of Faith*, c. 1671–4, oil on canvas, 113 x 88 cm The Metropolitan Museum of Art, New York.

Introduction
Reception and Interpretation

No. 299: A young courtesan with a young man – Vermeer. Good.
<div align="right">— JOHANN WOLFGANG VON GOETHE, 1794[1]</div>

At the sight of this astonishing painting by Vermeer one stands as if confronted by a postcard sent from a better world by someone who has died, or sent into the world of the waking from out of the abyss of sleep. Here something incredible is happening.
<div align="right">— JEAN COCTEAU, 1956[2]</div>

The high artistic quality of Vermeer's paintings has been an accepted truth ever since their "rediscovery" by Théophile Thoré in the mid-nineteenth century. And as Goethe's laconic annotation in his copy of a guide to the Dresden Gemäldegalerie suggests, this quality was apparent to some viewers long before Thoré's masterly definition of Vermeer's oeuvre as different from all others. But neither "historical value" nor "art value," to use the terms coined by Alois Riegl in his groundbreaking critique of the "modern cult of monuments" (1903), alone guides one's assessment of a particular artist's work.[3] Nor is this assessment likely to be stable; instead, it is subject to time, place, and the individual circumstances of beholder and beheld. Jean Cocteau's reaction to Vermeer's *The Procuress* (1656) may serve as an example of such a specific assessment, which, moreover, is based on a kind of instant recognition, articulated in Cocteau's dialogue with Louis Aragon about paintings in the Dresden Gemäldegalerie.[4]

Cocteau was an artist and yet, on this occasion, he also acted as an art critic. The director of such a film as *La Belle et la bête* (1946) may well have been predisposed to encounter in Vermeer the "incredible" presence of "a better world" in the past, or in the "abyss of sleep." Put simply, the Surrealist filmmaker Cocteau encountered in Vermeer a Surrealist painter. What should we make of this? One answer might be that Cocteau's interpretation is of no consequence to Vermeer

scholarship because scholarship has nothing to do with self-mirroring. Another answer might be that Cocteau's interpretation addresses something very particular in Vermeer's painting precisely because Cocteau is unhistorical and subjective. If one accepts the viewpoint that the study and criticism of art is an interpretive practice and not a science, then the second answer, while perhaps insufficient, is preferable. It makes room for the possibility that within Vermeer scholarship such projections as Cocteau's are also at work, and that rather than being principally a deplorable imperfection in art scholarship, these projections may be very productive. Whether or not this is true in each case, it is instructive to study how a given interpretation as well as the method it privileges is inflected with these projections. Here, too, Cocteau's account serves as a good example, for the elective affinity between Vermeer and himself appears based on method, rather than subject matter, as when he describes how the painting acts on him, how it functions, and not what it depicts.

Cocteau is not the only modern artist who responds so directly to Vermeer. In fact, throughout this century painters, sculptors, fiction writers, and lately also film-makers have referred to the paintings of Vermeer. Though perhaps overly schematic, it is useful to distinguish three modes of reference in the responses of modern artists to Vermeer. First is the imitation of Vermeer as a paradigmatic painter. Here we might think of Victor Pasmore's remarkably original *The Lacemaker (after Vermeer)* (Fig. 1).[5] Pasmore focuses entirely on translating Vermeer's color harmony and lighting into his own painterly idiom, which at the time of his study – it is dated c. 1938–9 – means the inclusion of a bright yellow-green for the background. Surprising as this choice may appear today, it allows one to see how easily the lacemaker's hair merges with such a green background and thus how Vermeer, contrary to conventional accounts, has not removed green from his color harmony. Apparently this study after Vermeer is unique in Pasmore's oeuvre.

A rather different painterly emulation of Vermeer is George Deem's *Vermeer's Chair* of 1994 (Fig. 2).[6] Taking as his point of departure several Vermeers, among them *Young Woman with Pearl Necklace* (c. 1664) (Fig. 11), the artist creates a new "Vermeer" while staying as close as possible to the original's style, painting technique and color harmony. There is a subtle irony in *Vermeer's Chair* in the way that this chair is inaccessibly placed to the left, in the corner of a spare Vermeerian interior that to the right appears to come forward toward the beholder, and then gradually dissolves into the abstract self-evidence of the canvas. While thus visualizing the difficulty of understanding Vermeer's places he also suggests that as painter, that is in the process of painting, he can temporarily hold his place in a Vermeer. Perhaps more than any other of Deem's many "Vermeers," *Vermeer's Chair*, in its simplicity, pays homage to the seventeenth-century painter.

A second mode of artistic reference to Vermeer is verbal. Often it is a significant gesture proclaiming the purity of the art value of Vermeer's paintings. The first such reference, unsurpassable in its interpretive complexity, is made by Marcel Proust in his *Remembrance of Things Past*. Later, from Lawrence Gowing (1952) to Zbegniew Herbert (1991) and Iris Murdoch (1993), a painting by Vermeer, certain characteristics of his oeuvre at large, or even his mere name suffice to invoke a paradigm of the metahistorical aesthetic object.[7] Finally, in the third and apparently most recent mode of reference, artists have focused on a certain peculiarity of Vermeer's work: its

1. Victor Pasmore, *The Lacemaker (after Vermeer)*, c. 1938–9, oil on canvas, 29 x 24 cm, private collection, England.

silence, its conspicuous tension between concentration and elusiveness. Jon Jost's film *All the Vermeers in New York* (1992), in which a passage from Proust's novel is recited, has been judged by some film critics to be abstract and aesthetic, psychologically subtle, and rather abysmal.[8] In another example of this mode of reference, Susanna Kaysen's autobiographical book *Girl, Interrupted* (1993), life in the

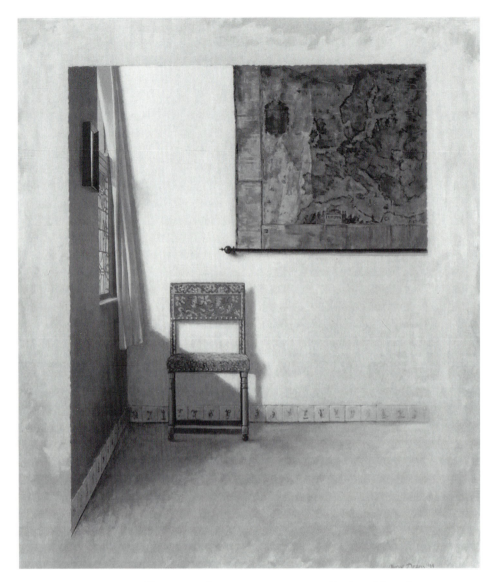

2. George Deem, *Vermeer's Chair*, 1994, oil on canvas, 71 x 61 cm, collection of the artist.

"looney-bin" is repeatedly represented through invocation of the Vermeer paintings in New York's Frick Collection, in particular the work referred to in the book's title, *Girl Interrupted at Her Music* (Fig. 16). The author thereby suggests that Vermeer's excessive abstraction of women's lives, on the one hand and the concrete eloquence of their objects in the paintings, on the other, appear to mirror her own life and her diagnosed "character disorder."[9]

To conceptualize these references to Vermeer is a difficult task. As far as painterly imitations are concerned, a thorough investigation of works by Victor Pasmore and George Deem as well as those of Howard Hodgkin, Malcolm Morley, William Wilson, and others lies outside the scope of this study. The overtly interpre-

tive modes of verbal reference, on the other hand, are linked to my purposes here. In the title of this book, *Vermeer: Reception and Interpretation*, I refer to the relationship between various genres of writing about art and the structures of visual representation, placing Vermeer and his work at the center of my critical enterprise. I do not offer a monograph on the art and life of Johannes Vermeer van Delft, 1632–75; exemplar studies by Albert Blankert, Arthur Wheelock, and John Michael Montias exist. Nor do I narrate the complete history of Vermeer's critical fortunes. My primary concern here is with the relationship of selected interpretations of Vermeer's art, including my own, to its first significant critical receptions – a reception that took place in France and then Germany in the nineteenth and early twentieth centuries. What distinguishes these two traditions from others is that on the most general level they both attempt to locate Vermeer's paintings in modern aesthetics and to claim this location as their due historical place. My goal therefore is to lay out the French and German receptions of Vermeer, both independently and in their reference to one another and implication of one with the other. In doing so, I show how the French and German receptions continue to inform and even determine the most resourceful interpretations of Vermeer's painting. This is an enterprise with many facets, both on the level of theme and critical concern and on the level of methodology. I here offer a preliminary clarification of some of these facets, in order to provide the reader with certain guidelines.

The work of Alois Riegl is the logical place to start. His essay of 1903, "The Modern Cult of Monuments: Its Character and its Origin," is mostly concerned with tracing conflicting values and positions in the field of preservation and restoration of monuments, but has deep significance for the analysis of art-historical interpretation.[10] Riegl recognizes that any art-historical canon is a debatable construction conceived from a point of view that itself has a subjectively and objectively limited scope. Consequently, any appeal made at the beginning of the twentieth century to an absolute artistic paradigm and value will be an illusion (*Einbildung*). The problem Riegl perceives is the difficulty of developing a critical theory or procedure that can lend legitimacy and relative validity to a given construction of art history and its values without dismissing the part played by illusion or imagination.

On the one hand, it appears that Riegl, having spent many years delimiting the history of art as a discrete scholarly discipline – separate from both history and philosophy – resisted the idea of once again having recourse to these fields. On the other hand, it appears that he saw the need for a formulation of the changing relation of art to culture and of the art of the past to a given present. Only in this essay of 1903 does Riegl truly recognize this fact by using the word "cult" (*Kultus*) in the title. "Cult of monuments" refers to the veneration, reception, and conservation of monuments from or of the past – that is, to artifacts and their reception in a broad and inclusive sense. Riegl investigates the different kinds of values connected with the cult of monuments, values that conflict and compete with each other in a highly individualized modern consciousness of the past.

Briefly summarized, the most important among these values are, first, the historical value, the factual, documentary character of a work within the historical circumstances of its production; second, the age value, the respect for a monument's

age and its general testimony to the past, subjectively enriched by reflections on the temporality and transience of both the work and its beholder; third, the art value, the established perception of a monument as a work of art; and fourth, the present-day value, the appropriation of the work for a specific contemporary purpose or statement.[11]

Riegl distinguishes among these values but lacks any general rubric under which to link them. This is most apparent in his separation of the historical value from the age value and from the present-day value. Thus he does not realize how the present-day value, as appropriation or legitimation, might be productively criticized by, for instance, a close attention to what he calls historical value. Conversely, he also does not account for the possibility that the renewed actuality of a monument might have a critical dimension, precisely by ignoring or ironically invoking the supposed historical value. As examples for these possibilities we might again cite Cocteau's Vermeer interpretation, which addressed the aspect of the uncanny in Vermeer's art long before psychoanalytic Vermeer scholarship; or Pasmore's study after Vermeer, which appears to correct conventional views about Vermeer's color harmony. Failing to recognize the dialectical relationship of historical and present-day value, and underestimating the role the age value might play in their mediation, Riegl never acknowledges his peculiar mixing of what are now distinguished as reception aesthetics and reception history. He never separates the notion of a work's metahistorically implied beholder, in whom the study of reception aesthetics is interested, from actual audience behavior and response, in which the study of reception history is interested. Consequently, he also never struggles with the critical integration of the two.

Such a distinction as well as integration is what I intend to accomplish in this study of Vermeer. When I take up Riegl's terminology here, my interest lies in his discovery of the friction among the various different values attached to monuments. In my view it is this friction that makes the integration of reception aesthetics and reception history a worthwhile project. It is this friction of values that allows me to speak about meaning in Vermeer's art – about how its meaning has been constituted and how it might be otherwise constituted. Here it is appropriate to distinguish three approaches to the study of reception that I use in this book.

One approach is primarily historical, focusing on the critical reception of art, not only its contemporary reception but particularly its later reception. Here I am not making a relativistic assertion that the meaning of a work of art resides primarily in the audience response it receives. Instead, I assume a dialectical process, one that, acknowledging the difficulty of access to an original historical meaning, assumes as its task the determination of what makes a work of art historically meaningful and gives it renewed actuality in the context of its modern artistic adaptation, critical reconsideration, and commemorative contemplation. In this method of interpretation I am influenced by Walter Benjamin's as well as Aby Warburg's work on the relationship of memory and knowledge.

A second approach is structural as well as aesthetic, attending to the responses and spectatorship implied in the work of art. I have studied and made extended use of the foundations for this method in Hegel's *Aesthetics* and of the more recent scholarship of Wolfgang Kemp. In his attention to what he calls "constitutive

blanks" in the work of art – blanks to be filled variously but never arbitrarily by its spectators and thus constitutive of its meanings for them – Kemp brings to bear on the analysis of visual art and its reception the structural reception theories developed by the literary critics Wolfgang Iser and Hans Robert Jauss.[12]

A third approach is related to the work of Hans-Georg Gadamer. Gadamer's concept of temporality is strongly influenced by Heidegger's analysis of the phenomenon of time in *Being and Time*. According to Gadamer, the temporality of a work of art is neither something immanent to or inherent in the work of art as such nor something that the beholder brings to the work of art. Following Heidegger's lead, Gadamer defines temporality instead as the horizon of understanding as such, an horizon that embraces work and beholder alike. This horizon itself is by no means fixed. On the contrary, it is fundamentally open and has the character of an event. For this reason, Gadamer sees understanding neither as something unearthed from the work of art nor as something brought to it by the beholder, but rather as something that happens to both. This happening, or event, is the properly temporal character of the work of art. The art historian Gottfried Boehm has adapted this notion of understanding in his own work on the temporality of art and on what one might translate as "mnemonic seeing." This approach focuses on the phenomenon of a primarily visual, rather than text-oriented interpretation, and on the integration of what is seen with what is already known, familiar, or remembered, in the process of beholding and understanding a work of art.[13]

Clearly, there are frictions among these three approaches that cannot be overlooked, inasmuch as the first is most interested in the objective transformation of interpretations, the second in subjective representation and affirmation, and the third in the process of understanding as such. But in my view the links and commonalities among the three approaches are stronger than their differences. These commonalities include a basic respect for the artist, for art, and for details of appearance and technique, as well as the acknowledgment of a factual difference between, on the one hand, the various genres of writing about art and, on the other, the processes and structures of visual representation in painting.

This study is not a comprehensive Vermeer monograph, but rather an analysis of Vermeer engaged with a historical problem. This is the unacknowledged problem at the core of most interpretations of Vermeer's art: the difficulty of locating this art and its interpretations in history. The fact that some of the most persuasive interpretations of Vermeer's work are largely anachronistic raises the question: How it is that Vermeer's art, as an art of the seventeenth century, has come to participate in certain cultural concerns, intellectual interests, and emotional needs of the later nineteenth and twentieth centuries? For example, can we know why Proust has Bergotte die in front of Vermeer's *View of Delft*? Why did Hitler, using political pressure, acquire Vermeer's *The Art of Painting* from the Czernin Collection in Vienna, first for his private collection and then, presumably, for his projected Linz museum?[14] The question "why" here has to do not only with these actions, but also with these paintings and furthermore, with their reputation, as established by traditions of writing about them.

In the context chosen here, the challenge of interpretation is based upon the recognition that meaning originates in more than one or two particular historical

moments. My own interpretations of certain Vermeer paintings will therefore consider not only aspects of the seventeenth century as the moment of his artistic practice but also the renewed interest in Dutch painting in general that led to the rediscovery of his work in the mid-nineteenth century, the late nineteenth- and early twentieth-century notion of the modernity of Vermeer's paintings, and the contemporary genre of art criticism that uses Vermeer as a point of departure for its self-reflection.

One reason for this intensive dialogue between the modern viewers of Vermeer – the travelers, writers, artists, critics, and theorists – and Vermeer's work is that before the nineteenth century there was no tradition of writing about his work. In other words, the often presumed "stillness," "silence," and "presence" of Vermeer's art is partly rooted in the fact that this art does not appear to have an original history, a "historical value" in the sense in which Riegl used the term. Instead, its historicity seems to be rooted in a later present and its construction, evocation, and imagination of a past. Vermeer's canonical status as a great painter was therefore established entirely within the concepts of art criticism developed during the period we call modernity. ("Modernity" refers here to a secularized historical consciousness and to the establishment of art criticism as first of all a bourgeois domain of judgment and intellectual self-assertion and then a field of teaching and research at the institutional level of research libraries and universities.)

These concepts, however, were first developed in the context of a general reappraisal of Dutch painting, particularly in Germany and France, and then used to build up a language, or languages, for the discourses on Vermeer. Ironically, their authors share not so much an awareness of the critical tradition itself as, on the contrary, a notion of "presence" in Vermeer; a presence, to be sure, that differs for each of them in their individual descriptions. The ambiguous phenomenon of an interpretive history of "presences" can be elucidated in an instructive way. It is striking that Vermeer scholarship to this day has often raised fundamental questions about art, methodology, and the responsibilities of the art critic, questions that have led to confrontational debates about these things. The heightened significance of Vermeer scholarship is itself the outcome of a certain competition among the legacies of three genres of writing about Dutch painting and about Vermeer. These genres of writing correspond to the three parts of my study:

Idyll

The first is rooted in the Hegelian tradition of perceiving an aesthetic unity between Dutch art and Dutch history, as well as one between the individual artist and his contemporary audience. In the nineteenth century the partly critical and partly sentimental retrieval of such a unity through the notion of the idyll figures strongly. The preservation of this retrieval in writings about Dutch genre paintings, in particular by de Hooch and Vermeer, in the early twentieth century (and even later) is striking. At the same time, this critical tradition was subject to questioning from several different viewpoints. Awareness of this tradition's two sides allows me to reinterpret some of Vermeer's genre paintings as "disturbed idylls."

Fiction

The second genre developed out of the French literary tradition of travel literature, art criticism, and fiction writing about Dutch art and Vermeer. Here accounts of color in Vermeer's paintings figure prominently, accounts that themselves stand in the tradition of orientalist writing in France. This part of my study is most concerned with Marcel Proust's interpretation of Vermeer's art, and of *View of Delft* in particular, in *Remembrance of Things Past*, an interpretation whose significance exceeds its narrative and thematic functions within the novel. My aim here is to give Proust's interpretation a context in the earlier French tradition as well as in turn-of-the-century formalist art criticism and psychologizing aesthetics.

Allegory

Here I return to the largely German genre of *Kunstwissenschaft*, a focus on the preoccupation in that tradition with adequate critical terminology and the authoritative interpretation of art; and with Renaissance and Baroque iconology, emblematics, and allegory, rather than any exploration of realism. This approach has obviously taken root in Dutch and American scholarship as well. My reexamination of various concepts of allegory, from Cesare Ripa to Walter Benjamin, with which this genre of criticism is linked, aims at an understanding of what I call the problem of interpretive authority in Vermeer's allegorical scenes, *The Art of Painting* and *Allegory of Faith*.

While I separate these three genres of critical writing for the sake of analysis, they are by no means isolated from one another. Whenever possible, I try to show their relations to one another and how these interconnections aid me to reinterpret Vermeer's paintings. As an example of this procedure I might name the problem of allegorical representation in Vermeer, a problem inherent in his paintings but also enhanced by the common perception that the presumed modernity of Vermeer's art must exclude the possibility of allegory proper. Whereas Vermeer's modernity is postulated primarily by the French tradition, it also occurs in some recent interpretations of Vermeer's *The Art of Painting* and *Allegory of Faith*, even when the term "modern" is nowhere mentioned. Only once this legacy is recognized is it possible to reconsider these paintings as allegorical paintings of the Baroque and to probe theories of allegory in relation to them. And only then is it possible to account for their peculiarity, be it called modern or not.

Each of these three critical genres associated itself with a certain kind of Dutch painting and, in Vermeer, with certain works. Like Rembrandt, but unlike most other Dutch painters of his generation, Vermeer did not specialize in one particular genre of painting but practiced several: portrait, genre proper, history and allegory, and cityscape. Thus, as each part of my study is devoted to examining one critical genre, within each I reconsider some of the paintings particularly associated with that genre. Through an assessment of the standards of each genre, its accomplishments, its selectivity, and its borrowings from the other two, I hope to provide an understanding of an element peculiar to Vermeer's art: that ill-defined temporal quality called "presence," or "stillness." As I shall argue, these terms may best be interpreted as the works' temporal openness.

"Presence," "instantaneity," "timelessness," and "stillness" are ubiquitous terms in the Vermeer literature. Appearing to be primarily temporal terms, their connotation often hovers between the temporal and the spatial, and also between identifying a quality in Vermeer's art and describing the viewer's aesthetic experience. These terms are sometimes used as "stand-ins" for the unfathomable ability of Vermeer's paintings to address the beholder. Sometimes these terms are further explained, mainly through spatial concepts, for example with reference to Vermeer's interest in spatial immediacy, and his presumed use of the camera obscura to achieve the optical effect of a certain spatial abruptness in his interiors. On the other hand, Vermeer's *The Art of Painting* and *View of Delft* are well known for suggesting at once historical distance and contemporaneity. Yet as I see it, questions of temporality are pertinent to Vermeer's entire oeuvre. The challenge to Vermeer scholarship, then, is not to dismiss the continued use of words such as "presence" and "timelessness" as old-fashioned and repetitive but to explore their vague statues and to attempt the articulation of the perceived temporal quality of Vermeer's art in terms of temporal concepts. Access to such concepts, to the immanent temporality of Vermeer's art and its ways of suggesting particular kinds of presence, as well as to its unusual historicity, is gained through the modern history of the artist's reception, the critical fortune of his works, and the languages developed over time to speak and write about Vermeer.

Analysis of how temporality in Vermeer's art is at work in Vermeer scholarship achieves quite different objectives. In the three parts of this book temporality is examined through the lens of the three paradigmatic figures Hegel, Proust and Benjamin at the same time that my critical engagement with them takes its course via Vermeer's art and Vermeer scholarship. As I show in the following chapters, interpretive conclusions and what one might call success differ between the two traditions studied here (the French and German), among the three genres of writing about Dutch art and about Vermeer informed by them (idyll, fiction, allegory), and among the paintings by Vermeer singled out here for interpretation (*The Girl with the Wine Glass, The Glass of Wine, View of Delft, The Art of Painting, Allegory of Faith*). As a consequence of how I have set up my study of these works, my interpretations of Vermeer's paintings do not amount to a synthesis of their ultimate meaning, as I do not think there is such a thing. On the other hand, if asked which of the three practices of interpreting Vermeer, and thus which of the three parts of this study, I consider most relevant to current Vermeer scholarship, I should choose Part III, Allegory. If asked which of the three practices I find most productive in analyzing the art value, to speak with Riegl, my answer is Part II, Fiction, the most purely hermeneutic of the three. And if asked which of the three practices I believe to be most critically engaged with the history of our discipline, my answer is Part I, Idyll. None of the three should be considered exclusive of the others; indeed, each should be considered in light of the others.

What finally is achieved by such attention to temporality in Vermeer's art? The short answer is that it helps us to understand the incompleteness of the project of interpreting Vermeer's paintings. The long answer, as a consequence, lies in the reader's response to what follows here.

Part I: Idyll

The German Reception of Dutch Art and Vermeer's Paintings of Social Life

Introduction

115. Eine Bauernlustbarkeit. Teniers.
Treffliches Bild.
123. Parnaß mit den Musen. Poelemburg.
Die Ferne ist wunderschön.
129. Ein Mädchen mit brennendem Licht. Dou.
Sehr schön und sehr geistreich.
268. Ein Bauer sperrt das Maul auf. Brouwer.
Geistreich.
299. Eine junge Kurtisane mit einem jungen Menschen. Vermeer.
Gut.

– Johann Wolfgang von Goethe, 1794

We are all familiar with titles of books, exhibition catalogues, and lectures in which the phrase "golden age" is used to identify seventeenth-century Dutch painting, often genre painting. However cliché-ridden such titles may sound, they refer to a complex tradition of writing about this art. On the German side of this tradition the idea of the golden age is bound up with the concept of the idyll.

In Germany the linkage between the idyllic and seventeenth-century Dutch painting may be said to date to the early eighteenth century, when, for example, August II's court festivals in Dresden included so-called *Wirtschaften*. These involved the transformation of the palace's orangery, the royal park, or the city's main square into the site of a peasant kermis, country wedding, or pastoral gathering, and of courtiers and citizens into costumed participants in these convivial events.[1] At the same time that the court and the city played at lowlife, a significant number of the Netherlandish paintings now in the Dresden Gemäldegalerie were acquired for the court collections. During his visit to the museum in 1794 Goethe annotated its first catalogue with laconic observations on individual works, often with particular attention to what he takes to be their idyllic elements, calling for

example Brouwer's peasant with his gaping mouth ingenious in the sense of amusing and edifying. Later, on the basis of such writings as Hagedorn's *Betrachtungen über die Mahlerei* (1762), Hegel's *Aesthetics* (1827–9) and Schnaase's *Niederländische Briefe* (1834), these notions of the idyllic and the Dutch golden age became part of a paradigm of exemplary bourgeois culture, imitated in the art and literature of the Biedermeier era and gradually absorbed into art scholarship.

Vermeer, however, seemed to fit only with difficulty, if at all, into the paradigm of the bourgeois idyll at the center of the German reception of Dutch painting. Why was this the case and what consequences did this difficulty have for Vermeer scholarship? To understand Vermeer's difference we must first identify an important aspect of the bourgeois idyll, as understood by Hegel and Jean Paul in their writings on aesthetics, that is, its critical dimension. This dimension helps us to understand how Vermeer's genre paintings differ from similar works by his contemporaries, notably de Hooch and ter Borch. An initial assessment of the idyllic may be useful. This will lead into a discussion of what in the German critical tradition has been the most crucial instance of debating the issues involved here, focusing on Vermeer's *The Art of Painting*.

The Negated Idyll

Just as the idyllic as an idea of everyday life has become suspect, so too has the idyll as a genre of writing and painting. There are good reasons for such skepticism. What are these reasons with regard to art? Within a primarily German cultural context, their best formulation may be found in Theodor W. Adorno's *Aesthetic Theory*, in which the author modifies his famous earlier statement that "to write poetry after Auschwitz is barbaric."[2] In his *Aesthetic Theory* he does not proclaim the end of art or the impossibility of seeking truth through art, but instead asserts the impossibility of any resting place in art. Good and important art may exist, yet it must be prepared to silence itself through its own self-critical negation.[3] Such negation is not simply a retraction, which would come close to undialectical "message art" or to the mere gesture, both rejected by Adorno. Instead, negation means risk taking. It is productive within the work of art, leaving its mark on it. Particularly challenging in Adorno is that he is as skeptical of irony as of idyll.[4] He regards the ironical use of the idyllic as a dubious practice. As we shall see, there is a strong link between irony and the idyll, as well as between humor and the idyll in the German tradition of aesthetics. This link plays an important, albeit neglected role in the art historiography of Dutch genre painting – and not only in Germany.

In order to illustrate Adorno's profound skepticism of art as an idyll, or a resting place, let us look at two images made in the German historical context from which Adorno's argument derives its urgency. These are Adolf Wissel's 1939 painting *Kalenberg Farm Family* (Fig. 3) and John Heartfield's 1935 photomontage *Hurrah! the butter is all gone* (Fig. 4). Wissel's painting may be seen as an attempt in the idyllic mode to present the exemplary Aryan farm family around the table outside their home: a prosperous middle-class family, the children blond, all six figures healthy, strong, self-conscious and yet earnestly immersed in a world supposedly within their grasp.[5] The style of the painting is a version of Neue Sachlichkeit, emphasizing an unsmiling rigidity that contradicts the tradition of the family idyll in nineteenth-

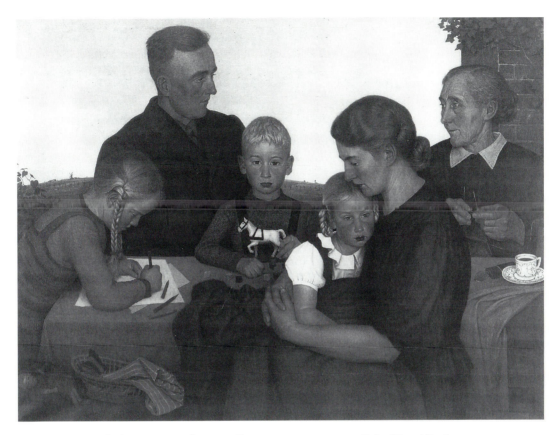

3. Adolf Wissel, *Kalenberg Farm Family*, 1939, oil on canvas, 150 x 200 cm, Federal Republic of Germany.

century German Biedermeier.[6] Carl Julius Milde's 1833 *Pastor Rautenberg and his Family* (Fig. 5) is an example of such Biedermeier painting. In *Kalenberg Farm Family* we may read this rigidity as expressive of something unseen in the image, as foreboding.[7] To use Adorno's term, one might speak of Wissel's painting as having a latent rather than an intentionally critical negativity.

It is easy to see this latency particularly when the painting is juxtaposed with Heartfield's photomontage. Heartfield assembles another exemplary contemporary family at home, emphasizing the members' togetherness during a meal. Yet he exposes what Wissel's iconography avoids in presenting his family at purposeful leisure, possibly after a meal. By substituting metal tools and other industrial objects for food, Heartfield exposes the implied misery of hunger and food shortage and the economic primacy of the war industry. Heartfield's distribution of "food" among the family members emphasizes their potential brutalization through the nutrition of propaganda. The family's youngest member feeds on an axe, a motif associated in Heartfield's iconography with National Socialism and in particular with Hermann Göring.[8] The wallpaper's swastika pattern, and the caption, "Hurrah, die Butter ist alle!"underscore the family's crazed, wholehearted participation in this disturbed and disturbing idyll. Heartfield's image is an intentionally critical one, but how can we describe its

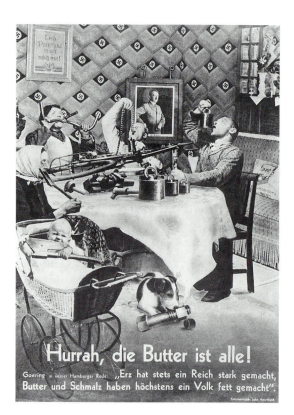

4. John Heartfield, *Hurrah! The butter is all gone*, 1935, photomontage, Heartfield-Archiv, Stiftung Akademie der Künste der Länder Berlin und Brandenburg, Berlin.

mode? One possibility is to call it a satirical treatment of the idyll. Such a description implies humor at the expense of the represented family as well as, perhaps, of artists like Wissel who painted family idylls.[9] This blend of idyll, humor, and the ingenious, (what Goethe in his annotations to the Dresden Gemäldegalerie catalogue calls *geistreich*) is traditional to German aesthetics.[10] This is not to suggest that Heartfield explicitly employed older traditions of conceptualizing the idyllic. By the time of Heartfield's image these traditions had no doubt simply become a part of his range of choices. Here, as always, we need to distinguish between the implied, ideal audience and the historical audience; the two may be identical but most likely are not. This is to say that the late twentieth century's revisionist art-historical gaze can be anchored in the image but not in Heartfield's concrete intentions.

In principle, these distinctions apply also to Wissel's painting. The boy's toy horse refers to playing at bravery and knighthood, but his play's supposed innocence has no resonance in his face. The mother may be consoling her daughter for a loss or sorrow of some kind. There is no eye contact among these glum figures, who sit around the table as if each was contemplating his of her fate in utter isolation. But this sad and tidy painting hardly functioned as a subversive image in 1939. On the contrary, it very likely functioned as a resting place.[11] What I have earlier called its latent negativity is thus to be distinguished from Adorno's later understanding of the conscious risk of negation in contemporary art. Such negation, based as it is on irony, seems to exclude the idyll altogether from its practice.[12]

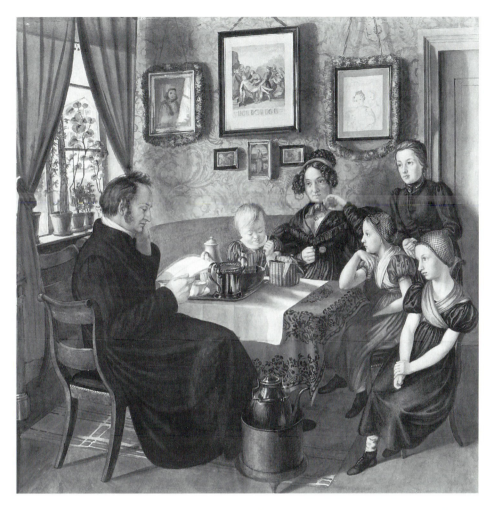

5. Carl Julius Milde, *Pastor Rautenberg and His Family*, 1833, watercolor, 44.7 x 45.1 cm, Hamburger Kunsthalle.

Adorno is concerned with the art of the present, not the art of the past, but this brief comparison of two family idylls in light of his skepticism toward art as a resting place suggests the possibility of a critical dimension in the idyllic work of art not only of the twentieth century but also of earlier times – as, for example, in Vermeer's depictions of scenes of social life. This critical dimension may be discovered in an analysis of such paintings, of their later art-historical reception as idylls, and of the ways that they are perceived to differ from the more familiar idea of the Dutch idyll. These possibilities are, or course, not alternatives to one another but interrelated. As an introduction to this complex issue let us observe a scholarly debate about Vermeer that took place in Germany early in the postwar period between the art historians Hans Sedlmayr and Kurt Badt. In this debate the paradigm of the idyllic is avoided and this conspicuous absence is very instructive.

The Denied Idyll

In the German scholarship on Vermeer, the exchange between Sedlmayr and Badt about *The Art of Painting* (c. 1666–7) (Pl. VII) stands out not only as an instructive controversy about the painting's meaning and about art-historical method, but also because of the intensity with which each author argued his position.[13] Badt's position was that of a phenomenologist; Sedlmayr proposed a structuralist method of interpretation. Each developed his method in the course of a hermeneutic circle in which Vermeer's canvas, titled *The Art of Painting* by Sedlmayr, and *Painter and Model* by Badt, becomes a vehicle for the proposed method of interpretation and also the proof for what the author desires to affirm. In the German academic context this controversy occurred at a time of widespread skepticism toward the traditional methods of historical interpretation. This skepticism led to renewed thinking about the need for an art history able, as Oskar Bätschmann later expressed it, to account for "art as the potential negation of a linguistically ordered world."[14] In the late 1960s and 1970s this meant a renewal of art-historical interpretation in Marxist, sociocritical terms, partly under the influence of the Frankfurt School. The German New Art History did not show any significant interest in Vermeer's art. This suggests that the earlier writings on Vermeer culminating in the Badt–Sedlmayr debate silently retained some of their authority in the absence of any critical analysis until the 1980s, when it began to be reviewed by von Mengden, Asemissen, and, more recently, Zaunschirm.

Today Badt's and Sedlmayr's interpretations of Vermeer's *The Art of Painting* do not seem, in their conclusions, so widely removed from one another. The authors' main differences lie in their procedures, in the degree to which they believe Vermeer's to be a secularized art, or an art of immanence, and in the challenge to the interpreter's self-legitimation that they see in this relative immanence.[15] Several aspects of this controversy about Vermeer are indebted to a German tradition of writing about Dutch genre painting rooted in Hegel's *Aesthetics* and in his reception of Diderot's writings. Two themes in the Badt–Sedlmayr exchange bear the imprint of this tradition. One is the perceived "presence" of Vermeer's work, the other is the comical as an element of its narrative mode.

Arguing that the work is a genre painting, Badt rejects the traditional title, *The Art of Painting*, calling it instead *Painter and Model*. He interprets Vermeer's achievement in it as a "transfiguration of the everyday," providing the painter himself and the work's beholders with the "experience of a timeless happiness."[16] Badt arrives at this interpretation in part by playing down the allegorical mode of the painting as something the artist did not seriously intend. He emphasizes the bourgeois interior (*bürgerliche Stube*) as Vermeer's setting here and as his artistic domain in general, and discovers humor in the represented female figure: "But the truly comical, even ironical thing is that she is presented to us at all as a model. This is absolutely linked with a disillusionment."[17] Vermeer's style, his "transfiguration of the everyday" and, in this sense, his illusionism, becomes linked with a comical "disillusionment" on the level of iconography, where Clio is revealed as a model.

Sedlmayr, on the other hand, proposes an interpretation of Vermeer's *Art of Painting* on the structural model of medieval biblical exegesis, the fourfold scheme of interpreting scripture: literal, allegorical, moral, anagogical. He bases this proposal

on Dante's letter to Can Grande della Scala, in which the exegetical method is transferred from scripture to art.[18] Simplifying the scheme and the interpretation, Sedlmayr suspends the moral sense. This step is quite problematic in view of Sedlmayr's 1948 publication *Loss of the Center* (*Verlust der Mitte*), in which he takes secular modernity to task for most of the evils that have beset Europe in recent history.[19] Sedlmayr concludes for Vermeer's *The Art of Painting*: "The first meaning of the image is the 'literal,' 'realistic' (Vermeer paints a model), the second the allegorical (the art of painting the fame of Holland), the third the spiritual and free of time."[20] The third level of meaning is quite obviously the one most important to Sedlmayr. He explains its contents in experiential terms: "Deep silence . . . a high spiritual silence fills the room: the silence of pure contemplation, of the high moment. Listening to the picture one cannot hear a sound. And yet this 'hermetic' silence is secretly alive. [Alive] with the solemnity of a feastday, like the silence of an illuminated church interior. This light . . . reveals the pure existence of things and transfigures the world."[21]

Sedlmayr's idea of a pure, religious existence invoked in Vermeer's painting stands against Badt's proclaimed Heideggerian acceptance of the impurity of existence, which he believes is opened up in art toward the experience of pure being. For him, the representation of this possibility in art is the task of interpretation. In a tautological phrase he calls the theme as well as the interpretation of Vermeer's *Painter and Model* "celebration through praise" ("Feiern durch Rühmen"). For both critics, interpretation is essentially representation, not critique. For Sedlmayr, however, this representation results in an assertion that Vermeer knew and offered a Christian, mystical experience of light. Whereas Badt's understanding of Vermeer's "transfiguration of the everyday" requires as its prerequisite the humorous, even ironical presentation of allegorical ideas, Sedlmayr's understanding of the painting's "solemnity of a feastday" explicitly accepts allegory and excludes the possibility of humor: "And yet all attributes of Glory, except for the laurel wreath, are negated, almost as in a travesty, and to some beholders this has – very mistakenly – appeared as slightly comical."[22] For him this negation is a function not of the comical but of the sublime.

On a certain level, humor and irony are also a thorny issue for Badt. He had spent a major part of his career writing on what may be called the classical, objective tradition of art – Veronese, Poussin, Cézanne – and had attempted to bring Heidegger's phenomenology to bear on an understanding of this tradition; his incorporation of Vermeer into the classical tradition via a phenomenological approach, while not surprising, is slightly flawed.[23] By including the topic of humor and even irony in his discourse, Badt invokes the subjectivity of art and its perception, something that in the introduction to his study he explicitly rejects and that he contends is at the basis of the Sedlmayr interpretation he disputes. Moreover, Badt is unsure whether he should take Vermeer's attitude to be humorous or ironic. The first is associated with an artistically naive engagement with the world, the second with a reflective dissociation from it in the tradition of German aesthetics. The relation between this issue of humor and irony and thus of subjectivity and the presumed objective, heightened presence of Vermeer's image in Badt's and Sedlmayr's interpretations bears some examination.

Both Sedlmayr and Badt agree that *The Art of Painting* accomplishes a transfiguration of the world. But they disagree about the nature of this world, about the quality of existence in it, and about the agent of this transfiguration. For both authors this agency is represented to some extent by the individual artist Vermeer. But what for Sedlmayr is ultimately a representation by virtue of divine grace is for Badt an immanent capacity of the world, namely, the transfiguration of itself through art and only in art. As an act of representation, transfiguration is for both authors essentially related to the painting's "presence." It unfolds before each beholder who contemplates Vermeer's *The Art of Painting*. But the authors differ again in their definition of this presence. For Sedlmayr "presence" is not art's essential atemporality but the instantaneous liberation from temporality, a liberation of both the art and its beholder. He coins the word *zeitfrei*, free of time, for the sake of emphasis. The *Zeitfreie* stands opposed to the *Zeitgebundene* of allegorical iconography, to what is bound by time, to what is historical. The *Zeitfreie* overcomes the *Zeitgebundene*. It does so not by transfiguring the historical, or *Zeitgebundene* – here, seventeenth-century Holland – but the "literal," which is temporal but not historical: "Vermeer paints a model." In Sedlmayr's view the "literal" is the situation of an artist painting a model: it happens all the time, is always understood, will always be the same.[24] The "literal" alone can be transfigured into the *Zeitfreie*, and in tandem the two leave history behind.

Badt, on the other hand, assumes the immanence of Vermeer's art and world, but has little interest in their historicity. Thus, he emphasizes the temporality of the everyday as a temporality whose accessibility is unproblematic. He understands the transfigured everyday as the "experience of timeless happiness." As time for him is an unproblematic conflation of historicity and temporality, a conflation he calls earthly existence (*irdisches Bestehen*), he further identifies the timeless in Vermeer's painting with what he calls presence: time at a standstill He then construes this "standstill" as a reflection of eternity – a reflection, to be sure, not a revelation. In Badt's view the presence of Vermeer's depicted world collapses all other notions of time, including the historical specificity of earthly existence then and now. Badt adds that the character of Vermeer's picture as a "document of wisdom" extends also to paintings by de Hooch, ter Borch, Metsu, Saenredam, Kalf, and others, paintings that in his words bear witness to a general manly virtue (*männliche Güte*) in seventeenth-century Dutch painting. By this inclusion of other painters he asserts that his discourse is not about individual subjectivity.[25]

The ways in which both Sedlmayr and Badt describe their alternatives to a historical interpretation *of* painting by actually bracketing the historical as something transcended *in* painting is productive for their accounts of what is essential in art. But by using Vermeer to this end, neither clearly reflects his relationship to the German tradition of aesthetics, whose appointed task it was to address both the historical and structural aspects of art. Moreover, Badt's references to collective wisdom and immanent transfiguration in combination with the comical and ironic make an association that Sedlmayr's religious transcendence means to deflect, but to which both authors nevertheless come close in their account of Vermeer: the idyllic, the homey, the withdrawal into privacy that is one aspect of the German reception of Dutch painting. That this fierce academic debate of the early 1960s might be thought

of as a debate about the right way *not* to invoke the idyllic seems at first in itself slightly comical. However, when seen in the light of Adorno's skepticism toward art as a resting place, the two authors' notions of presence begin to appear problematic.[26] Their attempt to provide an ahistorical definition of genre painting, or of the genre aspect of this particular painting by Vermeer, should be kept in mind as we turn to a discussion of Vermeer's genre paintings. But before entering into this discussion it is necessary to address Hegel's aesthetics of painting, and of Dutch painting in particular, in relation to Jean Paul's account of the comical, of what he calls the Netherlandish mode of narration, and of the idyllic. We must then examine the reception of these writings in modern German scholarship on seventeenth-century Dutch art and, specifically, on Vermeer.

Chapter I

Hegel's Legacy to German Scholarship on Seventeenth-Century Dutch Painting

Hegel

In his *Aesthetics: Lectures on Fine Arts* Hegel expresses a high esteem for the "romantic" and "subjective" Dutch school of painting, which he recognizes as an art reflective of its own historical present.[27] He distinguishes, within the practice of pictorial representation, between the activities of a creating (*Vorstellung* and *Darstellung*) and a beholding subjectivity (*Vorstellung*), while also pointing to their conceptual interdependence. To describe the dialectics of representation he uses the terms "appearance" (*Schein*) and "inwardness" or "interiority" (*Innerlichkeit*). "Appearance" extends both temporally and spatially without determinable limits. The value associated with it is freedom. The term is used throughout Hegel's *Aesthetics*. Here I will focus on its function in his section on painting and in the passages devoted to Dutch painting of the seventeenth century.

Seventeenth-century Dutch painting is treated three times in Hegel's *Aesthetics*: in Part 1, in the section on the relationship of the ideal of beauty to nature (H. vol. 13: 214–24; K.: 161–71); in Part 2, in the section on the dissolution of the romantic art form (H. vol. 14: 223–9; K.: 595–600); and in Part 3, in the section on the historical development of painting as a romantic art (H. vol. 15: 123–31; K.: 882–7). In all three sections it is clear that Hegel recognizes and esteems in Dutch painting the artistic mastery of a tension between individual and world, between internal and external existence. In the paintings this tension is described as the mediation between their realistic subject matter and their ideal representational appearance. By "representational appearance" Hegel means not only the virtuosity of Dutch painting as such, its capacity for producing illusionistic deception by capturing the most fleeting phenomena, but also the self-absorption of representation. He calls this self-absorption "pure appearance which is wholly without the sort of interest the subject matter has" (H. vol. 14: 227; K.: 598). The key phrase here is, literally, "disinterested appearance" (*interesseloses Scheinen*), a reference to Kant's terminology in *The Cri-*

tique of Judgment. Hegel shifts Kant's "disinterested pleasure" (*interesseloses Wohlgefallen*) from the judgment of beauty in art to the nature of art in general, and of Dutch painting in particular, and at the same time to the nature of representational practice. In doing so, he echoes the notions of "pure pleasure" (*plaisir pur*) versus "natural pleasure" (*plaisir naturel*), and of "interest" (*intérêt*) in classical French art theory, particularly that of the Abbé Jean Baptiste Dubos and Denis Diderot.[28] Hegel's debt to French art theory becomes clear in his concept of *Farbenmagie*, or color magic, discussed below. In general, Hegel makes much use of a French art-critical terminology, which he reinterprets in such a way that the polarity of affect and reason becomes dialectically mediated. In the case of his use of the phrase "disinterested appearance," this mediation relates to his view that while in Dutch painting representation is apparently absorbed in its subject matter, in fact it is primarily, if unconsciously, absorbed in the act of representation as such. "Disinterest," then, is neither a quality of the subject matter nor of the artist nor of the beholder alone. Instead, these separate qualities naively merge into a relationship and a shared attitude, which shows itself, or appears, in representation.

In the third section of Part III of his *Aesthetics,* "The Romantic Arts," i.e., the arts of the entire Christian era, the chapter on painting precedes those on music and poetry, because painting qualifies as the most material and concrete of all three. To the degree that the romantic art form is realized at all in painting, Italian painting of the Renaissance is the supreme and ideal representation of Christian subject matter for its own sake. But in one respect Netherlandish painting receives higher marks from Hegel, that is, in its free representational appearance. According to Hegel the content of painting is "subjectivity aware of itself," which means that it is the artist's visualization of the inner, emotional reflectedness of the work's given subject matter (H. vol. 15: 24; K.: 802). Of the historical schools of painting, Italian art requires Christian iconography and Roman Catholic doctrine as its external and internal reference, whereas Protestant Netherlandish painting no longer requires either iconography or doctrine. As this central religious reference "now falls away" (H. vol. 15: 127: "jetzt fortbleibt"), genre painting takes its place. Hegel uses the term *Gattungsmalerei* for painting categorized by subject, such as portrait, scenes of social life, landscape, marinescape, still life. Far from diminishing the spirituality and reflexivity of painting, this process liberates them in Hegel's eyes. It is in ordinary subject matter, in the insignificant detail of empirical reality that the artist creates all the more poignantly the effect of inwardness or interiority, making perceptible and transparent his own inner relationship to the world: "not only a mere copy of these external things but at the same time himself and his inner soul" (H. vol. 15: 26; K.: 804). As that world is attended to in its details, the awareness of its limitations and of the infinity of the "spiritual inner life" grows, resulting eventually in the "apex of personal independence" (H. vol. 15: 24; K.: 803). As a consequence, Hegel does not distinguish among genres in Dutch painting in a hierarchical manner. Still, his interest is clearly in depictions of social life and explicitly in scenes with lively and active figures. He names "peasant life and the down-to-earth life of the lower classes," with their "naive cheerfulness and jollity" (H. vol. 15: 130; K.: 886f.). It is with reference to the appearance of "utterly living absorption in the world and its daily life" in these scenes that Hegel ends with his famous phrase: "It is the Sunday of life which

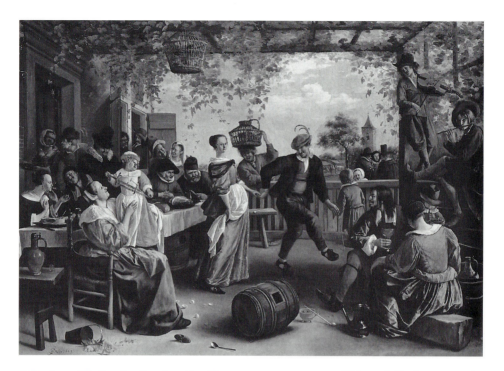

6. Jan Steen, *The Dancing Couple*, 1663, oil on canvas, 111 x 145.4 cm, Widener Collection, National Gallery of Art, Washington, D.C.

equalizes everything and removes all evil" (H. vol. 15: 127, 130; K.: 884, 887). Examples for the art he has in mind are Jan Steen's *The Dancing Couple* of 1663 (Fig. 6) and *Card Players Quarreling* of c. 1664 (Fig. 7).

Inseparable from this understanding of painting, and of Dutch painting in particular, are its material means: paint and its inherent capacity for representation, for "coloristic appearance" and "color magic" (*Farbenschein, Farbenmagie*). These are the terms Hegel borrows from Diderot, whose *Essays on Painting* of 1765/95 he quotes from Goethe's fragmentary translation into German of 1799.[29] In his essay on color, Diderot uses the word "magic" in the context of discussing the notion of *clair-obscur* to describe the irresistible affective power of color over the beholder.[30] His example is a painting of a lady in a white satin dress. Referring perhaps to this passage, Goethe used ter Borch's so-called *Paternal Admonition* (c. 1654–5) for the enactment of a tableau vivant by the protagonists of his 1809 novel *Elective Affinities* (Fig. 8).[31] Goethe specifies that they enact the scene as engraved by Johann Georg Wille and exhibited in the Salon of 1767. Wille was a very successful German printmaker and art critic living in Paris who was well acquainted with his neighbor Diderot; he introduced the Frenchman to Christian Ludwig Hagedorn's *Betrachtungen über die Mahlerei* (1762), which may have influenced the *Essais*.[32] Of particular interest to both Diderot and Hegel may have been Hagedorn's discussion of Dutch genre painting and his emphasis there on the "true naivety, the expression of the heart" and the "entirely original beauties" in the art of ter Borch and Steen – an art that he takes to have "its residence appropriately in bourgeois society."[33] Hagedorn

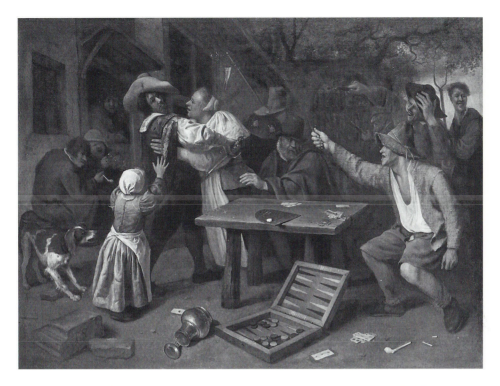

7. Jan Steen, *Card Players Quarreling*, c. 1664–5, oil on canvas, 90 x 119 cm, Staatliche Museen zu Berlin, Preußischer Kulturbesitz, Gemäldegalerie.

also speaks of these artists' "magic of color" (*Zauberey der Farben*).[34] Obviously, the tracing of the history of art-critical concepts to their origins is a very complicated task; here it is sufficient to compare the usage of "color magic" in Hegel and Diderot. Diderot uses the term "magic" not only for skillful imitation of the sheen of textiles but explicitly for an affective quality in color, "a seductive charm which attracts the beholders, arrests them with satisfaction and prompts them to admiration and astonishment."[35]

The term *Farbenmagie* reinforces Hegel's understanding of appearance, since it is the term by which he links the materiality of painting to its spiritual content. The praise of technical quality in Dutch painting, which, as Peter Demetz has shown, became an isolated function in apologies for this art, is directly and positively related in Hegel's thinking to the art's subjectivity and to the degree of freedom achieved by the Dutch artist's absorption in his representational practice.[36] Achievement of *Farbenmagie* – and according to Hegel, here "the Dutch too were the greatest masters" – is the achievement of "pure appearance of animation; and this is what constitutes the magic of colouring and is properly due to the spirit of the artist who is the magician." Hegel himself defines *Farbenmagie*:

> This magic of the pure appearance of colour has in the main only
> appeared when the substance and spirit of objects has evaporated and
> what now enters is spirit in the treatment and handling of colour. In

8. Willem ter Borch, *Paternal Admonition*, c. 1654–5, oil on canvas, 70 x 60 cm, Staatliche Museen zu Berlin, Preußischer Kulturbesitz, Gemäldegalerie.

general, it may be said that the magic consists in so handling all the colours that what is produced is an inherently objectless play of pure appearance which forms the apex of colouring, a fusion of colours, a shining of reflections upon one another which become so fine, so fleeting, so expressive of the soul that they begin to pass over into the sphere of music (H. vol. 15: 80; K.: 848).

Significant for the present context of Vermeer's paintings is Hegel's account of what in contemporary reception aesthetics is called the implied beholder.[37] If we keep the above definition of *Farbenmagie* in mind, a definition that seems to anticipate the relatively abstract painting of Romanticism, it would appear that the beholder is no

longer implied in the subject matter of painting at all. This possibility is of great consequence for the discussion of Vermeer. Hegel sees the beholder as having a share not only in painting's subject matter but in its color magic as well. Even if one accepts Adorno's assessment of Hegel's aesthetics as an aesthetics of content, it is necessary to see that for Hegel – as, in fact, for Adorno – the content of painting is brought forth by the reflective practice of painterly technique, a practice Hegel defines as the "disinterested" act of painterly representation. Only if we keep Hegel's understanding of painterly practice in mind will we avoid the content–form dichotomy of later accounts of Dutch art and learn from these earlier writings. Hegel writes:

> [I]n painting the content is subjectivity, more precisely the inner life inwardly particularized. And for this very reason the separation in the work of art between its subject and the spectator must emerge and yet must immediately be dissipated because, by displaying what is subjective, the work, in its whole mode of representation, reveals its purpose by existing not independently on its own account but for subjective apprehension, for the spectator. The spectator is as it were in it from the beginning, is counted in with it, and the work exists only for this fixed point, i.e. for the individual apprehending it (H. vol. 15: 28; K.: 806, trans. altered).

This idea of the implied beholder not only relates to the artist's practice, it also defines the beholder's authorship as an authorship that goes beyond the reconstruction of something already complete prior to its apprehension. In other words, in being dialogical and dialectical from the outset, artistic practice lacks closure. That much seventeenth-century Dutch painting appears so very finished – and here again we can look at the Steens and the ter Borch as examples of high finish (Figs. 6, 7, 8) – turns out to be yet another aspect of Hegelian *Schein*, or semblance, appearance, illusion. Of course, the works are indeed highly finished if by "finish" one means their show of skill and surface value. But if Dutch painting is quintessential painting in Hegel's sense, then it is never a finished (completed) product but instead a process animated through color magic. The beholder reflects the subject matter in its realization through color magic as something animated, developing, and unfolding. Hegel's model of the artist's and the beholder's respective participation is decidedly not that of producer versus consumer/receiver. The artist, of course, executes the work, but not as a mastermind fully in control of both his intentions and the beholder's anticipated reaction. Hegel's description of subjectivity's inner particularization and external absorption in a limited life world excludes any notion of a work's complete preconception or its creator's complete control. Since freedom is the ultimate goal, the idea of "personal independence" in the romantic art work relates as much to the viewer as to the painter. The viewer may experience this independence by an attentive absorption in the painting – in the subject matter as much as in its color magic. Hegel observes, in this context, how in the process of beholding a humble scene or some insignificant detail in a painting one is concentrated and attentive in a way impossible in an everyday encounter with those objects themselves, in which they are either overlooked or categorized by their use value or, to use

the French term, by the observer's "natural interest" (H. vol. 15: 63–5; K.: 835f.).

In Hegel's understanding of the "disinterested appearance" of the everyday in art, the aesthetic apprehension is conceived as a heightening of mental activity and emotional attachment. If, in view of this understanding of the content of painting, we reconsider Hegel's passage on the "Sunday of life" in Dutch painting, we see that it makes a clear association between tolerance and conciliation. This tolerance is historicized in two ways by Hegel. First, it is seen to evolve from the "civil and religious independence" of the Dutch nation; second, it is seen as something entirely different and missing from the cultural products of Hegel's own times. Of course Hegel's perception of a homogenous seventeenth-century Dutch middle-class population is flawed. For example, the Steens and the ter Borch chosen to illustrate his views clearly show a stratification within this middle class and an opposition of city and country. On the other hand, Hegel's simplification of the Dutch historical and cultural situation allows him to address the historical difference between his present and the Dutch past. Thus, he believes that it is the role of the comical to express the tolerance and openness of Dutch culture in the practice of painterly representation:

> In the Dutch painters the comical aspect of the situation cancels what is bad in it, and it is at once clear to us that the characters can still be something different from what they are as they confront us in this moment. Such cheerfulness and comicality is intrinsic to the inestimable worth of these pictures. When on the other hand in modern pictures a painter tries to be piquant in the same way, what he usually presents to us is something inherently vulgar, bad, and evil without any reconciling comicality. For example, a bad wife scolds her drunken husband in the tavern and really snarls at him; but then there is nothing to see, as I have said once before, except that he is a dissolute chap and his wife a drivelling old woman (H. vol. 15: 130; K.: 887).

In order to gain a more precise understanding of Hegel's negative judgment of contemporary genre painting we should study the catalogue of the 1828 Berlin Art Exhibition, for much of his critique of modern painting throughout the *Aesthetics* is based on his reflections on the works shown there.[38] While we can identify some genre paintings in this show, none really comes close in subject to Hegel's "bad wife." What we do find, however, are several copies of seventeenth-century Dutch paintings and works done in the manner of Honthorst, Brouwer, Ostade, de Hooch, and Netscher.[39] Between 1805 and 1840 copies in oil after Netherlandish and Italian masters accounted for between 10 and 17 percent of the works on view at the Berlin Art Exhibitions.[40] Two very prominent artists of the "neo-Dutch" type were Eduard Lebrecht, alias Pistorius (1796–1862) and Theodor Hosemann (1807–75). Pistorius, for example, contributed five "original" genre paintings ("sämmtlich eigene Erfindung") to the 1828 exhibition, one of which bears the title *A Lady in a Satin Dress at Her Toilet, Seen from the Back*, an obvious imitation of ter Borch or van Mieris the Younger. He is also known to have copied the Dutch masters during and after his visit to the Netherlands in 1827.[41] The genre painter and book illustrator Hosemann became the quintessential Berlin humorist, who, after finishing his training at the

9. Theodor Hosemann, *Vagabonds*, location unknown.

Düsseldorf Art Academy, specialized in very local lowlife scenes, drawing on Dutch genre paintings of all social classes.[42] To illustrate Hegel's judgment, we might compare Steen's *Card Players Quarreling* with Theodor Hosemann's *Vagabonds*, a work probably dating to a decade later than Hegel's unnamed example (Figs. 7 and 9).[43] Hegel might say about this work that the vagabonds are just good-for-nothings and that this is emphasized in the contrasting figure of the dutiful policeman questioning them. But in his view the contrast between the figures in no way redeems Hosemann's scene which thus does not deserve to be judged truly comical. Or we might compare ter Borch's *Paternal Admonition* with Hosemann's *The Caretaker as Father* of 1847, evidently modeled after the ter Borch, with a supposedly amusing shift in social class (Figs. 8 and 10).[44] Hosemann is showing off his knowledge of Goethe's "misinterpretation" of ter Borch's picture which, however, was still accepted by the art historian and director of the new Berlin art museum since 1830, Gustav Friedrich Waagen (1794–1868), in the 1851 edition of his guide to the Königliche Gemäldle-Sammlung.[45] Hosemann "reveals" the ter Borch as a scene of prostitution, and thereby also takes away everything worth seeing. What remains, if one takes Hegel's viewpoint, is a scene that borrows the three figures' double identity of father and customer, mother and procuress, daughter and prostitute from ter Borch, but without any trace of the playful oscillation between identities, or between roles and identities, in the original that allowed Goethe to call the scene "Paternal Admonition."

Hegel's negative critique of such art applies to its approving modern beholders as well. Lacking the dimension of *Schein*, these beholders too cannot "still be some-

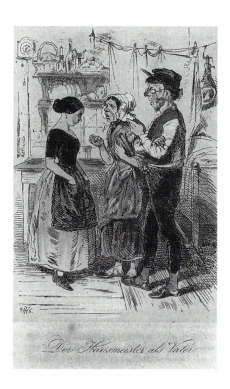

10. Theodor Hosemann, *The Caretaker as Father*,
1847 Staatsbibliothek zu Berlin, Preußischer Kul-
turbesitz.

thing different from what they are as they confront" the neo-Dutch painting "in this moment." In contrast, the *Schein* of Dutch seventeenth-century painting is its true character. It is an ideality with a material basis, an ideality earned through real historical and cultural accomplishments, above all the Dutch war of independence. If simulated, as happens in the nineteenth-century German genre painting of the Düsseldorf school of painting Hegel describes, the result is nothing at all, because such unity of art and culture is lacking.[46] Whereas he rejects contemporary German painting for its misguided imitation of an art of the past, Hegel is rather confident that he can enter that past art and partake of the subjectivity of seventeenth-century Dutch painting. Thus, Hegel claims that Dutch painting is a painting of its own time, yet capable of renewing its original historical presence in the encounter with the modern beholder – provided, however, that the modern beholder is willing to reflect his own time in it; or, to use Hegel's terms, provided that the beholder allows the *Schein* of Dutch painting to illuminate and expose that present. This lesson may be the function of Hegel's remarks on modern genre painting and its falsity.

Jean Paul, Hegel

The role of humor is not throughout a positive one in Hegel's account of the romantic arts; this is also true for their subjectivity. As much as he praises humor in his section on the Dutch masters, Hegel also has important reservations about some of humor's potential, depending on its historical circumstances. This modification is again worked out with reference to the Dutch.

The second of the three passages on Dutch painting, the one occurring in the subsection called "Dissolution of the Romantic Form of Art," bears the title "The Subjective Artistic Imitation of the Existent Present." In it Hegel states that "it is Diderot especially who has insisted in this sense on the naturalness and the imitation of the present" and asserts again:

> Yet if we wish to bring to our notice the most marvellous thing that can be achieved in this connection, we must look at the genre painting of the later Dutch painters. . . . Satisfaction in present-day life, even in the commonest and smallest things, flows in the Dutch from the fact that what nature affords directly to other nations, they have had to acquire by hard struggles (H. vol. 14: 225–9; K.: 597f.).

This is to say that among the Dutch such struggle renders marvelous and cultural what elsewhere might be considered simply common and natural. He continues by praising their works and then ends with the observation that if "it is the stark subjectivity of the artist himself which intends to display itself," then "art . . . becomes the art of caprice and humor" (H. vol. 14: 229; K.: 600). This ending turns out to be a negative judgment of humor on Hegel's part. No longer the result of a naive, absorptive and tolerant immersion in the world of the "existing present," with "the later Dutch painters" humor serves to dissociate them from that world. "Disinterested appearance" turns into apparent self-interest. This is to say that Hegel's Dutch painter remains throughout a romantic subject. Incapable of comprehending himself completely and to this degree subjectively free, he must also gradually lose his naivety and become aware of a sense of the inadequacy of his life world to his own infinite consciousness and vice versa. The painter's awareness of this inadequacy becomes associated with the very subject matter and style of his paintings in an obvious manner. It reveals itself in the narrative mode of humorous detachment from the subject matter of his life world or in a shift from highly finished representation to a consciously self-expressive style.

This detachment also lies at the root of Hegel's critique of Romantic subjectivity in the sense commonly used, that is, as a name for a way of thinking and for much of the art produced in the decades around 1800.[47] The loss of naivety is the subject of a discussion of "Subjective Humor," in which Hegel very briefly accounts for the phenomenon of Jean Paul (actually Johannes Paul Richter, 1763–1825), one of the most important fiction writers of Hegel's time and certainly one of the most original writers in German literature altogether:

> So with us Jean Paul, for example, is a favourite humorist, and yet he is astonishing, beyond everyone else, precisely in the baroque mustering of things objectively furthest removed from one another and in the most confused disorderly jumbling of topics related only in his own subjective imagination. The story, the subject-matter and course of events in his novels, is what is of the least interest. The main thing remains the hither and thither course of the humor which uses every topic only to emphasize the subjective wit of the author (H. vol. 14: 230; K.: 601).

It is in Hegel's account of Jean Paul that we see the connection made between what may be called an extreme case of the Dutch style of humorous "self-indulgence" (*Sichnachgeben*), the artist's simultaneous re-creation and undoing of a familiar world, and the idyllic and sentimental: "[H]umor readily slips into what is sensible and sentimental, and of this too Jean-Paul provides an example" (H. vol. 14: 231; K.: 602). The distinction between the earlier naively humorous and the later self-indulgently humorous Dutch painter, or the neo-Dutch author Jean Paul, is that "[t]rue humor . . . requires great depth and wealth of spirit in order to raise the purely subjective appearance into what is actually expressive, and to make what is substantial emerge out of contingency, out of mere notions" (H. vol. 14: 231; K.: 602). What is lacking in Jean Paul, one might conclude, is the sincerity of color magic and its presentation of "great depth and wealth of the spirit." Thus Hegel distinguishes between true and false appearance, between true and false humor, and between true and false affirmation of the present in art in his three accounts of Dutch painting. Recognizing that it would be wrong to align Jean Paul with the modern genre painter he scorns, Hegel assigns him a place nearer to those unnamed "later Dutch painters" whom I take to be mainly painters of the last quarter of the seventeenth century.

This is not the place to speculate what in literary writing might be the analogue to Hegel's *Farbenmagie*.[48] But it is possible to inquire further into the functions of humor as Jean Paul himself understood them. In his fiction Jean Paul engages in the sentimental retrieval of true and naive humor, accepting more fully than Hegel the historical distance between himself and the Dutch. As a consequence of this awareness of historical distance, he uses humor, along with irony and satire, for the sake of a scathing criticism of the provincial particularism that characterized the German society and politics of his day.

In the amplified second edition of his *Preschool of Aesthetics* (*Kleine Vorschule der Ästhetik*) of 1812 (the first edition is from 1804), Jean Paul makes several references to Dutch art. In paragraph 72 on the three schools of the novel, the Italian, the German, and the Dutch, he distinguishes the first as the school of an elevated style, citing no Italian examples but instead French and German works, including Goethe's *Sorrows of Young Werther* and his own masterpiece *Titan*. The second, intermediate style includes the German *Bildungsroman* and for this he mentions Goethe's *Wilhelm Meister*, his own *Siebenkäs* and *Flegeljahre*, Fielding, Sterne, and Diderot. The third, Dutch school of the novel is a low form in which he again includes Sterne and himself, citing his *Leben des Quintus Fixlein*, among other works. Hegel's connection of the naive with the true was indebted to Diderot, who also called the naive the "voisin du sublime."[49] But while Hegel further related the true and naive to the comical and applied these terms to Dutch lowlife painting, he did not take up Diderot's suggestion of the proximity of the naive to the sublime, and thus of the comic to the sublime. This is precisely what Jean Paul does. He proceeds to define "the low as the inverted high (altitudo)," considering both the "high" and the "low" equally conducive to the poet's wings. The intermediate level is difficult, its hero taking up "neither the sublimity of the figures of the Italian form nor the comical, or even serious depth of the opposed Netherlandish form."[50] Sometimes, he notes, a novel encompasses all three styles, "as in a picture gallery," naming again his own *Titan* as an example. This is only possible, he maintains, if the comical

is not expressed by the poet but instead by a "Dutch" character in the novel. In terms of Hegel's distinctions between true, naive humor on the one hand and destructive, self-indulgent humor on the other, Jean Paul explicitly aligns himself here with the former. In the long run, however, he will adopt a synthesis of the two, called "humorous contempt of the world."[51]

It is in the next section, in paragraph 73 on "The Idyll," that Jean Paul tries to come to terms with this hybrid form. He defines the idyll as "the epic representation of *complete happiness* in *limitation*."[52] This limitation may regard material goods, social rank, and horizon of insight. The site of the idyll may be the Alps, Tahiti, the rectory, the fishing boat, the flowerbed, the fenced-in garden – in short, anywhere. But the scale of the idyll on all levels – extent, number of inhabitants, implied larger world – must be contained and rather small. This condition is comparable to Hegel's condition for the spirituality of seventeenth-century Dutch art, namely, that the paintings be very small. For otherwise they could lead the beholder to respond to their limited subject matter not as appearance and metaphor but as an unacceptable claim to real importance (H. vol. 13: 224; K.: 170f.). Jean Paul categorizes his own short novels in the Dutch style as "indisputably" belonging to the genre of the idyll. Literary critics have agreed with him in this, albeit with the persuasive qualification that his idylls are "gestörte Idyllen," disturbed idylls.[53] What disturbs these idylls is the presence of the social and historical conditions from which they are wrested and which they comically reflect, specifically, the German "Duodezstaat" (Duodecimo State) of the eighteenth and early nineteenth centuries. In short, what disturbs them is their own critical dimension, something Hegel evidently did not perceive in Jean Paul's writings. This oversight is in keeping with Hegel's judgment of Jean Paul's bizarre metaphoric language as "baroque," by which he meant that it was arbitrary as opposed to the true seventeenth-century Dutch style.

In his autobiography, the *Selberlebensbeschreibung* of 1818–19, Jean Paul analyzes his preference for the idyll as indicative of his "own inclination toward the homey, the still life, and spiritual nest building." Here we may again think of Milde's family "nest" (Fig. 5) with its depitction of the pastor reading aloud something edifying to the women of the household, the little child at play, family portraits and the reproduction of Raphael's *Deposition* above the sofa, the potted plants on the windowsill.[54] But although Jean Paul, like Milde, subscribes to a taste for bourgeois privacy widespread in the Biedermeier era after the Congress of Vienna, his own understanding of the idyllic and the Dutch style in his fiction and in his *Preschool* differ significantly from this bourgeois complacency. The restlessness and the critical dimension noticable even in Jean Paul's idylls seem to be missing from Hegel's notion of Dutch art as an art of affirmation, as an "imitation of the existent present." Thus the most fundamental difference between the two authors is that of temporal sequence. In Hegel's account the Dutch style of "satisfaction in present-day life" is literally conservative, albeit a conservatism justified by the Dutch people's hard struggles for freedom, which preceded this artistic practice and in fact made it a practice of conciliation. As such a struggle had obviously not taken place successfully in the German states, Hegel dismissed any "neo-Dutch" style in Germany as "nothing at all." Jean Paul drew a different conclusion from the historical situation

and tried to integrate a satirical critique of the state of affairs with a humorous re-conciliation to it. To Hegel's emphasis on the preservation of the "high" (successful historical struggle) in the "low" (genre painting) through "true humor" contrasts Jean Paul's definition of the "low as the inverted high" and his description of the Dutch form of the novel as "comical or even serious depth." This is to say that the "low as the inverted high" might promise hope for a historical struggle to come. Hegel's *Aesthetics*, written a decade later, makes no reference to such a hope.

Jean Paul's paragraphs on humorous poesy are entirely in keeping with this variance. In paragraph 32 on "Humorous Totality" he writes: "Humor, as the invert-ed sublime, does not annihilate the individual, but rather the finite through the con-trast with the idea."[55] The difference between Hegel and Jean Paul is expressed most clearly in the word "annihilate" (*vernichten*), a word Hegel uses in discussing irony, not humor, nor even "subjective humor." Irony, for Hegel, is associated with Fichte, Schlegel, and Schelling's philosophies. It is synonymous with the attitude, seen also in modern Romantic art, of total negativity and destructive individual consciousness, not with freedom. Irony, therefore, is not discussed together with the historical art forms treated in his *Aesthetics* but instead in the general Introduction to it as part of a survey of recent writings on aesthetics. Even in his account of Jean Paul in the con-text of the "dissolution of the romantic art form" he does not use the term *irony*. Hegel sees no possibility for an absolute freedom of the human spirit in art other than as a negative abstraction and isolation of artistic practice, a prospect that he rejects. Jean Paul, by comparison, discusses both internal and external freedom in paragraph 34, on "Humorous Subjectivity," associating the one with the idyllic, the other with what is great or sublime. Both are capable of this kind of humor. One finds this "true comical-poetic spirit," which he explicitly calls "the spirit of the artist as well as the reader"

> everywhere, where there is either inner freedom . . . or external freedom,
> thus precisely in the largest cities and the remotest places, in castles and
> in village parish houses, in the imperial cities and the houses of the rich
> and in the Netherlands (Jean Paul 1980: 138f.).

The relationship between these two kinds of freedom, regarding both writers and readers, painters and beholders, is spelled out in paragraph 28, "Analysis of the Laughable." Here he uses the example of a Dutchman to illustrate the kind of comi-cal character and situation that becomes such only because of one's knowing or imaginative insight into the Dutchman's internal life. As might be expected, in this example the presumed internal and external freedom of the Dutchman becomes linked with the idyllic:

> For instance, a Dutchman stands in a beautiful garden at a wall and
> looks through a window in it at the scenery beyond: so far there is noth-
> ing about this man . . . that could be called comical in any preschool of
> aesthetics. But soon this innocent Dutchman is transferred to the realm
> of the comical, if one adds to the story that he, who saw all his neigh-
> boring Dutchmen enjoying villas or cottages with splendid views, did

what he could, and since he could not afford an entire villa, had built for himself at least a short wall with a window, from which, when he leaned into it, he could view very freely and without obstacle the scenery before him. However, if we wish to pass by his head in the window and laugh in his face, then we need to impute something to him, and that is that he simultaneously wished to wall up his view and to open it to himself (Jean Paul 1980: 112).

The comical Dutch character is naive and idyllic inasmuch as he is aware of the strategic role of self-limitation, yet unaware of the limitations of self-limitation. To him his practice is a satisfying mediation of internal wishes ("owning" a view in a country of ideally equal citizens) and external conditions (limited financial means). Thus, the comical character lacks irony and its critical dimension, two things of which his observers are all the more conscious. This means that Jean Paul's employment of irony and satire may be productively linked with humor. This is precisely what Hegel contests in his polarizing account of true, objective humor versus subjective humor, caprice, and irony. It is also what Sedlmayr in his account of Vermeer's *The Art of Painting* rejects and what Badt, as we saw, accepts. This discussion of Hegel and Jean Paul allows us to see that the question should not be whether *The Art of Painting* is a genre painting or an allegory – that is, a history painting – but rather how we might deal with its being both at the same time, the "high" in the "low" (Hegel), the "low as the inverted high" (Jean Paul). This question will be taken up further in Part III, on allegory.

Riegl, Hegel

It is useful to close this chapter with a brief account of Alois Riegl's contribution to this debate, as it provides another perspective on the German reception of Dutch *Gattungsmalerei* as idyllic.

The concept of attentiveness, not only as a characteristic of the beholder's share and of Dutch painting itself, but as itself endowed with a critical dimension, is at the center of Alois Riegl's adoption of Hegel's interpretation of Dutch painting. Margaret Iversen has recently examined Riegl's oeuvre in her important book *Alois Riegl: Art History and Theory*. After discussing at length Riegl's philosophical eclecticism and accounting for the Hegelian element in his work, Iversen ultimately emphasizes the Kantian aspect of his thinking as what most deeply informs his writings on art.[56] My own assessment of Riegl is that his eclecticism lacks a successful mediation and that this lack of mediation is most conspicuous in his essay on the modern cult of monuments and writings on Dutch art of the seventeenth century. In Riegl's *Das holländische Gruppenporträt* of 1902, the concepts of attentiveness, will, and feeling all work to describe the structure of representation in Dutch painting from Geertgen tot Sint Jans to Rembrandt as a structure of internal and external unity, of subordination and coordination, that is, as a structure presupposing from its very beginning the share of the beholder.[57] In this sense, his account is very close to Hegel's. Riegl links this structure not so much to the concept of a metahistorical *Kunstwollen*, but instead to the historical development among the Dutch of a com-

munity-oriented civic consciousness and sense of social responsibility. It is in his emphasis on these civic virtues that we can detect a reference to the Kantian categorical imperative and, moreover, a judgment of art in terms of its civic use value, hence also a reference to Schiller's reception of Kant. And yet such a judgment of art contradicts Riegl's declared goal to analyze nothing but the art's own development. Instead, his judgment of Dutch art is located within a specific view of history. In it the history of good middle-class citizenship culminates in the Dutch golden age, and the self-representation of the middle class culminates in Rembrandt's group portraits. What follows is a steady decline reaching its lowest point in Riegl's own time. This view becomes evident in Riegl's account of Jacob van Ruisdael.

Near the end of his essay "Jacob van Ruysdael," also from 1902, Riegl defines attentiveness as the all-encompassing concept in Dutch painting. He characterizes the beholder's share as either active or passive, and analyzes these two types of spectatorship in a way that is most instructive for an understanding of the presumed idyllic dimension of Dutch painting. His analysis describes the process of individuation of different kinds of beholders as something simultaneously linked to a history of beholding, or audience behavior, and to the very structure of the work of art:

> The entirety of Dutch painting of the seventeenth century, with the exception of its last phase, may be called most poignantly a painting of attentiveness. But now [i.e., in the last phase] we have reached a turning point where feeling ceases to be active and becomes passive. This turning point was an inevitable consequence of an ever-increasing subjectivism. As long as the mode of the artist's and beholder's attitude towards the external objects is exclusively the mode of attentiveness, the latter [i.e., external things] preserve a residue of objectivity. Thus, in its last consequences, subjectivism must strive for an ever more intimate effect of the objects upon the subject (beholder and artist); in this case the relation is no longer the relation of attentiveness, but the affect must expand and take hold: feeling must become passive [*leidend*]. Thus it was an unavoidable destiny of Dutch painting of the seventeenth century that it changed its course from Rembrandt to van Dyck, a change to be deeply deplored from the modern viewpoint of taste, but a change to be accepted from the viewpoint of universal history as being in the interest of progressive development (Riegl 1929: 141f.).

With regard to Ruisdael's *Jewish Cemetery* of c. 1674 this means:

> The final extreme of the late hypersubjective attitude of this master, touching almost the sentimental, is signified by the Jewish Cemetery in the Dresden Gemäldegalerie...[with its] elements noisily teaching us that now a specific interest has crept into pure attentive beholding, an interest no longer called for by an objective given but instead demanded by a heightened desire for feeling on the part of the creative and the beholding subject.

"This heightening of feeling", he continues, "by which the most high-strung mood comes to a rupture and instantly. . .turns into absence of mood," is a characteristic of Ruisdael's later works and contrasts with his earlier paintings, which for the most part are characterized by "that magical balance of mood." This last phrase clearly echoes Hegel's *Farbenmagie*. Examining balance and imbalance, activity and passivity, mood and absence of mood, Riegl here formulates the dissociation of artist and beholder from each other through the work of art, and thus of all three from society. This formulation represents an unsettling of the ideal democratic structure of art and of the artist's and beholder's share, as presented by Riegl in his book on Dutch group portraiture. In all likelihood he wished to see the historical analogue to this breach in the end of the Dutch Republic's political golden age. More important, it is related to the end of the social function of Dutch painting as the expression of commitment to a common good to which a collective attentiveness actively addresses itself.[58] This new affectedness is associated with van Dyck, who for Riegl connotes the refinement of court art, perhaps even an epochal melancholy. This understanding of Dutch painting of the later seventeenth century as an imbalanced, affective art posits both artist and beholder as *leidende*, passive individuals incapable of the kind of bourgeois self-assertion within the collective that Riegl sees in the earlier Dutch art of active attentiveness. In thus regretting the subjectivism of the later Ruisdael, Riegl retains Hegel's concept of subjectivity, a subjectivity pushed to an extreme of self-indulgence. One difference, however, is that neither the sublime nor caprice, nor even irony, and certainly not Jean Paul's disturbed idyll are considered by Riegl as ways to approach Ruisdael's later works. Nor does he ask whether even this utmost form of individuation and dissipation of subjectivity still carries any notions of responsibility and commitment for the beholder as critic; nor what these might be. Riegl thus states the limits of his own account; it is necessary now to work out the implications of the individuated beholder as critic, both in the scholarship following Riegl, including early German Vermeer scholarship, and in my own account of Vermeer's depiction of social life.

Chapter 2

Vermeer's Paintings of Social Life as Disturbed Idylls

Early Vermeer Scholarship

If we study the earliest writings on Vermeer in Germany, those dating before Sedl-mayr's 1951 article, we discover how much and how little they are in keeping with nineteenth-century aesthetics and the scholarship on Dutch art and culture emerging from it; how much they share in the praise of Dutch painting as a paradigmatic bourgeois art, and how little they take up the challenge of allowing Vermeer's paintings to illuminate or expose the present from out of their paradigmatic past. For Hegel – had he known them – the now generally acknowledged masterpieces among Vermeer's genre paintings, such as *Young Woman with Pearl Necklace* (Fig. 11) could not partake of the essential or intrinsic character of Dutch genre painting, inasmuch as they lack the appearance of naivety and of active immersion in the objective details of the world. From Hegel's perspective, Vermeer's treatment of paint as color and color appearance, color magic, is rather external, detached from object signification, and, in Hegel's sense, abstract. Here Vermeer's *pointillé* technique comes to mind, as well as the enamel quality of his later paintings – two stylistic characteristics one might call capriciously abstract, even ironical. Such an abstraction of the contents of painting as defined by Hegel, and thus a weakening of good subjectivity and of "utterly living absorption in the world and its daily life," would seem to dissociate Vermeer's paintings from their real historical basis. This criticism of Vermeer implicit in Hegel's aesthetics surfaces occasionally in later German writings on Vermeer, but more often than not in a rather distorted and unreflective manner.

A first sketch of the early bibliography on Vermeer in German might appear as follows. Théophile Thoré (alias William Bürger) wrote three essays on Vermeer, published in the *Gazette des Beaux-Arts* in 1866 and translated into German in 1906, annotated and edited by Paul Prina with certain alterations. The most obvious of these is a reduction of Thoré's catalogue of more than seventy paintings to thirty-four authentic works, in keeping with Hofstede de Groot's first book on Vermeer

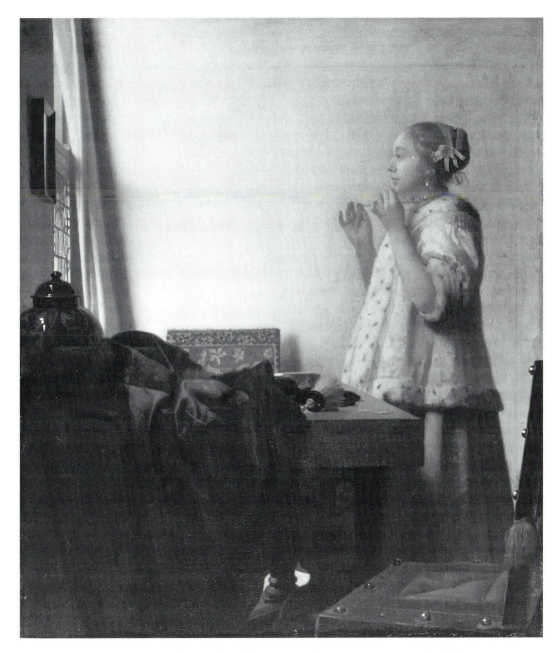

11. Jan Vermeer, *Young Woman with a Pearl Necklace*, c. 1664, oil on canvas, 44 x 45 cm, Staatliche Museen zu Berlin, Preußischer Kulturbesitz, Gemäldegalerie.

and Fabritius of 1905 (and 1907) and then his scholarly catalogue, published in German in 1907.[59] Other changes are more subtle and regard Thoré's art-critical terminology. Those works were followed by Eduard Plietzsch's monograph of 1911, reprinted in revised form in 1939. In 1916 Max Eisler published his study of space in Vermeer's art, focusing on a problem Riegl had emphasized in his writings. In 1924, Benno Reifenberg's *Vermeer van Delft* appeared in a popular series edited by the art

critic Wilhelm Hausenstein for a general audience and entitled *Das Bild: Atlanten zur Kunst*. Throughout these first decades Abraham Bredius and others "published" new Vermeer paintings to be added to de Groot's catalogue raisonné, in which he had radically streamlined Thoré's catalogue of Vermeer's oeuvre to list, in 1905–7, thirty-four works.[60] His final catalogue however, again contains fifty-four paintings. Such "publications" of new Vermeers appeared primarily in Dutch and in English, but also in German periodicals. The first substantial accounts of Vermeer in studies of Dutch genre painting in German art criticism appeared after World War I. These are Lothar Brieger's *Das Genrebild: Die Entwicklung der bürgerlichen Malerei* of 1922, Wilhelm R. Valentiner's article on this subject from 1932, and Franzsepp Würtenberger's *Das holländische Gesellschaftsbild* of 1937. After World War II there followed the last such study, Max J. Friedländer's essay "Vom Wesen der Genremalerei und dem Entstehen der Bildgattung" of 1947. Friedländer had earlier included two pages on Vermeer in his survey from 1923, *Die niederländischen Maler des 17. Jahrhunderts*, where he called him "strangely unproductive."[61] The next generations of writers on genre painting approached it primarily iconologically, via the study of emblematic imagery and literature.[62] Vermeer was only gradually included in such studies.

I will begin my review of early Vermeer scholarship with Paul Prina's translation of Thoré's essays on Vermeer into German and then discuss accounts of Vermeer as one among several genre painters.

Thoré's art criticism was held in high esteem, yet several German art historians shared the view that there was something "light" and "playful" about it.[63] In part this perception may have to do with the literary and ekphrastic strain in French art criticism, of which Thoré himself writes: "At that time we all regarded painting as a feast for the eyes and as an occasion to write beautiful descriptions."[64] The perception of a slightly objectionable lightness may also have to do with the translation of Thoré's writings into German, where an oversight or ignorance of French art-critical terminology on the translator's part results in its obliteration. Thoré's essays on Vermeer may serve an example of this.[65] Thoré uses a number of phrases conventional in French art criticism, such as *justesse*, *vérité de coloris*, or *manière large*. *Justesse* and *puissance* are terms Thoré uses repeatedly in these essays on Vermeer, speaking of "la justesse de ses teintes et de l'effet" (quoting Pérignon on Vermeer), and "la justesse de la lumière et la puissance de la couleur." These are translated by Prina as "Richtigkeit der Farben und der Wirkung," accuracy of the colors and the effect, and "Richtigkeit des Lichts und der Wirksamkeit der Farbe," accuracy of light and the effectiveness of the color.[66] *Richtigkeit*, accuracy, does not quite match the French usage of *justesse*. *Accuracy* suggests naturalism and mimetic skill, whereas *justesse* connotes rightness as a matter of artistic disposition, felicitous judgment, and their painterly representation.[67] Interestingly, Prina translates Thoré's *scènes familières* and *conversations* as *Gesellschaftsszenen* and *Gesellschaftsbilder*, thus showing an awareness of the current German art terminology.[68] On the other hand, he retranslates Thoré's French citation of Gustav Friedrich Waagen without looking at the German original, thereby losing Waagen's terminology.[69] He clearly has difficulties matching the tone of Thoré's exclamations, as when, in regard to the painter's pose in *The Art of Painting*, he translates *Quel gaillard!* ("What a chap!") clumsily as

"Welch ein munterer und kecker Ausdruck!"[70] Prina ends his annotations of Thoré by quoting Karl Justi's praise of the *justesse*, so to speak, of Thoré's art criticism and of his persuasive expression of the *erste Empfindung*, the first sensation or first impression.[71] The most obvious difference between Thoré's original text and Prina's translation of it, as I have noted, is Prina's reconciling of Thoré's catalogue of Vermeer's oeuvre with Hofstede de Groot's first catalogue of 1905. Thoré's description of Vermeer's distinct style and Hofstede de Groot's catalogue appear to have been the basis for the comparative accounts of Vermeer's genre paintings by such authors as Valentiner and Friedländer. Their critical criteria, however, can be primarily traced back to the tradition laid out in the previous chapter.

Valentiner describes Vermeer as the leading and most influential artist in a group of genre painters including de Hooch, Metsu, and Steen. Apparently he sees no problem in reconciling Vermeer's initial "irregular and explosive" development of different subject categories and different stylistic modes with his later stylistic and thematic "rigidity."[72] Friedländer, by contrast, declares that Vermeer was not really a painter of genre, but rather of still life, or, more precisely, of the tableau vivant. He suggests that "[f]ame has come late to this master, at a time when genre painting has become suspect. Vermeer is now considered a great painter, not despite being a genre painter but because he is not one," and because "with a heightening of artistic value the importance of the subject matter has decreased."[73] Friedländer's view echoes Hegel's account of the later Dutch painters with a significant modification, namely, his positive evaluation of what Hegel would have considered a problematic characteristic of Vermeer's art, its abstraction from the social and the negativity of that abstraction. In Vermeer's genre paintings action and activity are becalmed or altogether suspended. At the same time the value of Vermeer's artistic practice stands out in these paintings, as Friedländer asserts, with obvious reference to Riegl's distinction between active and passive attentiveness:

> His connection with human beings is neither one of sympathy [*gemütvolles Mitempfinden*] nor of interest in the joys of life, nor of a sense for humorous situations, nor of concern with psychological relationship. He observed the living as a still-life painter. . . . For him the human being is a model that keeps still in order to be painted. Individual women or heads of individual women, sometimes two figures, mistress and maid in indifferent relationship. Seldom any move in the direction of genre-like narrative. The figures silent and without affect (Friedländer 1947: 241; 1965: 193).

Rhetorically, Friedländer's incomplete sentences support the contents of this assertion, at the same time letting it be known that as critics we need to focus our attention on other qualities of Vermeer's paintings than their subject matter. In a similar vein, Brieger asserted in 1922 that "Vermeer tries to restrict himself to a minimum of gestures. He sees his true challenge in harmonizing the human figure and space through a bright, cool daylight which shows off his blue, his yellow, his white, and his grey with marvelous luminosity." This coloristic mediation of figure and space, which in *Young Woman with Pearl Necklace* (Fig. 11), for example, entails a shift

away from the centrality of the human figure to the image, is also what sets Vermeer apart from de Hooch, whom Brieger sees as "less reticent, not so completely distanced from the human and therefore closer to general love." By this he means closer to the essence of Dutch painting according to Hegel, whom he does not mention. Instead, he refers to the left-Hegelian philosopher Friedrich Theodor Vischer for his definition of genre painting as bourgeois painting, as painting of a conciliatory, tolerant society.[74] Vermeer's "cool" color harmony is part and parcel of his "cool" disposition, a disposition removed from "general love."

The other context in which Vermeer is discussed during these years is that of the art of Rembrandt. This approach was prepared by Wilhelm von Bode's writings of the nineteenth century. In partial keeping with Thoré's thesis, Bode, like Hofstede de Groot, believed that Vermeer was a second-generation Rembrandt pupil by virtue of his presumed training under Carel Fabritius.[75] Bode's scholarship on Netherlandish art was highly respected, as was the work of his assistant Max Friedländer, who shared this view of Vermeer as a second-generation Rembrandt pupil.[76] Finally, in his lengthy 1926 monograph on Rembrandt, Wilhelm Hausenstein attempted to rescue the presumed characteristic of Vermeer's cool, or even cold paintings and personality by construing them as classical and Grecian.[77]

Wilhelm Hausenstein (1882–1957) is an oscillating, interesting but also difficult figure in modern German art criticism. Ernst Bloch flatly denounced him as an opportunistic "art prattler" (*Kunstschwätzer*) in 1937.[78] Although trained as an academic art historian, Hausenstein chose the career of a popular art writer or, to use his word, a *Kunstschriftsteller*, taking Julius Meier-Graefe as his example. He started out as a leftist freelance art critic and supporter of modernism, particularly of Expressionism, in art and literature during the Weimar Republic. During the Nazi period, he became an editor at the *Frankfurter Zeitung* from 1934 until it was closed in 1943, after which he was forbidden to write and publish. Having converted to Catholicism in the meantime, he served after the war as the first German ambassador to France under Chancellor Konrad Adenauer and President Theodor Heuss. Between 1910 and his death Hausenstein authored several dozen books and many more articles on art in rapid succession, and edited short-lived art series, periodicals and a yearbook. These publications vary widely in quality and opinion, ranging from important first inquiries into topics – his books on the history of the nude in art (1911), Expressionist painting (1919), Paul Klee (1921), his widely read *Vom Geist des Barock* (1920, written in 1919, it went through five editions by 1921) – to shallow, cliché-ridden writings about old masters and whole periods of art. It is with the latter type that I am inclined to group Hausenstein's tome on Rembrandt. As in many of his books, he makes no reference to his sources. Nevertheless, in the case of his account of Vermeer, these are obvious, the primary one being his friend Reifenberg's monograph on Vermeer, which he himself had edited.[79]

Why would an author like Hausenstein be interested in calling Vermeer classical? For him *classicism* meant "normative existence," "a certain measure and asceticism," "reflected balance of internal and external forces of life," "a sense for everything proportional," "existence in the polis," "perfected civic consciousness – Res Publica," "a natural mildness of form." This list of partly Hegelian tropes mixes with vague notions of a Winckelmannian antiquity and of the controlled,

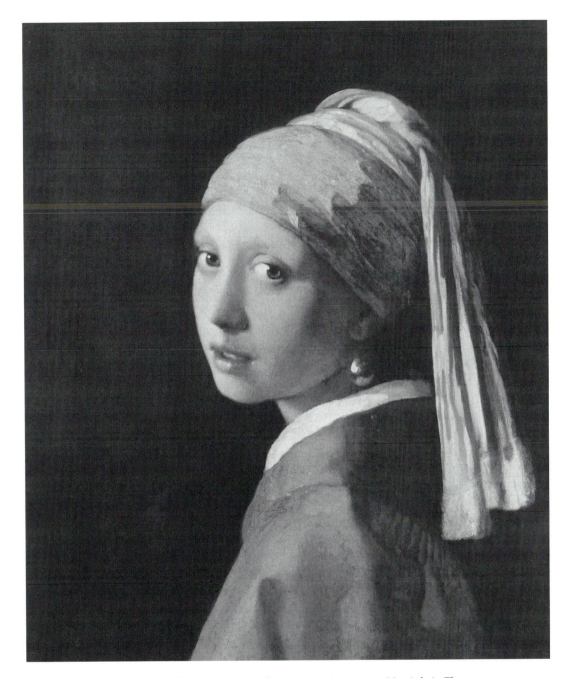

12. Jan Vermeer, *Girl with a Pearl Earring*, c. 1665, oil on canvas, 46.5 x 40 cm, Mauritshuis, The Hague.

undisturbed, bourgeois idyll to form, in Hausenstein's words, "a unity of existence in sensual and moral matters which is unique in the north and which is innately entitled to greet the Greeks." What Hausenstein understands by the Greek becomes clear in his interpretation of Vermeer's *Girl with a Pearl Earring* (Fig. 12):

[Vermeer's] privilege is to satisfy. With composure, with the quiet and
sweet desires of composure which by themselves become already per-
fected fulfillments...with such composure he depicts a beautiful girl;
he...the true Dutchman (for it is he, not Rembrandt) – he paints a lit-
tle bit according to the paradigm of the Greeks or the classical East
Asians; and he paints...the perfection of an incomparable pearl into
her ear.[80]

Hausenstein's conflation of Greece and East Asia should be seen in the context of
the popular reception of Nietzsche's concept of the Apollonian and Dionysian, used
here to interpret Vermeer's *Girl with a Pearl Earring* as their synthesis. This confla-
tion becomes especially evident when Hausenstein enthuses over what he calls the
bisexual nature of the pearl, for which he makes the claim that "it *civilizes*," and
further, in his associations of the motif of the "china-yellow" woman's jacket in sev-
eral of Vermeer's paintings, and their "enamel quality," "extreme sensations," and
"slippery smoothness" with "Japanese lacquerware," Delft imitation ceramics after
Japanese and Chinese porcelain designs, "Asian masks," and the "relaxed beauty of
Asian faces;" in short, in an orientalizing account of Vermeer's art. This account
may have its source in the many references to China and Japan in the nineteenth-
and early twentieth-century French writings about Vermeer discussed in Part II of
this book. The orientalizing aspects mentioned by Hausenstein are part of the per-
ceived eroticism of Vermeer's genre paintings and portraits of "maid[s] in yellow"
within the "classicism" of Dutch society and its "reflected balance of internal and
external forces of life." This latter is linked by the author with "Vermeerian blue,"
which stands for "the somewhat tired...Protestant and capitalist conservatism" of
Holland shared by "Vermeer: a burgher-cavalier of Molière's century." Hausenstein
sums up:

There is Vermeer: [both] lively and distinguished; colorful and in blue
monotony; the finest example of a social and a quasiantique art; and
thus he pleases. He satisfies the folk instinct of the Dutch burgher with
the lemon yellow of the shapely Melkmeisje which vigorously fits her
breast and hips like an uninhibited hand (Hausenstein 1926: 316).

Hausenstein's description of a divided Vermeer, blue and yellow, refined and
uninhibited, appears to contradict his earlier account of the classical synthesis of
Vermeer's art and to reflect his own ambivalent attitude toward it. Within the
lengthy monograph on Rembrandt, portrayed as a visionary genius exiled in his own
solitary greatness, the excursus on Vermeer, "the purest Greek of the Dutch" who
"pleases and wants to please," serves to epitomize Dutch art and culture and to
point up Rembrandt's difference from it. But it is clear that as much as Hausenstein
wants to portray Vermeer as the model citizen, he also has little interest in Dutch
civic consciousness. As the artist desires self-expression the beholder desires self-
indulgence. Still, Hausenstein persists in his bizarre attempt to rescue something of
the Hegelian, idealistic understanding of Dutch art, clearly against his own distaste
for bourgeois culture and his own taste for self-expression and self-fulfillment.

Accordingly, the sensual idyll he conjures up is disturbed, albeit less by seventeenth-century conditions – his mention of Dutch "Protestant and capitalist conservatism" remains isolated and unmediated – than by the author's own embrace of Expressionism.[81] In his essay "Der Kunstschriftsteller" (1916), Hausenstein had explained what he considered the primary task of the popular art writer: to speak "first of all of images, not of biography, not of history, but of the presence of all art . . ., as if one were called upon to create it oneself."[82]

This position brings into view problems of the modern experience shared by the other writers discussed here. It is an experience of the end of an era of bourgeois culture whose paradigm is sought in the genre paintings of de Hooch and Metsu and whose end is represented to them by the art of Vermeer. Thus, the study of Vermeer as a genre painter different from others may be seen in part as a study of this ending. In this sense, Hausenstein's problematic eloquence is very instructive. First, it allows us to see the reasons why, particularly from a political viewpoint, a methodical study of Baroque art appeared increasingly necessary to some art critics of the 1920s and 1930s. Second, by its general indulgence in subjectivism and by its historicizing assertion of Vermeer's own conflicted subjectivity, Hausenstein's account demonstrates Riegl's point about subjectivism's troubling implication: its increasingly isolating and antisocial self-indulgence. In the context of Vermeer's genre paintings, Hausenstein's writings suggest the necessity of exploring the tradition of interpreting Dutch genre painting for its unspoken, self-critical dimensions. This exploration will allow me to consider Vermeer's paintings of social life as disturbed idylls.

An inquiry into the interrupted, at times disturbed scenes that are the characteristic subjects of Vermeer's paintings of social life will be aided by the reconsideration of the last section of Friedländer's 1947 study of genre painting, "Vom Wesen der Genremalerei und dem Entstehen der Bildgattung," translated in 1965 as "The Genre: Present and Future," and Würtenberger's *Das holländische Gesellschaftsbild*.

Friedländer judges genre painting of the nineteenth century to be a failed attempt at a sentimental retrieval of the genre's original naivety in Dutch art of the seventeenth century. He takes the view that the extreme individualism of twentieth-century art is essentially opposed to genre painting, at least to genre painting in the sense of the depiction of what is typical of the middle classes.[83] Friedländer describes nineteenth-century genre painting as an art form marked by the theatricality of the tableau vivant, that is, by inauthentic simulation.[84] Significantly, he uses these words in an earlier section of the book to describe Vermeer's genre paintings, with the notable difference that he considers Vermeer's simulations to be authentic:

> A painting by Vermeer resembles a simulated "tableau vivant," yet
> without a disturbing or upsetting rigidity. The depicted figures do not,
> like the real ones of the "tableau vivant," evoke the tormenting ques-
> tion why they do not move.

In other words, the doubly negative and thus balanced definition of Vermeer's tableaux (one is *not* disturbed by the figures' *immobility*) means that Vermeer's tableaux show simulated scenes but are authentic art. By contrast, nineteenth-century genre painting is both simulated genre and simulated painting, a "manipulative proce-

dure." In this judgment Friedländer includes, for example, scenes of "family happiness, childish innocence, rustic jollity" by the Biedermeier artist Ferdinand Waldmüller.

Thus emerges, in Friedländer's view, the double nature of Vermeer's genre paintings. On the one hand, Vermeer appears "untimely modern . . . as if he had heard the battle cry 'l'art pour l'art.'" On the other hand, a tension inheres in his art in that the modernity of his style contradicts the genre it represents, in that he rejects the "warm Dutch chiaroscuro" used by his contemporaries. For Friedländer, this contradiction, or tension, in Vermeer's work is overcome through its "exotic," "un-Dutch" colorism: "Everything created by his hand flatters the senses like a gem, like jewellery." It also introduces the presentiment of a future "cold-hearted artistry"; Vermeer's early death, it appears, postpones this to the nineteenth century.

The second and third parts of this study will show just how much Friedländer's characterization of Vermeer's art is prepared and shared by the two principal traditions of its reception. Yet unlike his contemporary Hausenstein, Friedländer feels alienated by contemporary art and clearly expresses this in the last section of his study. Earlier, when discussing humor in Steen's art, he states with uneasiness that "every valid aesthetic derives from the art that happens to be effective at the moment, and changes with our mode of vision, not with our knowledge."[85] In this observation Friedländer echoes Riegl, who in the essay "The Modern Cult of Monuments" asks, "Or is the art value merely a subjective one invented by and entirely dependent on the changing preferences of the modern viewer?"[86] Friedländer's deepest concern is precisely with the extreme individuation of contemporary art, art's asocial status, and a Zeitgeist in which one experiences "existence too much as a dangerous duty" to be able to "abandon oneself to an approval of the given visual world." This ultimately political formulation not only recognizes that Hegel's notion of Dutch genre painting as a conciliatory affirmation of the present cannot have a modern parallel; it goes beyond that to suggest that one must not try to force it.

Friedländer's view of Vermeer's completely non-naive modernity as both a real historical contradiction in seventeenth-century Holland and as an illumination of what is problematic in the present is shared by Würtenberger's earlier, 1937 analysis of Vermeer's oeuvre. Würtenberger discusses Vermeer in a chapter called "Die Maler des Gesellschaftsbildes." By *Gesellschaftsbild* he means a scene of social life as well as representation of society, the one reflecting the other.[87] Quite in keeping with Hegel, his point of departure is the depiction of lively banquets and large social gatherings by Frans Hals, Willem Buytewech and, in Delft, Anthonie Palamedesz. The scenes of feasting by Palamedesz. are, by comparison with those of Hals, becalmed and restrained. In this view, Pieter de Hooch represents the height of Dutch bourgeois society, Vermeer its end, and Steen its comical travesty. Accordingly, de Hooch's *Gesellschaftsbild* becomes the paradigm by which to measure Vermeer's achievement with the same subject matter:

> In his [de Hooch's] works a harmony free of conflict between figure and
> space dominates, a harmony that is not matched in ter Borch and Vermeer. In the one [ter Borch] the figure has priority, while in the other
> [Vermeer] it becomes compressed into a still lifelike existence. With de
> Hooch the figures are never encroached upon by furniture.

Würtenberger further points out the absence in de Hooch of conflicts, rash movements, excessive behavior, these are replaced by the presence of a friendly attentiveness. Illuminated by incoming rays of sunlight, de Hooch's interiors fulfill Würtenberger's notion of a society "wherein the social gathering occurred in the consciousness of pleasure taken in this illumination." Society's natural self-evidence brings with it a new sense of human action: "here nothing special happens any more; instead, the event is subject to the law of accident." This means that "social gatherings are composed of small genrelike individual activities" and that "[w]ith this kind of unencumbered behavior [the possibility of] any common deed by the gathered society vanishes." Würtenberger praises de Hooch's works for depicting a seemingly infinite variety of social arrangements or situations, as he calls them, within the boundaries of house and courtyard, situations appearing "by themselves" and fully possessed of their own iconographic references. What Würtenberger describes here is a naturally harmonious society no longer requiring action or narrative for its self-representation. Its completeness is such – and here he actually confirms the Hegelian model of the beholder's share – that "[t]he relationship with the beholder is not considered; the power of light is stronger than the beholder's claim to the complete visibility of the social gathering." Würtenberger says this with reference to de Hooch's *An Interior, with a Woman Drinking with Two Men, and a Maidservant* of c. 1658 (Fig. 13).[88] One implication of Würtenberger's account is that de Hooch's naturally harmonious and luminous social gathering is indeed an idyll, a representation of something separate from the beholder's sphere and no longer wholly affirmative. As such, it makes room for the beholder's wishful imagination, possibly resulting in what Riegl called a passive, pleasurable attentiveness and, ultimately, in indifferent fatigue. In de Hooch's later paintings from his years in Amsterdam, with their iconography of luxurious interiors, upper-class leisure, and musical companies, such as *Music Party with Five Figures*, c. 1674 (Fig. 14), Würtenberger sees a dependence on the accidental and particular in which "the concept of the truly social [has been] destroyed."[89] That which disturbs and destroys de Hooch's idyllic *Gesellschaftsbild* is the shift from the natural medium of illumination to the artificial medium of chamber music. Würtenberger is not critical of de Hooch's appeal to other senses than vision – as is clear in his analysis of the earlier *An Interior, with a Woman Drinking with Two Men, and a Maidservant* – but criticizes the shift from nature to art as the binding medium for individuals in a social gathering. This shift dissociates the two meanings of the *Gesellschaftsbild*, image of a social gathering and image of a gathered society. It makes the depicted scene of social life no longer representative of what is common and "truly social," no longer the effect of the artist's specific color magic through natural illumination. Instead, the *Gesellschaftsbild* becomes an abstraction of a specific interest in art and in a group of people for the sake of their musicianship. The social gathering that had been a free and common event is now a functional structure, governed by "interest" and resulting visually in forced ensembles and in the disjunctive rhythms of momentary gestures. In regretting a loss of freedom in the shift from "disinterestedness" to "interest," Würtenberger is at his most Hegelian. What is lost here is the distinguishing factor for Hegel of Dutch art's "Sunday of life."

Würtenberger positions Vermeer's genre paintings as the historical and dialectical negation of the *Gesellschaftsbild*. Contradicting his own earlier statement, he

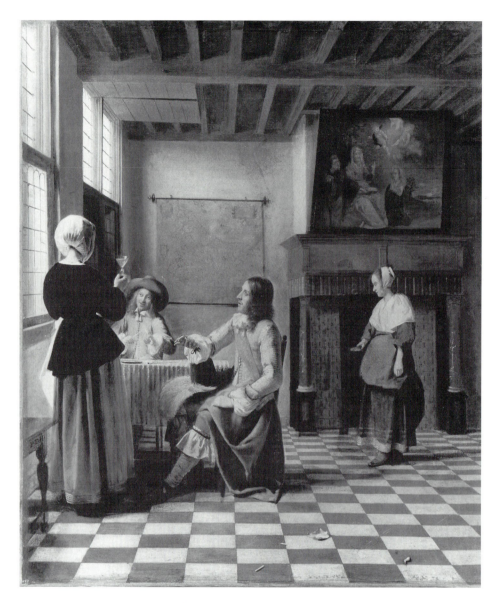

13. Pieter de Hooch, *An Interior, with a Woman Drinking with Two Men, and a Maidservant*, c. 1658, oil on canvas, 73.7 x 64.8 cm, The National Gallery, London.

expressly declares that "Vermeer's figures are autonomous and do not lead the existence of a still life." The difference between Vermeer's art and de Hooch's lies not in a real contrast but in Vermeer's pushing the *Gesellschaftsbild* of de Hooch to its furthest end: "If one assumes that the ultimate in quietness and inactivity has found its representation in de Hooch, Vermeer considerably exceeds this master." To demonstrate this claim Würtenberger selects four paintings for discussion: *The Concert*; *The Girl with the Wine Glass* (Pl. I); *Lady and Gentleman Drinking Wine*, also called *The Glass of Wine* (Pl. III); and the so-called *Music Lesson*. Of these *The Con-*

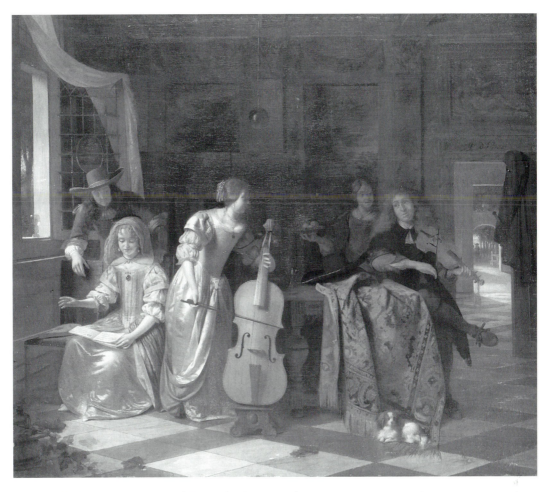

14. Pieter de Hooch, *Music Party with Five Figures*, c. 1674, oil on canvas, 92 x 105.5 cm, Statens Museum for Kunst, Copenhagen.

cert (Fig. 15) serves as the most direct comparison with de Hooch's musical companies, such as *Music Party with Five Figures* (Fig. 14).[90] Taking it to be an exception to Vermeer's negation of the *Gesellschaftsbild*, Würtenberger does not criticize *The Concert* for its particularity and abstraction but favorably contrasts it with de Hooch's comparable works, presenting it in terms of a simple internal and external harmony:

> No figure attempts to exert any influence on another. Each figure is entirely occupied with herself or himself. . . . The cohesion of the figures is not effected by any external means; instead, the rhythm of music keeps them collectively alone. They may therefore forego any subordination, as no figure wishes to impose her or his will on the other. Their psychic link is music; their external link the musical instrument, the piano.

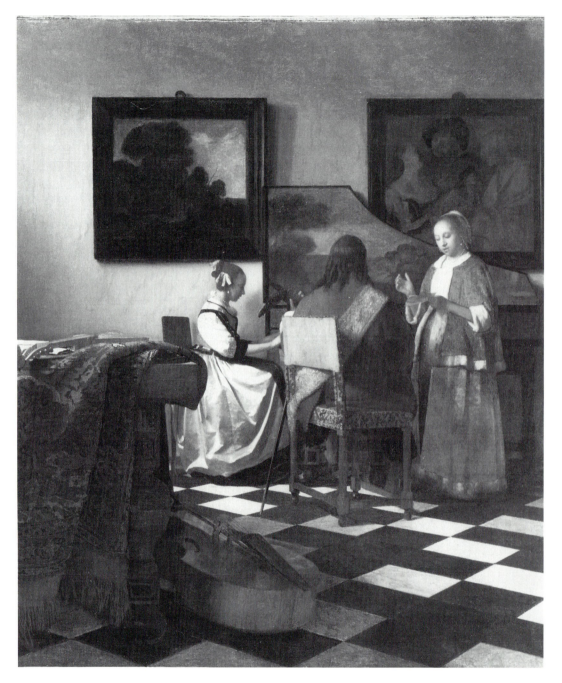

15. Jan Vermeer, *The Concert*, c. 1665–6, oil on canvas, 69 x 63 cm, Isabella Stewart Gardner Museum, Boston, present location unkown.

The terminology – internal and external coordination, subordination, feeling, will, attention – is clearly that of Alois Riegl, which Würtenberger employs here to show how Vermeer's painting, while containing no action, nevertheless depicts *Gesellschaft* and commonality. The observation of the harpsichord as the external link among the figures may relate to its function as a basso continuo instrument, but it also relates to the formal ordering of the three. Thus Würtenberger emphasizes what Riegl overlooks: the essential role played by things, by instruments, rugs, furniture, tableware, in Dutch art. In his descriptions of the other three paintings Würtenberger draws attention to the tension he perceives between figure and interior, going so far as to attribute behavior, in part disturbing behavior, to the objects inhabiting these interiors. In the following I shall focus my interpretation on two of these paintings in particular, *The Girl with the Wine Glass* and *The Glass of Wine*, and then take up Würtenberger's descriptions of them for further analysis.

Contradiction, Disturbance, Interruption

Vermeer's *The Girl with the Wine Glass* (Pl. I) is dated between 1659 and 1660; *The Glass of Wine* (Pl. III) is supposed to have been painted somewhat earlier, c. 1658–60.[91] The subject category of both paintings is generally identified as a merry company involving erotic elements, specifically, the theme of seduction. In this regard the history of the titles given to the later painting is instructive. The Herzog Anton Ulrich-Museum in Brunswick calls it *The Girl with the Wine Glass*, a title accepted by Wheelock and Blankert for their catalogues raisonnés. In the auction catalogue of the Dissius collection of 1696 the painting was identified as *vrolijk gezelschap*, that is, merry company. This general classification was maintained in the 1710 inventory of the Brunswick collections, which lists the painting as *Lustige Gesellschaft*. By 1714 a specific theme had been distilled from the painting and used as its title: *Junger Mann mit seiner Geliebten*, that is, *Young Man with His Beloved*.[92] Gustav Friedrich Waagen referred to the painting in 1862 as "a girl on a chair and two men."[93] By 1866, in Thoré's monograph, the painting had become *La Coquette*, but in his German edition of Thoré's text from 1906, Prina preferred the title *The Girl with the Wine Glass*, in keeping with Hofstede de Groot's catalogue raisonné, which was just then being published. Interestingly, the latter had also used a title of erotic allusion in his monograph (1905, 1907): *The Offered Glass of Wine*, a title suggesting the openness of the story's outcome.[94] Once the erotic theme had been established for this painting, the earlier painting in Berlin appeared to be a variant of it – Bode calls it a "similar representation." On the level of subject category, that painting might as well have belonged to the musical company, and more specifically to the subject of the music lesson. It has, in fact, been presented as a seductive *sujet musical*, situated somewhere between Utrecht Caravaggism and Laclos's *Liaisons dangereuses*, together with Vermeer's *The Concert* (Fig. 15), *The Music Lesson*, also called *A Lady at the Virginals with a Gentleman* (Fig. 17), and the painting known as *Girl Interrupted at Her Music* (Fig. 16).[95]

In *Girl Interrupted at Her Music*, as in *The Girl with the Wine Glass*, the viewer is scenographically engaged as the one who interrupts the scene in the role of its spectator. The device of a fictional *hic et nunc* is of course also used by many

16. Jan Vermeer, *Girl Interrupted at Her Music*, c. 1660–1, oil on canvas, 38.7 x 43.9 cm, The Frick Collection, New York.

other seventeenth-century Dutch artists, most notably in the group portraiture studied by Riegl, but also in many of Jan Steen's genre paintings and in Nicolaes Maes's variants on the theme of eavesdropping. Yet there is an important difference between these works and Vermeer's genre paintings. The latter specifically determine the moment of viewing, however short or long its duration, as one that actively interrupts and arrests the scene beheld, suspending the painting's representation. The specific device of arrest can be seen to focus Hegel's general structure of the implied beholder in all painting and to locate it in the motif of the exchanged looks, that is, in the most external of motifs. The motif is so external, indeed, that it becomes distinguished from the scene's content, color magic, and illumination as the thing that actually brings all these to the limit of their validity, to their ultimate halt. This is particularly the case with *Girl Interrupted at Her Music* (Fig. 16), where both figures are objectively close to one another, yet subjectively dissociated by the implied intruder.

17. Jan Vermeer, *A Lady at the Virginals with a Gentleman*, c. 1662–4, oil on canvas, 73.6 x 61.1 cm, the Royal Collection, Windsor Castle.

And yet the extended moment of interruption is not empty. Ironically, it is also the moment that constitutes the painting's content. In most circumstances a given beholder will try to find out what it is she or he is interrupting, without ever being able to reclose that gap of disruption. Each and every account of the scene's "before" and possible "after" would still have to include the disruption, however skilfully a beholder's imagination might try to work out a story that permits her or his inclu-

sion in or withdrawal from it. Through this device the painter both offers and with-draws an inclusive representation and manifests this active negation on the icono-graphic level, where all action has been halted.

How does the close reading of Hegel, Jean Paul, and Riegl help to conceptual-ize this halt? If a beholder simply gives in to the acknowledgment of her or his pres-ence as something anticipated and controlled by the artist's mastermind, such viewing is not what is meant by Hegel's concept of shared representation. For Hegel does not consider representation to be subject to any one individual's complete con-trol. In the case of Dutch painting, he considers it as an open-ended process tolerated good-naturedly by all participating individuals. It follows that once this commonali-ty is challenged by the built-in disruption that passes off as a disruption from the outside the limits of the idea of a humorous, good-natured tolerance, conciliation, and affirmation of society are tested, and what emerges then in place of this idea is indeed a notion of control. From a Hegelian viewpoint, Vermeer's *Girl Interrupted at Her Music* closes and arrests the subjectivity of painting and thus withdraws it as something that can actually not be shared. And this means that with Vermeer genre painting has definitely passed from the comical mode to that of irony.

This irony cannot be addressed through Riegl's concept of active attentiveness which, because his concept involves internal and external coordination and subordi-nation, effects an indirect, reflected affirmation of the scene, not its negation. In Riegl's example of Rembrandt's *The Syndics of the Clothdrapers's Guild* (1662) the gentle-man on the left is already in the process of getting up to greet me, speak to me, show me the door, or accept the message or refreshments I bring in on a tray. Any one of these possibilities is already part of the painting's story, in that Rembrandt has includ-ed the man's reaction to the interruption. This kind of interruption is different from the complete halt witnessed in some of Vermeer's depictions of social life. Nor does Riegl's notion of passive attention, the breach within painting between a self-expres-sive artist and a self-indulgent beholder, at first seem to pertain to Vermeer's art because of its coloristic "coldness" and his relatively affectless figures, which led Friedländer to the conclusion that Vermeer's art is objective.[96] But in fact, Vermeer's use of the device of an interruption of the painting's representation might be seen as an extreme case of this passive attentiveness, much more extreme than Riegl's own example of Ruisdael's *Jewish Cemetery*. The reception of Vermeer's genre paintings bears witness that in them painting and its contemplation have lost their commonali-ty, have become two private activities dissociated from a common history and a pub-lic culture. For Hegel, of course, this meant the end of painting, and the sign of that ending within Dutch art itself is its rhetoric of self-indulgence and caprice. For Riegl and, later, Friedländer, this meant the beginning of modern art. Such painting appears at once to release the beholder from responsibility for the painting's content and to invite an infinite *Betrachterphantasie*, suspending any binding criteria for its evalua-tion. Such a viewer fantasy would stand behind the history of reception in which a painting once known as *vrolijk gezelschap* becomes *La Coquette*.

If one accepts, as I do, that *The Girl with the Wine Glass* and other paintings by Vermeer embody the historical phenomenon of art's privatization, one faces the ques-tion of how to interpret this phenomenon. Is painting now simply the occasion for a feast of the imagination? There is, after all, a dimension of playfulness in the motif of

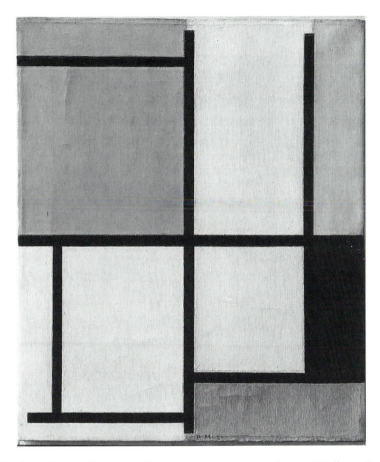

18. Piet Mondrian, *Composition*, 1921, oil on canvas, 49.5 x 41.5 cm, Emanuel Hoffmann Foundation, on loan to the Öffentliche Kunstsammlung, Basel.

interruption and exchanged looks. And perhaps there still lies within that playfulness, even as it is ironically framed, something of the idyll and its sheltered comedy, of the naive self-limitation celebrated in Jean Paul's wonderful story of the Dutchman and his scenic view. There, however, the reader's ironic stance was an added critical dimension, based on, to use Jean Paul's word, an "imputation." As Jean Paul suggests, such an imputation is debatable. With Vermeer, then, one faces the problem of how to link the arrest of subjectivity, the halt of its disruption, with the various possible critical "imputations" following it. Caution is necessary here, as is a detailed analysis of the paintings in question by which alone we can address this link.

It has been said that in certain of his genre paintings, notably *A Lady at the Virginals with a Gentleman* (c. 1662–64) (Fig. 17), Vermeer anticipated Piet Mondrian's planar compositions in similar hues, such as *Composition* of 1921 (Fig. 18).[97] Such an association is based on Vermeer's preference for the primary colors blue, red, and yellow, his use of black, white and a tonal range of grays, and his "geometrization" of the interior.[98] Regretted or admired in this comparison is the loss of – or liberation from – the concept of a separate, autonomous pictorial reality at work in what is seen as Vermeer's tendency toward formal abstraction.

Were it not for the underlying notion of progress – Vermeer anticipating Mondrian – the comparison might just as well be made in the other direction. In this case one would observe that Mondrian has lost – or liberated himself from – Vermeer's very specific, atmospheric chiaroscuro, as well as his simplified, near-geometric shapes, most often spheres and slightly rounded-off diamonds. But even this polarization suggests something rather problematic: that Mondrian edited out of his Vermeer paradigm the natural, or living elements – human figures, light, atmosphere – retaining in a more abstracted form its purely structural elements – the windows, ceiling beams, floor tiles, frames, maps, chairs. Mondrian would thereby have shifted the connotation of color from nature to artifice and structure. This suggestion is very instructive, for it highlights Mondrian's presumed goal of giving art complete autonomy, thus forestalling interruption, disturbance, and contradiction by its beholders.

But the idea of Mondrian editing Vermeer is doubly problematic. First, it reproduces the equation between a bourgeois art prior to modern art proper and "natural" genre painting, and with it the confidence that bourgeois autonomy is bound to nature so as to draw its dignity from it. This is the illusion of a naturally ordered and measured everyday world, of an idyll without historical basis and reference, undisturbed. Furthermore, this equation takes no account of the concrete existence of a world between the two poles of natural and structural elements in Vermeer's genre paintings, the world of manufactured objects, the many things of which the world inhabited by Vermeer's figures is made. For these figures are not placed within a natural setting but between the walls of town houses. It will be remembered that Würtenberger attributed to this world of things an independent and rather disturbing agency.

The independent existence of this world of objects between such opposed poles has a parallel in the function of color as something that cannot be called either natural or artificial. Could it be that it is just this world of objects with which the beholder's interruption of Vermeer's *Girl Interrupted at Her Music* or *The Girl with the Wine Glass* is bound up? Are the objects' disturbing qualities and the beholder's interruption continuous in some way or, instead, do they pose a mutual challenge? Could it be both? And how does the function and appearance of objects relate to the fact of the painting's implied irony? By implied irony I mean that the painting's scene *and* its interruption are there from the beginning. And finally, do these object have a connection to the fact that the moment of interruption will always stand and cannot be obliterated in any version of the beholder's share in the representation?

The Girl with the Wine Glass

In the background of *The Girl with the Wine Glass* (Pl. I) a man is seated. His face, shown in exact profile, is overshadowed and vague in expression. Seen supporting his head on his right hand, the figure may be identified iconographically as pensive or melancholy, perhaps saturated with wine and tobacco, as the objects next to him on the table seem to suggest. He appears to contemplate the empty space before him where there is nothing concrete to engage his attention. His left arm hangs loose in a relaxed gesture; the left hand possibly resting on his lap, or perhaps holding a glass. We cannot know for certain because the overlapping mantle of the other, standing man blocks our view. The relatively dark shadows enveloping the seated man impart a brooding mood

to him. His diffuse vagueness of mood is given its one unmistakable sign in the compact fist on which he rests his head. By specifying the conventional gesture of pensiveness or melancholy, Vermeer renders it significant for the picture as a whole. This is Thoré's ekphrastic account of its significance, familiar to a German audience through Prina's translation: "But there is, at the other corner of the table, on the left side and in half-shadow a third person who acts as if he were asleep. The man is in a bad temper, so much is certain."[99] What is the basis for this judgment? Vermeer's rendering happens on both the iconographic level and the level of painterly representation, through a simplification of the man and his immediate surroundings, through the use of analogous shapes, and through variation of the treatment and function of color. A strictly formal analysis of these characteristics yields the following detailed description.

The man's shape is inscribed in the form of a rounded-off diamond whose central axis comprises arm, head, and high forehead. The fabric pattern on his jacket converges toward this axis, while the symmetry is further enhanced through the vertical division along it into one illuminated and one shadowed half. This central axis structures and thus dignifies the man within the space he inhabits. This geometric unity is further differentiated, its calm outline containing the clearly pronounced shape of his white shirt ruffle and its play of folds, separated from the tense fist above it by a narrow black band around his wrist. Taken together, ruffle, band, and fist are associated with the white pitcher on the table and its formal characteristics, whereas the sharper diamond form of the seated man corresponds to the shape of the white tablecloth or napkin. Within these similarities and correspondences one inevitably notices the subtly contrasting effects of the change in modeling of textures and surfaces. All of this allows the viewer to consider the man complete, even though his figure is represented only in part. What we see is the entire phenomenon of his presence, there in the background, metonymically represented both in his partial rendering and in the motifs and shapes next to him.

The white pitcher is of course depicted in several of Vermeer's paintings in a variety of contexts, shapes, and conditions, sometimes compact and spherical in form, sometimes oblong and egg-shaped, never quite the same twice. Once, in *Girl Interrupted at Her Music* (Fig. 16), it is decorated so as to suggest Chinese origin; once, in *A Lady at the Virginals with a Gentleman* (Fig. 17), it stands isolated in its surroundings; once, in *The Glass of Wine* (Pl. III), it is held firmly by a hand; once, in *A Girl Asleep* (Fig. 27), it is depicted with a bulging lid, and with another jug, its double, overturned nearby.[100] On the other hand, one might say that in each case it is the same pitcher, but that it has a life of its own, undergoing transformations, and good and bad times, from painting to painting. Here, in *The Girl with the Wine Glass*, it is shiny and compact, drawing attention to its emphatically circular belly and mediating through its reflections various other parts of the painting, though it appears at first to belong to the seated man. The pitcher's roundness has a number of analogues in the painting, most obviously the fruit, an untouched and a partly peeled lemon lying on a platter on the table. The fruits, with their soft modeling, and the pitcher, with its handle turned obliquely toward the couple, introduce, from left to right, the erotic subject seen there.

These objects have been discussed elsewhere, but mostly insofar as they fit different interpretive approaches. An iconological reading might see the fruit as a symbolic

preview of the woman's seduction, and associate the smoking utensils, a tobacco paper and clay pipe, and wine drinking with immoderation and moral weakness.[101] A psychoanalytic viewpoint might consider the three-quarter-length portrait of the male burgher hanging on the back wall of the room as the superego of all the men involved, whose role is to admonish the two men in the image as well as their counterparts, the artist and – in this construction – the exclusively male viewer, to reason or propriety.[102] Such focusing on certain motifs alone, either on the figures or on the objects on the table, risks halting the process of interpretation too quickly. In either approach the painting's moral lesson is one directed for the benefit of men; the woman is still, though without his admiration, as Thoré describes her: "there is the utmost elegance in this *coquette*, with her fine and refined forms, with her attractive, voluptuous, spirited face."[103]

The question arises whether other forms of interpretation are possible. In order to answer this question, it is important to study the particular mode of representation in this painting and the subtle interrelation of objects and figures as a characteristic of Vermeer's pictorial language.

In the foreground of the depicted interior we see a single object: the open wing of a window. The significance of the window is not limited to its *repoussoir* function. Its slanted position as it protrudes into pictorial space is such that the geometric lead fitting points to the couple. Through this open wing we see the window's closed second wing, next to the table, corresponding perhaps to the seated man's "closed" situation. Because we do not see the window's hinges (beyond the left edge of the painting), its practical point of attachment to the house, its stained-glass image acquires an omnipresence in Vermeer's pictorial space that must be respected in our interpretation of the scene. A rounded-off diamond, the colorful shape in the window corresponds to that of the seated man, the oval escutcheon within it to the wine pitcher next to him, or more pointedly yet, to the other man's oval shirt ruffles framing the action still to be discussed here, the action interrupted by the beholder's presence. The allegorical figure vaguely recognizable in the glass image relates to the couple in the middle ground by virtue of its color. (Even the colors in the escutcheon have their analogues, but I will turn to these later.)

In the catalogue of the exhibition *Die Sprache der Bilder* (Brunswick, 1978), the allegorical figure in the stained-glass window Rüdiger Klessmann identifies as a personification of the cardinal virtue of Temperance, taken from Gabriel Rollenhagen's *Selectorum Emblematum Liber* of 1613. A direct comparison shows that Vermeer rendered a mirror image of that emblem (Fig. 19 and Pl. II). In keeping with such a rendering Vermeer's Temperance ought to turn her head toward the beholder, yet Vermeer has her turn toward the depicted interior instead.

It is important to keep in mind that the emblem's *pictura*, like any other type of image or iconography of some historical duration, changes style with periods and artists, and that such changes are meaningful not only in painting in general and in the autonomous print but also in these didactic works. The peculiarity in *The Girl with the Wine Glass* is that Vermeer assimilates the emblem to his painting in a manifold manner, without obliterating its character as image, as artifice, as representation. This is to say that the emblem of Temperance is not naturalized within the rest of the image, as so often happens in Dutch genre painting.[104] Instead, the stained-glass image of Temperance, while kept separate, is also animated and given a role in the pictorial

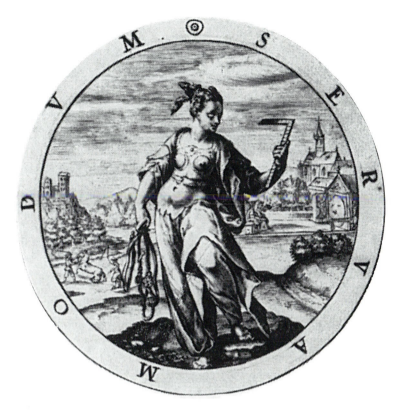

19. Crispijn de Passe, *Temperance*, engraving from Gabriel Rollenhagen, *Selectorum Emblematum Liber*, 1613, no. 35.

reality of *The Girl with the Wine Glass* by virtue of an acknowledgment of its original style and an enhancement of this style through vivid color. Everything about this motif of the window is, in my view, both deliberate and conceptual.

The personification of Temperance is a common representation, and a comparison of Rollenhagen's with other emblems of the same concept is therefore instructive with regard to Vermeer's choice of this version. Iconographically, Temperance is often represented with the attributes of a bridle, a set square, and the balance wheel of a clock. The Amsterdam edition of Cesare Ripa's *Iconologia*, Dirck Pietersz. Pers's *Iconologia of Uytbeeldinghen des Verstands* of 1644, shows a woodcut of Temperance in classical contrapposto (Fig. 20). Placed against the foil of a kindly elephant (according to convention an exemplarily temperate creature), she holds the balance wheel in her right hand while stretching the bridle between both hands, making it resemble a diagonal barrier, or borderline, between herself and the beholder, a compositional means that visually reinforces the concept represented. In the Augsburg edition of the *Iconologia* of 1758–60 by Georg Hertel, Temperance is placed in a landscape that is the site for further pictorial explication through narrative example, again involving an elephant.[105] There, the bridle dangles gently from the figure's arm, the changed style conveys the idea of friendly tolerance, if not resignation, in the face of human weakness.

20. *Temperance*, woodcut from
Dirck Pietersz. Pers, *Iconologia*,
1644, 8.1 x 5.7 cm, p. 317, Bryn
Mawr College, Pennsylvania.

Returning now to the Rollenhagen emblem, one recognizes in it a Baroque agitation of both figure and attributes, a characteristic that Vermeer also emphasized, in contrast to what is otherwise considered his own calm style. As, metaphorically speaking, this Temperance rushes into the scene of *The Girl with the Wine Glass*, an ironical contrast arises between her and the calm, composed scene. An additional effect of this contrast is that the agitation and the confused attributes relate this Temperance to emblems of Peace and Fortune in contemporary emblem books, where both allegorical figures are depicted in motion and carrying bridles.[106] These affinities, the emphasis on the liveliness of Temperance together with her presence as image suggest a reconsideration of emblematic contents in Dutch paintings. The function they serve is more complex than the moral stabilization of a painting's content *in bono* or *in malo*.

In sum, it can be said that Vermeer relates two images so that the stained-glass window is constitutive of the scene, which, in turn, renders the glass image significant. This mutual sustaining of elements is important for the entire painting. Primarily, it is a sustaining of the ambiguous pictorial reality from within, not from a "natural" viewpoint without. In other words, although it may be said that Vermeer indirectly motivates the peculiar presence of Temperance by natural means, that is, by implying a season that allows for open windows and by directing the daylight in such a way that it illuminates the stained glass as it does, these motives do not draw

attention to themselves. The escutcheon inserted into the figure like a protective shield signifies the emblematic figure as a device of the represented household. The scene does not therefore lose its ambiguity, and the attentive beholder of Vermeer's painting is warned against reaching judgment about its meaning too soon.[107] This ambiguity lies in the fact that, on the one hand, the stained-glass window, as part of the building, exists anterior to the scene that takes place in it and on the other, the separate image on the window cuts into Vermeer's image, so that the figure of Temperance appears to rush into the scene in progress, that is, appears to interrupt it. The sense of interruption is reinforced by the detail that the hinges of the window are not seen: as a separate image it appears endowed with its own agency, even as Ripa's concept of the personification as definition, not agent, is maintained.

Thus, as a motif of interruption, the window exactly parallels the beholder's interruption of the scene, an interruption implied from the very outset and yet apparently recurring in each viewing. Like the stained-glass Virtue, I interrupt and define the image as I look at it, though I have no practical agency. As we shall see in the third part of this book, this is precisely what Walter Benjamin considers to be the double tragedy of Baroque allegory and its criticism. However, here, in the class of genre painting, a tone of play prevails in that the scene remains full of possibilities.

The woman's facial expression has been called flattered and foolish at once, yet also helpless, an expression in search of advice and reassurance. Such an appeal is clearly directed at the implied beholder as a fictional person entering the scene. As beholders we are given the task of interruption, from which there is no withdrawal except in the form of turning away from the painting.

Klessmann (1978), in suggesting that the woman is "frivolous" (*leichtfertig*), and behaves like "ladies of dubious reputation" (*Damen von zweifelhaftem Ruf*) when she drinks in the company of men, no longer sees a choice: "Because of her consumption of wine the woman has left the path of virtue, [and] the seducer has an easy time with her." He also adds an absent husband, elaborating further on the moral state of this supposedly fallen woman. The issue here is, at least in part, one of temporality. Klessmann takes the moment shown as one in an irreversible course of events, as all the represented figures turn away from the figure of Temperance. This would be true, were it not that the beholder, too, is a represented figure who has a clear view of the entire scene and of Temperance. But without the least hesitation Klessmann takes the beholder to be an invited participant in this *Männergesellschaft*, encouraged "with a smile." In this interpretation the *Gesellschaftsbild* is a *Männergesellschaftsbild*, in which the two female figures are present either as powerless actors – no one pays attention to Temperance – or as frivolous companions. For Lawrence Gowing (1952), by contrast, the beholder's presence in the painting answers an urgent need for intervention, to the woman's "appeal to be released from the oppressive charade."[108] Others see the viewer's role as that of the neutral witness to a scene in which both members of the pair are equally engaged in flirtation. Thoré (1866) writes of "the Brunswick Coquette" that she "laughs with her gallant! This is life itself."[109] Following this clue Plietzsch (1911) sees a happily flirting couple (*schäkerndes Paar*), but interestingly considers the painting's particular appeal to lie in the strange contrast in mood between the couple and the melancholic man lost in thought.[110]

This strangeness of contrast is not only one of mood but also one of temporal relationships. I have already discussed the temporal ambiguity of Temperance's interruption of the scene: as an object the window is anterior to the scene and as a representation it suggests a device for the depicted household from which the scene might be seen as an aberration; on the other hand, as an animated, illuminated figure Temperance appears to rush into and correct that scene. The man seated at the table, seen together with the still life on it, suggests that this social gathering has been going on for a while and may represent "a lifestyle given over to pleasure" (Klessmann). But the man and woman in the foreground appear engaged with each other at the very moment of our implied appearance on the scene. If that appearance is ignored by the seated man, it is directly acknowledged by the woman and, I believe, by the man bending over her. It is a very pointed interruption, focused on a moment that cannot be interpreted otherwise than as a moment in an action, involving figures *and* objects.

Here it is useful to return to Würtenberger's analysis of Vermeer's *Gesellschaftsbild* as an image of society and social life coming to a halt within itself. He discusses *The Girl with the Wine Glass* as one example of this:

> Looking at the painting *The Girl with the Wine Glass* in Brunswick, [one realizes that] there is still a residue of action in the way the cavalier bends over the girl's hand and supports the hand with a finely sensitive gesture, touching it lightly. It is solely a measured homage to the girl through a mere cavalier touch and a clasping gesture of his hand. A smile appears on the gentleman's face at his close view of the girl, while the girl answers with a fine smile at the beholder. This slight action occurs within a very small area of the picture. In its course the two heads and the two hands come very close together. The action consists, as it were, in the pure gaze and in the pure touch. A certain psychic contrast with this contented couple is suggested by the cavalier sitting behind the table, lost in thought, with his head propped on his arm. It is typical of Vermeer to reduce the scene to three personages (Würtenberger 1937: 87).

The last sentence, of course, contradicts Würtenberger's earlier description of the action as one involving the beholder as a fourth person. The description itself is intent on pure relationships. By "pure" the author means an exactness that is both respectful and virtuous. This description inserts the painting into the author's concept of the *Gesellschaftsbild*, which allows for contrast and dissipation, but is built upon respect, tolerance, and restraint of will and desire. In order to see the painting as an example of this concept, he interprets the moment seen and interrupted as one of minimum action, as a moment halting that action at the point of demonstrating its virtue. There is no seduction here, no fantasized fall on anyone's part, no irreversible doom.

Würtenberger's attention to exact relationships is important, but his analysis is incomplete in two ways: It does not include objects and it does not account for the beholder, apart from giving her or him a simply affirmative role, in keeping with the concept of the *Gesellschaftsbild*. The exclusion of objects begins with his overlooking the clothed parts of the couple's bodies; the figures exist for him as heads and hands

alone. In fact, though, the woman's red dress has contributed to her negative characterization by some interpreters as a disreputable woman.[111] This perception seems to have mingled a long iconographic tradition of dressing the Magdalene in vermilion with a newer convention having to do with the fashionable mid-seventeenth-century use of a strikingly bright red dye for textiles; in genre paintings of the time women are often seen wearing such red dresses. The striking red of the dress in *The Girl with the Wine Glass* is doubly effective. As a referent to this iconographic mélange and as appearance, it both attracts attention and externalizes that attraction. As one admires the dress one also admires Vermeer's capacity for rendering the texture of satin, his virtuosity in rendering its appearance in the diffuse daylight illuminating the interior. The skirt is a separate shape, almost the only shape in the lower half of the painting, where otherwise we see only the tile floor and so take note of the physical distance between ourselves and the couple. This skirt does not quite touch the lower edge of the picture, but seems to be folding inward. As a motif of attraction it leads the beholder into the scene, perhaps more so at first than the woman's look, acknowledging our presence. It now becomes clear that we need to attend to the roles played by objects in this scene; I will ground this attention in a formal analysis.

The parabolic folds of the woman's skirt complement the shape of the man as he bends over her lap. This diamond-shape is horizontally divided by the girl's left arm, resting upon her lap, and her hand, crumpling a white cloth – a napkin, perhaps, like the one hanging from the table. That other napkin, however, appears starched and ironed. In fact, it appears to intersect the couple's composite shape at its widest point, the dividing line formed by the woman's napkin, hand, arm, and elbow with lace ruffles. This motif makes one realize that while the man is standing next to the table, the woman's chair is at a considerable remove. There is something very disparate about her pose and her appearance as shape. Even as we register the composite shape of the couple, we realize that this shape only regards the upper half of his body and the lower half of hers. This composite diamond-shape represents the sexual aspect of the couple's encounter. The two napkins appear to stress this, while also forming part of a circle of alternately stiff and soft pieces of white cloth and lace, which draw together all three figures. It is also true that as the man bends down and her torso and head appear parallel to his, she evades the sexual interest expressed in his encompassing or embracing form. This evasion is expressed largely through objects and very exact relationships of objects and shapes – none of which have a place in Würtenberger's account of the couple's polite encounter. The man keenly watches the woman's face which is turned away from him toward the beholder, whom I take to be the individuated single beholder, or the historical succession of beholders, one after the other. Because the man blocks the viewing axis between the two seated figures, all eye contact is interrupted, except for that achieved with the beholder. Moreover, this single eye contact is not directly witnessed by anyone else, as it is in a number of Steen's paintings or in Dutch group portraits.

In the figures' gestures we encounter the shapes of concentric circles and spheres inscribed within the oblong diamond-shape of the couple. At center are the figures' two right hands, circumscribing the wine glass of seduction. At first the woman's hand seems to be enclosed by the man's, as Würtenberger and others have suggested. But it is not clear that he touches her hand. A minimal distance seems to

be preserved between these hands, which do not overlap at any point. At the same time, the empty sphere formed by their hands opens toward the beholder in such a way as to render the encounter visible. In the openness of these gestures, the beholder's interruption manifests itself in the form of a real halt. This halt is further represented by the man's white shirt ruffle, framing the two hands. This shirt ruffle, with its dark, empty center, seems to be severed from the extremely foreshortened hand in front of it. What may at first appear as a smoothly unfolding scene of either respectful courtship (Würtenberger) or easy seduction (Klessmann) is halted and represented in its halt as a number of separate relationships of hands and things, concentrically layered and fully visible. The glass of white wine itself, held by the woman between thumb and index finger in a cultured gesture, is transparent and would be rather inconspicuous, were it not for all the envelopes provided for it.

This halted encounter contrasts in its openness with the closure of its counterparts, the firm shapes of white napkin with pitcher on the table and the introverted figure of the seated man, with whom our interpretation of the painting began – that is, with motifs of demonstrative separateness. Napkin and pitcher, shirt ruffles and collars thus serve both to contrast and to relate the figures in this scene, clarifying their relationships for the interrupting beholder at the moment of his or her appearance. The beholder's appearance, which at first was tied solely to the motif of exchanged looks, now increasingly discloses its Hegelian meaning as an appearance implied by the entire painting.

The painting includes another paired counterpart to the couple. This third counterpart is composed of Temperance in her window and the portrait of a man dressed in black that hangs on the back wall. These belong to the painting's upper horizontal register – the lower register being occupied by the woman's skirt and the floor tiles, and the middle one by the three figures and their objects. One might take Temperance and the painting on the wall, perhaps an ancestral portrait, to represent a respectable couple that contrasts with the "real" one. It is striking, however, that Vermeer gives the portrait a rather vague presence in the room. Klessmann sees in the portrait's sitter a direct paradigm of the male partner or seducer, a mixture of honorable man and dandy.[112] Temperance, however, is a strong, colorful, and emoted presence in this interior, Vermeer makes her look down at the couple. The blue and the red of her dress correspond to the blue of the tablecloth and the red of the woman's dress. The yellow in the escutcheon approximates the flesh tones of the woman, and the gold embroidery of her dress. In other words, Vermeer provides a coloristically defined diagonal between Temperance and the seated woman, a diagonal cutting across the middle horizontal register of the composition. Once again, this diagonal is made meaningful through the precision of the relationships between shapes and colors. If the escutcheon is seen as Temperance's shield, then the yellow color of its right half corresponds to the woman's gold-embroidered torso and sleeve, which escape the man's embracing shape.

Temperance's admonition can be seen to be directed at all suggestions of possible excess in the painting and thus to relate to the spiritual well-being of all figures involved. This interpretation is suggested in part by the strongly illuminated inner frame, on which the lead fittings' shadows appear to point in all directions. But beyond this general address, Temperance's admonition appears specifically directed, through coloristic correspondences, at the seated woman. At the level of social deco-

rum, she is the only one who needs to shield herself in terms of the rules of conduct represented by Temperance. The men, while needing to heed Temperance, have no need to shield their conduct.

If we extend the line of the slanted window into the room, its implied function as a separating screen between the couple becomes apparent. The window works like the starched white table napkin, as a screen or shield of protection or restraint. More precise in its reference than the napkin, the line created by the window separates the two right hands very neatly, a separation figured in the oval escutcheon, with its vertical divider. Furthermore, the procession of three geese in the yellow half seems like an ironic straightening-out and lining-up of the three personages in the room.

The beholder, as the interrupter of the scene, is not able to represent it to him- or herself in such a way as to withdraw from it and let it follow "its own" course. There is no such inevitable course. The course of events is determined by one's own interruptive presence. The scene is halted forever – from within and from without – in a very precise moment of both readiness and indeterminacy. It is a readiness for doom, seduction, or pleasure as much as a readiness for intervention and restraint; a readiness held in place by an ever more apparent dissipation of agency into things rather than human figures. In his attitude of melancholy, fatigued contemplation of past pleasures, or gloomy anticipation perhaps of future sufferings, the man at the table appears to be the negative, inactive double of the beholder. For him, as for us, the scene is a representation in which one is always already present. Yet there is an important difference: he is not interrupting the action, as we are – a fact the woman is possibly expressing in turning her face toward us. The collusion between the two men seems to be grounded in a certain ancestry, or lineage, represented by the relative distinctness of their rendering and leading from the seducer to the melancholic to the gentleman-dandy on the wall, and further back still into the shadowy past and depth of the scene. This line, extending in the other direction, it may or may not be broken by the beholder, who can choose to identify instead with the bright and colorful lineage of the open window, with its stained-glass image, and the seated woman. Counting oneself as a member in one or the other of these lineages, one might recognize either three (or four) gray men and a shadowy past and future, or two (or three) colorful women and a bright future. Thus, out of the historical distance of the painting from the beholder's present an important element of playfulness may enter the structure of interruption.

What troubles as well as interests me in such a scenario of dual playful, equally valid supplementations is how it could possibly be – however mediated or partial – a historical address made in c. 1659–60 to its contemporary beholders. A number of efforts have been made by Vermeer scholars such as Lawrence Gowing, Edward Snow, Martin Pops, and Svetlana Alpers to see Vermeer actively dignifying women in his art in a way otherwise unknown in his time. Though they each mean something very different by this, their efforts have a certain common thread. They all need to dehistoricize the represented women in order to attribute to Vermeer the ability to turn them, however briefly, into purely natural or essential beings. It seems to me that such an evaluation, which is often based on the elusiveness of Vermeer's women, simplifies the ambiguity and complexity of his representation of gender relations as social relations. The mere possibility of play and choice suggests that there is

no clear-cut gendered symmetry of dark past and bright future, but rather a luminous, undramatic chiaroscuro: coloristically and compositionally, the two lineages intersect in Vermeer's painting in the couple's concentric gestures.

Colors, chiaroscuro, composition, and objects play a large role in the generation of meaning in this painting. Their agency and appearance, in combination with the figures' gestures, are even more readable than the faces. Any positive or negative judgment of either man as such, or of the woman as such, or of their relationships as such ignores the fact that the painting refuses such judgments and such notions of individual, "natural" freedom. The woman possesses no particular agency of her own despite the fact that, in contrast to the two men, we see her as a complete, if divided, full-length figure. In the end, it may be more productive to acknowledge Vermeer's treatment of the female figure as dependent for her definition upon the interruptions and disturbances of the halted scene.

Disturbed and interrupted as *The Girl with the Wine Glass* is, both by objects, shapes, and colors endowed with agency, and by the beholder, its status as a bourgeois idyll comes into question. In order to test further the possibility of interpreting Vermeer's genre paintings within the framework of the genre painting as *Gesellschaftsbild*, and as disturbed idyll, I will now compare *The Girl with the Wine Glass* with *The Glass of Wine*.

The Glass of Wine

In *The Glass of Wine* (Pl. III) the beholder is not directly and forcefully implied as one who interrupts the ongoing action. This is borne out by the painting's current title, which omits any human agent. Like *The Girl with the Wine Glass*, the painting in Berlin also has a history of different titles. Again, the eighteenth-century titles are primarily descriptive: *A seated woman drinking, with a man standing* (1736); *A gentleman standing with a lady who in a large room sits at a table and empties a glass* (1785). When acquired by Bode for the Kaiser Friedrich-Museum in Berlin in 1901, the painting was soon catalogued as *A Girl Drinking, with a Gentleman* (1904), the same title by which Hofstede de Groot catalogued it in 1907 in his catalogue raisonné, while in his monograph on Vermeer and Fabritius (1905, 1907) he called it *Lady Drinking a Glass of Wine (Dame ein Glas Wein trinkend)*.[113] In its contracted form this title suggests a particular theme. Oskar Fischel, in his 1905 catalogue for visitors to the collection, called the painting *Wine Sampling (Weinprobe)*.[114] Later, the Gemäldegalerie in Dahlem chose the title *Gentleman and Lady Drinking Wine (Herr und Dame beim Wein)*. This present title may be called neutral, yet in its vague attempt at equal treatment of man and woman it at once obliterates the differences between the two figures and sandwiches the lady between the gentleman and the wine. In Dutch, English, and American publications the painting is mostly called *Het Glas Wijn, The Glass of Wine*, a metonymic title that seems to promise an exciting narrative of virtue and vice, but also suggests that an object, not a person, is the center from which any action will unfold.[115]

To point out these changes in the painting's title may seem pedantic, but this history of names has important implications. All these titles reflect specific attitudes not only toward Dutch genre paintings and scholarship, but also toward codes of

social conduct and morality. From the late seventeenth- to mid-eighteenth centuries one finds no distinction made between the title and description of a painting in a given inventory or auction catalogue. Later, one notices an increasing awareness of the difference between title and description and of the interpretations presupposed by titles and conveyed by them. This process was well under way at the turn of the century, when Bode, for example, still placed a comma between "drinking" and "with" in his title, *A Girl Drinking, with a Gentleman*. The comma suggests a mere itemizing of the two figures; if it were omitted, the title would focus on the woman and characterize her occupation as "drinking with a gentleman."

Hofstede de Groot's description of the painting – the earliest one I can find in the Vermeer literature – is a description of its minimal action, which he interprets as the woman's action. Most interpreters of the painting follow him in this. "To the right of a table, placed in the left-hand corner of a spacious room, a girl sits in profile to the left, drinking a glass of wine, which a man standing at her side has poured for her." One only needs to take out the phrases "to the right" or "placed in the left," and the description will turn into an ekphrasis: "[I]n . . . a spacious room, a girl sits, drinking a glass of wine, which a man standing at her side has poured for her." Hofstede de Groot starts with the motif on the far right of the painting, the seated woman, and then integrates motifs further to the left of it; he does not read the work as one would a text, from left to right, but in the reverse direction. In its focus on the action, Hofstede de Groot's account of the image is linked with the concept of the *Gesellschaftsbild*.

In contrast to the Brunswick painting, there is no overt motif of interruption or disturbance in this representation, such as a figure looking outward. Thus, logically a beholder and interpreter will try to determine the temporal moment of viewing less as one dramatically implied from the very outset than as one in a narrative sequence. The representation appears as one of many possible moments in a preconceived narrative with beginning, middle, and end, and yet a moment that can be objectively determined in the analysis of the temporal, if not causal, relationship of the actions of both figures, gentleman and lady. Arthur Wheelock determines the relationship of figures in *The Girl with the Wine Glass* as a triangle of emotions: "Sitting behind the table is a man in a melancholic pose who is either reacting to too much wine or to the girl's obvious attraction to the other man." But he declines to speculate about the relations in *The Glass of Wine*: "The demeanor of the man and woman is also so proper that no explicit associations of love, such as one might make given the presence of the lute and a glass of wine, can be made." For him the objects are primarily signs of the material wealth and elegance of a "genteel society".[116] This might suggest that *The Glass of Wine*, the only painting by Vermeer today bearing a title referring exclusively to an object represented in it, is characterized by the exceptional status of containing largely ineloquent objects. This paradox is not new. Interestingly, Hofstede de Groot, who enumerates most of the objects in the room, notes something like an avoided connection between the figures and the spectator, a phenomenon that appears to entail the muteness of the objects: "She wears a red dress; her face is almost entirely concealed by a white cap. The gentleman, who almost faces the spectator, looks intently at the girl." From this formulation it appears as if the two figures were indeed denying the beholder's presence, the duration of which is difficult to determine. Its relation to the narrative sequence is open.

This openness is connected to the distances represented in the painting. As the man stands watching the woman drinking, the distance between them inflects his attitude with a sense of appraisal. The beholder, meanwhile, sees the configuration of woman, man, and furniture as something set well into the interior, something to be appraised from a certain distance. With this sense of distance comes a sense of crescendo or even of procrastination. Considering the lute so carefully placed opposite the woman, one might interpret the man to be lingering while taking leave of her after a music lesson has ended, delaying the moment of separation by offering to refill her glass. In that case, the glass of wine and the various distances become quasiromantic motifs of longing and inevitable separation. There are other possibilities, such as seeing the woman reduced to an object as mute as the lute opposite her. Any of these possibilities is ultimately concerned with the strangeness and tension of the ponderous moment represented, a moment that has nothing to do with interruption. On the contrary: the implied interruption in *The Girl with the Wine Glass* ultimately brings the beholder's imagination of the narrative progression to a halt, whereas the extreme contraction and mismatched parallelism of the scene in *The Glass of Wine*, as we will see, spurs such imagination forward. At the same time, the moment of interruption is absent or deferred.

The narrative contraction revolves around the man. He stands still, dressed in coat and hat, grasping the pitcher by its handle, perhaps in the act of setting it down or perhaps preparing to refill the woman's glass as she empties it. Can we say that he is just setting the pitcher down, while she is already emptying her glass, or that he is urging her to drink the next glass as she empties the last? Either possibility suggests a haste that creates a foreboding mood for the scene, a haste, moreover, that appears to relate awkwardly to the open-ended appraisal going on at the same time. There is a mismatched parallelism between the two figures that highlights the absence of a common action. The man's watchful gaze is shadowed by his broad-brimmed black hat. The woman's gaze, too, is hidden by the wine glass, whose shape slightly distorts what can be seen of her face, while its reflection seems either to direct itself toward or to issue from her eyes – a motif that also occurs in ter Borch's and de Hooch's works.[117] By contrast to their works, Vermeer's painting shows a lack of any friendly relationship between the couple. The man's lips are slightly parted, but in view of his hasty gestures, it is not at all clear whether this indicates speech or not.

It is instructive to compare the objects and motifs Vermeer's two paintings share and the "behavior" and possible functions of these objects and motifs in each. If the circuitous gestures in *The Girl with the Wine Glass* allow a differentiated understanding of relationships, in *The Glass of Wine* the foreshortened gestures and rigid poses are stiff and functional. They strike the beholder as self-conscious. Nor does an examination of the relation between gestures and objects yield any sense of connection among the elements of the painting. The dense group of self-centered, rounded forms and objects primarily emphasizes the isolation of each, despite their physical proximity to one another. The man's hand is arrested and rather immobile between the puffed-up starched ruffles of his cuff and the ovoid wine pitcher. All the same this configuration appears determined by his will, since most of his draped mantle's folds converge on it. The lowest of these folds connects his gesture with the woman's where her hand overlaps his draped elbow. The semihidden gesture of the

man's left arm akimbo suggests that he is challenging her, a suggestion underscored by the folds of her skirt, which echo those of his mantle, as if molded by them.[118] The couple's poses diverge slightly from the vertical and from one another. Not a single object is directly connected with the woman. The lute, the music sheets, the table with its Turkish rug seem far away from her. The relationship between the Temperance figure in the familiar stained-glass image in the window and the couple is weak and characterized by distance, particularly since here, in contrast to *The Girl with the Wine Glass*, the window's wing is firmly anchored and set deep in its bay.

It is here that the theme of interruption arises after all. The relationship between the window, with its quatrefoil image of Temperance, and the couple is not only weak but also interrupted by the gold framed dark picture on the far wall. This is barely identifiable as a landscape painting and, like a negative double, cancels the window's effect, as it were. Further, the window's spatial thrust toward the couple is blocked by the prominent chair, whose back is a bright, sunlit double of the dark picture on the wall. Just as that dark picture becomes associated with the man through the rhyming shapes of its trees and his hat, the chair serves as a strange mediator between window and woman. The two gold-trimmed velvet cushions on bench and chair seem to make that point. The one on the bench might be the standing man's former seat; the one on the chair is occupied by the lute and sheet music. These relationships among objects and figures tend to relieve the tension of the couple somewhat. They appear only slightly forced, as long as one does not realize that they have been established in a way significantly different from that in *The Girl with the Wine Glass*.

In *The Girl with the Wine Glass* most shapes and colors converse directly in bright daylight; in *The Glass of Wine* it is the function of chiaroscuro to mediate these relationships among figures and objects and then between the two figures, with their respective supporting objects. This difference becomes clear as one focuses on the window motif. In *The Glass of Wine* the angle of the window's slant into the room is sharper than in *The Girl with the Wine Glass* (Pls. III and IV). The colors of the window's stained-glass quatrefoil are distinguished by their function as local color, thus producing an image of relative iconographic clarity and legibility. Interestingly, the escutcheon's colors are equally brilliant in both paintings. But in *The Glass of Wine* the allegorical figure of Temperance is rendered only in pale pastel tones, not in the same saturated hues as the escutcheon. Almost illegible, and perhaps entirely illegible if one does not know its other version, Temperance appears more remote in this painting. This is caused in part by Vermeer's guidance of sunlight through the entire front of both window panels, seen through the open wing, a filter he avoided in *The Girl with the Wine Glass*. In general one might say that in *The Glass of Wine* Vermeer subordinates color to the dramatic chiaroscuro of zones alternately illuminated and submerged in shadow. In the Brunswick painting light itself is rendered colorful, slightly bluish and evenly spread over the entire room, so that a distinction between local color and illumination plays no role at all. In the Berlin painting, mediation as well as the interruption of relationships among figures, objects and figures, objects and objects, and strongly colored shapes take place in the realm of the polarization of color and illumination, or of chiaroscuro. The most striking complication of relationship regards that between the stained-glass image

and the woman, with the rug's pattern helping, but also distracting a little. Of course, as in the previous painting, it is possible here to imagine the line of the window extended across the chair's back and between its lion finials, so that further to the right it separates the couple like a screen. But here it is, significantly, the entire window, rather than the figure of Temperance, that serves this purpose, while both Temperance and the woman's face remain invisible behind illuminated glass and reflections. Thus, both light and darkness have a potentially obliterating effect in this painting. The entire scene is laid out before the beholder, all the figures and furnishings arranged around the table. Yet as the figures appear to avoid the beholder, it not only becomes easy to dissociate oneself from the scene but difficult to account for one's presence in it. Its peculiar temporality, the lack of a temporal unity in it, exacerbates this difficulty. If one accepts that the painting's functions of isolation and temporal disjunction are implied from the outset, then an interpretive challenge of the painting lies in seeing how these functions negatively imply the beholder.

Here it is useful to return to Würtenberger's observation that in some of de Hooch's paintings the beholder appears to be ignored by the painting, an effect he ascribes to de Hooch's way of integrating and enclosing the world of his *Gesellschaftsbild* through illumination. If for Hegel *Schein*, appearance, is original to Dutch painting and at the same time spatially and temporally infinite and thus capable of illuminating Hegel's present, Würtenberger, by contrast, sees the luminosity of de Hooch's best paintings as temporally and spatially finite, as that which renders a de Hooch painting a separate and autonomous world. Given this account of de Hooch, what does Würtenberger have to say about Vermeer's *The Glass of Wine*, one of the four *Gesellschaftsbilder* he selected for discussion? He starts out by asserting the absence of a represented action in this painting, which he calls, in 1937, by its current German title, *Herr und Dame beim Wein*. After describing the rigidity of the figures and gestures, he focuses on the couple:

> This lady is completely absorbed in drinking wine. All her feelings and will are concentrated on it. Of the two, only the gentleman gazes, and his gaze is predetermined by the dark contour of his garment and at the same time veiled by the shadow of his hat.

He then discovers a new kind of

> dramatic life in the peculiar way in which the furniture stands bulkily in the room. The couple gets pushed to the side by the table, out of the center of the image. The left half of the painting is dedicated to the furniture, whereas the right half belongs to the human figures. The true conflict in the image consists in the chair standing violently [*gewalttätig*] [and] obliquely to the table and possessing in its structure more humanity than the human beings, wrapped in fabric. On the chair lie a stringed instrument and sheets of music. The objects that have been laid aside indicate the couple's former occupation and have more pathetic life in them than do [the couple] in their paralyzed drinking of wine (1937: 88f.).

Taking all this to be the ultimate representation of the figures' interiority ("an innerem Gehalt der Figuren"), he concludes: "[W]ith such a creation the realization of the concept of the social was lost."[119]

Würtenberger sees Vermeer's *A Lady at the Virginals with a Gentleman* (Fig. 17) as a further development of the displacement of social activity from human figures to objects. These objects, in turn, seem grotesquely alive and yet like memorials to a social past.[120] He observes that not even music serves to establish a relationship between the two figures and, further, that "the psychic relations are not established through a direct gaze" but through the mirror's reflection of the woman's face above the instrument. He concludes: "This testifies how much the figures have merged with the furniture." The "solitary wine pitcher" on the table represents "the ultimate consequence of a long development from the grand banquet with music and sumptuously set table to this couple standing at the virginals."[121]

We might assume that Würtenberger saw himself as standing at the end of this development away from the social, partly regretting its course. But he does not reflect his familiarity with this development through modern experiences of the social sphere, certainly not of the political sphere, making no connection between the topic of his study and the situation in which he undertakes it. On the contrary, he understands this end point as a turning point, inasmuch as he sees Jan Steen, the artist he discusses next and last, as returning from the seventeenth-century *Gesellschaftsbild* to the sixteenth-century *Sittenbild*. By *Sittenbild* he means genre painting that furnishes moral lessons about virtue and vice and humorous admonitions in which the relationships of figures to figures and figures to objects affirm, however comically, a given order to the world: "In such pictures the attempt is made to reflect on the world on the basis of the sphere of the home and to represent a mirror of the world (speculum mundi), insofar as this was possible with genre motifs based on arbitrarily invented situations and . . . through the accumulation [of such motifs]."[122]

In this way Würtenberger highlights once again what to him is the main characteristic of de Hooch's and Vermeer's *Gesellschaftsbilder*: they affirm no such allegorical meaning or world order. In this sense they are entirely free, as free as this type of painting never was before or after, to affirm nothing but their own representation. Beyond these works there could only be an inaccessibly subjective and socially unbound art. Würtenberger concludes his account by making reference to Riegl's essay on Ruisdael, reminding the reader that by the end of the seventeenth century Dutch art has historicized itself. Ruisdael's *Jewish Cemetery* is sentimental, not naive, longing, through an accumulation of motifs, for the lost wholeness of the past. The last words of Würtenberger's book are "ein Ende," less an ironic phrase than a Hegelian one suggesting both an end of this art "in its true identity" and its continuation in later types of genre painting, such as the French eighteenth-century genre painting of Chardin and Greuze, the despised nineteenth-century genre painting of Germany, or the nineteenth-century Dutch revival of its own golden age of painting. In this way, Würtenberger may be said to have recognized "the monuments of the bourgeoisie as ruins even before they have fallen apart," as his contemporary Walter Benjamin wrote with reference to Hegel.[123]

Chapter 3

Temporality and Difference
"The Chinese Hat"

[T]he distances between the people and the objects, between one person and another, between the furnishings and the figures, are something astronomical. One has the impression of the illusory stillness of the heavens, a sky furnished with immovable stars. . . . We wouldn't recognize him in our time, any more than they recognized Vermeer in his. Surrealist? No. Naive? No. Abstract? No. Therefore nothing at all.
<div align="right">– J<small>EAN</small> C<small>OCTEAU</small>, 1954[124]</div>

It is striking that in German art historiography after Würtenberger only Friedländer, in his 1947 study of genre painting, recognized the disturbed bourgeois idyll in Vermeer's art, when he suggested its comparability to modern genre painting, in his view a necessary failure.[125] By contrast, first Sedlmayr in 1951, then Badt in 1961, and finally both in the ensuing debate dehistoricized their own reasons for proclaiming the relevance of Vermeer's art and thus established an undialectical understanding of it.

To some extent, their views have recently been reestablished by French scholarship on Vermeer, particularly Bernard Lamblin's study of the temporality of painting, *Peinture et temps* (1987). Lamblin includes Vermeer in his analysis of Dutch genre paintings as paintings of repetition, of the eternal return of the same everyday life situations. Vermeer's as well as de Hooch's genre paintings stand out from this art as paintings distilling this repetitiveness into a permanence. For Lamblin, their silent duration suggests the quiet passing of time, but in such a way that "the present no longer carries any sense because it is confounded with eternity" and the beholder "is in the presence of the painting of duration."[126] This interpretation of Vermeer's genre paintings not as idylls, and certainly not as disturbed idylls, but as pure painting, is comparable in particular to Badt's interpretation of Vermeer's *Painter and Model* as a "transfiguration of the everyday," which offers its beholders the "experience of a timeless happiness" and "celebration through praise."

By his own account, Lamblin's study of time and painting is much indebted to German philosophy, but it may also be seen in connection with the modern French

tradition of writing about Vermeer, a tradition where the space of contemplation is ultimately filled by a literary representation of the art work. Such a literary representation, however, temporalizes as well as historicizes its own interpretive ambition, often deliberately, sometimes unknowingly. It is to this tradition of literary art criticism that I shall turn next.

It is useful at this point to provide a preliminary distinction between the narrative, partly dramatic dimension of the disturbed idyll and this critical tradition – of the strongly literary genre of writing about Dutch painting in nineteenth- and early twentieth-century France. To do so, I return briefly to Hausenstein's account of Vermeer as classically oriental, in his Rembrandt monograph of 1926. This study serves as a bridge (although a flawed one) between the German and French traditions. In its understanding of the temporality of Vermeer's genre paintings, Hausenstein's account looks comparatively uncritical and even lazy. He seems to prefer the use of an orientalizing language for a perceived difference in Vermeer's paintings, to a careful analysis of their unusual temporality and its involvement of the beholder as critic. Hausenstein's account is a paraphrase, in part, of his friend Benno Reifenberg's essay on Vermeer. It may well be that both, with their close affinities to France and French culture, are directly influenced by the French critical reception of Vermeer and its strongly literary aspects. Quite obviously, Hausenstein is not the kind of critic who would ask himself questions about this critical tradition, but in his effort to practice the most lively, re-creative *Kunstschriftstellerei* he uses whatever will advance this goal.

Quite ironically, there is an anecdote of Hausenstein's early years that connects him to the fictional world of Marcel Proust. While sojourning in Paris in 1906 he found employment with the Queen of Naples as her companion and reader.[127] The Queen of Naples, who had been exiled fifty years earlier, was fictionalized by Proust, who has her make highly valued visits to certain salons in *Remembrance of Things Past*. The French connection can also be found in Hausenstein's own classification of his writing on Vermeer. In 1923 he published "Der chinesische Hut," a text that he calls "eine Erzählung," "a story," on *Young Girl with a Flute* (Fig. 21).[128] Today this painting is not unanimously believed to be by Vermeer, but at the time Abraham Bredius's ascription was accepted.[129] It was exhibited in the Spring of 1921 in the Alte Pinakothek, Munich where Hausenstein saw it. In his story he writes:

> The mysterious polygon of things [i.e., flute, hat, vase, tapestry] nevertheless has its equivalent in the human element (because the human, through the magic of the objects has itself become objectlike, factual, unsubjective): in the woman's gaze and in her half-open mouth, which are vegetable and also infinite; in the perfection of Dutch phlegm toward a parable of that simple and even unreflective state of neutrality [*Zuständlichkeit*] that is the ideal of Asia – which exhales and again inhales eternities.

In this descriptive paragraph Hausenstein mixes three clichés: Dutch phlegm, the identification of Vermeer's women with ahistorical nature, and the identification of Asian culture with unreflective resignation and nothingness. It is the last of these identities that interests me most, as it stands in strongest opposition to the various procedures of negation of and reconciliation to the historical found in the German

73

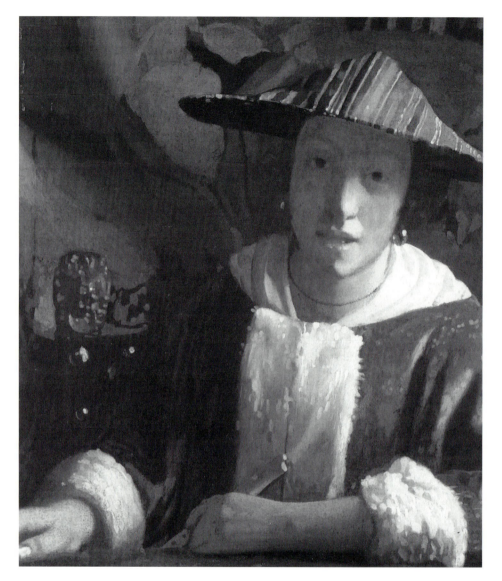

21. Circle of Jan Vermeer, *Young Girl with a Flute*, c. 1665–70, oil on panel, 40 x 17.8 cm, Widener Collection, National Gallery of Art, Washington, D.C.

critical tradition. Except perhaps for the first, the commonplace about Dutch phlegm, these clichés are borrowed by Hausenstein from French writings about Dutch culture, as is the strategy of embedding them in a text classified as a story.[130] As we saw earlier, Hausenstein meant to achieve an expressionistic liberation from the preoccupation with the historical and the social so prominent in the Hegelian tradition of interpreting seventeenth-century Dutch painting. Therefore, he adopts certain surface features of French literary art writing, but entirely ignores the cultural and critical functions for which the three clichés – Dutch phlegm, feminine elusiveness in Vermeer, and Asian nothingness – had once been vehicles. To trace these cultural and critical functions is the purpose of Part II of this study.

Part II: Fiction

The French Reception of Vermeer
and the Modernity
of Vermeer's Cityscape

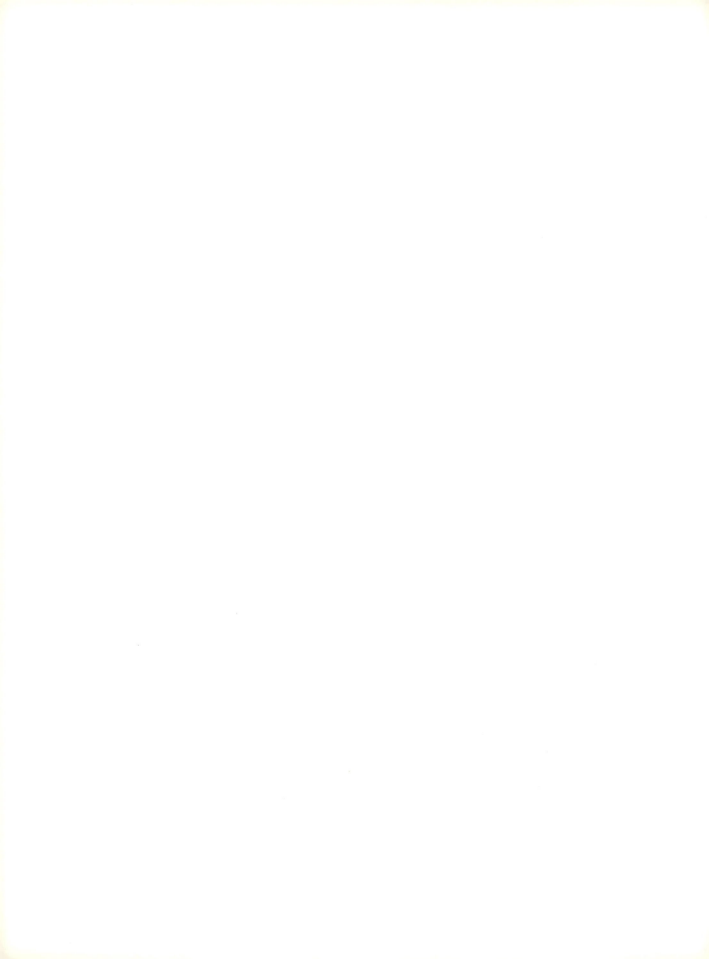

Introduction

[I]n naturalistic styles . . . works, if they are to be judged art, must retain, and indeed must employ more industriously, procedures to qualify the intimation of particularity, to counter the strong impression of events entirely foreign to oneself.
— ADRIAN STOKES, 1965[1]

The dialectics of realism in art – that the real is the foreign – have found many formulations in modernism. The "procedures to qualify the intimation of particularity" that Stokes asks his readers to consider have been conceptualized by voices as different as Freud's and Heidegger's. Vermeer's paintings, and especially his *View of Delft* (Pl. V), have become the site of such a formulation.[2] Lawrence Gowing writes of the painting: "The *View of Delft* presents us with the most memorable image of the remoteness which is the essence of Vermeer's world."[3] According to Gowing, it is the achievement of Vermeer to make the remote memorable and, by implication, recognizable. Gowing's statement may be said to summarize one hundred years of critical reception of Vermeer's art, a reception that for the most part originated in France and continues to have a profound influence on Vermeer scholarship to this day. As is well known, the art critic Théophile Thoré's encounter with *View of Delft* in 1842 prompted him to set out and "rediscover" the artist Vermeer.[4] Between Thoré's pioneer work on Vermeer and Gowing's monograph of 1952 lie numerous encounters; these require reconsideration within the framework of two modern concepts, that of the real as the foreign, as the true enigma, and that of pure art. This reconsideration will provide insight into the fabrication of Vermeer and his remote history as contemporaneous with his modern viewers.[5] These insights in turn raise questions about the temporality of art and about the status of scholarship within other genres of writing about art.

Several such genres of "art writing" can be distinguished in the history of Vermeer's reception during the nineteenth and early twentieth centuries.[6] First, there is fictional writing about Vermeer, above all, Marcel Proust's novel *Remembrance of*

Things Past, in which the author relates habit to revelation through time, remembrance, and – among other exemplary artists – Vermeer's art and name. Another genre comprises mainly French publications of journeys to the Netherlands and its museums and private art galleries, texts that sometimes include long passages on Vermeer. Last, there is the art-critical essay, based on the model and adopting the format of travel literature. With Gowing's statement about the memorable remoteness of Vermeer's world in mind, I shall examine all three genres of writing as practiced in nineteenth- and early twentieth-century France. While it is doubtless true that there are German and English as well as American examples of such writing, I would argue that these are based upon the French paradigm. One characteristic of this paradigm is that the same author often practices two of the three genres of writing. This is true of Proust, as it is of the nineteenth-century art writer Henry Havard.

On a different level of discourse, and of interest here, are attempts to conceptualize some of the experiences described in this body of literature. This category includes the art critic Max Eisler's study of space in Vermeer's art (1916) and the artist Adolf Hildebrand's solution to what he saw as "das Problem der Form" (1893) in the concept of the *Fernbild*, or distant image. This primarily spatial concept was soon applied to Dutch painting and especially to Vermeer's paintings by the art historian Hans Jantzen. The concept of the *Fernbild* was reinterpreted as a temporal concept and attributed to the melancholy disposition of the art critic by Walter Benjamin.[7] By introducing an allegorical dimension into this concept, Benjamin's use of the term will provide the link with the last part of this study, which discusses Vermeer's explicitly allegorical paintings. My purpose in this second part is to examine the French critical reception of Vermeer and to bring aspects of this reception to bear on a reinterpretation of Vermeer's cityscape painting.

In Proustian terms, one would have to claim that Thoré's mid-century recogniton of Vermeer as a great master was belated, only possible after the initial discovery of 1842, a discovery that itself lacked the dimension of cognition. I myself undertook my first trip to the Netherlands as a high-school student solely upon the imaginary "invitation" of Vermeer's *View of Delft* and in search of its equivalent – whatever that might have been – in the contemporary reality of the Netherlands. The question, however, is not whether scholarship is capable of finding what is sought and not – or no longer – found in travel. Of greater interest is the phenomenon of belatedness as the Proustian phenomenon of the historicity of language. I hope to situate Vermeer's cityscape within this belatedness, rather than outside it, beyond reach, and thereby mediate the contradiction of Gowing's comment that "*View of Delft* presents us with the most memorable image of the remoteness which is the essence of Vermeer's world."

Is the Dutch cityscape a historical document? And if so, why has its function as document made the cityscape so fascinating to its beholders, leading them, as Walter Liedtke puts it, to discover in the painting "this and that building and grandmother's house?"[8] Why does this act of recognition afford such pleasure? When a painting shows a particular city, whose history is it documenting? The pleasure afforded by this complex act of recognition appears on the one hand in the increasing historical interest in the Dutch cityscape during the past twenty-five years and on the other in the aesthetic interest taken in it by modern authors. Perhaps the fascination with the Dutch cityscape is root-

ed in the beholder's inability to separate whatever its documentary component may be from the more subjective kind of recognition. There is, perhaps, a singular pleasure in that one is looking at the city of Delft as seen from the south and at the same time at a painting by Vermeer; at this particular city and at this particular artist's unique rendering which might become one's personal – perhaps one's only – view of it. In one breath one can name the churches, the gates, the approximate viewpoint, and yet acknowledge that this most convincing cityscape is made visible by Vermeer alone and in a manner separate from "reality" or "nature." And far from being offended by this seeming contradiction, one may even be aware of the effort its mediation demands. Adrian Stokes addresses this phenomenon by locating the initiative for this mediation in the work itself, calling it the incantatory element, the enveloping pull, the invitation in art, an invitation that in the Hegelian sense reckons with and implies the beholder's acceptance. Stokes sees this initiative at work particularly in naturalistic or realistic art. As such an art, the Dutch cityscape, including Vermeer's painting, has been addressed under widely differing premises.[9] The particular challenge posed by Vermeer's *View of Delft* consists in understanding the synthesis of the documentary character of the cityscape and its profoundly aesthetic, metaphorical character.

To this end I shall discuss examples of nineteenth-century travel and art literature whose authors describe the reality of the Netherlands as they experienced it and who identify that reality with certain kinds of Dutch art. Certain aspects in the genre of travel literature, for example, the description of scenery as conditioned by such issues as historical distance, geographic nearness, accessibility, technology, and modes of travel, are very instructive. Art criticism and art-historical writings about Dutch art have been much influenced by this travel literature.

When, in 1977, the Historisch Museum Amsterdam and the Art Gallery of Ontario exhibited *The Dutch Cityscape in the Seventeenth Century and Its Sources*, the word "source" was used in a historical, archival sense, rather than that of intellectual origin. In his introduction, Richard J. Wattenmaker quotes from Henry James's *Transatlantic Sketch*, "In Holland" (August 8, 1874):

> If you come this way, as I did, chiefly with an eye to Dutch pictures,
> your first acquisition is a sense, no longer an amiable inference, but a
> direct perception, of the undiluted accuracy of Dutch painters. You have
> seen it all before; it is vexatiously familiar; it was hardly worthwhile to
> have come! At Amsterdam, at Leyden, at The Hague, and in the country between them, this is half of your state of mind; when you are looking at the originals, you seem to be looking at the copies; and when you
> are looking at the copies, you seem to be looking at the originals. Is it a
> canalside in Haarlem, or is it a van der Heyden? . . . And so you wander
> about, with art and nature playing so assiduously into each other's
> hands that your experience of Holland becomes something singularly
> compact and complete in itself – striking no chords that lead elsewhere,
> and asking no outside help to unfold itself.[10]

James is struck by identity: the seemingly impossible identity of the contemporary Dutch world with seventeenth-century Dutch painting, of what is out there and

apparently always was out there with the historic, but apparently timeless art. He half-seriously complains that his consciousness has not gained from this identity, that in a certain sense he has had no experience at all: "it was hardly worthwhile to have come!" Thus, worthwhile experience is defined as an inadequacy between preconceptions, in this case between Dutch land- and cityscape painting and the reality of the contemporary Dutch scenery and city. James desires a confrontation of the one with the other. The lack of such an experience, the *déjà vu* impression of the journey, renders the country and its reality a mere preconception, an image of the mind, "something singularly compact and complete in itself." In other words, country and art seem to lack the dimension of history that might have accounted for the experience of difference and inadequacy.

The tone here is only half-serious, the statement "it was hardly worthwhile to have come" corresponding to another aspect of experience important to James, that of circumstance. He describes a tour down the Rhine and the experience of viewing scenery from the aesthetic distance of a boat ride. He observes that the castellated crags and dungeons still "*compose* as bravely between the river and the sky as if fifty years of sketching and sonneteering had done nothing to tame them." And why is this so? James explains: "The fine thing about the Rhine is that it has that which, when applied to architecture and painting, is called style. It is in the grand manner – on the liberal scale; that is, it is on the liberal scale while it lasts" (James 1875: 381). The experience of the sublime depends on aesthetic distance which in turn allows the inadequacy between certain art ("sketching and sonneteering") and such generous natural sublimity to stand. While the meaning of the phrase "liberal scale" remains obscure, the temporal condition, "while it lasts," can be related to James's entry to Holland, where there is no natural sublime, no style, where art and nature appear as one. The at once natural and aesthetic distance provided by a boat tour on the Rhine is replaced by a wholly contemporary means of travel, the railway. There, in the different means of transportation and their comparison, resides the dimension of history that at first appeared to be missing in James's account. His "first impressions of Holland" about the supposed exchangeability of art and scenery, of "original" and "copy," were gathered "from the window of the train;" already framed, as it were. But James does not explore this contemporary viewing frame and its historicizing functions further. His opinion that "[t]he most pertinent thing one may say of these first impressions is that they are exactly, to the letter, what one expects them to be" shows that the memory of the Rhine's "grand manner" still looms over these *déjà vu* impressions and suggests after all a desired inadequacy between art and scenery (James 1875: 381f.).

Wattenmaker enlists the quote from James in support of his own understanding of art as a document for the "near-intactness of the Dutch seventeenth-century city or parts of cities, something to be admired, cherished, preserved," in contrast to the Impressionists' originals, which have been so "obliterated, so denatured." While agreeing that the "cityscape is the artistic interpretation of a city motif," he nevertheless seems to suggest that there could be such a thing as a document for the unchanging.[11] If, on the other hand, we take the word *document* in a metaphorical sense, we shift our interest in the cityscape to aesthetic questions. In this regard Wattenmaker's confident conclusions contrast with James's bewilderment. In particular, James's own

conclusion that the experience of a "compact" identity between art and scenery can be related to the absence of "grand manner" raises more questions for him:

> Is it a canalside in Haarlem, or is it a van der Heyden? Is it a priceless Hobbema, or is it a meagre pastoral vista, stretching away from the railway track?[12]

Furthermore, how can the Dutch city be considered plain nature in 1874, particularly since he perceives it as lacking in style? The complete passage "In Holland" reveals James's uneasiness about this forced or presumed identity of paintings with "nature," an identity resting on an illusory absence of history.

Was this already a historical illusion of the seventeenth century, before the grand tour by railway was dreamt of? These questions become even more difficult to answer when one considers the role seventeenth-century technology played in the composition of the cityscape by van der Heyden and in the composition of interiors or the use of color by Vermeer.[13] For it is precisely these technical devices of lenses and complex geometry that enhance the illusion and experience that all we see is perfect craft; that the city, being totally "handmade" and re-created as such by the artist, becomes something both natural and yet within human scope. This point of view is shared by an uneasy, half-serious Henry James and some twentieth-century epigones living in an age of high technology beyond their grasp and, more likely than not, in an urban structure not at all of their own making. To such eyes the Dutch cityscape appears as the good city within hand's reach as well as the representation of a well-being beyond our grasp. Thereby experience becomes, as Henry James has it, "something singularly compact and complete in itself, striking no chords that lead elsewhere, and asking no outside help to unfold itself." But the sense created by the cityscape of perfect wholeness and self-containment is deceptive. One aspect of this "deception" in the cityscape is that the artist relied on technical trickery to make it.[14] Another aspect is the representation of cultural and political nostalgia. To take up Liedtke's phrase, to represent grandmother's house as part of a model of a perfect civilization turns grandmother's house into an artifice, or in this sense into an emblem. Like most seventeenth-century Dutch painting, cityscape painting affirms the economic achievement of prosperity by the urban middle classes; it never shows the growing proletariat, the early industrialization, the child labor, the common misery.[15] It is not my intention, however, to criticize this affirmative function as such but rather to pursue further the implications of an "urban pastoral" of the good life in Vermeer's painting.

Seen this way, the *View of Delft* is at once a vision of cultural perfection and a vision of cultural crisis. This cultural crisis was manifested in the separation in the seventeenth century of scholarship, religion, and art and the emergence of a problematic subjectivity of bourgeois self-determination. To some modern viewers, *View of Delft* promises, if only to a certain degree, the harmony, even the identity of these newly distinct and problematic entities. One may argue, conversely, that it is the intensity of this promise or illusion offered by the painting that allows the critic to discern the crisis at its basis and the tension and anxieties accompanying it. From this latter point of view it becomes difficult to share the optimistic view of cultural

progress first enunciated by Gombrich and adopted by Alpers and others. In this account, Dutch art of the seventeenth century, under the influence of empirical science, emancipates itself from an earlier ritual or mythological context, so that empiricism itself becomes the vantage point of art, thus prefiguring such nineteenth-century painters as John Constable or Gustave Courbet. While convincing in many ways, such an explanation of art as a form of visual technology may now itself seem to be a form of nostalgia in our own age of technologically advanced visual mass media.[16] The investigation, therefore, of the perceived aesthetic subjectivity of Vermeer's cityscape is indispensably an investigation of an ambiguity in cognition and for that reason not an uncritical affirmation of, to use Riegl's words, "the modern cult of monuments."

Chapter 4

French Travel Literature of the Nineteenth Century

There is a splendid land, they say, a Land of Cockaigne, which I dream of visiting with an old love. A curious land drowned in the mists of our North, it might be called the Orient of the Occident, the China of Europe, so fervently and capriciously has fantasy indulged itself there, so patiently and persistently has it been given luster by a cunning and delicate vegetation.

A land of Cockaigne, where everything is beautiful, rich, tranquil, honest. . . .
– CHARLES BAUDELAIRE, 1857 [17]

The uneasiness and underlying reflection upon the nature of his experience are entirely Henry James's, as is the peculiar juxtaposition of the Rhine tour by boat with the first impressions of Holland by railway. Otherwise his account resembles the extensive body of French travel literature on the Netherlands from the early nineteenth century onward.[18] The most distinguished French writers on the Netherlands, among them Alexandre Dumas (*Excursions sur les bords du Rhin*, 1841), Victor Hugo (*En Voyage*, 1842), Gérard de Nerval (*Les Fêtes de Hollande*, 1852), Maxime du Camp (*En Hollande*, 1857), Théophile Gautier (*Caprices et Zig Zag*, 1865), and Eugène Fromentin (*Les Maîtres d'autrefois*, 1876), all adopted an attitude that I shall call, with a broad range of application, orientalism. Indeed, it is striking that each of these authors had already published an account of his travels to the Orient when he came to write about the Netherlands. They set an orientalizing tone for the whole genre of travel writing about the Netherlands, though it had more to do with metaphor, rhetoric, and diction than with literal Dutch colonial politics.[19]

Different as these authors are, they share the effort to evoke the enigmatic, the fantastic, the peculiar, and the foreign in what they describe and the manner in which they choose to do it. This is not to say that a French *Voyage en Hollande* employs this style consistently throughout, yet it occurs frequently enough to succeed in rendering the Netherlands as a marvelous land with strange customs, remote areas, enigmatic women, peculiar tastes, and a watery, floating climate almost incom-

parable to anything geographically near it. Writing in this manner, the authors take up the topos of the Dutch as "[d]e Chinezen van Europa," a topos that had originally to do primarily with trade relations, with an administrative ideal, and with economics issues such as the simultaneity of agrarian progressiveness and industrial backwardness.[20] Functioning mainly as a topos of well-being in the travel literature, it is to some extent related to Baudelaire's evocation of Holland as the China of the Occident in his prose poem *L'Invitation au voyage*.[21]

For closer study I have selected the following authors and texts that combine travel with art writing: Gérard de Nerval, "Les Fêtes de Hollande" (1852); Alphonse Esquiros, *La Néerlande et la vie hollandaise* (1859); Théophile Thoré (William Bürger), *Musées de la Hollande* (1858, 1860); Maxime du Camp, *En Hollande* (1857); Eugène Fromentin, *Les Maîtres d'autrefois* (1876); Henry Havard, *La Hollande pittoresque: Voyage aux villes mortes du Zuiderzee* (1875), *Amsterdam et Venise* (1876), and *Histoire de la peinture hollandaise* (1881); and Paul Verlaine, *Quinze jours en Hollande* (1893). The inclusion of Thoré and Fromentin might suggest even more names, since the format of a guidebook or fictional trip to the museum was adopted frequently in French art criticism. In choosing the above texts, I am making a plea for a more flexible definition of relevant art-historical writing, one not confined to academic prose.

Recurrent themes in this literature include: the notion of art mirroring life or reality, techniques and means of transportation, remoteness, Dutch cleanliness, a taste for strongly and varicolored houses and decoration, the collecting of Far Eastern objects, the "oriental" towns of Broek and Zaandam, religious tolerance and the Jews in Amsterdam, the humid climate and misty atmosphere, the country seized from the sea.[22] This list of topics differs from the list in the Hegelian tradition, which describes not the contemporary but the seventeenth-century Netherlands. Writing in this tradition, Taine, Huizinga, Weber, and recently Schama emphasize the themes of political freedom, the War of Independence from Spain, citizenship, morals, charity, progress in science and technology, naturalness of conduct, and bodily indulgence both culinary and sexual. These two lists overlap in a few instances, such as religious tolerance and land reclamation. Still, even these overlapping themes become differently contextualized in each group, thus creating two entirely different Dutch realities. To today's art historian, the more familiar reality is that of a model republic sustained by a middle-class society and a national culture of naturalness and progress. The other, orientalizing tradition, has largely fallen into oblivion.

The orientalizing tradition was perhaps in part motivated by French military and political interventions in the Netherlands (1672–8, 1688–97, 1701–13, 1795, 1806, 1810) and was therefore concerned to deemphasize the country's post–golden age social and political structures. The examples of this tradition convey, together with the emphasis on the country's foreignness, a predominant sense of artifice and artificiality. That is certainly the case with regard to discussions of land reclamation, for example, which figures in the Hegelian list less as a marvelous artifice than as an example of technological progress. In the end, for French writers, contemporary nineteenth-century Netherlands is far less knowable, rational, and understandable than the Netherlands of the seventeenth century. Yet it is during the nineteenth century, when many authors began to marvel at the sight of contemporary Holland, that the

now more familiar Holland of the seventeenth century golden age was constructed. Tensions resulting from this dichotomy are most evident in the writings of Havard, Thoré, and Fromentin about golden-age Holland. In contrast, the only author interested in the contemporary Netherlands and its avant-garde poetry and painting is Paul Verlaine. Accordingly, his *Quinze jours en Hollande* of 1893 reads as an account of a country with certain peculiarities and a distinct culture, yet all the same comparable in interesting ways to the France of his day.[23] With respect to Vermeer it is the tradition of the foreign, oriental, and artificial that has sustained the most interesting accounts of his paintings – those writings which take account of the enigmatic and the uncanny, the elements in his work so difficult to understand historically.[24]

Henry Havard (1838–1921), a merchant and politician, had been involved in the Paris Commune and became a French expatriate in Holland. He worked as a prolific journalist and art critic who published, apart from the three books listed above, a monograph on Vermeer, *Van der Meer de Delft* (1888), which was first published in the *Gazette des Beaux Arts* in 1883, a monograph on Michiel van Mierevelt of Delft, and several books on the minor arts, especially on Dutch faience and ceramics.[25] After his return to France he became a government official in cultural affairs, working after 1875 as a researcher in Dutch archives.[26] In his books, Havard, like Henry James, includes long sections on travel and transportation, such as the steamboat and the railway, in part to emphasize and verify the present suddenness of his experience, but also to motivate the license he takes in selecting certain aspects of the Netherlands and passing over others. Toward the end of *La Hollande pittoresque: Voyage aux villes mortes du Zuiderzee* (1875, English edition 1876), a book described as an adventure into the unknown, he writes:

> We remained a few minutes at Utrecht, sufficient time only to change
> over to the train leaving the Central Railway for the well-known Dutch
> Rhine; and soon we were once more flying along the rails for Amster-
> dam, losing sight of Utrecht. . . . In the midst of the great meadows as we
> passed by at railway speed we scarcely saw the cattle. . . . Nature seemed
> to us in holiday attire; but suddenly a shrill whistle greeted our ears,
> massive buildings were seen on all sides – we were in Amsterdam.[27]

There follows a reflection on the course of history, on the ruin of the ancient cities of the Zuider Zee and the more recent wealth of Amsterdam, and on the railway system (Havard 1876b: 320). He sums up: "I have often heard leading men of other countries complain that Holland was completely unknown outside her frontier. This is too true" (Havard 1876b: 326). Havard presents the overwhelming result of his meticulous studies in libraries and town archives of chronicles, legends, folklore, and customs, in order to publicize the country as one with a rich history and culture. Yet he often departs from his empirical approach and embellishes his findings by shifting into the orientalizing mode. For example, he notes the houses on stilts in Vollendam and then writes of their inhabitants:

> Seated cross-legged in oriental fashion, in groups of six or eight, smok-
> ing their pipes in silence – immovable and indifferent, with a vague and

doubtful look more like Turkish fatalists than Dutch fishermen – there is everything about them to keep up the illusion.

And of their houses:

> The houses, as at Marken, are of wood painted light green and black; a streak of white and a bright streak of red surround the windows and the gables. . . The walls are lined with little delf [*sic*] tiles, with figures painted in blue. They rise in the walls some three feet from the floor; the rest of the wall is lime-whited or coloured blue. . . . We also visited the house of a fisherwoman, painted blue, with the usual pottery on the walls; all however of that blue Japan ware of which the Dutch are so jealous, and which they so marvellously copy at Delf [*sic*] (Havard 1876b: 36–8).

The juxtaposition of jealousy, artifice, and copy in Delft with the natural Orient in the northern provincial villages is well-calculated. It also conditions Havard's description of scenery. Of some villages in northern Holland he writes:

> The first one was Operdoes, rising in the midst of fields of coleseed. The houses from a distance appeared to be alternately blue or red according to the view we had of them – fronts or the roofs – producing a most singular impression. This mingling of the three primitive colours made the most singular and pleasing effect. As we approached, the general harmony of the tones was complicated with others more gay and lively, which, far from weakening the effect, gave it, on the contrary, more intensity.
>
> It is not extraordinary, with these spectacles constantly within their view, that the inhabitants are naturally great colourists. . . .
>
> They absolutely paint Nature; for the ground and even the trees are whitewashed or coloured pearl-grey or sky-blue, giving them the strangest aspect, and the ground surrounding the house is often painted pale yellow, with bands of red on each side of the space reserved for a footpath. This bizarre colouring. . . clashes disagreeably with the clipped hedges and the flowers in the beds.
>
> The fences, gates, balustrades, and the little bridges – for every house is close to a ditch full of water – are also painted in bright colours; as to the house, the dark shade is enlivened by painting the window frames pale yellow, or the shutters spinach-green (Havard 1876b: 99f.).

This passage is obviously a condensation of observations of different places and sights. Yet the almost Proustian beginning, with its focus on impressions of one village as seen first from a distance and then from nearby, makes it appear that all the following observations on the Dutch as "natural colourists" and on painted surfaces relate to one place – a place that, in turn, as the passage opens up to a survey of ubiquitous colorful details, seems to be the epitome of a disagreeable Dutch taste for artifice.

Havard draws here on a topos that can be found in travel literature from Diderot's *Voyage de Hollande* (1774) to *Baedeker's Belgium and Holland* of 1894–1910: the features of the "multicolored" Broek-in-Waterland, "the village of a fabulous originality and exaggerated cleanliness," and of Zaandam, north of Amsterdam.[28] The fifteen-year-old Arthur Schopenhauer wrote in his travel journal of 1803–4:

> Brug [Broek] is only a village, but certainly one of the strangest in the entire world. It much resembles the idea one has of a Chinese village. It is intersected and surrounded by many narrow channels, and consists of one meandering road. It has no other characteristics than that it is so clean and colorful: but it is *so* clean and *so* colorful that whoever has not seen it cannot imagine it for himself. The houses, made completely of wood, are painted from top to bottom and gilded. In front of each house is a garden of boxwood, cut [in shapes of] apes, hares, and stags; often covered with shells and corals, these little gardens are enclosed by the daintiest multicolored fences: horses do not enter here, for they would dirty the entire town. The inhabitants of Brug are mostly immeasurably rich people who have retreated to this monastic solitude because they did not know what to do with their money: they are so shy that one sees almost no one on the street or at the window.[29]

Schopenhauer's entry of May 16, 1803 presents Broek as the idea of a Chinese village, conveying at once a sense of the marvelous and the absurd. On the other hand, Havard's seemingly casual remark about the Dutch as "natural colourists," in the midst of describing the spectacle of "oriental" villages, may be seen as a means of delimiting the art in Dutch art that is, artifice as a natural aspect of Dutch painting. He suggests an analogy between an artificial and oriental Dutch reality and a coloristic Dutch art that suspends history and presumably lacks meaning. As we shall see, Havard thereby sets the tone for a long history of writing about the presumed lack of meaning in Dutch painting, beginning with Fromentin's *Les Maîtres d'autrefois* and recurring through writings on Vermeer, where it often is coupled with the notion of pure art.

In "Les Fêtes de Hollande" (1852) Gérard de Nerval, like Schopenhauer, emphasizes the oriental look of Broek, but then dwells mainly on the riches that made it possible and on the absurdity of it all: "These nabobs feed on carrots and potatoes to the eternal laughter of their china and their grotesque treasures." He adds, linking the Far East and Dutch art, "Each house is a splendid museum of porcelain, bronzes, and paintings," and continues to list other features of the village, such as the painted houses and topiary gardens, only to break off abruptly: "These details are familiar."[30] The same associations can be found in Maxime du Camp's *En Hollande* (1857). His account includes mention of Dutch collections of Far Eastern artifacts, a description of Broek and Zaandam, and a comment on the bad influence he thinks the Far East has had on the Dutch: "The Dutch would do well to rid themselves of this taste for little things and puerile frivolities that Japan has obviously communicated to them."[31]

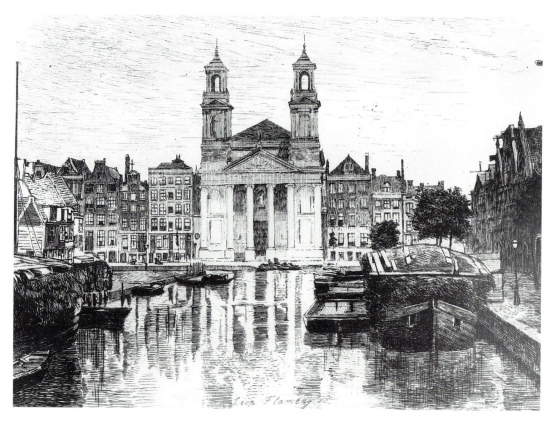

22. Léopold Flameng, *Amsterdam, L'Eglise de Moïse et d'Aäron*, etching, 10.8 x 13.8 cm, from Henry Havard, *Amsterdam et Venise*, 1876, Bryn Mawr College, Pennsylvania.

In contrast to both du Camp and Havard stands Alphonse Esquiros (1812–76), a socialist fiction writer, historian, literary critic, temporary expatriate in Holland and Belgium, and, from 1869 on, a member of parliament, who published *La Néerlande et la vie hollandaise* in 1859.[32] Esquiros's interest is mainly in the social and political structures of the Netherlands, which he sees as having progressed in an exemplary manner since the seventeenth century.[33] Interestingly, his brief mention of Broek as a place "lifted from a Chinese vase" precedes his only passage on Dutch art of the past. He sees this art characterized by a "light [which]. . .gives value to each object," and by an attention less to an ideal and a whole than to color and detail, thus interpreting what is strange in other accounts as aspects of a democratic milieu.[34]

Havard's other effort to acquaint the French with the Netherlands, precisely by making the latter appear distant and marvelous is his book *Amsterdam et Venise* (1876). This is a voluminous comparison of the two cities and two cultures that attempts to stress their similarities, albeit mainly on the level of appearance and surface-oriented observation and rarely by analysis.[35] So much is evident in the book's illustrations, which use the tradition of Venetian view painting for images of both cities, as a comparison of a view of Amsterdam by Léopold Flameng (Fig. 22) and a view of Venice by Léon Gaucherel (Fig. 23) makes clear.[36] This same tradition also inflects some of Monet's views of Zaandam and Amsterdam of 1871, such as *The Zuiderkerk, Amster-*

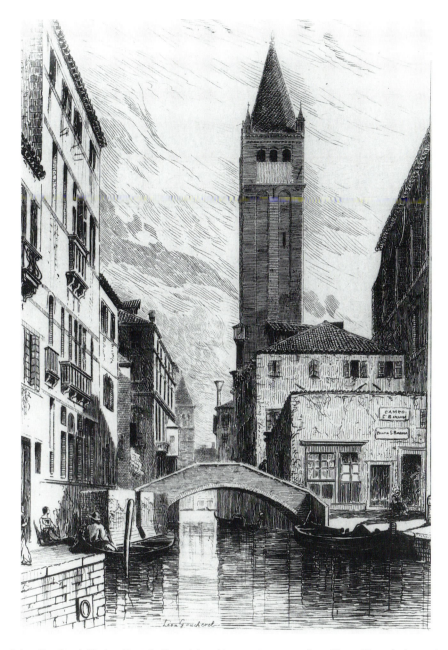

23. Léon Gaucherel, *Venice, Pont St. Barnabé*, etching, 16.8 x 12 cm, from Henry Havard, *Amsterdam et Venise*, 1876, Bryn Mawr College, Pennsylvania.

dam (Looking up the Groenburgwal) (Fig. 24). Monet and Havard became friends during Monet's first stay in Zaandam in 1871, when Havard may have inspired him to pursue coloristic view painting.[37] Whatever Monet's interest in merging Venice with Amsterdam and Zaandam may have been, for Havard throughout this book it is the picturesque in both cities, which he sees as literally based on color (Havard 1876a: 10–18). Havard always speaks of "les deux Venises" and "la Venise du Nord," never of

24. Claude Monet, *The Zuiderkerk, Amsterdam (Looking up the Groenburgwal)*, 1871, oil on canvas, 54.6 x 65.4 cm, Philadelphia Museum of Art. Purchased with the W. P. Wilstach Fund.

"les deux Amsterdams" or "l'Amsterdam du Sud." Clearly Amsterdam is meant to gain from the comparison with Venice, whereas Venice is considered to be above losing anything by it. Often, differences are first admitted and then immediately minimized, as in the theme of the railway. Concerning the Netherlands, the complaint, "the arrival in a town, whichever it may be, is always a hopeless banality. All railway stations look alike," is followed by a poetic evocation of an arrival in Venice. It introduces the theme of color which thenceforth binds the account of the two cities. The description ends by praising the "marvelous spectacle." The arrival in Amsterdam by boat is described in the next section as a "marvelous spectacle" as well. Like Venice, Amsterdam contains "strange forms, laced in a bizarre way, oriental or Spanish for the most part" (Havard 1876a: 17). Color analogies are soon introduced: "Venice lifts itself up in white and pink against a dark blue sky and an emerald sea. Amsterdam elevates itself in brown-red against a pale blue sky and a silver sea" (Havard 1876a: 21). Now that Amsterdam is the true likeness of Venice, he adjusts his descriptions of the Netherlands, even of oriental Zaandam, to this color scheme:

> The China of Holland... paints in the most diverse and strangest colors. Large trees and crazy houses are reflected in the river, which also reflects the blue sky with its large white clouds. Transport yourself there

suddenly. You believe yourself in China, in Japan, in the Indies, perhaps (Havard 1876a: 258f.).

The Far East, China, Japan, "the Indies" – exactly which does not really matter to him – are evoked, yet the colors mentioned by Havard are not those "primitive colors" of red, blue, and yellow he uses for his pastiche of Operdoes, Broek, and Zaandam in *La Hollande pittoresque: Voyage aux villes mortes du Zuiderzee*. They are only the blue and white that, together with the emphasis on water and reflections, fit the Venetian comparison. Havard reminds the reader of the Venetian color scale in the conclusion to the book's first part: "white and pink marbles" and "almost black shadows . . . against . . . a dark blue sky and an emerald green sea." To this he adds, to make Amsterdam fit in nicely, "the red tones of brick" (Havard 1876a: 261).

Finally, in his *Histoire de la peinture hollandaise* of 1881, Havard tries to come to terms with Netherlandish painting and history. He begins by mapping the art of the fifteenth, sixteenth, seventeenth, and eighteenth centuries onto a geographic area ruled successively by Burgundy and the Habsburgs, before attaining its own rule and then succumbing to French domination (1881: 7–11). Havard's explanation of the Dutch identity of the seventeenth century is most interesting:

> At that moment everything changes. The entire nation enters into its
> self-possession; one might say that it had gone to buy its apprenticeship
> to life and that it was finally allowed *to be itself* for some time.

The concept of youthful national selfhood as opposed to grown-up purposeful and conditional self-determination may remind the reader of notions of the classical, yet its analogue in the arts is not called classical but brilliant, "like a fire of marvelous artifice":

> From the moment it [the nation] definitively takes possession of
> itself . . . [t]he feeling and love for color manifest themselves with an
> extreme intensity in the works of all its artists.

Havard's use of the present tense here underscores his blending of color, origin, and self-possession, a blend that is increasingly a feature in his ahistorical account of Dutch painting. He continues to stress the ubiquity of color in the contemporary Netherlands, assuming this to be a timeless quality originating somehow in the time of the golden age, for the arts and "the nation" alike. It is as if the country itself had at a certain point in history (a point Havard does not date) suddenly put on a vivid colorful appearance, and as if color, where- and whenever we find it in the Netherlands, may be seen as the precious residue of that original moment of self-possession in the seventeenth century.

Havard classifies Dutch painting by genre: history and portrait, genre in the sense of scene of social life and interiors, landscape, marinescape, still life (Havard 1881: 70). In chapter six, on genre and interior, he writes of Vermeer and de Hooch that they achieve their color harmonies by the "juxtaposition of robust and powerful

tones that make these two artists colorists of the first order" and then lists the colors they use: blue, red, and Naples yellow, the "primitive" colors of Havard's *La Hollande pittoresque: Voyage aux villes mortes du Zuiderzee* (coleseed yellow, blue, and red). He distinguishes the two artists by their touch, considering that of Vermeer "unforgettable" (Havard 1881: 185). His observation that English collectors of Vermeer's paintings rehabilitated him is directed against Thoré. In his own monograph, *Van der Meer de Delft*, of 1888, Havard accuses Thoré of being ahistorical and of having deliberately avoided giving Vermeer his due place in history. To judge from his *Histoire*, that place is at the peak of vigorous colorism during the Dutch youth of artistic, national, and natural selfhood (Havard 1881: 189).[38] The notion of Vermeer's vigor – a term traditional to French art criticism[39] – was first introduced by Maxime du Camp, who in 1857 characterized the *View of Delft* as painted vigorously and solidly, concluding that Vermeer must have traveled to Italy and that he was "a robust painter, who proceeds with a broad touch."[40]

Over the years, Havard reduces his allusions to the Netherlands' foreignness and similarity to the Far East to a few brief, pointed references. At the same time, he further develops his idea that color, above all, sets the Netherlands and its art apart. With this unifying idea he preserves two temporalities of color: a first, which is natural and environmental color, enduring from the golden age of the seventeenth century down to the present and without any other specified origin; and a second, which is the painterly color, seen only in the art of the golden age and especially in the work of de Hooch and Vermeer. The two temporalities of color are mapped onto the (Jamesian) *déjà vu* experience, and together they make Dutch painting directly accessible to the modern viewer. Thus, in his writings on art Havard abandons his earlier efforts to obliterate the dichotomy of temporalities by orientalizing the Netherlands. He now leaves the dichotomy unexplained, unless it is argued that he entrusts color with the power of transcendence. Thereby Havard lays the ground for a view of Vermeer's art as at one and the same time the coloristic epitome of seventeenth-century Dutch painting and the guarantee of a continuity in color that speaks to the modern critic, artist, and reader. For Havard, orientalizing the Netherlands was an adjustable means for dealing with the initial *déjà vu* experience of the seeming identity of historic Dutch art with the contemporary Netherlands, a procedure that then resulted in an unresolved preoccupation with the power of color. Some of his fellow authors did not grasp or develop this problem in such a subtle manner; that is, they did not perceive such a puzzling link of color to questions of cultural origin and history. The subject of the power of color was only reintroduced at the turn of the century and during the first decades after, and then with particular regard to Vermeer. Yet the phenomenon of the *déjà vu* experience was of central importance to both Fromentin and Thoré, who sought different explanations for it.

Chapter 5

Art Criticism, 1857–1913
The "Oriental" Vermeer

Ce n'est rien, mais c'est exquis.

<div align="right">THÉOPHILE THORÉ, 1866 [41]</div>

Eugène Fromentin (1820–76) mentions Vermeer only in passing in his *Les Maîtres d'autrefois* of 1876. But he introduces the section called "Holland" with a description of the Netherlands of his day. As a visitor to the city of The Hague he lectures his reader:

> Its great domestic luxury – the only one, indeed, which it proclaims ostensibly with the beauty of its waters and the splendour of its parks, the one with which its gardens, winter and summer drawing-rooms, bamboo verandas, perrons, and balconies are adorned – is an untold variety of lovely plants and flowers. These flowers come from everywhere and go everywhere; it is here that India becomes acclimated before going to beflower Europe. It has, as a sort of heritage from the house of Nassau, retained a taste for the country – for carriage-drives. . . . Its fantasies, some of its customs, its exotic ornaments, and its atmosphere come from Asia (Fromentin 1981: 88).[42]

He then notes other features of The Hague, such as French architectural styles and English comfortableness, yet the passage on flowers and India certainly makes its impression on the reader, however much one may be inclined to overlook it as an example of subjective prose.[43] Fromentin was a distinguished orientalist painter and writer who had gone to Algeria in 1846, 1848, and again in 1852–3.[44] Since 1847, up to the time he set about writing *Les Maîtres*, a work based on a three-week trip to the Netherlands in 1875, he had regularly submitted his orientalist paintings to the Paris Salon. These paintings received very positive reviews. For example, in his critique of the 1866 Salon Théophile Thoré compares him favorably with Rubens, van Dyck, and Velázquez.[45] This background is often forgotten, but it strongly informs Fromentin's views on Dutch art.

In *Les Maîtres* Fromentin speaks on the one hand of the War of Independence and about much else from the Hegelian description of northern interiority, such as Dutch "goodness of heart, an affection for the true, a love for the real that give their works a value the things do not seem to possess," a "warmer sensibility" (Fromentin 1981: 101). On the other hand he emphasizes the sameness of the countryside and its atmosphere, the "permanence of things," and claims the "total absence" of subject matter and of artistic motivation in Dutch painting: "the Dutch school seemed to think of nothing but of painting well" (Fromentin 1981: 108, 115, 109). These two accounts clearly contradict each other. Fromentin neither sees, as the later Havard does, seventeenth-century art and culture as an exceptional interim period of youthful cultural and national selfhood, nor does he consistently argue the unity of art and history in the Dutch Republic. Nor does he continue to present the Netherlands as the country of Indian flowers and Asian atmosphere, its people lacking all self-determination, and its art as a phenomenon of Far Eastern nothingness. Instead, he considers his own contradictions to be factual, to be historical phenomena:

> There is not a sign of trouble or anxiety in this sheltered world which
> we might take for the golden age of Holland, did not history inform us
> of the contrary (Fromentin 1981: 110).

This is what becomes of Hegel's "appearance": illusion for illusion's sake. As a consequence, Fromentin struggles for four chapters with the task of reconciling his presumptions of deeply felt reflection and utter thoughtlessness in the oeuvre of Rembrandt, while Vermeer is not discussed at all. By contrast to the luxury of flowers, Fromentin finds color in Dutch art "so reduced – almost monochrome, yet so rich in results, common to all and yet so varied" (Fromentin 1981: 104).

The idea of painting without subject was first developed by Fromentin in his first African journal *Un Été dans le Sahara* (1854). There he speaks out against orientalist painting of biblical subjects, while admitting that despite his disapproval of such art he feels constantly reminded by his surroundings of the Bible. That is, he admits to himself the kind of *déjà vu* experience encountered in travel literature on the Netherlands.[46] His argument is: "To costume the Bible means to destroy it." Raphael's and Poussin's manners of biblical representation are to him not costume but ideals. "Local color," by contrast, is translation of truth both into history and into mere appearance. Thus, Near Eastern motifs and appearance come to stand together and against biblical truth. This strong view sheds light on Fromentin's claim that Dutch painting is, notwithstanding its realism, mere appearance, a painting without subject matter, and that Dutch art and life had assimilated aspects of Far Eastern culture that presumably precluded for the Dutch a motivation by truth and therefore thoughtful art.[47] In this regard a passage in Fromentin's *Un Été dans le Sahara*, describing a scene of dancing by the campfire, is instructive: Rembrandt's art, more than Delacroix's, is seen by him as the equivalent to this scene and is itself described as an irrational, fragmented rendering of chiaroscuro effects set in the darkness of the blind.[48] In *Les Maîtres d'autrefois* Fromentin includes a long discussion of Rembrandt's *Nightwatch* and decides that its arbitrariness and irrationality make it a failure. From all of this it appears that

Fromentin does not really distinguish between Near and Far East, but merely takes recourse to a generic notion of the Orient when it comes to presenting what is beyond his grasp in Dutch art.

How do Théophile Thoré's writings compare to those of Havard and Fromentin with regard to these issues?[49] Thoré (1807–69) is the art critic most obviously trying to straddle the two groups and two ways of writing about the Netherlands. The rediscoverer of Vermeer and the first to make sense of his art on several levels, he was also the one who transferred his republican ideals from contemporary French politics first to modern art, and then to Dutch art of the seventeenth century. He did so on the basis of his reading of Hegel and Charles Blanc, but also following the publication, together with Alphonse Esquiros and others, of the short-lived journal *République des Beaux-Arts* in 1848.[50] There are a number of signs of Thoré's attempts to merge the two goals of his life – to be politically effective and to be an art critic – with the two ways of writing on Dutch art identified earlier, i.e., the orientalizing account of colorful difference and the Hegelian account of a unified political and artistic culture of representation.

When Thoré began to write travel sketches during his exile from France since 1848, he used several pseudonyms. He traveled and resided during these years under the names Haeffely (London, 1852), Tilman, Laidaes, and Termont (Belgium, 1853), Tilman (Belgium, 1857), and finally, at least since 1858, published under the name William Bürger.[51] As Bürger, "a pseudonym under which he hardly wished to hide but which rather gave expression to a newly gained conviction," he wrote and published on Dutch art and on Vermeer.[52] The possibility of – to use Wölfflin's phrase – "Kunstgeschichte ohne Namen," and thus also names without art history, certainly fascinated Thoré. At that time Maxime du Camp wrote that until he saw the *View of Delft*, he had known nothing but the name "Jean van der Meer."[53] To Thoré this may have meant a particular challenge. Having just a name and no history, being an enigma, had been an exaggerated means of precaution in Thoré's own life, which he may have applied to his writings on Vermeer. Denying Vermeer a history, he called him repeatedly "the Sphinx of Delft," even after he had more than just a name for and a *View* from him. In the second volume of his *Musées de la Hollande* of 1860, he begins his passage on Vermeer, exclaiming: "Van der Meer de Delft. – Encore le sphinx!" but ends it by admitting that the signature and date on Vermeer's Dresden *Procuress* allow one to clarify somewhat the biography of "the sphinx" (Thoré 1858, 1860, vol. 2: 67). The motif of the enigma may even be seen in the headpiece illustration chosen for the first of the three articles on Vermeer in the *Gazette des Beaux-Arts* of 1866 (Fig. 25). A genre painting owned by Thoré and attributed by him to Vermeer, *Interior of a Béguinage*, is engraved and fragmented so that presumably a beguine nun, a hooded figure seen from the back, appears to open a Dutch half door toward the name "Van der Meer de Delft" (Thoré 1866: 297).[54] In the dedication of this monograph to Champfleury, Thoré repeats:

> I in turn dedicate my sphinx to you, if you will recognize it as an ancestor of artists in love with nature, of those who understand and express nature in the sincerity of her appeal (Thoré 1866: 297).

VAN DER MEER

DE DELFT

A CHAMPFLEURY

Vous êtes de ceux qu'attirent l'Inconnu et le Méconnu. Vous êtes à la fois curieux du mystère et de la réalité, de l'ombre et de la lumière, — les deux extrémités de l'art et de la vie.

Si vous passez près d'un puits, il faut que vous y descendiez pour voir ce qu'il y a au fond. Et vous y trouvez des *Violons de faience*, quelque rareté ou quelque vérité.

Vous aimez les points d'interrogation, pour en faire des points d'examation et d'admiration.

25. Headpiece illustration, 12 x 11 cm, from the *Gazette des Beaux-Arts*, 1866, p. 297, Bryn Mawr College, Pennsylvania.

The shift toward modern art and nature in combination with the epithet "sphinx" is striking. In the section on Vermeer in Thoré's *Musées de la Hollande*, one finds orientalizing and naturalizing aspects side by side; here, this combination is perhaps the result of a need felt by Thoré to insert Vermeer into an account of Dutch painting in general, which was, to him, an art of the people. The two "sphinx" statements frame an account that points out three characteristics of Vermeer's paintings emphasized by Thoré: the enigma of the depicted woman, the ample use of the color yellow, and non-European traits both iconographic and stylistic. This account is a shift away from the first one given by Thoré in volume 1 of *Musées* (1858). There he quotes Maxime du Camp's passage on the *View of Delft* and a similar remark by Théophile Gautier, concluding for himself: "One might say that he wanted to build his town with a trowel, and his walls are made of real mortar. Too much is too much. Rembrandt has never abandoned himself to such excesses" (Thoré 1858, 1860, vol. 1: 273).[55] After this harsh judgment, however, he praises the painting's technical refinement and concludes: "The *View of Delft*, despite this masonry, is throughout a masterly painting." Elsewhere he finds that Vermeer "turns his figures with a certain violence, very particular and very fantastic" (Thoré 1858, 1860, vol. 1: 272). In contrast, the passage in volume 2 refrains from any judgment of quality in its description of, for example, Vermeer's *Girl Reading a Letter at an Open Window* in Dresden (Fig. 26):

The other Reader, holding her sheet in her two hands, is seen in profile, from the left, in three-quarter length, behind a table with a Turkish rug

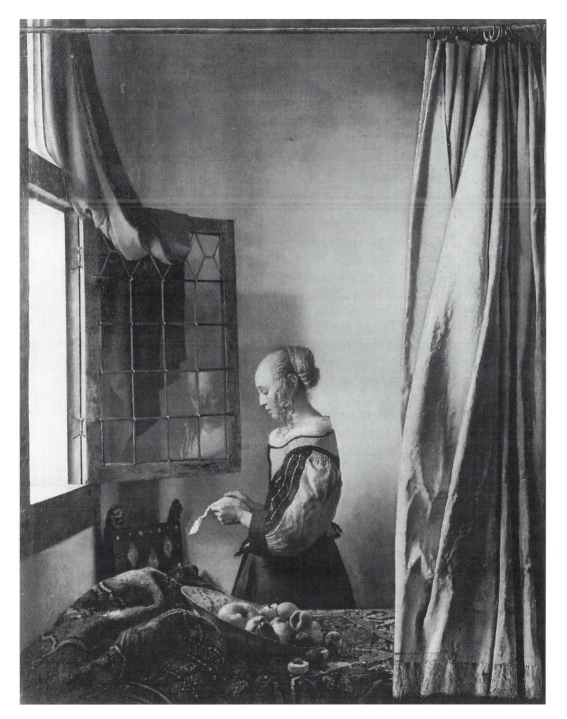

26. Jan Vermeer, *Girl Reading a Letter at an Open Window*, c. 1657, oil on canvas, 83 x 64.5 cm, Gemäldegalerie Alte Meister, Staatliche Kunstsammlungen, Dresden.

in coarse wool, on which are apples and peaches in a Japanese blue bowl. She wears her hair in Chinese style above her forehead with long English ringlets falling over her shoulders; a small white shawl in her yellow bodice streaked with black lines; a dark green skirt. Her figure mirrors itself vaguely in the panes of the half-open window in front of her (Thoré 1858, 1860, vol. 2: 76).

Here, Thoré merely focuses on the different colors in the painting (blue, white, yellow, black, green), the general iconography, its foreign features (Turkish, Japanese, Chinese, English), and the woman's reflection, passing no further judgment on it. The difficulty of judgment is set up in part by the author himself, inasmuch as he claims this difficulty to be inherent in Dutch art. Here, he resorts to a factual description of Vermeer's work in terms of color and diversity of motifs depicted in it. In his introduction to *Musées*, he compares Rembrandt and Rubens, summarizing the viewer's reaction as a contrast: Rubens "causes you to open up," whereas before Rembrandt, whom he takes to be Vermeer's master, "one does not know what to say, one withdraws and one reflects. Before Rembrandt, one is plunged in meditation" (Thoré 1858, 1860, vol. 1: 21f.).[56] It appears that Vermeer fits neither of these modes of viewer response.

After Thoré had developed his Vermeer studies over the course of many years, his work was acknowledged, with some uneasiness, by Charles Blanc (1813–82), the editor of the *Gazette des Beaux-Arts*. In his *École hollandaise* of 1861, volume eight in the series *L'Histoire des peintres de toutes les écoles* (1848–76) which Blanc edited since 1852, Blanc devotes only four pages to Vermeer, as compared to the eight he devotes to Pieter de Hooch (or sixteen to Jacob van Ruisdael). His ranking of Vermeer is supplemented by a description of Thoré as "a critic enraptured by his discoveries." He ascribes the *Girl Reading a Letter at an Open Window* to de Hooch, with no reference to its foreign aspects pointed out by Thoré in 1860, aspects that for Thoré set Vermeer apart from de Hooch.[57] Blanc never uses Vermeer as a point of reference as he might use Rembrandt, de Hooch, or Ruisdael throughout his *École hollandaise*; here he sets the paradigm less for comparing de Hooch and Vermeer with one another than for deciding who is the better artist. For him, de Hooch was the more important and talented of the two. In his 1866 monograph, Thoré claims, to the contrary, that while over time Vermeer had "disappeared" behind de Hooch, he was very different but equal to both de Hooch and Metsu, if not superior, and that in the past, with a few eighteenth-century exceptions, "van der Meer and de Hooch had been mistaken for one another – always to the advantage of the latter."[58]

Philip Hale (1865–1931), an American luminist painter, wrote a monograph on Vermeer in 1913, characterizing him as a modern colorist. Hale pays tribute to the accomplishments of Havard and Thoré, yet ignores the image of Thoré as political exile, pioneering art critic, and connoisseur in favor of an almost comical image of him as an eccentric *flâneur*, the "man of leisure who was often in one or other part of Europe, and during his travels made it a point to look through the galleries for other Vermeers" (Hale 1913: 56f.). This allows Hale to dissociate himself from the larger implications of Thoré's work. Rather than projecting a compact unity of

Dutch national history and art, he emphasizes the foreignness of the Netherlands by basing it loosely on Dutch colonial power and related cultural experiences. Hale's generalizations about the Netherlands share an orientalizing tendency with Thoré's writings on Vermeer. His evocation of the Dutch art patron in Vermeer's times is an overblown counterpart to Thoré's description of Vermeer's *Girl Reading a Letter at an Open Window*:

> The men who bought these pictures were men who had adventured in the India trade. . . [in] Brazil. . . who tasted curiously every form of aesthetic enjoyment then known. These were men who could go to war over a few precious tulips. They were great collectors of rich wares from China and from Japan. They knew and collected rich rugs brought on the backs of camels. . . and they brought home beautiful Japanese vases, curious furniture, and. . . some quaint book of outland prints, or one of the strange wall pictures that the slant-eyed children of the chrysanthemum are wont to hang on their paper walls (Hale 1913: 42f.).

Vermeer's representation of women such as *Young Woman with Pearl Necklace* and *Girl Reading a Letter at an Open Window*, and their polished appearance and surroundings, are generalized by Hale into a description of all Dutch women of the rich merchant class:

> They were proud of their fine houses with their tesselated floors, their fine rugs and their Chinese vases. Proud, too, they were of their women, with pretty white satin dresses and natty morning jackets trimmed with swansdown (Hale 1913: 40).[59]

This fantasy of the potential collectors of Vermeers, this anything-but-cautious match for Thoré's very cautious description of Vermeer's *Girl Reading a Letter at an Open Window* in Dresden, contrasts drastically with John Michael Montias's scrupulous and meticulous archival study, *Vermeer and His Milieu* of 1988. Whereas Hale fabricates his Vermeer patron by scrutinizing Vermeer's paintings (and by reading Thoré, Havard, and others), Montias itemizes the contents of Vermeer's genre paintings, women included, in terms of documentary evidence of the Vermeer household and in relation to Vermeer's social success and ambition.[60] What constitutes information in Hale's writing has little in common with Montias's scholarship of material and economic history, and yet Hale's account is instructive here in a very particular way. Unlike the French authors examined earlier, he uses the oriental as a historical category, in the specific sense of a historical Dutch orientalism and taste for the exotic in general. In this view, the oriental is a historical aspect of the Dutch golden age, as much as it may be emulated by the author to enhance his account of Vermeer's modernity, by which he means his bold colorism and cool, unprejudiced observation.[61]

Hale's views, then, suggest that we distinguish between the different notions of orientalism that are drawn together by him. This possibility merits further speculation.

Excursus: Hegel's Aesthetics and the French Reception of Dutch Painting

The following speculations take us back to Hegel's *Aesthetics*. They may help to explain the *déjà vu* effect of Dutch art on travelers and art critics, and their choice of an orientalizing description of their experience of this art as identical with both the modern and the historical Dutch reality. The significance of this experience has not yet been sufficiently addressed, nor has its metaphorical quality. It is this quality, however, that has affected viewers of Vermeer's *View of Delft* with a sense either of the promise of something to come or of something believed lost, and that may provide the scholars among them with means to elucidate the painting's language, its temporality, its colorism, and its dialectics of the familiar and the foreign, of the near and the distant.

Peter Szondi, in his commentary on Hegel's *Aesthetics*, deemphasizes the evident, progressive chronology of Hegel's large periods of symbolic, classical and romantic art and the contrast between the classical Greek and the romantic Christian art worlds. Instead, Szondi makes room for the comparability of pre- and postclassical art, that is, of the symbolic and romantic art forms, as Hegel understood them.[62] This comparability may come into view through a brief survey of the development of the symbolic art form as ancient oriental art in Hegel's *Aesthetics*.[63] Hegel distinguishes between ancient Persian, Indian, and Egyptian art in such a way that, within the symbolic art form of sculpture, Egyptian art is represented as the quintessential symbolic art. A formal symmetry between symbolic and romantic art follows from Hegel's consistent tripartite structure.

The main characteristic of symbolic art is that rather than possess an internal identity, it depends exclusively on an external identity of object, form, expression, or image with a spiritual, religious, cult-related meaning or content. This external identity is arbitrary, essentially inadequate, and lacking in freedom. In Egyptian art this lack of freedom which Hegel saw in Indian sculpture, retreats as something merely external, inasmuch as Egyptian symbols are self-conscious symbols. Interestingly, Hegel does not focus on hieroglyphs to make this distinction, but on sculpture. In his account, the sculpted Egyptian sphinx is a symbol of the symbol, a symbol of the self-conscious status of Egyptian art as symbolic art. At the threshold of cognition, it reappears in classical art and sculpture as the Greek sphinx, who demands cognition. For Hegel, only in classical art does the idea of art as divine truth represent itself both freely and completely; that is, objectively and autonomously. Returning to romantic art, we remember that Hegel considers Dutch painting as free appearance, as an imitation approaching the point of dissolution, whereby the inadequacy of subjectivity represents itself in its inability to grasp itself and its affective relationship to the world, to grasp the "limits" of unlimited, free interiority. What, then, could relate romantic art to symbolic art, since they are diametrically opposed in Hegel's view? The answer lies precisely in that opposition. As we saw earlier, when speaking of irony, Hegel himself distinguishes between good and bad subjectivity. Since romantic art in general goes beyond classical art with regard to the idea of freedom, its representations become internally inadequate or excessive. Dutch painting can be seen to close itself off from that very freedom in the process of factual particularization of subjective consciousness, of getting lost in the detail, in

the incidental, in things. This is the danger of getting lost "here again,"[64] Hegel writes, suggesting with this phrase the possibility of repetition or regression, despite his relentlessly progressive notion of history in the *Aesthetics*. "Here again" can only refer back to symbolic art and to "symbol proper." Getting lost "here again" in material reality leads, as Szondi points out with regard to Hegel's ridicule of romantic love, to the Marxist concept of alienation and fetishism. Szondi's point is nowhere to force a near-identity of the symbolic and the romantic in the visual arts, but rather to make his audience, as readers of Hegel, reconsider the conventions of viewing the two in static opposition to one another.[65]

Consideration of a reciprocal symmetry between symbolic art and romantic art allows the comparison of the inadequacy of content and form in each, symbol and metaphor.[66] But whereas in the first that inadequacy is recognized only by the critic of a later age, in the second it is an internally reflected part of the artistic endeavor. With regard to Dutch art, the mutual excess of form over content and of content over form, means a lack not *of*, but *in* freedom, a lack that presumably pertains to the work, the artist, and the beholder, from the moment of the work's inception. We can see now that Hegel perceives two extreme positions of inadequacy in romantic art: one is regressive, a false or failed return to symbolic art, and really a mode of materialism; the other is grounded in irony and ironic detachment.

In the first chapter of *Truth and Method*, Hans-Georg Gadamer investigates the concepts of "symbol" and "image" with regard to the hermeneutic procedures of *Kunsterfahrung*, defined by him as "an encounter with a still unfinished process and itself part of this process."[67] He distinguishes the term *symbol* from associated terms such as *allegory* and *sign* and concludes: "The foundation of nineteenth century aesthetics was the freedom of the symbol-making activity of the mind."[68] Yet Gadamer himself doubts the real possibility of such a freedom and suggests in its stead the "continued existence of a mythical, allegorical tradition." This suggestion is in keeping with the temporal openness of his definition of *Kunsterfahrung* and should be kept in mind, as they will be given further consideration later in order to understand Proust's interpretation of Vermeer.

Surprising in Gadamer's account is his somewhat rigid distinction between neoclassical and romantic notions of symbol and image on the one hand and, on the other, the concept of the oriental art symbol as developed in Hegel's *Aesthetics*. But as we just saw, while for Hegel the symbolic art form is restricted to ancient oriental art, he makes room for its latency in romantic art when he uses the phrase "here again." Reading Gadamer, in this instance, against the grain might help us to understand the difficulties and particularities encountered in the orientalizing travel and art literature on the Netherlands. What Gadamer calls the "freedom of the symbolizing activity of the mind" in nineteenth-century aesthetics and its roots in allegory, applies not only to the artist but also to the art critic – here, the orientalizing critics of seventeenth-century Dutch painting. At first puzzled by its familiarity, they focus on what, with Hegel, one might call the latent symbolic art form in Dutch art, the excessive attention to the material world, declaring it distant and foreign through an orientalizing description. That description then allows them to represent this artifice to themselves as art criticism and its object as art. In other words, in their search for a means by which to articulate their own viewing experience, they have recourse

to the assumed externality of oriental art and so explain to themselves the value of Dutch art – in fact, the art in Dutch art.

To be sure, Hegel's ancient Orient has nothing to do with Fromentin's Near East or Havard and Hale's Far East, or even Thoré's "sphinx of Delft." These authors' vague conflation of Near and Far East, and of different cultures within these geographic areas, suggests that they never studied oriental art. For them, in contrast to Hegel, reference to the Orient meant reference to something outside of history. This view was of course not new. In his *Groot Schilderboek* of 1707 Gérard de Lairesse had excluded oriental subjects, in his words "Barbaarische Geschiednissen, gelyk Indiaansche, Japansche of Chinasische,"(Barbaric Histories, such as Indian, Japanese or Chinese) from the domain of history painting, because such subjects were not grounded in available texts.[69] By the same token, the supposed ahistoricity of the Orient served authors like Havard in shaping their authorship on an occidental subject, the Netherlands and its art. They must have been fully aware of their generally metaphorical employment of their references to the Orient, and of their attribution of a particular function to that metaphoricity as such.[70]

But what, finally, is the relation between the oriental comparison (in part through objects, in part through color) and the mention of the railway so frequently encountered in the travel and art literature on the Netherlands? Both kinds of references point out the inadequacy of the viewing intelligence (Hegel's *Anschauung*). They put circumstance, such as a distance and a cursory, free-moving framing device, between the beholder with his memory of travel, and the art before him, and between the traveler, with his memory of the art, and the land- and cityscape out there. Through the self-conscious employment of these motifs of circumstance and distance the art critic and traveler separates, if only formally, both the scenery and the art as bearers of meaning, in order to reclaim the latter as an appearance, in Hegel's sense of the word, and as a *Kunsterfahrung* in Gadamer's sense. Such representations are necessarily subjective, incomplete. They are at once in a perpetual process of being established and in perpetual danger of being lost.[71] They are based on the subjective and temporal dimension of recognition implied in the *déjà vu* experience, as well as on the objective anachronism of that same experience.

The levels of awareness of this differ greatly from author to author, as the examples of Havard, Fromentin, and Thoré have shown. In Havard's writings, for example, a critical separation of scenery and art ultimately does not occur, and color and colorism above all dominate what he himself claims to be *histoire*. We will see that in Proust's *sources* on Vermeer, such difference in awareness is heightened and played out in various ways that proved useful to Proust, who himself moves purposefully between irony and *symbolizing*, or, rather, modern allegorizing.

Chapter 6

The Modern Vermeer
Marcel Proust's *Remembrance of Things Past*

While it may be impossible to determine with complete certainty why Vermeer's *View of Delft* is a masterpiece for Proust, it is both appropriate and instructive to study how the *View of Delft* functions in Proust's *À la recherche du temps perdu* (1913–22, 1927) as a metaphor for artistic perfection and for the most extreme crises of human relationship. It is also interesting to see how the interpretation of Vermeer in the novel and in other of Proust's writings from as early as 1908 overlaps with the French legacy of travel and art literature on the Netherlands. Proust sets the painting in relation to the experience of foreignness, to the Orient and Venice, and he invokes more specific motifs and topoi mentioned above: the mode and means of transportation as circumstance of viewing scenery, perceptions of color, the experience of a lack of meaning as it intertwines with themes of nothingness and death, and the temporality of the *déjà vu*.

Recent literature on Proust and the visual arts falls into two categories. One group of scholars focuses on the function of paintings, frescoes, historical art and artists, and fictional art and artists in Proust's novel, to contribute to a better understanding of Proust's concept of art.[72] The second group of scholars investigates Proust's work as an art critic, tries to assess his models in art criticism and the significance of his translating Ruskin, considers his preference for certain artists and genres of art, and identifies the works he refers to. Like the first group, they do this throughout with an eye to the novel, but they in some ways view the novel as a fictionalized version of Proust's art criticism.[73]

The questions that have not been addressed sufficiently, in my view – to my knowledge they have only been asked by literary critics – are these: what does Proust's *Remembrance of Things Past* contribute as an interpretation of art and in particular of Vermeer's art? How does this contribution relate to the modernity of Vermeer? One way of approaching these questions is provided by Theodor W. Adorno, in his essay "Valéry Proust Museum," where he addresses Valéry's and Proust's attitudes toward the museum as an institution. Noting their common aversion to historicism,

Adorno contrasts Valéry's negative view of the museum as the tomb of art with Proust's pleasure in the museum. As *flâneur*, as amateur consumer of visual art, "Proust, the novelist, virtually begins where Valéry, the poet, stopped – with the afterlife of works of art."[74] Adorno's statement is a cautionary warning against a one-sided attention to questions of origin in Proust's novel and against any search for a single "key" to his interpretation of Vermeer or for a single concept of art in his work. Other consequences of Adorno's statement follow from this.

Vaudoyer's Articles on Vermeer

What are Proust's critical sources for his Vermeer? Among them may have been two French admirers of the painter, Charles Ephrussi, editor of the *Gazette des Beaux-Arts* in Proust's time, and the artist Paul Helleu. His sources also include Gustave Vanzype, whose 1908 monograph on Vermeer Proust owned, and possibly Clothilde Misme's review article, "L'Exposition hollandaise des Tuileries," in the *Gazette* of May 1921. In the past the articles by the art critic Jean-Louis Vaudoyer, which appeared in *L'Opinion* on April 30, May 7, and May 14, 1921, as well as in the *Gaulois* of June 20, 1921, have been named as Proust's main source.[75] I will consider Vaudoyer's essays closely, but wish to look first at Misme's article and later at Vanzype's monograph.

Misme reviews the entire exhibition of one hundred paintings supplemented by watercolors, drawings, and oil sketches, and divided into two sections, one of old masters, one of modern Dutch art, but she focuses most intently on the Vermeer paintings. His other paintings included in this exhibition were *Girl with a Pearl Earring* (Fig. 12) and *The Milkmaid*. Of Vermeer's *View of Delft* she writes that between the gray clouds and the "yellow" shore there "developed, subordinated to a masterly unity, the refinements of a more modern sensibility."[76] For Misme it is obvious that "modern sympathies," rather than systematic scholarship, were the main motivation of the exhibition's organizing committee, among whose members were Dutch artists. The show's modern section of late nineteenth- and early twentieth-century painting included works by the The Hague school, Vincent van Gogh, and Jan Toorop, the last himself one of the committee members. Misme speaks favorably of the moderns, but, slightly annoyed by the obvious French influence on them, clearly prefers the "modernity" of Dutch seventeenth-century art. On balance, she concludes, "this exhibition, which we owe to the current sympathy for Holland, reveals once again the intimate chord that has existed across time between her [Holland's] sensibility and ours."[77]

Proust's own visit to this exhibition is linked with Vaudoyer's articles. The two men were acquainted and Vaudoyer accompanied him to the Jeu de Paume in the spring of 1921. Thus Proust was able to see Vermeer's *View of Delft* again; he had seen it nineteen years before, on his 1902 trip to Holland with Bertrand Fénelon, and had considered it from that time forward "the most beautiful painting in the world."

Vaudoyer's articles are included in the collection of his essays aptly called *L'Art est délectation*, under the title "Vermeer de Delft."[78] Other topics included are Watteau, the body and clothes, and "Le Cinquantenaire d'Eugène Fromentin."[79] In this last essay he doubts that anyone would be interested in Fromentin's paintings had he

not written his four books. (It will be remembered that this is quite the contrary of Thoré's opinion, who mentions the good quality of Fromentin's early writings only as a matter of hearsay.) Vaudoyer adds that the paintings "depict a saccharine Orient, without great mystery or accent."[80] Because Vaudoyer's articles on Vermeer make use of the oriental comparison, it is instructive to look briefly into his conception of a good orientalism, as he presents it in his review of the exhibition *L'Orientalisme en Europe au XVIIIᵉ siècle* in the *Gazette des Beaux-Arts* of 1911.[81] Dealing mainly with painterly representations of Turkey, this exhibition, as Vaudoyer explains, was organized by the Union Centrale des Arts Décoratifs, which the year before had presented an exhibition called *La Chinoiserie en Europe au XVIIIᵉ siècle*. That exhibition had included almost no paintings, presumably because only Dutch artists had felt drawn to China and because subsequently French artists had lacked any source of inspiration, except for "the small grimacing personages who dance and run, prisoners under the enamel of porcelain or fixed like golden and bizarre insects on the glittering and obscure linings of a chest of drawers and a cabinet."[82]

As a contrast to these Far Eastern prisoners of the decorative arts, Vaudoyer offers the liberation of the Turkish subject and model in painting, first through the oeuvres of three French painters, Jean-Baptiste van Mour (1671–1737), Antoine Chevalier de Favray (1706–91) and Jean-Étienne Liotard (1702–89), and then through Venetian painting leading up to the work of Tiepolo.[83] Tiepolo elevated the oriental subject so as to present "the Turks along with the Olympian gods" and "to open for them the prison gates and give them wings together with their freedom." Finally, so he fantasizes, one of them took the liberty of flying off with some "sweet beauty" and falling with her "into the voluptuous land where Fragonard painted and breathed roses."[84] He imagines sexual pleasure with the blonde slave in Fragonard's *Pacha* and ends his essay with the description of an aristocratic lady in Turkish costume portrayed by Jacques A. J. Aved (1702–66).[85] In this review, Vaudoyer proposes that eighteenth-century orientalism comes fully into its own, after two passages through Venice (Liotard and Tiepolo), in the art of Fragonard, where it comes to mean the enjoyment of sensuality and freedom both within the painting and within the beholder's imagination.

This notion, even if only half in earnest, of a history leading to an association of orientalism with freedom in art, and particularly in French art, figures also in Vaudoyer's article on Vermeer. A crucial difference, however, lies in the fact that freedom in Vermeer's case consists in his power over the beholder. This power is no longer rendered in terms of an anecdotal erotic fantasy but in terms of pure coloristic and profoundly sensual artifice. Vaudoyer begins by stating the dilemma all critics of Vermeer face:

> Never so much as when speaking about Vermeer, do we feel so keenly
> all the vanity that there is in the attempt to translate into words the
> impression and the emotion brought about by the spectacle of a work of
> art. . . . For Vermeer, the subject and its expression are one. He is the
> painter type; the power which emanates from his canvases stems
> uniquely from the way in which the material color is used, treated,
> worked. . . . Vermeer invents nothing, comments on nothing. In his can-

vases the art of composition is employed in the most secret, the most dissimulated manner (Vaudoyer 1968: 83).

Here Vaudoyer is quite sincere. On the basis of this introduction, he defines "the true magicians" in painting as those who without disguising the appearance of reality convey a sense of "grandeur or mystery, of dignity or purity" (Vaudoyer 1968: 84). With regard to Vermeer's art, he calls these moments of profound perception "sensations whose nature it is to be ineffable." After a brief survey of Vermeer's paintings, he singles out *View of Delft* and what he calls *The Painter's Studio* (Pl. VII) for interpretation. Among the French critics, Vaudoyer is the first to show through these two paintings the essential elusiveness of the original meaning and intentions of Vermeer's art and the paradoxically lasting impression it makes on the beholder (Vaudoyer 1968: 86f., 95f.). It is only when speaking of Vermeer's "scènes d'intérieur," that he uses an orientalizing language. He does more than simply point out the oriental origin of items represented in Vermeer's interiors. Through the slightly varied repetitiousness of the described iconography he intends to convey to his reader – and says so explicitly – at once "an impression of monotony" and of mystery (Vaudoyer 1968: 90). Like most critics before and after him, he emphasizes Vermeer's use of blue and yellow, but with the claim that they are "the true actors of the drama."[86] Pressing the point of "this spiritual property of the colors" further, he shocks his reader by declaring that Vermeer's art makes him dream of blood. This declaration follows certain associations of the noted mysterious monotony with "a Chinese patience, a faculty to hide the detail and the process of work that is only found in the paintings, the lacquers and the carved stones of the Far East" (Vaudoyer 1968: 90f.).

For Vaudoyer this Chinese faculty sets Vermeer apart from the modern French painters, who, while attending to light and color, achieve easy success by making the viewer, through their sketchy brushwork, avoid and escape what they themselves avoid and escape, namely, the material world. Included in his notion of an appreciable, aesthetic, material world in Vermeer is the notion that whatever smallest detail one singles out in a Vermeer painting, one might "imagine oneself before a glass case enclosing the most precious and most singular knick-knack [*bibelot*]." The theme of the precious, glazed and polished Far Eastern art object functions here as the real analogue of Vermeer's technique and colors and leads Vaudoyer to discern in the succulence of surface in Vermeer's material the painter-magician's blood: "But blood is evoked here not as hue, but as substance," he insists, as "a yellow blood, a blue blood, an ochre blood."[87] He then justifies his somewhat unusual exposition as prompted by "that cruel profundity of tone" in Vermeer's art, "even if that tone is a white, a grey, a blond."

Cruelty, coldness, and even the power to arouse hatred are qualities in Vermeer's painting we encountered to a somewhat lesser degree in the German reception of Vermeer, where these characteristics were related to the dissolution of social cohesion in his genre paintings. Here the context is one of the high formal and technical quality of Vermeer's art. Vermeer's cruelty and coldness are also noted by Philip Hale in his monograph of 1913, where he links them to Vermeer's "genius of vision," and to the rightness and refinement of color and "edge" (contour, form, silhouette).[88] Cruelty

and rightness, in the sense of *justesse*, become linked for Hale with Vermeer's "modernity." In his paintings color "has been seen and understood as we moderns understand colour" while at the same time they convey a dignity and serenity that "we moderns" lack. But rather than developing these associations critically, Hale resorts to employing the oriental comparison: "Vermeer suggests no one unless it be the Japanese".[89] What he accomplishes thereby is the distinction of Vermeer's cruel "rightness" in color and technique from any notions of naturalistic accuracy. Unable or unwilling to explain this rightness, he lets it stand as an element of difference.

If Vaudoyer is to be seen as an influence on Proust's interpretation of Vermeer, one must keep in mind not just the coinage of certain phrases repeated or modified by Proust, but, more important, the acknowledgment of an unsettling power in Vermeer's paintings. This phenomenon is addressed in part through the oriental comparison in the different genres of art writing examined here; Vaudoyer, to be sure, has made the most imaginative use of it to this point.

Proust's Settings for Vermeer

Before moving to the famous passage in Proust's novel on Bergotte's death before Vermeer's *View of Delft*, let us consider the novel's preparations for this scene by looking at the structures, the sequences of thoughts and images, to which the frequent references to Vermeer belong and through which they become meaningful. No single group of motifs and themes, except for the general themes of time and remembrance, can claim to provide the primary interpretive key to the novel.[90] I shall focus on the manifestation of time and remembrance through those issues in Proust that have been of continuous interest to me here, such as realism in art, accounts of travel, circumstances of viewing, light and color; but also on some larger issues to which Proust relates them, such as name, impression, and allegory.

Near the end of the novel, in the volume titled *Time Regained*, Marcel sums up some of his insights:

> I had arrived then at the conclusion that in fashioning a work of art we are by no means free, that we do not choose how we shall make it. . . . But this discovery which art obliges us to make, is it not the discovery of our true life, of reality as we have felt it to be, which differs so greatly from what we think it is that when a chance happening brings us an authentic memory of it we are filled with an immense happiness? In this conclusion I was confirmed by the thought of the falseness of so-called realist art, which would not be so untruthful if we had not in life acquired the habit of giving to what we feel a form of expression which we nevertheless after a little time take to be, reality itself (Proust 1982, III: 915; 1987, IV: 459f.).[91]

In this judgment of the falsity of realism in art, Proust's conception of habit relates quite directly to the way in which Hegel defined the symbolic, namely, as an accepted convention, an essentially arbitrary identification of a form or expression with a content. Habit is contrasted with authentic memory through the difference

in their respective temporalities. Habit and convention are entrenched in a linear temporality, in the mere passing of time ("after a little time"), whereas memory is temporally structured by chance happenings that help bridge the gap between a given present and a remote authenticity, or truth. If art depends primarily on authentic memory and not on convention, then, indeed, the artist is not absolutely free, as Proust's narrator realizes. The possibility of cognition in art, for the artist as for the reader and viewer, is linked to an original attention:

> In reality every reader is while he is reading, a reader of his own self.
> The writer's work is merely a kind of optical instrument which he offers
> to the reader to enable him to discern what, without this book, he
> would perhaps never have perceived in himself (Proust 1982, III: 949;
> 1987, IV: 489f.).

Such original attention is retrospective, is authentic memory. Yet the chance happening and involuntary memory, so much discussed by the narrator throughout the novel and subsequently by Proust scholars, will not be discussed here. For my interest is in the novel's own hermeneutic procedures rather than the fictive trust in certain intuitions (i.e. involuntary memory), a trust that I see as structured by those same procedures. I take seriously, therefore, the alternatives to the fictive "method" of involuntary memory, regardless of the fact that these alternatives are fictively dismissed. For the novel's structure, what the narrative dismisses is just as functional and important as what it accepts and privileges.

These dismissed or underprivileged alternatives are the reliance on the first impression and the compilation of information. The latter, practiced for instance by Marcel and by Swann when they are beset by jealousy, destroys their notion of the beloved, Albertine and Odette, as a work of art. Compilation of information is likened in one passage to voluntary memory and also to the work of the "bad painter" who does not use fresh, pure colors "as from the little tubes used in painting," but instead uses "conventional and undifferentiated tones" (Proust 1982, II: 5f.; 1987, II: 311f.). Reliance on the first impression, on the other hand, is considered a desirable challenge almost impossible to meet, not only in the novel, but also elsewhere in Proust's writings. In his *Carnet de 1908* we find the challenge formulated:

> One can spend hours trying to repeat to oneself the first impression, the
> imperceptible sign which was upon it and which said: explore me, with-
> out approaching it and without making it come nearer. And yet, this is
> the only art.[92]

The task of profound perception, of contemplation *without* appropriation and *without* a narrowing of the distance between the object of contemplation and the artist, is not to be confounded with the "innocent eye." The sign character, the language of the impression itself, is anterior to the contemplating subject, to whom the impression, as it were, happens. Proust's emphasis on a temporal sequence and contemplative distance is crucial. It is decidedly different from other accounts of first impressions encountered in art and travel literature, where some of the stated diffi-

culties and disappointments stem from exactly that which Proust explicitly seeks
here. In Proust's view, topic and subject matter do not constitute the impression's
sign character: "It matters little of what it treats. A steeple when it is imperceptible
for days has more value than a complete theory of the world."[93] He continues:

> Suppose someone speaks to us of a more humane art. That does not
> make sense to us. The buttons on a leather-covered chair, a point in a
> fabric (VerMeer de Kahn) a bodice (Straus) are more valuble than a
> humane art.[94]

Proust makes reference here to Vermeer's *A Girl Asleep* (Fig. 17), then in the
collection of Rudolf Kann in Paris, as the example of a work of art more valuable
than one with a "more humane" – presumably narrative or instructive – content. A
work of art like this Vermeer is comparable to a steeple hidden in clouds or fog,
whose presence is incomplete by one account, yet superior by another.

A disrupted temporal sequence and contemplative distance provide a setting
for the first impression and allow it to subsist by itself. In the novel this is borne out
in the theme of the journey, where the "in between," the distance between the place
of departure and the final destination, is filled with other places, external and inter-
nal sites, the sight of which may play a role in the "first impression" made by the
place of arrival. Transferred to the temporal level, perspective and distance, too, are
filled with "in between" points in history for Marcel, his "états de moi." Reliance on
the first impression means the ability to contemplate it and to refrain from reordering
its setting, however subjective its fabric may be. The place of departure, very often a
railway station, sign and site of the historical present, belongs to this setting.[95]

If, with this in mind, one considers the arresting moments and impressions in
the novel, which often are presented in the form of a sight or a view, it becomes clear
that they are set within such a structure of circumstantial, filled perspectives. These
perspectives accomplish what Proust demands in his 1908 notebook: they prevent
appropriation and make impossible the narrowing of the distance, yet they also
account for the sign character of an impression. Here is an example:

> Easter was still a long way off; but in the range of days that stretched
> out before me the days of Holy Week stood out more clearly at the end
> of those that came between. Touched by a ray, like certain houses in a
> village which one sees from a distance when the rest are in shadow, they
> had caught and kept all the sun (Proust 1982, II: 144f.; 1987, II: 441).

That which fills the distance, secondary as it seems at first, provides a setting of
significance. This is what Proust may have meant in 1908 when he referred to the
buttons on a leather-covered chair and to a detail of fabric in Vermeer's *A Girl
Asleep* as more meaningful than a "humane art."

The perspective on names is comparable to these spatial or temporal views:
their sign character very much depends on what fills its distance. In one instance, at
the beginning of *The Guermantes Way*, the novel's narrator uses the simile of the
relationship between gray and vivid colors for this phenomenon:

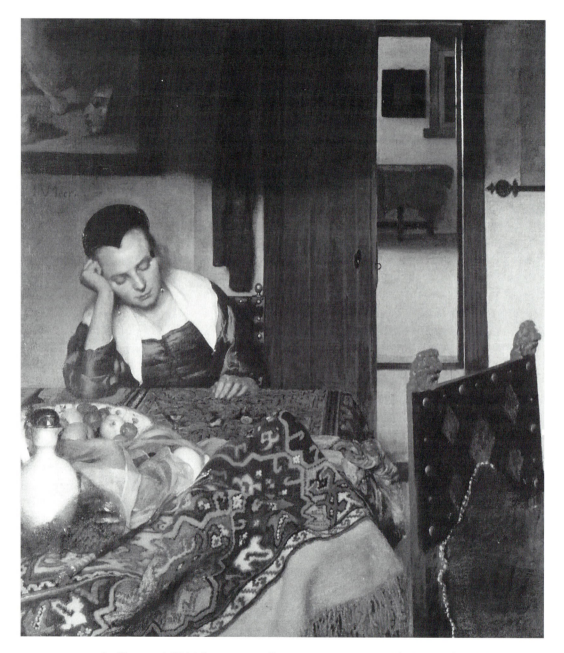

27. Jan Vermeer, *A Girl Asleep*, c. 1657, oil on canvas, 86.5 x 76 cm, The Metropolitan Museum of Art, New York.

[I]f in the dizzy whirl of daily life, in which they serve only the most practical purpose, names have lost all their colour, like a prismatic top that spins too quickly and seems only grey, when, on the other hand, we reflect upon the past in our daydreams...gradually we see once more appear, side by side but entirely distinct from one another, the tints which in the course of our existence have been successively presented to us by a single name (Proust 1982, II: 6; 1987, II: 312).

The narrator also approaches the issue of names from the reverse perspective, namely, as anterior to any real encounter with their bearers, be they people or cities or countryside:

> At the age when Names, offering us an image of the unknowable which we have poured into their mould, while at the same moment connoting for us also a real place, force us accordingly to identify one with the other to such a point that we set out to seek in a city for a soul which it cannot enshrine but which we have no longer the power to expel from its name, it is not only to towns and rivers that they give an individuality, as do allegorical paintings, it is not only the physical universe which they speckle with differences, people with marvels, it is the social universe also (Proust 1982, II: 4f.; 1987, II: 310f.).

In this case, the sign character of the name, the symbolizing activity of the subject ("we"), is excessive. The name and the preconceptions of its significance overwhelm the first impression in a relationship of a profound inadequacy, which Proust calls allegorical. It is necessary to distinguish this specific kind of "allegorical" inadequacy from the earlier one, which he called "false" and which, rather than resulting from individual symbolizing activity, resulted from habit, from individual submission to convention. In the novel it turns out that both can be rectified over time, separately or in combination, as happens with the great expectations Marcel ties to the name "Guermantes" and with his initial bourgeois acceptance of the authority and superiority of the aristocracy. Yet the allegorical character of names is not rectified in all instances in the simple form of disillusionment. Instead, this character may appear all the more clearly in its own right and function.[96] Allegory, then, is not of necessity a negative term for Proust, just as realism is not, per se, a negative term (it "would not be so untruthful"). Yet in each case, accounting for distance and for the "in between" has a critical function. The contemplative retrospect, or reflective daydreaming, be it on names, views, or first impressions, is critical even as it leaves its object in its distant place. It is most closely linked to art, to what Proust calls "the only art." But this moment of retrospect is very much circumscribed in the novel, only rarely presented as achieved.

Two characteristics of Proust's representation of art and artists in *Remembrance of Things Past* have been proposed, the fragment as an essential whole and the priority of "sensory knowledge" over "intellectual knowledge."[97] The two should exclude each other, since the first is a legacy from Romanticism and the second appears related to an Impressionist notion of the innocent eye, or ear. Yet from the previous discussion it follows that Proust does not distinguish between sensation and intelligence, but rather between these two on the one hand and convention and habit on the other. As for the fragment and its significance, I am inclined, despite its sometimes revelatory power, to see it as related to the notion of the first impression and its accompaniment by fragments and details, as in the examples of the buttons on a leather-covered chair by Vermeer or the illuminated days of Holy Week before Easter. The power of such details may appear overwhelming to Marcel, or to the reader, yet they remain signs of a truth beckoning from a distance, which, according

to Proust, cannot and should not be narrowed. And because these details are presented as truly unique, the logic of the novel's method requires that they always belong to an open series of related metaphors, as opposed to being appropriated, subsumed, and repeated by habit. This is true also of Vermeer's *View of Delft*, as will be seen shortly. Hans Robert Jauss points out the importance for Proust's novel of sequences of metaphors such as the steeple, the gate, the journey. Seen in this way, the novel's idea of the journey, for example, is not so much a being under way, or being on a search, as it is the ability to see the same world from differing viewpoints, as its narrator once notes. Later, he considers this ability the real accomplishment of painting.[98]

It is the metaphor of the gate and the door that sometimes comes closest to realizing the fulfillment of contemplating the first impression. It is bound to the experience of a work of art. Ultimately, Vermeer's painting will be seen to belong to this series of gates, doors, and illuminated panels, for which reason it will be useful to discuss several of them. But first I turn to the passages in Proust's *Remembrance of Things Past* where the name "Vermeer" and the painting *View of Delft* are the leitmotifs of human failure and artistic perfection. They are located above all in the first and sixth novels, *Swann's Way* and *The Captive*.

The Name "Vermeer"

Already in the "Overture" we read that Marcel, at his grandmother's behest, is given engravings or other prints of paintings, buildings, and cities, rather than photographic reproductions, because she considers the latter vulgar (Proust 1982, I: 43f.; 1987, I: 39f.). Swann provides the child with these modestly artistic renderings or mediators of city views and other works of art, which stimulate Marcel's fantasies of foreign places and masterpieces. In this short catalogue of masterpieces Vermeer is only one of several historical artists whose names recur throughout the novel. Others are Giotto, Carpaccio, Mantegna, Bellini, Botticelli. In one of his letters to Jean-Louis Vaudoyer, written in 1921, Proust appears to suggest to him – he may very well have already known about Vaudoyer's articles – to write on the three Vermeer paintings exhibited in the Jeu de Paume:

> Yesterday I read a Ver Meer [j'ai lu un Ver Meer] to whom you perhaps might have less occasion to abandon yourself but by whom I am touched more than by anything else. Ever since seeing the *View of Delft* at The Hague, I knew that I had seen the most beautiful painting in the world. In *Du côté de chez Swann* I could not refrain from making Swann work on a study of Vermeer. I dare not hope that you will do such justice to this extraordinary master.

After reading Vaudoyer's articles Proust writes:

> Still I have not been able to talk to you of your latest Ver Meer, not having written to you since. It is marvelous. This artist who keeps his back to us, who does not set store upon being seen by posterity, and who will not

know what posterity thinks of him, is an admirable, poignant idea. You know that Ver Meer has been my favourite painter since age twenty.[99]

Proust, or Vaudoyer originally, is certainly referring to Vermeer's *The Art of Painting*, but we should not take him to mean exclusively that painting. In his articles, Vaudoyer twice emphasizes the extraordinary significance he sees in the fact of the artist turning his back to the beholder. He concludes: "He allowed us to know how he dressed; but his face remains unknown to us, like his life, like his death."[100] Together with Vaudoyer, Proust understands the anonymous painter's pose as the sign both of a certain audacity in Vermeer's art and of something grand and challenging. It will be remembered that Thoré had already exclaimed: "What a chap!" ("Quel gaillard!"). This attitude makes the painter for Proust an eminently subjective and personal artist, yet at the same time an objective and anonymous one. Vermeer achieves something Proust would not only admire but also question, insofar as true artistic achievement – the *View of Delft*, "the most beautiful painting in the world" – is so closely related to the willful failure of human relationship. In this regard it is useful to note that Vaudoyer speaks of the figure of the painter as "allegorical."[101] Indeed, it is the peculiar aspect of Vermeer's career and unknown life, as he saw it, that Proust introduces first in his *Remembrance of Things Past*, and not the painting *View of Delft*.

Some scholars, having located Proust's key passages on Vermeer, focus first on Bergotte's death before *View of Delft* and second, on the substitution by Swann in his own life of Odette for his projected Vermeer essay and for art in general.[102] While largely convincing, this view of the second occurrence of Vermeer in Proust's novel suggests too sweeping a change in Swann and reduces the function of "Vermeer." For a more differentiated view of Vermeer's function in the novel it is necessary to retrace its development and to take into consideration other passages from the work. The following sequence of passages seems important to me.

1. After a long hiatus Swann returns to his essay on Vermeer at the same moment Odette enters his life. He does so from "fear of affection," a link to which Odette responds by the false surmise, "Some woman must have made you suffer" (Proust 1982, I: 215f.; 1987, I: 195). She anticipates her own role at the end of their love relationship and before their conception of a daughter, their subsequent marriage, and new kind of affection for one another.

2. The "national anthem" of their love, the "little phrase" by the composer Vinteuil, isolated from the sonata, is compared by Swann to an unidentified painting by de Hooch. In it an illuminated door frame appears to promise another world "in the far distance, of a different color, velvety with the radiance of some intervening light" (Proust 1982, I: 238; 1987, I: 215).[103] But even then, at the height of his love for Odette, Swann is suspicious of his own comparison and perceives in both the "little phrase" and the de Hooch a "hollow grace."

3. At this point and for a certain time thereafter Odette appears to him as if painted by Botticelli (Proust 1982, I: 244, 306; 1987 I: 219, 234), but it is Odette herself who erodes this identity and her distinctness from the Dutch paintings in Swann's imagination when she interrupts Swann's work on his Vermeer essay. This interruption is likened to a fragmentary work of art, the multiple smiles, isolated,

"neutral and colorless," seen on sheets of sketches by Watteau. She wishes to participate in Swann's study, asking him whether Vermeer had been made to suffer by a woman (Proust 1982, I: 262f.; 1987, I: 236f.). Realizing Odette's lack of education and her insensitivity to that which he values, Swann fears and anticipates her analogous disappointment in "his" art and his love. Soon Odette is recognized as a "kept woman," "embroidered [as if by Gustave Moreau] with poison-dripping flowers" (Proust 1982, I: 292; 1987, I: 263). Later, after their marriage, Odette will consciously style herself after the model of Watteau's women – understood here as some kind of synthesis of Botticelli and Vermeer – while Swann secretly remembers and honors the "early" Odette, her melancholic, Botticellian "droop" (Proust 1982, I: 664f.; 1987, I: 606f.).

4. Odette takes up the role of a concerned, ambitious wife and asks Swann: "'Have you left your essay on Vermeer here, so that you can do a little more to it, tomorrow... What a lazy-bones! I'm going to make you work, I can tell you.'" Swann first basks in the illusion of a possible reconciliation of their strained, deteriorated relationship and in the dream of a home and a life in common, only to realize suddenly that he prefers the fantasies and the anxieties of jealousy to a "recovery" in a peaceful bourgeois home. Such a recovery strikes him as death, for he lives off his images. He briefly considers their drastic revision by cutting Odette, the "precious thing," out of his life, but lacks the strength to face the resulting *dérangement* of its order and the unforeseeable new composition of its images (Proust 1982, I: 325–33; 1987, I: 293).

5. In order to remove himself from Odette, Swann turns to his essay on Vermeer and plans trips to Dresden, Brunswick, and, above all, The Hague, where he wishes to verify his intuition that *The Toilette of Diana*, ascribed to Nicolaes Maes, is really a Vermeer. Odette and a nightmare keep him from traveling and from the hoped-for recognition of the Vermeer *Diana and Her Companions*.[104] It is between this passage and Swann's receipt of an anonymous letter about Odette's life as a courtesan that we learn of Odette's "ulterior plan of getting him to marry her" and of Swann's recent, brutal, secret wishes for Odette's death (Proust 1982, I: 384–7; 1987, I: 347–50).[105] Swann himself does not analyze this graphic correlation of final events, plans, and feelings, having abandoned for the time being his former pleasure in imagining old masterpieces representing people of his acquaintance whom they never intended to portray (Proust 1982, I: 243; 1987, I: 219).

Swann's postponement of his work in art criticism corresponds to his inability to detach himself from his images, fantasies, and pictorial illusions, despite an increasingly vulnerable situation. His assimilation to his art objects becomes an involuntary captivity. The one identified painting, the *Diana and Her Companions*, is never confronted. The function of the name "Vermeer" in *Swann's Way* thus differs greatly from the function of Vermeer's *View of Delft* in *The Captive*, as will be seen shortly. It is precisely the function and power that the narrator ascribes to names, with their excessive significance, utterly individual and impossible to shed, and that he calls "allegorical." Proust's concept of allegory differs from other modern reconsiderations of allegory, notably that of Walter Benjamin (discussed and used in the last part of this study). Here it is most practical to use the term as Proust used it and as it resonates with Hegel's notions of excess and inadequacy of symbols and metaphors.

What can be learned from Proust's use of the name "Vermeer" in *Swann's Way* with regard to Vermeer's painting? The rivalry between Odette and Vermeer, both in Odette's and in Swann's minds, regards the artist's name. Both Swann and Odette can transport themselves and each other into Vermeer, as critic or observer, as precious object, as lover, as rival, as threat, as victim, while at the same time Vermeer turns his back to them, as Proust phrases it in his letter, and remains inaccessible to both. But then they, too, turn their backs to Vermeer, a name which has come to stand for the mercilessly frank description of their relationship's development as they take up and display themselves in the new roles of a perfectly matched married couple:

> Mme Swann laughed. "That is a lady who's supposed to have been violently in love with Charles," she explained in the same tone in which, shortly before, when we were speaking of Vermeer de Delft, of whose existence I had been surprised to find her informed, she had replied to me: "I ought to explain that Monsieur Swann was very much taken up with that painter at the time he was courting me. Isn't that so, Charles dear?" (Proust 1982, I: 575; 1987, I: 525).

Much later, in *Cities of the Plain*, there is a mock echo of the power of Vermeer's name. Madame de Cambremer asks Albertine, who has just mentioned that she has been to The Hague, whether she saw the Vermeers there. "Albertine replied in the negative, thinking that they were living people" (Proust 1982, II: 843; 1987, III: 209). Vermeer has become nothing more than another society name. Because Marcel, however much it costs him, maintains the distance of perspective in matters of art, he can demystify to the point of irony the excessive meaning of Vermeer, can do it for Swann, as it were, who could not do it for himself, because he lacked such distance with regard to Odette and to art.

If the name "Vermeer" prevents the characters preoccupied with it from transcending themselves, the art of Vermeer, violently prompts Bergotte to do so. The occurrences of the name "Vermeer" are related and refer allegorically to a particular field of meanings and associations. In keeping with the rules of the novel's own procedures, this cannot be the case with *View of Delft*. It occurs only once and with the sudden power of an authentic memory, and is itself part of a series of metaphors whose function resembles that of the painting.

<div align="right">

Chapter 7

</div>

Seriality and Originality
Vermeer's *View of Delft,* His "Identical World," and Dutch Painting in Proust's *Remembrance of Things Past*

Nous sommes toujours dans le pays que peignit Vermeer.

<div align="right">

– GUSTAVE VANZYPE, 1908[106]

</div>

Bergotte's Death and the Image of the Butterfly

As is well known to readers of Proust, the novelist Bergotte dies before Vermeer's *View of Delft*. While for both Marcel and the novel's first person narrator Bergotte remains exemplary even in his death, they relate to us that Vermeer's painting evokes a final vision in Bergotte, that of a peculiar balance.[107] Vermeer's "little patch of yellow wall" (Pl. VI) makes him realize that his last books were lacking in refinement of language, in the element of the purely artistic that he believes inheres in Vermeer's color. In the same moment, he feels that his own death is imminent: "In a celestial pair of scales, there appeared to him, weighing down one of the pans, his own life, while the other contained the little patch of wall so beautifully painted in yellow. He felt that he had rashly sacrificed the former for the latter" (Proust 1982, III: 185; 1987, III: 692). As he realizes his recent – not principal – failure, his death as well as the artistic goal of his life appear to him epitomized in Vermeer's detail. But at once he denies this tragic relation to himself and prefers to rationalize his feeling of imminent death as accountable to his having eaten undercooked potatoes before he went to the museum. And so Vermeer's detail, the yellow "precious, little patch of wall," becomes balanced (or unbalanced) against the artless, banal detail of life, of doubtless yellowish, indigestible potatoes. Bergotte dies with this disillusionment and without having faced its tragic aspect, the disconnection of his life from the purely artistic achievement that was its goal. Once again Proust makes use here of Vermeer as the artist turning his back, this time to another artist, whose final insight is that he has turned his back on art.

Much has been made of Proust's own enactment of this scene (short of dying), when he went to see the three Vermeers at the Jeu de Paume in the spring of 1921,

116

accompanied by Vaudoyer, and thereafter never went out again.[108] Yet there is another fictional enactment in Proust's essay on Rembrandt of c. 1900.[109] Its narrator imagines himself at a Rembrandt exhibition, the climax of which is the visit of the ancient, white-haired John Ruskin. On the way to his grave the frail man wants to see again the Rembrandts that at age twenty he had experienced as essential.[110] This meeting, Ruskin's final homage to Rembrandt, enhances and dignifies the Rembrandt paintings in the narrator's eyes:

> It seemed all of a sudden as if Rembrandt's canvases had become something more dignified to have visited, since Ruskin, having come from so far, had entered the gallery.

This is possible, because Proust's Rembrandt, unlike Thoré's Rembrandt, or Proust and Vaudoyer's Vermeer, cares about his beholder and about posterity:

> It also seemed...that, if the gaze of Rembrandt, which seems to consider us from the background of his finished canvases, could have seen Ruskin, the master might have been to him like a sovereign who recognizes another sovereign in a crowd.

This is not at all what happens to Bergotte, whose death may strike us by comparison as excessive. Again, we need to consider circumstance and perspective. They are taken from the list of comparisons and metaphors known so well from the travel and art literature on the Netherlands from Thoré to Vaudoyer. What makes Bergotte go to see Vermeer's *View of Delft* is his reading of a review whose author compared "a little patch of yellow wall" to "some priceless specimen of Chinese art." He could not remember this detail in *View of Delft*, "a picture which he adored and imagined that he knew by heart." The desire to see the little patch of yellow and its Chinese preciousness leads him to seek out the Vermeer painting directly. "He walked past several pictures and was struck by the aridity and pointlessness of such an artificial kind of art which was greatly inferior to the sunshine of a windswept Venetian palazzo, or of an ordinary house by the sea" (Proust 1982, III: 185; 1987, III: 692). Recognition of the painting's foreignness; China, artifice, meaninglessness; Venice, naturalness; these are familiar elements from French travel and art literature that serve here as components of Bergotte's associations. The Venice sought in vain in the other Dutch paintings is linked to the anticipated Chinese specimen in Vermeer. The lack of sunshine and, presumably, evocative power is characteristic of Duch paintings in general but not of the Vermeer, despite, or – as we saw in the tradition of the art and travel literature on the Netherlands – precisely because of its evocation of foreign comparisons. The undetermined "ordinary house by the sea" somewhat smoothes out these opposites to give them the appearance of Bergotte's cursory associations, yet these opposites are then taken up by the motif of the celestial balance revealed to Bergotte once he arrives and stops in front of the Vermeer. Bergotte, scanning the *View of Delft*, "remarked for the first time some small figures in blue, that the ground was pink, and finally the precious substance of the tiny patch of little wall." Then circumstance and the perspective of viewing turn inward:

"he fixed his eyes, like a child upon a yellow butterfly which he is trying to catch, upon the precious little patch of wall." The three "primitive colours" of Havard (blue, red/pink, yellow), China, and the butterfly take him inward to his own art and life. The insight into their imbalance reveals to Bergotte his own failure. While "surrendering" his life to his art may relate to a sacrifice, it also relates to its vanity. Both vanity and *vanitas* make him reduce his insights and think, just before he collapses: "All the same." "'All the same,' he said to himself, 'I shouldn't like to be the headline news of this exhibition for the evening papers.'"

In contrast, had Proust's Ruskin died in front of the Rembrandts, his death would have realized what Proust only presents in the grammatical conditional: Rembrandt's acknowledgment of Ruskin and thus the latter's enhancement and revitalization in the eyes of the world. Between Vermeer and Bergotte such a "contract" among "sovereigns" is impossible. The painter cruelly turns his back upon the beholder, and he, Bergotte, finds himself humiliated. He cares about posterity, but knowing that Vermeer could not lend his support tries, in vain, to avoid scandal.

The image of the yellow butterfly of childhood is, of course, an old symbol for the immortality of the soul. The narrator comes to Bergotte's aid: "He was dead. Dead forever?" Following Bergotte's death scene is a long section in which the narrator ensures Bergotte's posterity, and the immortality of his work and of true art in general. Here it is useful to pause and remember who else in the body of texts examined here uses the image of the butterfly. First of all, it contrasts with the image of imprisonment, with the bizarre image of the golden, fixed insect used by Vaudoyer to describe eighteenth-century chinoiserie. Vaudoyer himself used this image to set off that of the wings of freedom seen by him in French orientalist painting. The other author who comes to mind is the francophile Benno Reifenberg, who used the image of the butterfly for Vermeer:

> [T]he most ephemeral, the most transitory effect offered itself to him, tangibly near like the wings of the butterfly which has landed on the outstreched hand, light as a feather with its dense velvety splendor. In color he found more then the multi-colored garment of things, he found their essence.[111]

I do not wish to suggest that Reifenberg knew Vaudoyer's criticism, although this would not be so surprising. It is interesting that in his usage of the metaphor of the butterfly we see a non-contiguous opposition of freedom and imprisonment, of the ephemeral and the immortal, of the oriental and the Christian; and the association of color and painting with the essential. Proust's use of this metaphor for the "little patch of yellow wall" in *View of Delft* resonates with such oppositions and associations.

The contemporary painter William Wilson exhibited a work called *Gathering: After Vermeer* in 1991. This striking postmodern sequel to Proust is a copy of Vermeer's *Lady Writing a Letter* (c. 1666), "a woman dressed in yellow satin with fur."[112] What is different in the copy is that "behind a seated woman hangs a body swaddled in a shroud, bound with ropes and covered with monarch butterflies...the presumably dead male body."[113]

Seriality in Dutch Painting

Within the novel, Bergotte's experience of the painting is unique and yet one in a series of metaphors of illuminated gates and doors. It is this series that enables the narrator to be a seemingly conventional omniscient narrator with privileged knowledge of Bergotte's last thoughts and of Swann's experience in life. Proust uses the notion of seriality in different places, in his essay on Monet as well as with regard to the seascapes of his fictive painter Elstir. To understand its function, it is important to distinguish the series from the overlay of, for example, Proust over Ruskin over Rembrandt. The latter deals with the deep structure of history through direct acknowledgment, as in the example of the sovereigns who can find each other in a crowd. The series does not simply level history to an ahistorical plain of like elements. It can also be called historical, in the sense that it deals with differentiating artistic experience and experience of art. The series of images and metaphors regards the contemplation of the first impression, the *Kunsterfahrung* in temporal and spatial perspective. It allows the narrator of the novel to imagine Swann and Bergotte from within and yet also from a temporal and spatial distance. This ability is exemplified in Bergotte's death scene and other related or comparable scenes of experience. Proust relates them to four groups of visual art: Far and Near Eastern, Venetian, modern French, and Dutch. The first two groups become related in the novel through something of an analogue to Vaudoyer's winged iconography and its resettlement in Fragonard's art, namely, in Fortuny's gowns, which recreate Carpaccio's costumes. Peter Collier has elucidated this subject most interestingly in his *Proust and Venice*.[114] The modern French group includes the names of the fictional Elstir and the historical Monet. I limit my discussion to experiences of Dutch painting.

It is by way of reference to both Rembrandt and Vermeer that the narrator of *Remembrance of Things Past* looks back and ahead, at the end of the novel, at his accomplishment:

> [I]t is the revelation, which by direct and conscious methods would be impossible, of the qualitative difference, the uniqueness of the fashion in which the world appears to each one of us, a difference which, if there were no art, would remain for ever the secret of every individual. Through art alone are we able to emerge from ourselves, to know what another person sees of a universe which is not the same as our own and of which, without art, the landscapes would remain as unknown to us as those that may exist on the moon. Thanks to art, instead of seeing one world only, our own, we see that world multiply itself and we have at our disposal as many worlds as there are original artists, worlds more different one from the other than those which revolve in infinite space, worlds which, centuries after the extinction of the fire from which their light first emanated, whether it is called Rembrandt or Vermeer, send us still each one its special radiance (Proust 1982, III: 931f.; 1987, IV: 474).

In this passage Vermeer and Rembrandt serve as equal examples because the question of posterity is not what is at issue here. Instead, it is the possibility of cog-

nition in art, through the multiple worlds shining forth from the works, which constitutes their future. But why the example of Dutch art here, and not Venetian or French? The reason cannot be that of historical distance alone, because Venetian art would have served this purpose as well. It was of Dutch art that writers such as Havard, James, and Fromentin expressed the judgment, from differing angles, that it did not represent another world, but appeared somehow to be the same world as theirs, a *déjà vu* image and therefore pointless, once they had arrived in the Netherlands as travelers and critics. Proust, however, seems to see the point of Dutch art for just that reason – that it multiplies and modifies his world.

A closer study of the issue helps explain Proust's interest in a number of aspects of Dutch painting, including the possibility of "pointlessness." He chooses the most literal motif of seriality, the image of the gallery of Dutch paintings hung in rows, as a metaphor for his observations made during the course of an afternoon spent looking out of the window so as to not miss the Guermantes' return home. The diversion takes Marcel from his aristocratic surroundings to poorer ones, picturesque cityscapes in Venice and Paris:

> As a matter of fact I had made a bad choice of observatory, for I could scarcely see into our courtyard, but I caught a glimpse of several others, and this, though of no practical use to me, diverted me for some time. . . . It is of its [Venice's] poorer quarters that certain poor quarters of Paris remind one, in the morning, with their tall, splayed chimneys to which the sun imparts the most vivid pinks, the brightest reds – like a garden flowering above the houses, and flowering in such a variety of tints as to suggest the garden of a tulip fancier of Delft or Haarlem planted above the town. And then the extreme proximity of the houses, with their windows looking across at one another over a common courtyard, makes of each casement the frame in which a cook sits dreamily gazing down at the ground below, or, further off, a girl having her hair combed by an old woman with a witchlike face, barely distinguishable in the shadow: thus each courtyard provides the neighbours in the adjoining house, suppressing sound by its width and framing silent gestures in a series of rectangles placed under glass by the closing of the windows, with an exhibition of a hundred Dutch paintings hung in rows. (Proust 1982, II: 594f.; 1987, II: 860).

Mediated through the tulip craze, a Dutch peculiarity par excellence, Marcel's imagination wanders from the present to the seventeenth century and from reminiscences of cities he knows, Paris and Venice, to the art of Dutch cities, Haarlem and Delft, and to the evocation of paintings by Pieter de Hooch, Nicolas Maes, and others. Whereas the geographic locations, Paris, Venice, Delft, Haarlem, are named, these artists are not. The iconography invoked is considered generic Dutch iconography, related to lower-class urban districts and soundless everyday gestures of women. The spatial relationships are complicated. Marcel's imaginary diversion takes him from the spatial, labyrinthine complexity of those districts to the simile of the tulip garden, from there to courtyards and windows, and from the outdoor

spaces to the indoor spaces. What might be considered intrusive voyeurism, the criss-crossing of one-directional gazes from within houses into other houses, is presented instead as the diversion of a picture gallery. From there his imagination takes him back to his aristocratic surroundings and to an awareness of their own complexities. This whole passage introduces what he really sees and what really happens in the courtyard that afternoon. The reader learns a little later, in Part One of *Cities of the Plain*, that that same afternoon Marcel discovers Charlus's homosexuality, when witnessing the mating dance of Jupien and Charlus in the courtyard. Throughout *Cities of the Plain* the narrator analyzes how Charlus, because of his homosexuality, compromises and undermines his distinct class consciousness as a member of the aristocracy.

I should like to point out that Proust's essay, "Chardin et Rembrandt," of c. 1895, follows a similar structure, also involving the issue of class, though it proceeds in an inverse order.[115] A young man, discontented with his modest middle-class milieu, and without the means to travel, goes to the Louvre, grasps the aristocratic refinement of Chardin's representation of such a milieu as his own, and emerges from this gallery visit with the capacity for aesthetic detachment and a new, tender appreciation for his modest origins.[116] Proust's "Chardin et Rembrandt" provides a rather simple analogue to *Remembrance of Things Past*, where Marcel's pursuit of his goal to become an artist is paralleled by the narrator's increasingly pointed social criticism, the result, apparently, of a merciless observation of people in society and of real or imaginary class distinctions.

In Marcel's imagination the spatial complexity of the cityscape becomes leveled to rows of framed Dutch genre paintings under glass at the same time as the remembrance of poor urban districts becomes aestheticized as a *Kunsterfahrung*. So much was announced at the beginning of the paragraph, with the admission of the diversion having "no practical use," hence of its being disinterested. If elsewhere Proust names Vermeer and Rembrandt as "original artists," the genre painters here remain nameless. Style is not invoked, nor is naturalism; the subject is simply suspended. Presumably, this series of "a hundred Dutch paintings" does not present Vermeer's and Rembrandt's "many worlds" (Proust 1982, III: 932; 1987, IV: 474), but rather a more general occasion "to see the universe through the eyes of another, of a hundred others" (Proust 1982, III: 260; 1987, III: 762). This seems to be something that, outside of art, the nameless Dutch painters teach Marcel to do. In contrast, the chief example of the power of "original artists" to allow one to transcend one's own world is Bergotte's experience and death before Vermeer's *View of Delft*. Here I do not wish to reflect further on the nature of the difference between individual "original" and generic "one hundred" Dutch artists, but focus on how Proust uses them, once he has set up the difference.

Interestingly, in either of those passages examined here, the first on Dutch painting in Bergotte's thoughts before he reaches Vermeer's *View of Delft*, the second on the original artists Rembrandt and Vermeer, and the third on generic Dutch painting, a vaguely natural mediator is at work. Thus, in the first, the "the sunshine of a windswept Venetian palazzo, or of an ordinary house by the sea" in Bergotte's thoughts corresponds to the unknowable landscape on the moon in the second, and to the "tulip fancier" and his garden of colorful chimneys in Marcel's imaginary

window view in the last passage. None of these mediating images lacks in visual sug-
gestiveness while each lacks in temporal determination. Each of them thereby bridges
the different temporalities invoked, of a world experienced by the narrator in his
lifetime and of the world of the art of the past. Each of them presents a pause for
simplicity in the complexity of the entire passage in which it occurs. In the last pas-
sage, it is the "garden flowering above the houses," "the most vivid pinks, the bright-
est reds," "such a variety of tints," that suggest "a tulip fancier of Delft or Haarlem"
and thereby introduce the Dutch comparison that follows. Furthermore, preceding
the passage on "original artists" is the narrator's contention that "style for the
writer, no less than colour for the painter, is not a question of technique but of
vision" (Proust 1982, III: 931; 1987, IV: 474). This would seem to apply to Vermeer
and Rembrandt as much as to the unnamed Dutch painters. The image of the tulip
garden suggests that the "hundred Dutch paintings hung in rows," nameless as they
remain, do not lack in vision and color. (This, then, contradicts Bergotte's harsh
judgment of Dutch painting apart from Vermeer and thereby softens his self-con-
demnation for having recently belonged to that class of artists.) Vision and color
were, as will be remembered, the means by which Havard in his writings traveled
through time and related the temporalities of a scenery "out there" to the Dutch art
of the past, though without ever succeeding in mediating the two.

Number XVIII of Proust's "Regrets, Rêveries" is called "Memory's Genre Paint-
ing." It sheds light upon Proust's grouping of Dutch art, the series of images or even
pictures, and aesthetic contemplation, precisely because it lacks all the nuances of this
grouping observed so far. It lacks a critical function (e.g., Marcel's "diversion" and his
observation of Jupien and Charlus, and on homosexuality and social class); it lacks
revelation and cognition (e.g., Bergotte's viewing of Vermeer's *View of Delft* as pure
art); and it also lacks the artistic dimension that makes the novel's narrator use
metaphors such as "the sunshine of a windswept Venetian palazzo, or of an ordinary
house by the sea" and "the garden of a tulip fancier of Delft and Haarlem planted
above the town." The first of its two paragraphs reads as follows:

> We have certain memories which might be called our memory's Holland
> school of painting, in which the people are usually of modest station,
> caught at some ordinary moment of their lives, without solemn happen-
> ings, often without anything happening at all, in a setting that is not in
> the least extraordinary, without grandeur. The whole charm lies in the
> naturalness of the characters and the simplicity of the scene, remoteness
> throwing its lovely light between us and the picture, and bathing it in
> beauty.[117]

Important among these commonplaces about Dutch art is the rendering of the
Dutch school as a section within memory, for it pictorializes the contents of what is
remembered: remembering is pictorializing. But pictorial remembrance pertains here
only to a certain part of the faculty of memory, that part which deals with regularity,
the everyday, the only slightly varied or plainly repetitive aspects of life. The author's
example from his life experience is therefore less surprising than ironical in its own
simplicity: "My military life is full of scenes of this sort. I lived them naturally, with-

out great joy and without great sorrow, and I remember them with great tenderness." "Memory's Genre Painting" ends with the assertion that its "series of little paintings" results from a period "of a happy reality and a charm over which time has now spread its gentle sadness and its poetry." How self-ironical this sentimentality is becomes clear when its author admits that these "little paintings" come "with many blanks, it is true." What is exposed, among other things, in this short prose piece is the plain falsity both of sentimental memory and of certain views of Dutch art. In the context of this study, the German tradition of the idyllic that I examined earlier offers itself as one obvious target, though not in its entirety, if we take into account Jean Paul's emphasis on disruption and negativity. In light of this association with the German tradition it is quite tempting to relate Proust's ironic mention of "many blanks" to Wolfgang Kemp's notion of constitutive blanks in works of art, blanks that are there to be filled by their readers or beholders. I would argue that this procedure of filling blanks does not necessarily strive for seamlessness. Instead, it may emphasize a discontinuity between the work of the past and a given presence; or, applied to Proust's passage, it may acknowledge a discontinuity between the sentimental part of memory and an ironic admission to a repressed part of memory that vaguely lingers in the mind of the reminiscing subject. "Memory's Genre Painting" may heighten the awareness of sentimentality in *Remembrance of Things Past*, a sentimentality that can be found in some of the nonpictorial analogues to Vermeer's *View of Delft*.

Originality and Seriality in Vermeer

Bergotte's revelation before Vermeer's *View of Delft* follows his dismissal of the "aridity and pointlessness of such an artificial kind of art" as the Dutch school in general. An unspoken part of his self-criticism is that his last novels come closer to that school than to Vermeer's painting. This dismissal may well apply to the analogues of *View of Delft* throughout the novel, that is, to the variations of two related metaphors to which the painting belongs, the metaphor of the threshold, for example, the gate, and the metaphor of transience, for example, the butterfly. In each of the following four occurrences these metaphors are central to different kinds of memory, the memories of early childhood, the memory of another (Swann), and Marcel's mourning for Albertine.

1. At the beginning of *Swann's Way*, the narrator writes of the isolation of his first memory, the trauma of going to bed without his mother's goodnight kiss:

> And so it was that, for a long time afterwards, when I lay awake at night
> and revived old memories of Combray, I saw no more of it than this sort
> of luminous panel, sharply defined against a vague and shadowy back-
> ground, like the panels which the glow of a Bengal light or a searchlight
> beam will cut out and illuminate in a building the other parts of which
> remain plunged in darkness (Proust 1982, I: 46; 1987, I: 43).

It is through a gate that he envisions Swann emerging as a visitor to his parents and entering his own life from without, all the while vaguely foreseeing the consequences of Swann's visit.

2. Another occurrence of the metaphor of the gate is in the description of Marcel reading in his room on hot summer afternoons in Combray. In his shaded room he perceives "the almost closed shutters through which, however, a gleam of daylight had contrived to insinuate its golden wings, remaining motionless in a corner between glass and woodwork, like a butterfly poised upon a flower."

Marcel's childhood butterfly relates, by way of contrast, to Bergotte's childhood butterfly. Whereas the dying Bergotte realizes the vanity of his hunt for the yellow butterfly, young Marcel is not trying to catch it. Having entered through closed shutters, it is already a metaphor for him and, holding still, presents "to my imagination the entire panorama of summer." To this panorama also belongs the bookseller's doorway, "a doorway more mysterious, more teeming with suggestion than that of a cathedral" (Proust 1982, I: 89–91; 1987, I: 82f.). Thus we find both metaphors of promise together here.

3. The next and most elaborated use of the metaphor of the gate also pairs illumination with surrounding darkness. Yet it is neither the darkness of oblivion nor of anticipation, but, in a sense, of the present. It formulates Swann's experience of the "little phrase" of the Vinteuil sonata in its final appearance as a theme woven into a Vinteuil piece performed at Madame de Sainte-Euverte's soirée. There it seems to Swann like a door held open to him that "would otherwise automatically close," a door to "the cloak-room of his memory." Emanating from the violin's "wooden case, delicate like a Chinese box," and like "a protective goddess," it belongs "to a world of ultra-violet light" and thus is invisible. But it also reminds him of Odette's very first letter, with the letterhead "Maison Dorée," of her expression of longing for him, and of early conversations between them. In the end it vanishes like a bird, a soul, a fairy (Proust 1982, I: 375–84; 1987, I: 339–47). Here, again, images of the ephemeral, or fleeting, and of the stationary threshold are brought together. The Vinteuil phrase illuminates the cloakroom of memory, allows Swann to see successive aspects of his relationship to Odette in its former goodness and to see as well its definite pastness.

4. The last metaphor of the gate is one in which a window frames too much light, blinding Marcel. Framed by the gothic hotel-room window in Venice, this light is seen both from within and from without. The narrator emphasizes that the building's facade, "still half Arab," is "reproduced in all the architectural museums and all the illustrated art books" (Proust 1982, III: 639; 1987, IV: 204). Through it he sees in the mornings "blazing there, instead of the gleaming black marble into which the slates of St. Hilaire used to turn, the golden angel on the campanile of St. Mark's. . . .I could see nothing else" (Proust 1982, III: 637; 1987, IV: 202). The angel as seen through the medieval window gestures the promise of pleasures "half an hour later," an arbitrary interpretation possible because of Marcel's exclusive attention to it. Upon returning to the hotel, Marcel claims that "from a long way . . .I caught sight of this ogival window which had already seen me, and the thrust of its pointed arches added to its smile of welcome the distinction of a loftier, scarcely comprehensible gaze" (Proust 1982, III: 639; 1987, IV: 204). The window's dazzling gaze is doubled by his mother's "impassioned gaze" at him from "behind its multi-coloured marble balusters" and her white veils. The forced personalization, nearness, and immediacy of these phenomena, the exceptional lack of contemplative perspective,

correspond to the fact that the Venetian episode, long anticipated and postponed by Marcel, comes so late or even too late. Lacking, as it were, in the darkness of contemplative perspective, the "oriental city" is without its own presence and becomes merely a blinding, crowded passageway for Marcel's past and future. Here phrases such as "from far away" do not relate to his contemplative approach, but on the contrary to his sense of being anticipated, seen and greeted. The sign character of the first impression, discussed in the *Carnet* of 1908, has become the language or voice of the object itself. An art object – not a metaphor – the ogival window which is reproduced in "all" the museums and books functions very much like Hegel's "symbolic" art, like Proust's "allegorical" name. Like these, it is overdetermined in meaning. The metaphor of the threshold – the illuminated gate, the doorway, the panel, the shutters – and the metaphor of the fleeting – the luminous butterfly, the reflection, the fairy, the bird – are startling images of promise, if set in the past. As images of past promise they are constitutive blanks to be filled subsequently with experience and meaning; conversely, they fill the darkness of the present with experience and meaning. On the other hand, if such images themselves are set in the present, then they are concrete objects – a famous, much reproduced ogival window and the angel of San Marco's campanile – whose promise is unsuccessfully wrenched from them or even imposed on them.

How does Vermeer's *View of Delft* function in this polarity of past and present? Both metaphors are applied to it in the images of the butterfly of childhood and of the "little patch of yellow wall." In fact, we are told that the two are one and the same in Bergotte's experience. The first becomes the second, and as this happens, he dies. Proust thus defines death most strikingly and simply as the identity of past and present.

View of Delft is also a very concrete object, an identified art object comparable in this respect to the Venetian window frame and the Campanile's angel. Proust wisely places this object in Bergotte's experience and not in that of Marcel, and at the same time provides for the episode an omniscient narrator, a device one might interpret as a gesture of temporary suspension of the distinction between subjective experiences.

In order to see the position and the interpretation of Vermeer's *View of Delft* more clearly, it is useful to turn to Proust's own idea of comparability. Given his intensive sense of the uniqueness of individual "worlds," the subject of the comparability of such worlds and their relationship occupies him frequently within the novel and without. It is less an issue of communication in general than one of the validity of an original interpretation. Thus, it is an issue related to the novel's own hermeneutic procedures. But how is a series of comparable individual worlds possible?

In his notes to *Contre Sainte-Beuve*, Proust's answer is complicated:

> [H]e does not die, or rather he dies but can resuscitate if a harmony presents itself, even simply if between two paintings of the same painter he perceives a same sinuosity of profile, the same piece of fabric, the same chair, demonstrating in the two paintings something in common: the predilection and the essence of the painter's mind. For he dies immedi-

ately in the particular, and recovers immediately to float and to live in
the general. He only lives in the general, the general animates and nour-
ishes him, while in the particular he dies instantly.[118]

According to this passage the artist as beholder lives through the dialectics of
identity and difference in another artist's œuvre. The comparability of repeated ele-
ments in an oeuvre regards what is general, what the individual works in it have in
common. What they have in common is, each by itself, the utmost particular stylistic
trait of the oeuvre, that which makes it unique in its entirety. Taken as a singular
instance, this trait means the death of the beholder who loses himself in it. The seri-
ality of an oeuvre, a seriality that refers to a multiple individuality, sustains the life of
the artistic beholder or reader as well as the posterity of the author.

This kind of "nourishment" at first seems to relate both to the anonymous
"hundred Dutch pictures hung in rows" and to "Memory's Genre Painting." Yet
Proust refers here to particular details, such as fabric, chairs, a certain profile recur-
ring in any two given paintings by the same painter. He considers individual style
as something absolutely distinct, and thus distinct also from the style of a school of
painting. His point of reference in this passage, as in the *Carnet* of 1908, is Vermeer's
oeuvre. This seems confusing at first, since Vermeer's paintings, in all the other
instances examined here, are used by Proust as works by an original artist and as
distinct worlds. Vermeer, as the example of Bergotte's death before the *View of Delft*
shows so drastically, should be related here to the statement that "in the particular he
dies instantly." But in this passage in *Contre Sainte-Beuve* it is related instead to the
nourishment of seriality. In a footnote to this text Proust elaborates that Vermeer
actually belongs to both, that two of his worlds are distinct, unique, incomparable,
and yet that something spiritual "between the two" and belonging to neither exclu-
sively transcends them to "a kind of ideal painting." Its recognition means supreme
nourishment and happiness.[119] In transcending chronology, seriality frees originality
from it.

Proust does not explain further how this life-sustaining dialectics of identity
and difference as a dialectics of seriality and originality applies to Vermeer. In the
novel, there are only two possibilities. A third, the positioning of *View of Delft*
among other Vermeers, is avoided. The two are: first, the invocation of the "ideal
picture" of Vermeer's oeuvre and its comparability to other ideals; and second, the
participation of a single Vermeer painting, *View of Delft*, though fatal to Bergotte, in
the seriality of illuminated gates, doorways, panels that sustain and nourish the
novel's narrator and Proust's art through their temporal sequence. This sequence of
Kunsterfahrung is temporally determined, but it is virtually unlimited. Similarly, the
butterfly of childhood, though fatal to Bergotte when encountered in *View of Delft*,
becomes an image of the "entire panorama of summer" for Marcel, one in a series of
similar crucial experiences. There might even be a way in which we can connect this
image of the limitless "panorama of summer" with Vermeer's panorama of Delft. I
will attempt an interpretation of the painting with Proust's guidance in the next
chapter. Here I remain concerned with the specific contexts Proust provides for it.
What these suggest to me is an effort to achieve an understanding of originality as
something other than uniqueness. Here I should like to refer again to Adorno's sur-

prising argument that Proust's primary interest is in the afterlife of works of art and not in their origins. That is, Proust's interest is in separating originality from origin. The position and interpretation of *View of Delft* in the novel are those of the exemplary work of art. If seen as unique, it annihilates its beholder. If placed within a series of certain metaphors, it keeps a promise of renewal and nourishment. Seen in the context of my study, Proust's interpretation of *View of Delft* provides an important explanation of the phenomenon of the presence as well as endurance of Vermeer's art, a phenomenon remarked upon in so many studies of the artist, in so many genres of writing, in so many methodological efforts to come to terms with the meaning of his paintings. Yet the explanation is far from complete.

The thought comes to mind that *View of Delft* does not fit the seriality of Vermeer's oeuvre, to which Proust refers in the above-quoted passage on the "ideal picture." It does not show profiles, fabric, chairs. On the contrary, it is unique in Vermeer's oeuvre, and also in Dutch seventeenth-century painting. Why does Proust choose this painting and not, say, *Girl with a Pearl Earring* (Fig. 12)? So far we have looked at Proust's positioning of *View of Delft* in the novel and at his discussion of Vermeer's oeuvre in *Contre Saint-Beuve* and in the *Carnet* of 1908. What context does Proust provide for the account of seriality in Vermeer's oeuvre when he addresses this subject in the novel itself?

Since Swann and Marcel never give up the ideal of artistic harmony and the comparability of "ideal pictures" in the above sense, their effort to reach this ideal is sometimes forced. This occurs when Marcel explains to Albertine what is essential and permanent in great art by comparing two seemingly incomparable artists, Dostoevsky and Vermeer, through the beauty they each achieved in their art. It is not a beauty of action, of course. On the contrary, beauty in Vermeer is "an enigma at that period in which nothing resembles it, if one doesn't try to relate it all through subject matter but to isolate the distinctive impression produced by the colour." It is "the creation of a certain soul, of a certain colour of fabrics and places," of "fragments, of an identical world . . . the same table, the same carpet, the same woman" (Proust 1982, III: 384; 1987, III: 879). Color, identity, fragments and monotony make up the seriality of Vermeer's oeuvre. They render the soul, and presumably the "ideal picture," permanent. What is new here is that Marcel provocatively and forcibly attempts to sever beauty and permanence not only from subject matter, but also from morality, when he attributes to Rogoshin's house of murder in Dostoevsky's *The Idiot* a beauty equal to that of the Vermeers. The vague, triangular transition he provides here between Vermeer's interiors and Dostoevsky's interior is a comparison of Dostoevsky's women with those of Rembrandt. Through beauty, murder in the one and soul in the other are made comparable. None of this is explained any further in the novel, but it will be remembered that in his *Carnet* Proust expressed his contempt for a "humane art" as something to which he saw Vermeer's oeuvre standing in preferable opposition.

Proust's distinction between the seriality of Vermeer's paintings of interiors inhabited by women posing in profile and his *View of Delft* is meaningful in ways not yet fully accounted for. Within the novel the distinction is marked by different kinds of comparability. At this point it is useful to turn once more to the writings on Vermeer available to Proust.

Vanzype on Vermeer's "Sublime Lie"

In Vaudoyer's articles on Vermeer, *View of Delft* is considered an exception to the oeuvre,[120] whereas the words *nourriture* and *général* in Proust's *Carnet* of 1908 are reminiscent of Vaudoyer's perception of a succulent monotony in Vermeer's art. The temporal aspect of nourishment and sustenance of existence of which Proust writes, as well as the notion of an identical world that Vermeer's oeuvre represents, may be related to another of Proust's readings on Vermeer, Gustave Vanzype's monograph *Vermeer de Delft* of 1908. This book was the fourth volume in a series called *Collection des grands artistes des Pays-Bas*. It is conceivable, though not known to me, that Proust also owned or read volume fourteen, Arthur de Rudder's *Pieter de Hooch et son oeuvre* of 1914.[121]

Vanzype emphasizes that Vermeer was completely and literally his own resource, a truly original painter who needed only his familiar surroundings, the city and site of his origin, to be creative. Vanzype discusses the use of color and light in the paintings and what he calls Vermeer's respect for *les choses*, things, for their substance and their materiality. He claims that Vermeer understood what he calls the solidarity of things among themselves and "the relations between these things and man" as no one else had in premodern art. He praises Vermeer's ability to achieve an equilibrium between the human figure and the object in order to avoid the domination of the one by the other, something he sees otherwise as characteristic of Baroque art.

Such thoughts resemble Proust's ideas on Vermeer's harmonious and identical world, and it may be assumed that he saw them validated in Vanzype's interpretation. Of particular interest to Proust may have been how Vanzype writes about time, both with regard to the spectator and to Vermeer.

Vanzype tells of his trip to Delft, prompted by Vermeer's *View of Delft*. Once there, he is at first disillusioned: "Does nothing remain? No, nothing, nothing evidently survives" (Vanzype 1908: 80). It is July and hot, the town's colors are dull. Thoroughly disappointed, he suddenly, "without even searching," finds something of what Proust might call the "ideal picture," in this case, of the town. He observes in the middle distance a boat on a canal and its passengers illuminated by rays of sunshine, among them a woman: "Everything is grand, everything lives with intensity and opulence; this immobile and vulgar woman has found again the expression of heroism which one might believe dead." Vanzype projects his expectations of Delft on the woman he sees. She represents to him the heroism of self-confidence, which is central to his interpretation of Vermeer's paintings. He concludes: "We are always in the land painted by Vermeer" (Vanzype 1908: 84). This "always" refers to the temporal incompleteness of interpretation, or *Kunsterfahrung*, through which both the art and its viewer live. The distant image of the illuminated woman and the boat does for Vanzype what the oriental comparison and the power of color had done for Havard: it identifies the art with the Dutch scenery or city and vice versa, not as something that befalls one like a *déjà vu*, but as something consciously enjoyed, as a pleasurable experience of "Vermeer's world" above which the "as if" remains hovering. This experience permits Vanzype to imagine a continuity of art and everyday life. He does so quite uncritically, abandoning himself to fantasy, and the content of

his fantasy is that of the continuity of art and everyday life. In each instance the image of an illuminated and immobile woman provides the transition.

Vanzype imagines Vermeer and his wife, Catharina Bolnes, in the painter's studio. This time man, woman, and things are supplemented by the background noise of the Vermeers' numerous screaming offspring. Time has left its marks on the couple: Catharina is a tired, broad, thin-haired matron; Vermeer is without patrons, and sits melancholically at his easel; the family is without bread. Suddenly, as Catharina opens the shutters, the sunlight illuminates her and the room. Vermeer asks her to stand still. Like Swann at Madame de Sainte-Euverte's, Vermeer sees with his mind's eye the entirety of the goodness of their married life and his artistic career. Catharina seems rejuvenated in the light both of the sun and his own remembrance, and another work of art is born. One of his daughters is overheard appeasing the baker's clerk at the door by promising the payment of debts quite soon. The work that is born, however, is not *The Art of Painting*. Instead, as for an extended moment Vermeer and Catharina represent to themselves a tableau vivant of that painting's iconography, the artist realizes the identity of his life and art. Vermeer's own "Memory's Genre Painting" allows for additions to its seriality. Drawing strength from this experience, Vermeer sets out "tomorrow" to paint the *Girl with a Pearl Earring* (Fig. 12), presumably a portrait of the daughter who went to the door (Vanzype 1908: 84–8).

The known factual detail from Vermeer's life of his debts at a baker's has also captured other authors' imagination, evidently as a genre detail, a touching image of the painter's actual difficulty to earn his bread.[122] In Vanzype's account this detail serves a kind of Proustian seriality that extends out of the artist's oeuvre. Plates of *View of Delft* and *Girl with a Pearl Earring* accompany the two stories with which Vanzype ends his book. It is difficult to imagine that Proust did not take advantage of these accounts, which argue that we are always in the country Vermeer painted. Their sentimentality breaks down, however, with Vanzype's interpretation of *View of Delft*:

> Never has one achieved more vibration. And the forms appear with vigor, the colors with an infinite variety of tones. There is a brilliant lesson in this. One sees here how wholesome light is painted but also how pathetic it is, enveloping the robustness of things instead of substituting itself for them; how one fixes its caresses and eternalizes its dazzlements without thereby diminishing that robustness, by impregnating, by plating, by gilding the material and colour of which it is made; . . . the life of thought assumes the superiority of contemplation. . . . Vermeer accomplishes this: he is the realist who purifies himself, the dreamer who contemplates and transforms the realities, who lies sublimely to people in order to give them more confidence, more hope, in a bold and clear optimism (Vanzype 1908: 69, 77).

Equilibrium as the promise and nourishment of a sublime lie – this thought is not at all foreign to Proust's novel. It appears related to the possibility there that what appears as a promise either is itself or is accompanied by a mere blank. This possibility applies first of all to allegorical names, such as "Venice," "Vermeer," "Guermantes," as well as to the techniques of self-representation used by members

of high society. One important difference between that application and Vanzype's passage is that in Proust's novel the possibility of the sublime lie does not apply to Vermeer's art. It does *not* apply to artistic vision – color, or rather hue and tone – that which in painting he takes to be the equivalent to style in writing, and also not to those who contemplate art. Yet it is precisely to these that Vanzype applies the sublime lie. In his two stories this sublime lie clearly sustains the critic's and the artist's lives, rescuing Vanzype from the dullness of Delft in July and Vermeer from his melancholy. These lives are isolated and centered by the very concept of art as conciliatory illusion, a concept that, if supplemented by more stories to form a "series," always reproduces the primary sentimental "sublime lie."

By contrast, Proust insists on the difference between such illusions (names) and original works of art, like *View of Delft*, which in *Remembrance of Things Past* are intricately interwoven with other realities. However, we saw that for Bergotte the *View of Delft* is excessively original, and that within Proust's notion of Vermeer's identical world(s) it seems to represent an exception. Vanzype is of no further help here. At this point one might resign oneself to the not at all simple fact that according to Proust the *View of Delft* is the most beautiful painting in the world. Doing this would mean resigning oneself to the inevitable difference between the artist and the critic. But then Proust is both artist and critic, and the purpose here is to see what that entails for an enhanced understanding of both Vermeer and Vermeer criticism; hence my unwillingness to reconcile myself to Proust's dual interpretation of Vermeer, the painter of multiple images of a nourishing "identical world," and Vermeer, the painter of the beautiful, deadly *View of Delft*.

The two possibilities I see for addressing the problem further are an additional examination of Proust's instructive "art-historical" juxtaposition of Vermeer and de Hooch in his novel and an art-historical use of Proust's account of *View of Delft*, aided by a piece of rigorous art criticism.

Art Historical Probing

Beginning with the latter, I will now relate Proust's interpretation to that of an art historian whose critical discourse on Vermeer is rooted in the German tradition. It is structured by a terminology that takes the individual painting within the entire oeuvre to be a variation of an identical world. With a productive ambiguity that Proust would have appreciated, he calls that world Vermeer's space.

In his 1916 study, "Der Raum bei Jan Vermeer," Max Eisler sees *View of Delft* as the epitome of Vermeer's oeuvre and as the turning point in its development. Eisler takes as the distinct achievement of the Delft school of painting its "mature capacity to identify a minimal spatial segment with the intimation of absolute space" (Eisler 1916: 217). Landscape becomes interiorized, both in the sense that it is literally turned into an iconographic interior, a room, and in the sense that it is an internalized existence. Seen this way, *View of Delft* is not at all an exception to Vermeer's oeuvre but participates in its seriality. The development from free, open space (*Freiraum*) to interior is supported by the topography of the Dutch city, in particular by the free flow of air and water in and through Delft, which helps to bring about a total decentralization of pictorial space. For Eisler, art thus becomes a parable or

simile of nature and Vermeer must be seen as the epitome of this achievement of the Delft school: "But no one has devoted himself so exclusively to the goal: to be natural without surrender to nature; no one positioned himself so fixedly between the poles in the weightless point of balanced tension as Vermeer" (Eisler 1916: 214).

Does Eisler conclude therefore that Vermeer himself occupies no place in pictorial reality?[123] Not quite, but Eisler finds missing in Vermeer an authoritative artistic order. He determines the placid richness of Delft, a city saturated with inherited wealth, "subsisting almost without motion," as the social, historical reason for the painter's intellectual acrobatics of balancing the contradictory in his paintings.[124] Just as the patriciate of the city is inactive and lives off its capital, so Vermeer, the *Malbürger* (painter-burgher), immerses himself in a "festive enhancement of the banal" (Eisler 1916: 219). But does he do so effortlessly or unscrupulously or ironically? What really is the mode and the corresponding intellectual scope by which the artist enhances festively, though in such a manner as to appear natural, what in social reality is the result of labor, social ambition, and advancement, the city's as well as the artist's?[125] Among the earlier modern critics of Vermeer who went beyond the assumption that balance is merely the visualized result or mirror of a serene artistic nature was Vanzype with his notion of the nourishment of the sublime lie. The relevance of Eisler's study comes into sharper focus when his argument about balance is referred to as a counterpoint and supplement to Proust's interpretation. Proust's use of the image of the balance was as an image of utmost tension at the moment of Bergotte's death. Otherwise he uses images of threshold and transition, or even transcience such as the gate and the butterfly, and not of stasis.

"Everything becomes inner tension," Eisler states lapidarily, not allowing for disconnection within the balancing act (Eisler 1916: 219). In his view, this tension appears visually as equilibrium, rendering Delft as something precious. When viewing the painting in the Mauritshuis I myself have most often heard the word "beautiful" applied to it, and on one occasion heard it compared to jewelery. Recent scholarly judgment of the painting, meanwhile, is disquietingly ambivalent: irony here, sanctification there. Martin Pops, for example, proposes that *View of Delft* is a "city blessed by light, a New Jerusalem." But he adds: "The intersection of Heaven and Earth lies in the middle distance."[126] Sixty-eight years earlier, Eisler had noticed this phenomenon as well and interpreted it as a sign of interiority: *View of Delft* has a foreground and a middle ground, but no third ground of distance. In fact, the longer one looks at the painting, the more it seems as if the represented space of this partial city view exceeds its atmospheric rendering, or rather its effect of immediacy, owing to a heightened clarity of hue and strong local colors throughout the picture.

Lacking a third ground, *View of Delft* lacks what Proust's Swann calls the hollow grace of the unknown world, suggested by the illuminated door frame in the middle distance of de Hooch's paintings; unlike de Hooch, Vermeer does not make false promises. De Hooch's *Two Women beside a Linen Chest* of 1663 (Fig. 28) illustrates this kind of space. Its illuminated door frame, "of a different colour, velvety with the radiance of some intervening light," differs from the whitish daylight entering through the nearer source of a window.[127] What Vermeer's *View of Delft* provides, however, is something different yet. It is a subjective tension endured between the first and second ground, brought about, as Proust suggests, by the reflections of

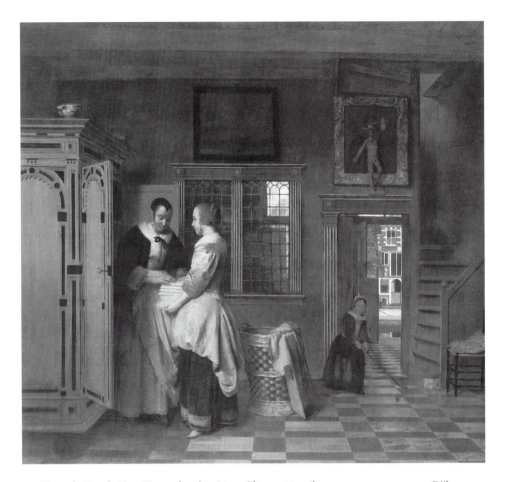

28. Pieter de Hooch, *Two Women beside a Linen Chest*, 1663, oil on canvas, 72 x 77.5 cm, Rijksmuseum, Amsterdam.

an artist who has turned his back to the audience or, as Eisler suggests, by a true promise, or at least a supreme resignation. The painting that at one moment represents to Eisler a natural equilibrium based on endured tension, he analyzes at another moment in terms of bourgeois self-determination. What might be the account of a psychological problem is presented as one of artistic form, of a "language of space," of "formal thought," that is, of an external structure for an inner tension, strictly analogous, not expressive. And, speaking in this formal sense, Eisler continues with a detailed description of Vermeer's mediation between ornamental arrangement, the softening of the structural harshness of verticals and horizontals through curved lines and forms, and open, free space, *Freiraum* (Eisler 1916: 245). And so the city is truly a free interior and can be perceived as such, as content turned in upon itself, as a balance of structure and free space which neither demands nor suggests a further distance and expansion. It is an accurate mirror, *not* of the site but of the "Delft community" (*Delfter Gemeinwesen*) and its material and social reality.[128]

Not, then, a "New Jerusalem," but the self-image of a complacent city: this understanding relates well to Eisler's secularized visual evidence of Vermeer's paint-

ing. We may now understand, why Proust contrasts de Hooch's interiors with Vermeer's *View of Delft* in the novel, the former as a deceptive hollow grace, the latter as deadly truth. The golden illumination in a de Hooch promises transcendence, insofar as it appears exceptional as well as superfluous, a gift to the world as it is depicted in his paintings. But the yellow patch or patches in the Vermeer simply fit in with his color harmony, so much so that they can be overlooked or forgotten by Bergotte.[129] Once they are seen, however, Vermeer's color harmony appears bold, and this boldness is then taken up by the oriental comparison and declared to be one of immanence. Thus there is also a temporal dimension to this contrast. The de Hooch appears to promise something in the future or from the past, but this is a promise that it conveys to the already present and familiar. The Vermeer, on the other hand, is a sudden presence in its immanence, for which the beholder is always unprepared.

Just what does Eisler mean by calling *View of Delft* an interior? How does this enable him to see it within the seriality of Vermeer's world or space? Unlike Proust's seriality, Eisler's is one of development and chronology. As a Hegelian art historian he looks for the origin of this development in the chronological middle, not the beginning. It is in that middle that he places Vermeer's *View of Delft*.

Eisler's chronology of Vermeer's oeuvre is as follows: after the early history paintings, *Christ in the House of Martha and Mary* and *Diana and Her Companions*, Vermeer develops the interiors, which are worked out by the intermediate, double exploration of the female portrait and the cityscape (Eisler 1916: 242f.). Their epitomes, *Girl with a Pearl Earring* and *View of Delft* (Fig. 12 and Pl. V), face one another in the Mauritshuis as "variants of the free space, from which the interior of Vermeer would continuously nourish itself (*fortwährend nähren*)."[130] If for Proust Vermeer's interiors are variations of "an identical world," and thus partake in the nourishing "ideal picture" of Vermeer's oeuvre in which the *View of Delft* is an exception, for Eisler the cityscape as well as the female portrait are variations of a structured "free space," his idea of Vermeer's nourishing "ideal picture." This remarkable establishment of a relation between female subject and cityscape as intimated "free space" anticipates Paul Claudel's relation of female body and Dutch landscape in his *L'Oeil écoute* (1935). It also appears to refer back to the oriental comparison in early French art and travel literature on the Netherlands.[131] This perception of "free space" is absent in Proust. In *The Captive* the narrator regrets:

> But these very similarities between desire and travel made me vow to
> myself that one day I would grasp a little more closely the nature of this
> force, invisible but as powerful as any belief or, in the world of physics, as
> atmospheric pressure, which exalted cities and women to such a height so
> long as I did not know them, and . . . as soon as I had approached them,
> made them at once collapse and fall flat on the dead level of the most
> common-place reality (Proust 1982, III: 169f.; 1987, III: 677).

What in Proust's novel belongs to the sphere of the illusory, of the overdetermined allegorical name, is in Eisler's interpretation part of the painting's own discourse. Eisler's study does not include a detailed discussion of color in Vermeer's

art, though the art criticism he probably knew considered it one of its most important attributes.[132] Nevertheless, in concluding his chapter on the early history paintings, Eisler does take notice of the perceptible and increasingly important yellow and cream color as bearers of *Farbenbewegung* in Vermeer's art, by which is meant both the effect of motion through color or hue and its affective quality.[133]

Using his terminology of bright *Freiraum* and dark nothingness, Eisler concludes that a painting like Vermeer's *Girl with a Pearl Earring* succeeds in transcending the dark space behind and around her through her illuminated features, features built up around her large eyes. Their balanced contrast of dark and light focuses the work's intimation of absolute space. Eisler considers the girl's eyes the breakthrough from conditional to unconditional free space.[134] In this way he addresses the question of origin and originality as a problem that all Vermeer paintings have in common, a problem to which all of them are variable solutions, and one that in his view is itself original to Vermeer. How does Eisler describe the analogy of the cityscape to the female portrait?

In *View of Delft* the beholder is guided from the river's near bank across the water to the compositional as well as factual joint of Vermeer's cityscape, the drawbridge of the Rotterdam Gate on the right, and then drawn beyond it into the city (Eisler 1916: 248f.). The first wooden gate of the drawbridge, the place of the beholder's pause in Eisler's view, encloses a "yellow patch," an illuminated piece of wall perhaps. This silhouetted gate appears to be Eisler's analogue to Bergotte's "little patch of yellow wall," as which we may identify the illuminated roof seen to the left of the Rotterdam Gate's turrets, and also the analogue to Swann's false illuminated doorframe in the unnamed de Hooch interior (Proust 1982, I: 238; 1987, I: 215). In Proust's novel, these details belong notably in each instance to the paintings but also to a serial structure outside of the paintings that makes possible further distinctions between true and false. Eisler, in contrast, looks at the detail and its function exclusively within what he considers the structure of the painting, and then at the painting within the oeuvre. His approach also implies that he abstracts from obvious iconographic aspects of *View of Delft*, shifting attention from the stone bridge at center to the drawbridge on the right.

Acceptance of this shift in attention from iconography to structure and color in Eisler's reading of *View of Delft* implies a temporal prolongation of the viewing and might result in the following description: At far right is a drawbridge with two wooden gateways, one silhouetted against a sunlit wall, the other framing the dark entrance to the Rotterdam Gate's building, distinguished by its two towers. The form of this framed darkness is repeated by the tunnellike entrance to a canal under the Rotterdam Gate and by an arch in the Schiedam Gate, on the other side of the stone bridge at center. Through and under the bridge across the Oude Delft, connecting the two gates, one perceives slightly muted colorful reflections on the water of the nearby houses, illuminated by the sun. This darkening of all points of visual entrance but two, the illuminated gate on the Rotterdam Gate's drawbridge and the stone bridge framing the colorful reflections, is peculiar to Vermeer's painting. This literally eccentric chiaroscuro element is not seen in any of the many prints and drawings of the same view of Delft.[135]

Through technical analysis of the painting it is now known that Vermeer enhanced the darkened zone of the city's facade. He overpainted sunlit parts of the

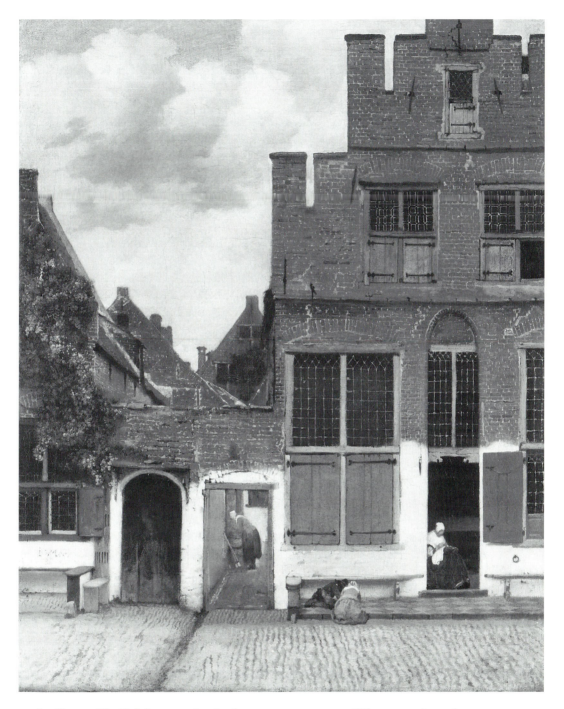

29. Jan Vermeer, *The Little Street*, c. 1657–8, oil on canvas, 54.3 x 44 cm, Rijksmuseum, Amsterdam.

roofs of the Armatorium behind the stone bridge and the Rotterdam Gate's turrets and lengthened the shadows cast across the water by those buildings, shadows that hush their reflections in the water.[136] These changes, unknown to Eisler, in fact support the tension and difficult balance he saw between closed, darkened entrances, and inviting, illuminated ones. This contrasting effect of the near and yet remote leads him to conclude: "In the luminous mirror of the vain is captured a thought of the eternal."[137] Using the metaphor of the mirror, attribute of the allegorical figures of both Vanitas and Truth, he interprets the synthesis achieved by Vermeer as a synthesis of vanity and eternity. This conclusion may not seem so different from Bergotte's insight, yet it is different enough. Bergotte draws from it a critical insight into his own work, whereas such self-reflection does not occur to Eisler. His assumptions of a Vermeer chronology with a double origin at its middle – constructively absent in Proust – turns out to be problematic for his argument for Vermeer's achievement of a free inner space in *Girl with a Pearl Earring* and *View of Delft*. Since that freedom is "arrested" in these two paintings, Eisler implies a thenceforth stagnating or even declining oeuvre, that is, Vermeer's repetitive genre paintings.

Of the relationship between *View of Delft* and *The Little Street* (Fig. 29) Eisler writes: "Certainly this painting [*View of Delft*] marks the middle of his way" (*Mitte* connotes center as well as turning point of Vermeer's oeuvre in this context).[138] *The Little Street* marks the next step, "where the Chamber [i.e., the closed, interior space of subsequent genre paintings] has almost completely captured the artist and he is capable of only this *one* expression. Chamber and alley have become one in the mind of the master, bearers of a serene mood of undisturbed, self-centered hominess."[139] The interiorization of free space ("Interieurisierung des Freiraums") is complete. This however, seems to endanger the artist's very achievement, as is manifest in a new painterly mode: Vermeer's monotonous "*one* expression" in variations, the series of genre paintings that Eisler believes held the artist captive from now on. This emphasis on monotony, complacency, and limitation comes close to Vaudoyer's perception of Vermeer's iconographic monotony and of the Chinese patience in his color; or to Marcel's explanation to Albertine of Vermeer's paintings as things made of elements from an identical world, possessing beauty and a soul.

In the end, comparison of these two interpretations of Vermeer's "world," or "space," points not only to a lack of insight on Eisler's part but perhaps to a similar lack on Marcel's part, at the moment in which he is made to explain Proust's understanding of seriality in Vermeer. For this seriality, too, has a position in another chain of images, the numerous variants of the metaphor of captivity. In that context seriality in Vermeer, "the same fabric, the same carpet, the same woman," is decidedly *not* for Marcel what it is for Eisler: an – idyllic? – hominess [*Heimgefühl*] (Eisler 1916: 252). The comparability for Marcel of soul in Vermeer and of murder in Dostoevsky finds therein at last an explanation. By this point in the novel, the relationship between Marcel and Albertine is so deteriorated that the novel's title, *The Captive*, might relate to both Albertine and Marcel (were it not clearly gendered in French as feminine). The interior of his apartment comes to resemble less and less the Vermeerian ideal and more and more Rogoshin's house in Dostoevsky's *The Idiot*. In this way the comparison of Vermeer and Dostoevsky may also be seen as an anticipation of Albertine's departure and death.

Chapter 8

Fernbild

Proust addresses the question of seriality and originality in Vermeer's art in important ways. He uses images of the threshold (the gate, the panel) and of the transitory (the butterfly, the fairy), whose common function it is to suspend any notion of stasis, a function that extends to Vermeer's *View of Delft* contrary to what might naively be expected from a poetic utilization of a specific work of art. It follows that one cannot do justice to Proust's interpretation of Vermeer by confining its significance to the specific functions it serves in one famous passage. Instead, Proust challenges the art historian in the way formulated by Adorno: to accept that the "afterlife of works of art" is all we have when we ask about origins.

The concern with both the origin and afterlife of works of art came to stand at the center of Warburg-school scholarship, flourishing in Germany at about the same time that Proust was writing *Remembrance of Things Past*. The principle concerns of this scholarship, in addition to questions of origin and afterlife, were with the problem of validating interpretation in art, a problem that will be further addressed in the third part of this book on Vermeer's explicitly allegorical paintings. Another connection between Proust's challenge and German art scholarship I see in the increased interest in spectatorship following Riegl's writings at the turn of the century, as well as an earlier impulse provided by the artist Adolf von Hildebrand and brought to art scholarship by Hans Jantzen. Jantzen was the first to detect in Vermeer's paintings the identity of the *Nah(raum)bild* and the *Fern(raum)bild*, that is, the presentation of what is near, in relatively small format, as something remote and beyond reach. There seems to be a similarity between this concept and Proust's choice of metaphors for *View of Delft*. To be sure, the similarity again leaves out color, so important to Proust.

According to Jantzen, the Albertian authority of the painting to place the beholder "correctly," to determine her or his physical viewing distance to the image as a counterpart to and continuation of pictorial space, is not suspended but somewhat relieved by this double identity of nearness and remoteness.[140] Whether or not

its consequences were clear to Jantzen himself, his view no longer assumes the autonomy and complete presence of a Vermeer painting at any privileged point in history. His view could not have been derived from Riegl's *Dutch Group Portrait* nor even from his essay on "The Modern Cult of Monuments" alone.

In his treatise, *Das Problem der Form*, the neoclassical sculptor Adolf von Hildebrand (1847–1921) discusses what he calls the *Erinnerungsbild* and the *Fernbild*, the "image of memory" and the "distant image." *Das Problem der Form*, first published in 1893, had gone through nine editions by 1914.[141] Its influence on German art history of this period was considerable; its most prominent reviewer was Heinrich Wölfflin.[142] Hildebrand advocates a visual literacy, which he understands to be a competence in reading form. As we read forms in art and outside of art, he maintains, "we provide as a background, as it were, for the subject of the appearance a past or a future or an enduring efficacy."[143] This literacy, this "spatial reading of the appearance" before one, is universal and temporal, depending on corporeal experience of movement and gesture. All visible phenomena have an "actual form" for themselves (*Daseinsform*) and a "perceptual form" for us (*Wirkungsform*).[144] The "perceptual form" relates to our habits of selective perception, of imparting what we know to what we see; and it relates to our visual memory, to the images of memory (*Erinnerungsbilder*). Neither artistic practice nor perception is pure. Such notions of purity and evidence he identifies as a mistaken and misguided "positivism in art," the presumably naturalistic results of which "are, so to speak, dumb because the capacity of speaking to our representation of form has been artificially expelled" from the art.[145] There can be, accordingly, no knowledge of art unless the relationship between form and appearance in art has been understood. For Hildebrand, the work of art is perceived as another representation of the representations belonging to general, nonartistic visual literacy. However, for this artistic representation of a nonartistic, ordinary representation to have a cognitive value, the artist must re-create the conditions, the circumstances, that produced that ordinary "perceptual form." While Hildebrand respects the individuality of artistic talent, seeing in it an objective meaning and importance, he does not believe that artists have a unique, direct access to the "actual form" of the world out there. Thus, showing how the "perceptual form" is produced is not a question of tracing origins. Instead, it means varying the conditions and the setting of the "perceptual form" of a given object, gesture, motion. This variation is an enriching function of the work of art. It adds, to use Proust's words, other "worlds" to our own, not fantastic, imaginary worlds but "normal" and "typical" worlds, which are nevertheless quite distinct, not continuous with each other (Hildebrand 1918: 14, 21–4; 1909: 28f.). Only in this immanent sense does a painting transcend the "image of memory" and habitual seeing, and it is more successful in this the more – not the less – "typical" and "normal" it is.

What the beholder sees in a work of art of this kind is the *Fernbild*, the conceptually distant image. It is a "pure, unified, planar image" ("reines, einheitliches Flächenbild") whose representation consists of invitations for the beholder to single out appearances, to "move" into it, to "touch" it, to "take a walk in it," to see it successively; and it allows the beholder, if only for one moment, to grasp it "stereoscopically." The "distant image is never entirely static, but contains characteristics that invite representations of motion."[146] This presumably implies the momentary

ability to see one's *Erinnerungsbilder* and habitual representations at a classical remove: the familiar becomes the distant and vice versa. Depending on the awareness of representation on two levels, one of which is always and already with us, beholding is a production without a product. This is for Hildebrand its critical dimension: to strengthen our sense "of how anything comes about at all."[147]

Hildebrand's *Fernbild*, insofar as it vaguely claims the future rather than the past, differs from Proust's contemplative perspective, which issues in an act of recognition as self-recognition. Moreover, Hildebrand transforms the temporality of viewing into that of form and into the primarily, though not exclusively, spatial concept of the *Fernbild*. With these differences in mind it may be useful to consider briefly the human figures in Vermeer's *View of Delft*. They seem almost to be missing — a few, anonymous, modestly attired figures on either shore of the harbor outside of the city. They almost blend too well into the scene, small as they are and situated somewhere below the viewer.[148] But in an internal, thematic sense they do indeed enhance the "invitation" in Vermeer's painting. For they do not seem to see what we see; they notice nothing unusual about the city, to which those on "our" side of the canal seem to be waiting to be brought by a small ferry, without visible excitement. The breach between the painting's internal inhabitants and its beholder could not be stronger; the latter's sense of the city's desirability, strangeness, and unattainability, and the illusion of being its first viewer could not be more effectively enhanced. One might call this effect ironic, if such a label did not ascribe to the artist a knowable attitude.

In conclusion, it can be stated that while the documentary or informative character of Vermeer's cityscape *View of Delft* may be minimal and inferior to many contemporary prints of the city from the same viewpoint, its historicity is difficult and complex. It is the painting's profoundly metaphorical quality that accounts for its actuality and its temporal openness. The *Fernbild* may offer a conceptual analogue to what the earlier French authors tried to achieve through their oriental comparisons. Observers of Vermeer from Maxime du Camp to Marcel Proust have shown how Lawrence Gowing's statement that "the *View of Delft* presents us with the most memorable image of the remoteness which is the essence of Vermeer's world," may be inverted to read: "The *View of Delft* presents us with the most remote image of the memorable, which is the essence of Vermeer's world."

Part III: Allegory

The Question of Authority in Vermeer's
The Art of Painting and *Allegory of Faith*

Introduction
"The Rat and the Snake"

On Blitzschlag mit Lichtschein auf
Hirsch, *environment, 1958–85 by Joseph Beuys:*
"Das versteh' ich nicht. Wo ist
denn da der Hirsch?"
"E quello!"

<div align="right">

– VISITORS, MUSEUM FÜR MODERNE KUNST,
FRANKFURT AM MAIN, JUNE 25, 1991

</div>

On a sunny day in early June 1991 three people walked up a path, past orchards, villas, and gardens to the ruins of the ancient palace of Tiberius high up on the island of Capri. On their way, they joked about how much this site and its beauty should have helped the Roman emperor to believe in his own power. Having paid the entrance fee and passed through the gate, the visitors paused on a small terrace, from which one caught a glimpse of the turquoise and emerald sea, far below. A little later, they found themselves alone among the ruins of the palace, each silently exploring this place. Near the church erected in later times over the Roman ruins, one of the three discovered a snake winding its way among the twigs and branches of a bush. Moving nearer, they observed that the snake and a rat were chasing each other, first one and then the other retreating, and then returning to renew the attack. The rat appeared the more aggressive, but also the more disadvantaged; no decisive defeat or surrender was imminent. There seemed no natural purpose to this struggle of equal opponents. Each was too small to eat the other, and a mere bush could not possibly count as trespassed territory – or could it? The animals were completely absorbed in their contest, neither of them noticing a human presence. Or did they simply not mind it?

I was impressed by these fighting animals. Their indifference to our presence enhanced my sense of the occurrence as a spectacle meant to be seen, as allegorical, something reminiscent of the animal fables of Aesop, Lafontaine, Lessing, or even

Kafka, making me see before my mind's eye the title in print: "The Rat and the Snake."

Yet as the story was neither known nor knowable, neither was its lesson, nor, consequently, its place in any allegorical entity that it might delimit and illuminate. What surprised me most about this incomplete experience was my sensation of its authority. *Superstition* is the common word to describe this sensation, but it may too easily dismiss the reality of the experience. The enigmatic aspect of the incident clearly stemmed from my perception that it possessed a sign character. But this in itself did not explain sufficiently the notion of authority as such, for did I not have reason to think myself practiced in the art of deciphering visual signs and of analyzing their claim to authority?

"The Rat and the Snake" was not presented in a proper medium of culture, such as a printed story, an engraved image, an emblem, or – one level removed – a picture represented within another, be it in a Dutch genre painting or in a Hogarthian satirical print. Instead, the medium of "The Rat and the Snake" was the rat and the snake, that is, nature itself. The form it took seemed to me borrowed from the visual media of culture. This mixture of natural medium and cultural form, then, must be what sustained my sense of the incident's meaningfulness, a sense one might call mythological or surreal or superstitious. Yet the allegorical character of it might be explained by my own education, and stimulated by the ruined, classical setting, itself a mixture of nature and culture, a historic Mediterranean landscape with ruins and a church.

The explication of my story of the rat and the snake might entail an exploration of place and time, of the allegorical experience as one not happening but sought out; it might include the experience of the *hic et nunc* of a history other and older than one's own personal story, such as Tiberius's refuge, his melancholy, and his subjective inability to leave Capri.[1] In the previous chapters we have seen that, according to Proust, the subjectively overdetermined allegorical image, motif, name (e.g., "Guermantes," or "Vermeer") manifests its truth or falsity over time in the course of a reflected experience by unfolding itself in the affairs of the world, or by failing to do so. The more the references to art and nature merge – the more, for instance, Giotto's Caritas becomes the pregnant kitchenmaid at Combray,[2] or the "medieval" image of death becomes identified with Albertine asleep ("that twisted body, that allegorical figure")[3] – the more this mixture will serve the subject of its experience, Marcel. It is by this means that he will come to understand the workings of society, the relationships and actions of its groups and individual members, whom he observes and analyzes without mercy, as well as his own limitations. It is by thus accepting, albeit hesitantly, what seemed at first a forced association or identification of general concept and individual (Caritas/kitchenmaid, Death/Albertine), that Marcel comes better to understand the world and himself. This can be seen in the episode in which Albertine becomes an allegory of Death:

> It was all a lie, but a lie for which I had not the courage to seek any solution other than my own death. And so I remained...beside that twisted body, that allegorical figure. Allegorising what? My death? My love? Presently I began to hear her regular breathing...that soothing

cure of breath and contemplation (Proust, 1982, III: 367: Proust 1987, III: 862).

Marcel's understanding is primarily contemplative, not critical, not even aesthetic.[4] Nor does the allegorical image, motif, or name as such have the power to stabilize or destabilize his internal and external balance. Rather, both the image and the world to which it applies become established together over time, within his individual consciousness. But the notion of unique allegory, alternatively paradoxical, monstrous, and fragile, is what leaves Marcel on the brink of resignation in the face of it all. Walter Benjamin may have this paradox of unique allegory in mind when he ends his 1929 essay "On the Image of Proust" (published 1934) with the troubling observation that Proust's self-incurred suffering is also a reflection of his "deep complicity with the course of the world and existence," that is, with the almost uncanny immanence of his world.[5]

This characterization of Proust may be seen in the light of Benjamin's own study of allegory and emblematics of 1924–5 (published 1928), *The Origin of German Tragic Drama*.[6] This study is situated in the context of a renewed interest at the time in Renaissance and Baroque iconology, which was in turn part of a general interest in baroque art and architecture, an interest fed by very diverse sources.[7] The neo-Baroque architectural style was widespread across Europe in government buildings of the late nineteenth and early twentieth centuries; such buildings demonstrated the power of the state and thus also represented civil obedience and subordination. This style was a challenge to scholarship on the Baroque. Wölfflin's stylistic term "painterly," applied in his *Principles of Art History* of 1915 to seventeenth- and eighteenth-century art and architecture, was not a neutral art-historical tool. When used in the context of the neo-Baroque decorative style it connoted a "vitalistic fatalism" and a politically ominous drive for unscrupulous self-expression.[8] Thus the Baroque could be associated with an authoritative, codified content, but also with individual emotional expression. What was urgently needed, therefore, was the methodical study of visual topoi, of iconography – then called iconology, in the older (i.e., Cesare Ripa's) sense of the word still used by Aby Warburg – to understand the basis for both claims being made in the name of the Baroque, the claim to individual expression and freedom and the claim to the institutional regulation and even instrumentalization of such freedom.[9]

Aby Warburg, Fritz Saxl, Edgar Wind, Erwin Panofsky are the names associated with such studies, carried out first in the area of Renaissance symbolism and mythology, and then in that of Renaissance and Baroque allegory and emblematics. Since Benjamin focused on Baroque drama and allegory in their own right, rather than as a derivative of Renaissance art and literature, he expressed more directly than others his own suspicions of modern subjective, individual modes of symbolization. While he saw their beginnings in Baroque allegory, he perceived their end in his own time. In his correspondence from the years 1923 and 1924, Benjamin discusses connections between his own interest in allegory and his reservations about Expressionism.[10] These reservations are formulated with reference to H. Cysarz's work *Deutsche Barockdichtung: Renaissance, Barock, Rokoko* (1924), a book he cited often, but that he thought of as expressionistic in its lack of critical consciousness:

It is quite characteristic of the style of the Baroque, that whoever once suspends his rigorous thought during an examination of it immediately becomes addicted to an hysterical aping of its style.[11]

I have already spoken in Part I of this study of the ambiguity of Benjamin's other expressionist source, Hausenstein's *Vom Geist des Barock* (1920). Hausenstein emphasized the sensual and affective aspects of Baroque art, ignoring its conventions (subject matter) and conceptuality (allegory). Benjamin's seven references to Hausenstein's *Vom Geist des Barock* include one to Baroque art as "an art of small distances" and of "abridgement of distances," in both a spatial and an emotional sense. Hausenstein is ambivalent about this aspect of Baroque art. While he calls it "disgusting" and "overpowering," he is also intrigued by it.[12] This lack of distance in Baroque art is the direct opposite of the notion of the *Fernbild* or "distant image" in modern German art criticism and theory, which relates to a reflective neoclassicism as well as to a perceived and thus controlled phenomenal totality in Impressionist painting. It may be the aspect against whose imitation, or aping (*Nachäffung*), Benjamin warns in the above quotation.

These brief allusions to the complexity of the modern critique and reconsideration of Baroque allegory hint at how much art-historical, ideological, and other value judgments of the style inform the scholarship on specific allegorical paintings, be they by Rubens, Rembrandt, Poussin, or Vermeer. Some general observations on the reception of Vermeer's allegorical paintings will demonstrate the problem at hand.

Early in this century, Hofstede de Groot had this to say about them: "His few allegories on the New Testament and on painting are unsuccessful; they are empty and tiresome."[13] "What a remarkably down-to-earth allegory it is!" exclaims Madlyn Kahr in her 1978 account of Vermeer's *The Art of Painting*.[14] Instead of "airborne creatures," Vermeer "employs human figures engaged in a situation so commonplace, in a setting so realistic. . . [t]his is a humanized allegory." In contrast, his *Allegory of Faith* seems "un-Dutch" to her, and she suggests that "Vermeer apparently felt under constraint, which shows in the result. Still, there are some brilliant passages that only he could have painted." Kahr's account exemplifies the way in which most studies of Vermeer treat his two explicitly allegorical paintings, *The Art of Painting* and *Allegory of Faith* (Pls. VII and VIII).[15] Most devote more attention and discussion to the first, many mentioning the second only in passing, and few engaging in any detailed discussion of it at all. For a long time it was customary to compare the two paintings in terms of achievement and failure. If *The Art of Painting* was seen as Dutch, self-conscious and free, ironical, modern, engaging, and observant, *Allegory of Faith* was viewed as Romish, servile and dependent, ridiculous, belated, and an iconographical tour de force. In such juxtapositions, praise was heaped on the female model posing as Clio while the figure of Faith was showered with scorn. In the consciousness of many authors, the two allegorical women compete with one another. But even within that mode of thinking one might ask why, since *The Art of Painting* was painted before *Allegory of Faith*, it went so much farther. John Michael Montias suggests an external reason: "It is quite possible that someone saw the earlier picture in the artist's studio and ordered a Catholic allegory with a similar composition."[16] To oth-

ers who seek in vain an internal connection, the two works, although painted in the same decade, seem to belong to different eras, the one to a modern, if not postmodern, period, the other to a premodern.

Occasionally, both allegorical paintings have been seen as treating a genre not in keeping with the authentic Vermeer, either because they do not agree with a certain view of his modernity or because what is perceived as his ability to create personal symbols is seen as betrayed.[17] In recent years *The Art of Painting* (and in one case even both paintings) has been seen as an antiallegory, a pièce de résistance, as it were, resisting institutional authority in matters of art and religion by somehow manipulating and undermining allegory proper. In such a view, shared – with due allowance for differences – by Daniel Arasse, Harry Berger, Christopher Braider, and Ann Hurley, Vermeer is considered to be ahead of his time in a very specific sense. These authors make Vermeer's paintings engage with a modern idea: the work carries out in its own isolated right an act of a critical self-assertion. This view exploits the fact that Vermeer, unlike Rubens or Poussin, did not lead the life of an artist who negotiated the content and appearance of his paintings with the powerful institutions of state and court, church and academy. I am very skeptical of this notion of Vermeer as a private freethinker, and am puzzled by its unquestioned assumption of the existence of an allegory proper, separate from whatever it may be that Vermeer painted and thought. For it is not at all clear what allegory proper is or was. Kahr, for example, considers it to be a Roman Catholic art form, thereby ignoring the copious use of allegory in emblematics and in Dutch seventeenth-century drama.[18]

Allegory and its authority play an important role in the modern reconsideration and critical redefinition of the art of this period. If Vermeer's two paintings are to be understood as "pieces of resistance," then we must know what it is that they resist. The background to this investigation is the popular and scholarly reputation of allegory at the end of the nineteenth century, followed by its critical reconsideration by German scholars from Winckelmann to Benjamin. Only a critical review of concepts of allegory permits a critical interpretation of Vermeer's two paintings and their reception.

Chapter 9

Theories and Concepts of Allegory

Albert Ilg's *Allegorien und Embleme*

It is instructive to begin with the reputation of allegory on a popular level and in a local context. A certain Karl Weiß reviewed Martin Gerlach's three-volume edition of *Allegorien und Embleme* of 1882–5, introduced by Albert Ilg, for the popular German family magazine *Die Gartenlaube* in the October issue of 1882.[19] There he determined, drawing on the ideas of Ilg, curator and temporary director of the Kunsthistorisches Museum, Vienna, that in allegory "the topic [*Gegenstand*] and image must coincide with one another in such a way that both are simultaneously valid without diminution."[20] In Weiß's view allegory must "cover but not conceal" ("decken, aber nicht verdecken"), and this paradox is resolved by allegory's function "to build the bridge that will connect the fabulous realm of beauty with our modern life, our hopes, and our wishes." Allegory is considered to be a connection between two separate realms, not their representation in a mode of coexistence. Thought of in this way, allegory points to that which presumably separates the realms of fabulous beauty and modern life: the river of time, considered not to run through both but between and past them.

In 1872 Ilg had produced a study of Francesco Colonna's *Hypnerotomachia Poliphili* (Venice, 1499), focusing on the problems of deciphering its hieroglyphs and emblems and the question of their application. He dismissed for the most part the immediate context of their application, the ironical "modern art novel" of Poliphilus's search for love in the dreamland of art, monuments, ruins, and emblematically remembered myth, populated by mythological persons and nymphs.[21] But in *Allegorien und Embleme*, Ilg is interested first of all in the application of allegory and emblems to modern life, using the word "modern" twice in the publication's subtitle. His audience included readers of *Die Gartenlaube*, a publication quite removed from esoteric concerns.[22] Weiß's description of "our artists" as nostalgic for an imaginary past – but not at all skeptical of modern life – is connected to his

notion that allegory and emblem can be either elitist properties of the mind or practical artistic "assets." On the other hand, an uneasiness about "high" and "low" art is noticeable in Ilg's general introduction to *Allegorien und Embleme*, and also in his introductions to the two parts of the text, "Allegories" and "Trade Emblems and Guild Coats of Arms." As all of these works were by German and Austrian "modern artists" such as Franz von Stuck, Gustav Klimt, Max Klinger, and many others now less well-known, Ilg felt the need to justify not only the revival of these art forms but also, given his institutional and scholarly authority, his own support for them. It is particularly in his preface to the second part, that on trade emblems, that such concerns are expressed. Next to allegory, "this great anthropomorphosis of idea and concept," there are topics that art cannot represent "in their entirety" but can only refer or allude to through "symbol, sign, emblem, and heraldic coat of arms, using practical, material representations of the everyday." Significantly, Ilg calls these signs shibboleths, "whose interpretation is left to the wise and knowing" (*den Verständigen*). Rather predictably, he then distances himself from Baroque emblematics:

> There were times whose mystically trifling secretiveness turned art outright into a Sybil to make her speak an enigmatic language of emblematics that borders on the riddle and from which the picture puzzle – the rebus, in fact – originated. This was a period of icons [*Icones*], when it pleased the high gentlemen both to reveal and to conceal their views, principles, and experiences, the mottoes of their houses or their rules of life in a picture language, that is, in symbolically speaking pictographs.[23]

Ilg juxtaposes allegory, the "great anthropomorphosis of idea and concept," with emblematics, the frivolous pastime of "high gentlemen," associating the former with the sublime and the latter with the merely elitist. He poignantly illustrates this comparison with examples that both "reveal and conceal" an elitist class consciousness on the part of these gentlemen emblematists:

> There the thorny thistle speaks: "No one touches me unpunished!"
> there the jewel laments under a cloud that hides the sun from it: "Without her no brilliance," or the turtle preaches patience from under the carriage wheel rolling over it.

Ilg appeals to those readers whose sympathies are not with the educated elite but with "the people," to whose trade emblems he will turn in the next paragraph. He gives the reader to understand that his three examples may once have been enigmatic but are now self-explanatory and distinct, because his readers are neither the historic "high gentlemen" nor "the people," but presumably an enlightened middle class who reads them in terms of oppression and submission. Ilg justifies the modern revival of the emblem by contrasting Baroque emblematics as a pastime of the aristocratic and patrician upper classes with the "emblems of trades, the numberless activities, businesses, and crafts of the people," asserting that "[t]he people dressed *their* wisdom of life preferably and more fortunately in proverbs, instead of sensually perceptible representation." The industrial worker is not included in Ilg's account of "the

people" and of their "practical" and timeless semiotic, which could flourish in 1882 as well as it had in 1500, the sign of the glove referring then as later to the glovemaker and the pretzel to the baker. Referring to the growing importance of the applied arts in Vienna, Munich, and other art centers, Ilg links trade and craft with individual fulfillment. Neither an "archaeological reproduction" nor "dead, barren copying" is the purpose of "modern" trade emblems, but the ability "to create something that is characterized by the valuable imprint of our individuality."[24] The author leaves it to the reader to find this imprint in the "modern" trade emblems that follow.

How does Ilg deal with allegory? Given his work on the *Hypnerotomachia* it is striking that in his discussion of emblems he never mentions the Italian Renaissance. Instead, he dwells on the "decadent" Baroque. A strong distinction between these two periods and their uses of allegory is precisely what enables him to retrieve allegory for the present. In contrast to the trade emblem, allegory is understood to be historical. He therefore emphasizes that "[t]he *Allegories* included in this picture atlas are artistic creations in a thoroughly modern sense" and "prove themselves to be children of our times."[25] He concedes that allegorical art is at times "incomprehensible, vague, farfetched, and lame," an art that, in the face of its inability to represent sensibly what is by definition abstract, has recourse "to the meagre means of information by purely external additions, attributes, symbols – yes, even captions." The reasons for this are historical as well as artistic. Ilg intends to retrieve allegory from the threshold between the symbols of "naive original cultural epochs," which "have nothing to do with allegory," and such decadent times "in the cultural life of nations" when one "wanted to realize everything possible and impossible in the same familiar personifications."[26] According to Ilg this threshold is occupied by the Christian humanistic allegory of the Renaissance: "Until the end of the Renaissance . . . the great masters lent life and truth to dead moral concepts and other abstractions."[27] Ilg's examples are Giotto's Virtues and Vices in the Arena Chapel, Dürer's engraving *Melencolia I*, and Raphael's Theology, Poetry, Jurisprudence, and Philosophy in the Vatican Stanze. These allegories are self-explanatory images by virtue of the "life and truth" lent to them by their creators.[28] Thus, for Ilg, what counts is not the truth of the concept but its formally or rhetorically persuasive representation:

> Giotto's angry man does not just stand for *Wrath*, he *is* full of wrath,
> and the image captures us therefore with the complete power of reality.
> This is the value of allegory in earlier periods of art.

Ilg is careful not to dismiss the Baroque and Rococo. Having derived allegory from an original "naive" cultural authenticity, which he hopes to retrieve sentimentally, he is interested in continuity. He explains that whereas the Renaissance artist imbued his allegorical representations with his own "life and truth" and individuality, the Baroque and Rococo artist imbued them with the energies of the dramatic, colorful, decorative paintings in which the allegorical figures occur. Ilg's definition of modern culture as lacking in faith and principles and as accepting individual pleasure and interest above all else takes up aspects of his definitions of both Renaissance and Baroque allegory. Modern allegory mixes individual life and

expressive creativity with an arbitrarily chosen context of application.[29] What do the allegories included in Ilg's publication look like?

With an eye to the later discussion of Vermeer's allegorical scenes, *The Art of Painting* and *Allegory of Faith*, I have selected for close inspection representations of Time and History from Gerlach's *Allegorien und Embleme* and as well as Ilg's commentary on them. The existence of such a commentary may appear contradictory, after all that Ilg says about good self-explanatory allegory.[30] His justification is that he wishes to accelerate the beholder's understanding of "the intentions of the creative artist, his thoughts, perception, and tendency." In other words, while the art form is general and self-explanatory, its modern motivation and usage are particular, if not obscure. The offer of speedy guidance to his readers may be a polite gesture, yet it also acknowledges a modern audience's impatience and want of the contemplative attitude required for the understanding of allegory. Not coincidentally, the very first allegory reproduced in the book is Anton Seder's *Time* (Fig. 30), an exception to the other allegories, since it does not include an allegorical human figure:

> On a rail car with winged wheels an elaborately decorated hourglass is riding. Here the artist very thoughtfully combines elements from the world of ideas of the past and present; uniting the hourglass of the Middle Ages with the symbol of the modern steam engine – the one corresponding to the quiet, quaint nature of the old ways, the other to the hasty bustle of modern times, but both equally subject to the mightiest of gods, Saturn, who has chosen this strange vehicle for his triumphal car; both bear the escutcheon of eternity toward which – in silent trickling as much as in frantic pace – they hasten.[31]

Ilg's allegorical reading of Seder's image takes Saturn to be its agent and eternity to be the essence of *Time*. But Saturn is hardly meant to have control over *Time*'s components. He is really only part of the hour glass's elaborate decoration, a historicized, tiny, crafted figurine, clearly being carried off by the rail car of Time. Not eternity but a sense of fatalism dominates Seder's image.

Superficially viewed, the other allegories make little effort to be modern; but upon closer inspection one might say that they cannot help being modern. Of Franz von Stuck's *History* (Fig. 31), Ilg writes: "With a searching gaze History strides forward, holding pen and writing pad."[32] This gaze and gait are indeed the most striking features of Stuck's History. But why does she have to search for topics to write about? Are there not plenty? Her gaze reaches far beyond the powers personified at her feet, with whom, according to Ilg, she has to reckon and whom he identifies as "the demon of destruction" and "the genius of creative progress," the former rather old and weak and the latter young and Cupidlike. History has something of the tragic Cassandra about her, of an exceptional individual on whose shoulders weighs the burden of her knowledge of historical events yet to come. Stuck was primarily interested in such exemplary individuals. He named his depictions of single female figures *History* or *Sin*, for example, rather than *Cassandra* or *Eve*.[33] In Stuck's *History* it is the future that counts, not the past, and this view is supported by the contrasting figures at her feet.[34]

30. Anton Seder, *Time*, c. 1882–5, print after pen and ink drawing, 29.5 x 22 cm, from Martin Gerlach, ed., *Allegorien und Embleme*, Bryn Mawr College, Pennsylvania.

The very awkwardness of Gerlach and Ilg's publication makes it an instructive introduction to other, more thorough accounts of allegory and emblem. In these, however, the same difficulty is encountered of distinguishing mere objects from metaphors and symbols, and individual characters from allegorical figures within a single representation. This difficulty is discussed in Albrecht Schöne's emblem theory and its book-length critique by Peter Daly as one of the key problems in distinguishing emblem proper, its "allegorical variant," and allegory proper. At stake in these distinctions is the determination of just how the authority of each of these types of sign is derived.[35] The ambiguity of interwoven levels of representation destabilizes clear distinctions, producing *wahrhaffte Lügen*, or true lies, according to Georg Rollenhagen in 1603. In anticipation of a later discussion I should like to

31. Franz von Stuck, *History*, c. 1882–5, print after pen and ink drawing, 28 x 16.5 cm, from Martin Gerlach, ed., *Allegorien und Embleme*, Bryn Mawr College, Pennsylvania.

point out that Rubens masterfully used this ambiguity surrounding authoritative representation in his Medici cycle.[36]

Benjamin

Regardless of their differing appearance and composition, Gerlach's "modern" *Allegorien und Embleme* and Ilg's readings of it share the desire to retrieve the past as something pertinent to modern life by means of a simple, nondialectical continuity. In contrast, the discussion of allegory within the framework of Walter Benjamin's "rigorous art criticism" (*strenge Kunstwissenschaft*), a term he borrowed from the title of an article by Hans Sedlmayr,[37] was inevitably a critique of modernity, as Benjamin states: "Riegl proves in an exemplary way that at once sober and courageous research never misses the vital interests of its present."[38]

Such confidence may seem astonishing at first, given the year of Benjamin's review article, 1932, and the skepticism toward historicism already voiced in *The Origin of German Tragic Drama* in 1925. Yet Benjamin, in his *Origin*, embraced this rigorous approach when he distinguished contemporary Expressionism from Baroque art so as to understand their relationship better.[39]

By the time Benjamin's *The Origin of German Tragic Drama* was published, scholarly revision of Renaissance and Baroque iconology was well under way. With respect to allegory one focus of his scholarship was Dürer's engraving *Melencolia I*. Benjamin took advantage of Karl Giehlow's articles of 1903–4 and Panofsky and Saxl's study of 1923.[40] He placed his own discussion of the engraving, which dates so much earlier than his primary literary sources, at the center of his book.[41] In the introduction he generally criticizes the scholarship on Baroque literature as flawed by "indifference to intellectual rigor," anticipating his own later demand for a "rigorous study of art" in 1932. His own study proceeds "[b]y approaching the subject from some distance and, initially, foregoing any view of the whole."[42]

Benjamin's theoretical discussion of allegory reckons with two issues that were only negatively implied in Ilg's exposition of Baroque allegory and emblematics. These are the question of authority in allegory and of that authority's immanent temporality and historicity, both in the context of its original appearance and in its later criticism. From the vantage point of Benjamin's book, one gap in Ilg's account stands out: because all his attention is focused on progress, Ilg never mentions one of the largest themes of Baroque allegory, the *Vanitas* theme. So when commenting on Seder's *Time*, he considers Saturn complicit with progress rather than destruction. In contrast Benjamin's general topic is tragedy and failure, not progress, and this leads him to focus on authority and temporality in the context of vanity and melancholy, decadence and violence.

Benjamin's theoretical discussion of allegory takes as its point of departure German Romanticism and its theories of symbol and allegory, and the differences between the two:

> Within the decisive category of time, the introduction of which into this field of semiotics was the great romantic achievment of these thinkers [Joseph von Görres and Friedrich Creuzer], it is possible to define the relationship between allegory and symbol. Whereas in the symbol, with the transfiguration of decline, the transfigured face reveals itself fleetingly in the light of salvation, in allegory the observer is confronted with the *facies hippocratica* of history as a petrified, primordial landscape. History . . . imprints itself in a countenance, no, in a death's head.

According to Benjamin, symbol transforms time and decline into the history of salvation, whereas allegory contemplates the profane sufferings of world history; symbolic revelation is bound to a subjection to God, allegorical contemplation to a subjection to nature. Their relation in time means that allegory raises questions about "the essential nature of human existence as well as the biographical historicity of the individual."[43] It is on the threshold between symbol and allegory, between salvation history and world or natural history, that Benjamin, not unlike Ilg before him, locates Dürer's *Melencolia I*. The print's threshold position may also be deduced

from his observation that in Baroque allegorical prints fragmentation abounds, the allegorical person retreats and the "emblems" – here meaning attributes and objects "stripped naked" – "mostly offer themselves to view in desolate, sorrowful dispersal."[44] Benjamin does not consider allegory a decadent form of symbol; instead, the transition from the one to the other is marked by an opposition. He insists that "the primacy of the thing over the personal, the fragment over the total, represents a confrontation between the allegory and the symbol, to which it is the polar opposite and, for that very reason, its equal in power."[45] By Benjamin's reasoning, if symbol and allegory are related to opposite temporal concepts (salvation history and natural history), their critique must be philosophical rather than historical, for a historical critique could only grasp and extend allegory, not criticize it, and would be flawed by inevitable empathetic involvement.

It is in this context that we may read another, often-quoted passage, in which Benjamin takes up the historicity of allegory; more specifically, the dialectic of the enduring character of its ruinous appearance, which he thinks makes possible its criticism in the first place:

> [C]riticism is implied with rare clarity in the fact of their [allegories'] continued endurance. From the very beginning they are set up for that critical dissolution [*Zersetzung*] effected in them by the course of time. . . . What remains is the strange detail of allegorical references: an object of knowledge nesting in these consciously constructed ruins. Critique means mortification of the works. The nature of these [works] more than any other production accommodates this. Mortification of the works: thus not – romantically – the awakening of consciousness in the living [works], but settlement of knowledge in those dead ones.[46]

The image of knowledge nesting like birds in the ruin of allegory – not by chance, but because this place was so prepared for them – reflects Benjamin's notion of allegorical decay as natural history.[47] The image may seem peaceful, if melancholy, yet it points to the essential forlornness and negativity of allegory, as Benjamin sees it. What does this critical settlement of knowledge, the exposure of its extraneous origin, have to do with mortification? Benjamin answers this question with the inevitability of the subjectivity of the settler whose knowledge is "only knowledge of evil":

> Evil as such, which allegory nurtured in its enduring profundity, exists only within it, is nothing other than allegory, means something different from what it is. It means precisely the non-existence of what it presents. The absolute vices, as represented by tyrants and intriguers, are allegories. They are not real and they possess their identity only within the subjective gaze of melancholy. . . . They point toward the truly subjective pensiveness to which alone they owe their existence. By its allegorical form evil as such betrays itself as a subjective phenomenon.[48]

Benjamin goes on to distinguish between this "primary" knowledge of evil and the "secondary" knowledge of good, the first resulting from contemplation, the sec-

ond from practice, neither of them factual and both subjective.⁴⁹ This distinction implies that the only practice the allegorist is capable of is that of contemplative exposure. For Benjamin only philosophical critique may result in primary "knowledge of good," in something beyond mortification. Benjamin's engagement here with the philosophy of language and later with historical materialism may be seen as a continued engagement with the ethics of criticism. He himself acknowledged the immanent method of fragmentation and mortification in *The Origin of German Tragic Drama*, rightly insisting, however, on its dialectics.⁵⁰

Winckelmann, Benjamin

Benjamin's early theory of the essential negativity of allegory and of history may be extreme, yet it has its precedent in Winckelmann and Hegel's theories of the inauthenticity of allegory. Each understood something different by this inauthenticity and neither related it to tragedy. If Benjamin saw the retreat of the allegorical person from the wasteland of attributes and objects as inevitable, Winckelmann certainly did not. In his *Versuch einer Allegorie* of 1766 he aims at a "revitalization [Wiederbelebung] of classical allegory." To this end he demands a symbolic totality of allegory, as expressed in the humanistic privileging of the human image, thus inspiring Ilg's "great anthropomorphosis" of allegory in 1882. In the first chapter, "Von der Allegorie überhaupt," Winckelmann conceived of "the most perfect allegory of one or several concepts in a single figure," who guards the image's "Einfalt," its simplicity, its literally "one-folded" signification:

> Each allegorical sign and image must contain within itself the distinguishing characteristics of the significant object, and the simpler it is, the more intelligible it becomes, just as a simple magnifying glass represents the objects more clearly than a composite one.⁵¹

The metaphor of instruments of visual aid implies the transparency of allegorical configuration, an idea also encountered in other writings on allegory. The metaphor is used here to express the relationship between the ideally simple appearance of the visual sign and the far from simple concept it represents. Winckelmann continues: "Therefore, allegory must be self-explanatory and must require no caption; this distinctness [*Deutlichkeit*], however, is to be understood negatively."⁵²

Through the modification of his claim, that allegory must distinctly represent what is absent from it, that which it is not but only refers to, Winckelmann exposes "perfect allegory" to indirectness and inauthenticity and, if taken to the extreme, to Benjamin's essential negativity of allegory.

Before Winckelmann makes this modification to his definition, he provides a historical survey of allegory and "picture language" (*Bildersprache*). This history evolves from nature and natural signs through Egyptian hieroglyphics, Greek mythology and its Roman adaptation, representations of ethical and religious concepts in antiquity and, later on, representation of Christian virtues and vices, and ends in Cesare Ripa's *Iconologia*. Under the rubric of new or modern allegory Winckelmann considers Ripa's work and influence on the Roman Counter Refor-

32. Guido Reni, *The Penitent Magdalene*, c. 1633, oil on canvas, 231 x 152 cm, Galleria Nazionale d'Arte Antica, Palazzo Barberini, Rome.

mation and Baroque allegory to have brought about the dark ages of art ("Finsternis der Kunst"].[53]

Classical allegory will be revitalized using a new iconology, comprising three categories: first, the new use and understanding of ancient allegories; second, new allegories inspired by the wisdom, customs, and proverbs of antiquity; and, third, allegory presenting exemplary individuals from ancient history, meaning both "heroic" and "true" history. Despite Winckelmann's general contempt for nonclassical allegory and for the allegorization of virtue and vice as such (which he sees as impossible, because they are states without specific intention),[54] he does not completely rule out Christian allegory. This may be inferred from the example he chooses when finally returning to the subject of the relative distinctness of simple, perfect, and (in this sense) "classical" allegory:

> One cannot expect that a painting be intelligible at the first glance to an entirely uneducated person. Yet an allegorical image will be clear, if it bears a near relation to the representation, as are the pair of white turnips that Guido Reni gives to his penitent Magdalene in the Barberini Palace in order to signify her ascetic life.[55]

This example of applied allegory omits the allegorical person, the figure personifying the concept of asceticism, the Magdalene's *strenges Leben* (Fig. 32).[56] This

157

omission is possible because of the context of application, the story of the repentant Magdalene, who herself takes the place of the allegorical person. This context is both self-explanatory and commonly known, or so Winckelmann assumes, as an allegorical type that gives meaning to the attribute of white turnips. Their close relation (*nahe Beziehung*) to the saint's story in turn aids the relative distinctness of this allegory. Winckelmann would probably concede that Reni interpreted the penitent Magdalene as an allegory of asceticism, as this is also the case in Winckelmann's third category of allegories, those derived from ancient history. His surmise about Reni's procedure – that it is based not on identity but on a "close relationship" – concerns the distinction between the mere rhetorical clarity of an allegory and the validity of the concept it represents – in this case asceticism.

The difference between the two is addressed more clearly and critically by Hegel, to whom we shall shortly return. What conclusions did Winckelmann himself draw from his observations on the relative distinctness of allegory? He concluded that by itself allegory lacks completeness and is inauthentic because it derives its authentication from the context of its application and derivation. He argues that in the Renaissance allegory played the role of an auxiliary art form, before the "dark ages" of the Counter Reformation gave it greater importance.

His example of the Reni shows that Winckelmann's notion of an acceptable allegory is not entirely secular. An item like the white turnip is meaningful not because it is a natural, self-evident sign, but because of the authoritative narrative context in which it occurs. An allegory of asceticism by itself, represented, for example, as an allegorical person holding a turnip, would require a caption, and it is such captioning, such authoritative naming, to which Winckelmann primarily objects. For him captioning is barely acceptable in a handbook, such as an *Iconologia*, and never in painting or sculpture. A representation requiring a caption is not classical, not autonomous; in its captioned incompleteness it is ridiculous. Here Winckelmann's argument overlaps with Benjamin's critique of the subjectivity of allegory: captions are at the mercy of the subject who provides them; they are without binding authority. In the first part of *Origin*, Benjamin links this claim to power, a self-assertion without real intentions and decisiveness, with the fictional characters of the tyrant, the martyr, and the intriguer of Baroque tragedy, and later to the melancholic contemplative critic of allegory, himself an allegorist. Thus, in his view, both allegory as a method of art and allegory as a method of interpretation suffer from an overreliance on this hollow power.

Mentioned only in passing, Winckelmann's example for such an empty claim is the tomb of Sixtus IV in St. Peter's, which shows a Diana with the caption THEOLOGIA, something he finds ridiculous. This example refers here to Antonio Pollaiuolo's bronze sculpture of the *gisant*, Sixtus IV surrounded by reliefs showing personifications of the cardinal virtues and the liberal arts, including Theology, represented as a reclining nude with bow and arrows. Modern art critics have confirmed Winckelmann's iconographic identification of Theology as Diana, finding this highly interesting, rather than ridiculous.[57] Winckelmann's example of Reni shows that while he wants to sever his "revitalized" classical allegory from the tradition of Christian allegorical exegesis and thinks it possible to do so, he is prepared to include Christian subjects in his project. His impatience with Pollaiuolo's Diana/Theology perhaps

betrays a puzzlement over his project's difficulty as a difficulty of his own historical position. It is not really clear whether it is primarily the mislabeling of Diana or the violation of Christian decorum that exasperates him.

Perhaps the most famous example of Winckelmann's own practice of classical allegory occurs in his *Reflections on the Imitation of Greek Works in Painting and Sculpture* of 1755, when, in the course of interpreting the *Laocoön* group, he allegorizes it using the following analogy: "Just as the depth of the sea always remains calm however much the surface may rage, so does the expression of the figures of the Greeks reveal a great and composed soul even in the midst of passion." Using nature here as if it were a biblical type and the sculpture its antitype, Winckelmann's allegorical practice successfully relies on the notion of the self evident, natural sign.[58]

Hegel, Winckelmann, Benjamin

What is gained from a clear distinction between levels of allegorical representation can be seen in Hegel's *Aesthetics*, specifically the chapter entitled "Conscious Symbolism of the Comparative Art Form."[59] Hegel, who considers Winckelmann's account muddled, distinguishes between conscious symbols that begin with the comparison (fable, parable, metamorphosis) and conscious symbols that begin with the concept and meaning (riddle, allegory, metaphor). Conscious symbolism (as opposed to unconscious or sublime symbolism, which he treated in previous chapters) is defined as follows:

> By conscious symbolism, I mean, we are to understand that the meaning is not only explicitly known but is *expressly* posited as different from the external way in which it is represented (H. vol. 13: 486; K.: 378).

The relationship between such finite meaning (*Bedeutung*) and its form (*Gestalt*) is "a more or less accidental concatenation produced by the *subjective activity* of the poet, by the immersion of his spirit in an external existent, by his wit and his invention in general," regardless of whether he sets out from meaning or from form (H. vol. 13: 487; K.: 378). According to Hegel, the riddle has essentially nothing to do with enigma, and none of the comparative art forms has anything to do with myth and religion. This insight radically separates Hegel's account from Winckelmann's. A conscious symbol is not a "true symbol" (*eigentliches Symbol*).[60]

The "true" symbol is characterized by the original inadequacy between its infinite meaning, God, and that meaning's appearance in the form of an object or image. The conscious symbol, however, by virtue of its finite, determined components, is characterized by a calculated adequacy which strategically borrows the appearance of inadequacy from the symbol proper. The conscious symbol, by being expressly a mere representation, appears endowed with the authority of the absolute ("das Absolute, der eine Herr"), that is, with the authority of unconscious symbols. But it is not, since it originates from subjectivity and arbitrariness (H. vol. 13: 488; K.: 379).

That this model applies to riddles, fables, and parables may be grasped more easily if one thinks of it with reference to specific authors. But how it applies to allegory

and metaphor is a more difficult question. Allegory belongs to the second type of conscious, comparative symbol, that which departs from meaning and idea, rather than from form. Hegel notes: "This mode of representation cannot for the most part amount to independent works of art and must therefore content itself with annexing its forms, as purely incidental, to other artistic productions" (H. vol. 13: 490; K.: 381).

In allegory, form is subject to meaning and thus results from a subjective choice among forms and images; at the same time, it is not autonomous. And yet, subjectivity and arbitrariness are not synomymous in Hegel's account. Allegory tries

> to bring the specific qualities of a universal idea nearer to our vision through cognate qualities of sensuously concrete objects . . . [with the] aim of producing the most complete clarity, so that the external thing of which the allegory avails itself must be as transparent as possible for the meaning which is to appear in it (H. vol. 13: 511; K.: 511f.).

The subjection of form to content is understood as a transparency, a trope used also by other writers on allegory, although nowhere quite as clearly related to a notion of dependence and service. For example, when Winckelmann used the ocean as a type for Greek sculpture, he suggested the inseparability of outward appearance and inner substance, or essence, even as the two seem to contradict one another (*Laocoön*'s external emotion, internal calm). Not until Nietzsche's *Birth of Tragedy* was this relationship in Winckelmannian classicism understood as dialectical. When Hegel uses the image of transparency, he suggests, like Winckelmann, a continuity rather than an antithetical relationship between surface and substance, appearance and essence. To this extent, he is a classicist; this, however, changes when he speaks of the allegorical person.

The main function of allegory is the personification of abstract concepts from human and natural life, such as Justice, Fame, and Winter, but the allegorical person is conceived "as a *subject*." Here Hegel takes up his previous general statement on conscious symbols, that they borrow the forms of absolute authority and origin but essentially lack these things. Transferred to allegory, this means that the allegorical person only borrows its seeming identity as a subject, but "this subjectivity in neither its content nor its external shape is truly in itself a subject or *individual*." In essence, the allegorical person remains an abstract, general idea that borrows "the *empty* form of subjectivity . . . in a grammatical sense." Therefore, Hegel concludes, allegories can never be as specific as Greek gods, Christian saints, or "some other actual person": "It is therefore rightly said of allegory that it is frosty and cold" (H. vol. 13: 511f.; K.: 399).[61] This cold barrenness consists of a number of components: first, a borrowed, grammatical subjectivity; second, an emphasized separation of subject and predicate, general and specific; and, third, the relation of objects to this subject through *attribution*, rather than practice.

Here it may be useful to pause and compare Benjamin's understanding of allegory with Hegel's at the point where they come closest to one another: in their assertion of its emptiness. Benjamin begins his long passage on the evil in allegory and in subjectivity with the following citation from Sigmund von Birken's *Die friederfreute Teutonie*: "Weeping we scattered the seeds on the fallow ground / and left

mournfully [Mit Weinen streuten wir den Samen in die Brachen / und giengen traurig aus].” This he later paraphrases as “Allegory leaves empty-handed [Leer aus geht die Allegorie].”[62] In keeping with his notion of allegory’s melancholy negativity, Benjamin reads “mournful” (*traurig*) as “empty.” But it is here that Benjamin also fundamentally differs from Hegel, for his assertion of the essential negativity of allegory is existential, whereas Hegel’s definition of the emptiness of allegory is formal and functional. For Benjamin, mourning as emptiness is related to the melancholic’s purely negative knowledge of truth through allegory. In contrast, in Hegel’s *Aesthetics*, the formal definition of allegory and its emptiness precedes any consideration of the interpretation of specific allegorical works. Accordingly, this emptiness is not the tragic failure of allegory’s subjectivity, but simply functional, a condition for allegory’s formal borrowing of subjectivity.[63]

To understand this functional emptiness it is necessary to look closely at Hegel’s initial exposition of different kinds of allegory in the chapter on conscious, comparative symbolism and also at his account of the history of painting in the *Aesthetics*. The latter we have already done in Part I of this study, where I presented an exposition of Hegel’s only detailed discussion of seventeenth-century painting, that on Dutch art. He considers Dutch painting historical, secular, particular, anything but allegorical, but rather as altogether subjective and self-conscious in the best sense: conscious of its own freedom, as well as its limitations. The “grammatical subject” of allegory, on the other hand, neither determines nor realizes itself. Here Hegel and Winckelmann are the farthest apart.

Among the figures that Hegel does count as allegorical are the Christian virtues: Faith, Hope, and Charity. Here Hegel’s formal definition, that allegory essentially lacks divine authority, yet pretends to possess it, is crucial. Unlike Mary and Christ, symbols of absolute truth, Faith, Hope, and Charity only assert the universality of Christian truth, which they already presuppose as something known and familiar. The assertion of Catholicism is served “in the easiest and most appropriate way” by allegory, because allegory has the mere form of divine authority but essentially lacks it (H. vol. 13: 515; K.: 402). Crudely stated, Hegel considers the allegories of the Christian virtues to be secular and principally institutional instruments of power. Where Benjamin sees an infinite abyss of subjectivity, Hegel sees subjectivity manipulating and imposing its own contents and forms. Much more clearly than Winckelmann, he sees that allegory’s power is also its weakness, and vice versa. Because it is not autonomous and essentially true, it can be instrumentalized, and this instrumentalization is itself open to critique.

Hegel, it will be remembered, states in his analysis of the Dutch school of painting that the absolutely authoritative center is absent from it. Insofar as he considers allegory complementary to an infinite romantic subjectivity and *not* to classical autonomy, he considers its primary epoch the Middle Ages, in his sense romantic. Interestingly, his preferred historical example is Dante’s *Divine Comedy*. In contrast to Winckelmann’s dismay over Pollaiuolo’s Diana/Theology, Hegel praises what he sees as Dante’s arbitrary, subjective invention of the double identity of Beatrice/Theology. Through this invention Theology comes alive, for it now has a borrowed, yet at the same time real subjectivity. Dante’s general discourse becomes a chivalric adventure, motivated by the “inner subjective religion of his heart” (H. vol. 13: 515f.;

K.: 402). In this romantic closing of the section on allegory, Hegel moves allegory into a modern consciousness seen, for example, in Proust's paradoxical concept of "private allegory." But this ending should not distract us from allegory's other aspect, its identity as an instrument. Hegel emphasizes allegory's clarity and transparency, yet however true this may be as a formal definition, it is not so obviously true for concrete allegorical practice. A reader or beholder, in attending to a given allegorical representation, may lose sight of the fact that in it topic and representation are two finite entities subjectively chosen and connected with each other and that its authority is therefore subjective, rather than the absolute authority it appears to be. This fact exposes allegory to critique and contradiction.

How did the critical potential that Hegel discovered in allegory play out in earlier times, for example, in the seventeenth century? Andreas Haus has suggested that the analysis of the passions by Descartes and their representational control through *pathos formulae*, as taught by the French art academy, be seen as an attempt to rationalize the opacity of symbolism.[64] Should we consider this with regard to allegory as well? This question takes us back to Braider, Hurley, and Berger's proposals, mentioned in the introduction to this discussion of concepts of allegory, that Vermeer's allegorical paintings are "antiallegories," *pièces de résistance*. I suggest that these works manifest an engagement with possible positions *within*, rather than *against*, the concept and practice of allegory.

Ripa, Burckhardt, Benjamin

What links exist between Benjamin, Hegel, and Winckelmann's thoughts on allegory, on the one hand, and the ways in which Ripa and his translator, Dirck Pietersz. Pers, present the *Iconologia*, on the other? To answer this question I call upon Jacob Burckhardt as mediator.

Benjamin criticized a proposed affinity between Baroque and Expressionist art, as deceptively style- and surface-related, but he did not reject the idea of constructing a relationship between the modern critic and the Baroque past. In his view, the critic's modern attraction to the Baroque is an inescapable given, requiring critical examination. But wherein lies the true affinity between the modern critic and his Baroque subject? Perhaps it should be sought in structure, rather than appearance, as Richard Shiff argues in his recent essay, "Handling Shock: On the Representation of Experience in Walter Benjamin's Analogies." Shiff suggests a link between Benjamin's profuse use of analogies in *The Origin of German Tragic Drama* and the function of Baroque allegory investigated in it: "[A]nalogy and allegory convert one thought into another." To illustrate this function, Shiff points to the key example of what he calls Benjamin's "four-term analogies": "Allegories are, in the realm of thoughts, what ruins are in the realm of things."[65] But ironically, by its very content this particular analogy cannot function as a conversion, at least not within Benjamin's account of allegory. In this example, one thought is not converted or convertible into another, because of Benjamin's "modern" (critical, melancholic) distinction elsewhere in the text between the realm of thoughts and the realm of things. Only if both are considered equal does an analogy allow for such a conversion. Shiff's suggestion that a structural parallel exists between allegory and analogy

in Benjamin's book leads to an ironic insight: Benjamin's own rhetoric (analogy), in itself a powerful parallel to the structure of Baroque allegory, underscores the modernity of his concept of allegory. As in the above phrase cited by Shiff, the oppositional and dialectical relationship between thoughts and things in Benjamin's study of Baroque tragedy widens into a breach for which we must account.[66] With regard to allegorical imagery, this change implies a split between conceptual and optical seeing in Benjamin's own time.[67]

The development toward this split was first addressed by Jacob Burckhardt, in his lecture "Die Allegorie in den Künsten," of 1887. His historical account of allegory in the arts takes him up to his own day, to the kinds of allegories published in Gerlach's *Allegorien und Embleme* in the 1880s and their use in the decoration of public buildings, such as stock exchanges, banks, and city halls. Burckhardt found such a use conceptually ludicrous, albeit visually decorative, impressive, and intriguing.

In his first paragraph, Burckhardt defines allegory proper as a figure personifying a concept, or "Abstractum."[68] He argues that twice in the history of allegory such figures were endowed with a subjective consciousness that allowed them to struggle with their assigned roles as with a kind of fate. These two moments in history are classical antiquity and the Baroque. Burckhardt cites the figure of Madness in Euripides' *Heracles* and Rubens's *Allegory of the Thirty Years War* in the Pitti Palace as key examples.[69] They are distinguished by differing degrees and functions of independent, struggling consciousness. About Rubens's allegories he writes: "Usually motivation and decision are shifted [*verlegt*] to an allegorical figure." He repeats this observation in his posthumously published *Erinnerungen aus Rubens* (1898), first in the section on allegory in general and then in his discussion of the Medici Cycle, explaining that, for instance, Gallia, Amor and Hymen prompt Henry IV to marry Marie de' Medici in *The Presentation of the Portrait* (Fig. 33).[70] In contrast to historical figures such as Henry IV, allegorical figures possess, in the purity and limitation of their role, a heightened consciousness of its intent and effect. Of Euripides' Madness Burckhardt observes that she is able "to abstract entirely from the task of her role and to express a consciousness separated from it," before finally succumbing to that task.

Burckhardt modifies Hegel's insight that allegory borrows the subjectivity and authority it lacks. He considers allegory's subjectivity to be authentic, yet sees the function of a personification as a task, a responsibility, a burden, even prescribed by fate, and not merely a form or guise. Burckhardt thus changes what Hegel considered an institutional authority (e.g., the Catholic church) into an ambiguous individual authority, motivated and determined from both within and without. Given this historical conception of allegory, he finds little of interest in Giotto's allegories, which in his view lack such consciousness and function entirely in the service of theology.[71] While maintaining a notion of allegory as instrument, he locates not only an apparent, but a real agency within the allegorical person itself. By defining allegory and concept as identical and self-reflective, he is able to endow allegory with a relative autonomy.

Burckhardt's definition of allegory is comparable to Cesare Ripa's understanding of the *imagini* of his *Iconologia*. But the tension emphasized by Burckhardt between the individual, allegorical subject and its object, caused by its function as a

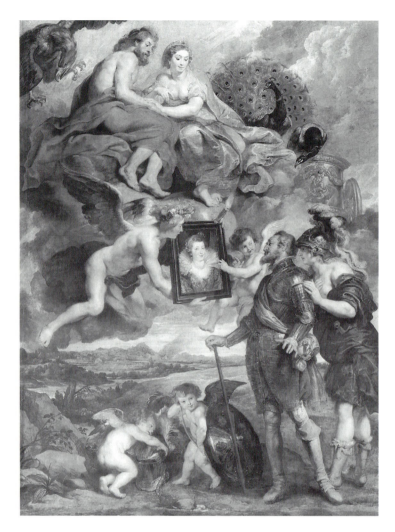

33. Peter Paul Rubens, *The Presentation of the Portrait*, from *The Life of Marie de' Medici*, 1622–5, oil on canvas, 394 x 295 cm, Musée du Louvre, Paris.

task, or as burden, is discernible neither in Ripa's *Iconologia* of 1603 nor in its later editions and translations. The absence of such a tension in Ripa's handbook and its presence in Burckhardt's interpretation of Baroque allegorical art suggests an important transformational process not anticipated by Ripa. This process appears to be at work in the representation of time in some seventeenth-century allegorical paintings. If we remember that Proust unfolds and validates his allegories in experiential and mnemonic time, then the unproblematic simultaneity of attributes and references in the *imagini* of Cesare Ripa's *Iconologia* may strike us as an indication of their assumed atemporality.

Ripa understood these *imagini* to function as visual definitions, not narrative representations. In his introduction to the *Iconologia*, he speaks of allegory as operating by an analogy that he calls "proportional analogy."[72] What he calls a three-term analogy is in Shiff's sense a four-term analogy. Two of the four terms together,

however, function as the "third" term, as the hinge that makes all of them part of one world, the world wherein the analogy is valid, where thoughts and things belong in the same way. The *imago* of Fortitude functions in this way: "As the column bears the whole edifice, so Fortitude can bear all afflictions of the heart."[73] Column and fortitude are seen together as the "third" term or hinge, thus functioning in a way lost for Benjamin, for whom the "whole edifice" is in ruins.

But Ripa himself considered analogy the weakest form of allegory, inferior to allegories structured by more complex rules of relationship. Derived from Aristotle's exposition of a definition's structure in his *Rhetoric*, Ripa's structure of the *imago* ascribes to the allegorical figure the evolution of a concept from the material of attributes, gestures, and countenance to full effectiveness. In this concept of the *imago*, Ripa locates agency in the allegorical figure. For Ripa, however, allegory's agency is limited to self-structuring (just as the agency of a definition is); the probing of the *imago*'s intended effectiveness, or truth, lies outside of its scope.

Mandowsky and, following her, Becker, assert that in practice Ripa's entries in the *Iconologia* are often not in keeping with his ambitious notion of the *imago*. Becker takes the main distinction in Ripa's introduction to be that between allegory as proportional analogy and allegory as exemplary history, both mythological and biblical. In either case it may be argued that Ripa's understanding of an *imago*'s regulated structure is an attempt to reconstruct for his own age what he sees at work in those exemplary ancient gods and heroes, who evolve a certain concept by their own authority. His material for this task is the largest group of concepts included in the Iconologia, namely virtues and vices. In other words, when an allegorical figure refers to a story through an attribute, it imitates myth, while also being reasonable and graspable. In a sense rather different from Benjamin's association of allegory and historical critique, Ripa's *imagini* of the *Iconologia* rationalize symbolism, not in order to leave it mournfully behind but in order to improve the arts through its inclusion. This inclusion is, like Winckelmann's later *Versuch*, a purposeful retrieval of ancient mythology.[74] It has been argued that in Ripa's *Iconologia* an allegorical figure is never herself an example of the concept she represents, that she lacks agency.[75] But as we have seen, the *imago* is capable of instigating a redefinition of the represented concept by its beholder.

At the beginning of this chapter I myself so criticized "modern allegories" (e.g., History as a journalistic Cassandra). As Burckhardt has shown, such allegories miss or mock – *vide* his example of the decorated stock exchange – the reference to an authority outside of the allegorical agency in the image. It is the authority of fate or history that makes Madness in Euripides and Love/Venus and War/Mars in Rubens accept the "task of their role," in spite of their initial resistance. Burckhardt's distinction between authority, "Pflicht der Rolle," and conscious agency manifests itself less perceptibly when such resistance is missing. In Rubens's *Presentation of the Portrait* (Fig. 33), we do not question whether Gallia is herself a French patriot, or is struggling with her role. Apparently, she simply inspires Henry IV to marry Marie de' Medici for the good of his country. Just how this version of the event fits Marie de' Medici's preferred story of her life – the kind of critical question Hegel's account of allegory encourages us to ask – is to be answered separately for Burckhardt.

In Burckhardt's allegory, as in Ripa's *imagini*, the nature of the figure is not human, but mythological. And yet, as Burckhardt demonstrates in setting the muses

apart from allegory proper, while the allegorical figure is a mythological *and* a rational, self-conscious being, not all mythological figures are allegorical in this specific sense. Ripa differentiated here as well: mythological and biblical narrative is mainly present as a reference and attribute in the *imago*, in keeping with its purpose of rationalizing symbolism. Such is the case of Ripa's concept of Faith and her reference, Abraham's sacrifice (as we shall see in Vermeer's *Allegory of Faith*). Rarely is the mythological figure him- or herself the subject of an *imago*. When he or she is, one may speculate, then such a rationalization is not desired. Such is the case of the Muses, and this may have consequences for Vermeer's *The Art of Painting*.

Chapter 10

Vermeer's *The Art of Painting*

Vermeer's *The Art of Painting* (Pl. VII) is a subtly complicated painting. Its iconography of a painter depicting a female model posing as Clio, the Muse of history, is straightforward. And yet this painting, more than any other work by Vermeer, has challenged its viewers to propose ever new interpretations.[76] Seemingly programmatic, in the eyes of many critics, and in this respect comparable to Courbet's *The Studio of the Painter (Real Allegory)* (1854–5), *The Art of Painting* may be seen to present us not only with Vermeer's convictions about art and, in this sense, with a self-portrait, but also with the critical positions from which such interpretations can be proposed. One thing these interpretations have in common is their reflection on the purposes of art-historical criticism. But rather than give a full account of the painting's critical fortunes, I intend to link my analysis of its iconography and style to a discussion of the problems of Vermeer's representation of allegory and to the question of authority in allegory as framed in the previous chapter. This will be linked to the related problem of how we may speak historically about the ineffable in Vermeer's art, a problem addressed most recently by Daniel Arasse.[77] I shall investigate three questions. First, how might we interpret Clio, beyond identifying in her a model posing for a painting? Second, within which concepts of history and time can *The Art of Painting* be situated? Third, how does the immanent temporality of the painting speak to its modern and postmodern viewers? To answer the first question requires an examination of how the Muses were perceived and represented in the seventeenth century and after. The second question deals with the notions of history and historical truth in the context of the topos "Veritas filia Temporis." The third will take up discussion of the immanent temporality of painting both within Vermeer scholarship and beyond it, and will be answered in the course of answering the other two, rather than by itself.

Two recent accounts of Vermeer's *The Art of Painting* raise these issues in a very poignant manner. In his *Einführung in die kunstgeschichtliche Hermeneutik*, Oskar Bätschmann remarks:

> Not without pleasure I note that just when, in Germany, by way of Vermeer's *Schilderconst*, painting in one's Sunday's best was elevated to the secret ideal image of artistic creativity, Jackson Pollock was splashing and dripping paint on a canvas lying on the floor of a wooden shed in New York. The woman in the studio is no longer the model, but the witness of the labor process which simultaneously is a work and calls forth a work.[78]

This polemic is most likely directed against Badt and Sedlmayr, whose interpretations of *The Art of Painting* I have already discussed. Of particular interest here is the final sentence of Bätschmann's remark. It suggests another, modern ideal of painting than that proposed by these authors and by Vermeer: namely, the total, immediate artistic expression, that identifies artistic production with its product. Such an identification overcomes the presumed alienation of the work of art from its production and demonstrates the existence of autonomous artistic creativity as a unity of mind and body, thereby redefining what in Kantian aesthetics is called genius. This ideal of the total presence of art has sometimes been imposed on Vermeer by his critics, as we have seen. It is in the context of this ideal that Bätschmann declares that Pollock has broken with the convention of the painter and his model. The photograph published by him to illustrate this claim shows Lee Krasner seated not far behind Pollock on a high stool, looking on as he paints. The caption reads: "Jackson Pollock, in the process of painting *One* in his studio, with Lee Krasner, spring 1950, photograph by Hans Namuth." Of course, we must question whether the notion of the woman as witness is entirely opposite to that of the woman as model, if we believe in the accuracy of the modernist ideal suggested by Bätschmann. Once work, work space, and art are one ("die Arbeit und das Werk") and in this sense *One*, the witness may just as well be seen as work material, or her act of witnessing as a source of inspiration: the model as audience is actually a muse.

A noteworthy aspect of Bätschmann's critique is that he speaks about German scholarship as an outsider. Earlier German art historians (Sedlmayr, Badt) are mocked for looking to the Dutch Vermeer, as opposed to the American Pollock, for an ideal. The locations of this comparison ("im Sonntagsstaat," "in Deutschland" versus "in einem Bretterschuppen in New York") implicitly raise the question of authority, for "painting in one's Sunday's best" ("das Malen im Sonntagsstaat") ambiguously echoes Hegel's "Sunday of life" ("Sonntag des Lebens"). Bätschmann seems to refer to a continuing philistine German delusion, not only in matters of art but also of political history. What Bätschmann avoids here is the issue of allegory. Clio, the Muse of history, is called only "the woman in the studio," while the witness and the act of witnessing are associated with present time rather than with history.

This close reading of Bätschmann's passage shows its odd relation to his earlier call for an art-historical hermeneutics, an understanding of art as "the negation of a linguistically ordered world." Such a negation implies the artist's negotiation of such a world, not its denial. For Vermeer's *The Art of Painting* this in turn implies that by representing "das Malen im Sonntagsstaat" and the woman as model for Clio, Vermeer engages with the linguistic order of allegory.

Albert Schug interprets of Vermeer's *The Art of Painting* in the course of a discussion of Rubens's historiated portraits of Hélène Fourment. Here he is exam-

ining a type of portrait in which the artist openly plays with representing the sitter allegorically.[79] Schug calls Vermeer's painting *Lob der Malkunst*, that is, *Praise of the Art of Painting*, perhaps associating it with Philips Angel's *Lof der Schilderkonst* of 1642:

> There the model is removed from her allegorical function: she casts her eyes downward, thereby contradicting her conventional role – a role hardly taken seriously in iconological interpretations – either because her interest has been attracted by an object on the table, or because a remark by the painter has struck her. Arguing for the latter possibility is the fact that the only measurable distance in spatial depth, and thus the distance that effects spatial tension, stretches between the artist and the model. Originating in the picture's mode of appearance and in the historical location of its production, the dichotomy discernible within the image of the represented allegorical figure and the affected model as person is dissolved through their mutual absorption of one another. The artist's masterful realization of this dichotomy and of its resolution is one of the visually striking aspects of this painting. It is not affected by the varying interpretations of the allegorical figure because she belongs to another level of meaning: namely, to the meaning of the picture painted by the painter. These two levels may very well interpenetrate one another.

Several points are worth noting here. Schug is apparently inclined to think of the model as a portrayed sitter. Yet he does not relate the model's downcast eyes to the beholder, and thereby avoids the conflation of painter and beholder into one ideal viewer with one viewpoint – that of Vermeer. Given this important distinction it is striking that some authors, such as Gowing and Snow, relate the model to themselves, whereas others simply begin their account of *The Art of Painting* with the female figure.[80] In addition, Schug emphasizes that one of the painting's most striking themes is the distinction between the depicted artist's representation of allegory and Vermeer's ambiguously realized notion of allegory, which also frames it. What concerns the one may not concern the other, and from this stems what Schug calls the "play" in the painting. Drawing on a Hegelian notion of allegory, we might say that *play* here means lending the allegorical person the subjectivity she lacks, that of the Anonyma in the Vermeer, that of Hélène Fourment in several of Rubens's works.[81] That Hélène cannot fail to assert herself seems in keeping with Burckhardt's notion of the allegorical figure's subjective consciousness as a consciousness different from that attached to the "task of the role." The difference of Hélène from Vermeer's allegorical figure lies with Rubens's acknowledgment of the model's, or sitter's individuality in several paintings, indeed, as Schug has it (with Goethe's *Faust*), of "Helenen in jedem Weibe." The very different particularity of Vermeer's painting stands apart not least because of the motif of the painter. His play has more players and remains even more open in outcome, insofar as he fictionalizes the play itself. Not counting the beholder, the players in the Vermeer are four: an anonymous female model, Clio, the anonymous painter, and Vermeer.

The double anonymity of both painter and model is special to Vermeer's *The Art of Painting*. We recall Proust's amazement at the painter's boldness in turning his back to the audience and to posterity, and now are reminded that Proust showed no interest in this female model. Vanzype, leaning in the opposite direction, conjured a domestic scene, lifted out of Vermeer's daily life to enact *The Art of Painting* as a tableau vivant and delay the act of painting to "tomorrow." This delay and the invocation of future works are quite significant in Vanzype's account. Neither Bätschmann nor Schug, Proust nor Vanzype seem to notice that the only figure we can name in *The Art of Painting* is the muse Clio. This may be the best reason for focusing one's interpretation of the painting on her.

The Muse Clio

According to Burckhardt, the Muses are not, strictly speaking, allegories. This is also the understanding of Walter F. Otto, expressed in *Die Musen und der göttliche Ursprung des Singens und Sagens* (1955), a book that presupposes Nietzsche's *Birth of Tragedy* and is directed against linguistics, at least as regards the question of the origin of language. Otto emphatically reminds us that in ancient Greece the Muses were goddesses, the nine daughters of Zeus and Mnemosyne. They first appeared in threes, both in cult and representations, and later in nines. They were individualized by name, but also shared some of these names with nymphs. Not originally associated with domains of art, they all were related to song and music. The song of the goddesses was as immortal as they themselves. A *Musensohn* signified, literally, the offspring of a muse and either Apollo or Hermes, before topically coming to refer to the gifted artist. The *Musensohn*'s life, for example that of Orpheus, was brief and tormented, but not so his song. The allocation of a certain domain of song to each Muse dates from Hellenistic times and has survived in this way into modern times.[82] In the visual arts of modern times, numerous representations of Parnassus, such as Raphael's fresco in the Vatican Stanze, distinguish the Muses by domain. This notion eventually led to a (mis)understanding of the Muses as allegories, although this transformation must be considered carefully and might be better described as a settlement of the Muses in the vicinity of allegory proper. As long as the Muses were invoked by poets and orators to reveal song and language, they were primarily mythological, the shift being one from cult to symbol, not from cult to allegory. This tradition may be said to have survived into nineteenth-century neo-classical and Romantic poetry. The tendency toward allegory increased, once the Muse or the topos of the Muse was no longer a priori but functionalized to the point of detailing and prescribing to the muse what her "revelation" ought to consist of. Yet even the Muse, in this role as specialist in the service of an author, appears both allegorical and mythological because she is still endowed with subjectivity, a figure summoned to share responsibility for what the author writes.

This latter notion of the Muse is found in Samuel van Hoogstraeten's *Inleyding tot de Hooge School der Schilderkonst* of 1678. Following the example of the Hellenistic arrangement in Herodotus's *History* into nine books, each associated with one Muse, Hoogstraeten names the *Inleyding*'s nine books after the Muses, who are summoned to instruct the reader in nine different areas pertaining to the art of paint-

ing.[83] Clio, "de Historyschryfster," is considered the most important of the *Zang-godinnen*, named in the poem accompanying the volume's frontispiece, which shows the artist among the Muses. She is charged with showing him what is most beautiful in the visible world, "de zichtbaere werelt," named in the subtitle to the *Inleyding*. The nine books and Muses appear in this order: (1) Euterpe is invoked for the book on drawing; (2) Polyhymnia for the book on anatomy and proportion; (3) Clio that on history painting; (4) Erato is asked to give advice on narrative subject matter; (5) Thalia on good ordering and decorum; (6) Terpsichore inspires the book on painterly poesy, i.e., the use of color; (7) Melpomene the book on the use of illumination, chiaroscuro, optics, and perspective; (8) Calliope that on heroic subjects and perfection in painting; and (9) Urania that on patronage and the artist's striving for fame and posterity. In sum, while referring to their conventionally allocated domains, as specified in Ripa's *Iconologia*, Hoogstraeten relies on this convention only when speaking of painting's subject matter (books 3, 4, and 8). Otherwise he interprets the Muses and their domains as he sees fit. The frontispiece of each book strongly relies on Ripa's *Iconologia*, but whenever Hoogstraeten reinterprets the domain of a Mmuse he adds other attributes, motifs, and references to the allegorical figure in order to underscore his interpretation. His somewhat forced interpretation of Urania as the muse of patronage and fame leads him to retain her traditional attributes referring to astronomy but also to add a painter climbing a ladder to reach the stars and an escutcheon with a Vanitas still life (Fig. 34).[84] The still life curiously diminishes the value of fame and posterity, warning against the delusion of taking anything worldly to be of enduring value. This example most clearly shows the distance between Hoogstraeten's notion of the Muses and the invocation of divine inspiration in the Platonic tradition.

What, then, does it mean for him to invoke the Muses? Three decades earlier, Philips Angel had found it appropriate to say in defense of painting that, after all, one should be content with its material duration for a few hundred years.[85] Insofar as Hoogstraeten invents his own iconology of the Muses, he devises them as allegorical figures in Ripa's sense, as definitions. Appropriately, his frontispieces are accompanied by explicatory poems in which the first strophe forecasts the book's contents (*Inhoudt*) and the second strophe (*Op de Print*) explicates the print's iconography. In the title image and title poem to the *Inleyding* Clio's domain is defined in the broadest possible terms as "the visible world," with no reference to history; but in those to book 3, titled "Clio de Historyschryfster," reference to history is prominent (Fig. 35). In the introduction to this book the author invokes Clio to aid in the representation of history and in the use of allegorical and emblematic amplification ("byvoegselen en zinnebeelden"). He begins with a discussion of painting as an art in the sense of liberal art or science, next moves to the subject of specialization in painting, and thereafter explains the three levels of painting, and history painting in particular, as the highest level within the hierarchy of genres. History painting is said to include historical events, heroic epic, ancient mythology, biblical subjects and portraiture. In book 4, "Erato," an alternative hierarchy is proposed with the thoughts of man given third and highest position, only to be dismissed as a subject not belonging to the visible world. But this distinction, which would have interested Benjamin, between "the realm of thoughts" and "the realm of things" is not maintained, and

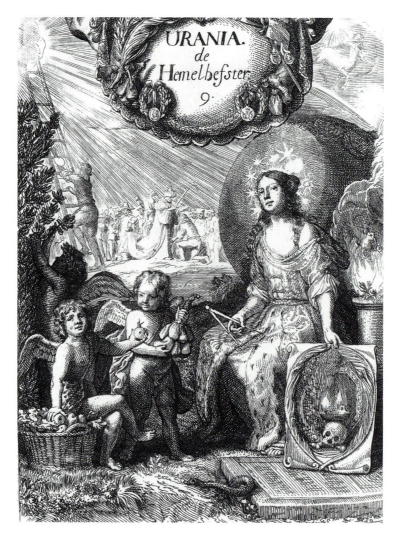

34. Samuel van Hoogstraeten, *Urania*, frontispiece to *Inleyding*, book 9, 1678, facing p. 324, engraving, 15.5 x 11.6 cm, private collection.

the first account of history painting in book 3, "Clio," includes both. Hoogstraeten concludes by again loosely referring to the frontispiece and asserting that Clio is first among her sisters: seated on the highest step of painting's pedestal and surrounded by a thousand open books, she offers topics enough to anyone even modestly fit for history painting.[86] The strophe *Op de Print* describes the iconography of the title print for "Clio":

> Here the *Historykunde* has climbed to the top of the world,
> She carries with her the book of heroes, and Fama's trumpet,
> Whereby is understood, how a venture is sometimes buried in ruins
> And extinguishes that which formerly glowed like torches.[87]

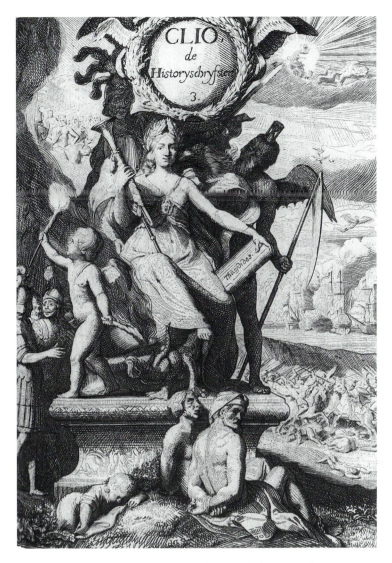

35. Samuel van Hoogstraeten, *Clio*, frontispiece to *Inleyding*, book 3, 1678, facing p. 68, engraving, 16.3 x 12.3 cm, private collection.

This reference to fortune as an important aspect of history is followed by such examples as Phaeton's hybris and fall, unspecified wars on land and sea, and scenes of victory and suffering, and is finally summed up by an association of the heroine (*Heldin*) Clio with the god Mars. The print shows Clio enthroned on a globe placed upon a high pedestal, or block, and crushing the monster of falsehood and calumny, a motif familiar from the Christian as well as secular iconography of the triumph of truth over untruth. Clio is not alone on her pedestal, but is accompanied by a muscular variant of Time the Destroyer, bearing an hourglass on his head and a scythe, which he firmly plants on the pedestal. He is placed next to, but slightly below, a towering Mars, who stands behind Clio. A putto or genius wields torches at her feet, one shining brightly, the other extinguished and smoking. Clio holds a trumpet and a

tome inscribed with the name Thucydides, as a ruler would hold her insignia. Below her throne we see two bound and fettered men seated on the ground and a young female mourner lying on a mound of grass and herbs. The wreath of laurel appears twice, once crowning Clio's head in the Roman style and once framing the winged cartouche inscribed "Clio de Historyschryfster." It is only in the introduction to book 3 that Hoogstraeten directly invokes Clio, following the ancient tradition of invoking the muse:

> Teach us now what the most wonderful things in art are, and which [things] one must grasp, in order to be trumpeted abroad by you with praise and glory. Throw open for us the book of heroes by your writer (1) [marginal reference: Thucydides], and the divine verses of your poet (2) [marginal reference: Homerus] and instruct us what the foremost parts in a history are. . . . [S]hare with us, so that everything has its proper greatness, through accompaniments and emblems, and impart the passion of your spirit.[88]

Nothing in the print or in this invocation suggests any doubt as to the power of Clio. Despite the announcement made in the introduction to "Clio," it is only in book 5, "Thalia," that Hoogstraeten discusses the amplification of history painting through emblems and allegories, and how to provide moral instruction through an exemplary story representing a concept such as fortitude or chastity.

Hoogstraeten's frontispiece series of the Muses is elaborate; in part it follows Ripa's *Iconologia*. With respect to the subject of the muses Pers's 1644 Dutch edition of the *Iconologia* is identical with the 1603 Rome edition: neither illustrates Clio. That Ripa has taken a new approach to this subject becomes evident if we remember that even late sixteenth-century representations of the Muses render the goddesses as a group of nine musicians without special attributes and domains.[89] In the 1645 Venice edition of the *Iconologia*, and the 1644 Dutch edition by Pers, Historia – not Clio – is visualized in a woodcut (Figs. 36 and 37). With slight stylistical differences, in each print a winged Historia is shown writing a book supported on the back of the god Saturn. Because she is "a memory of things past" ("een geheughnisse is van gepasseerde saecken"), she looks backward, presumably at the events that she will praise.[90] To write history in this way means also to triumph over Time the Destroyer. Historia, not Saturn, is the final editor of "things past." In this representation the divide between time and history is as important as it is narrow. Historia triumphs over Saturn, but also relies on him. She is thus an allegorical person in the broad sense used by Winckelmann, Hegel, and Burckhardt: she is a personification of a concept. Saturn is the mythological attribute of the allegorical person, and to this degree the book, the divide between Time and History, is a divide between symbol and allegory. The one is in the service of the other, is partially rationalized through the other, and in this the image of Historia in the 1644 and 1645 editions of Ripa's 1603 *Iconologia* can be seen as a model for the function of the muse Clio in Hoogstraeten's book. On the level of formal, rhetorical function Saturn is to Historia what Clio is to the users of Ripa's *Iconologia*, presumably in Pers's 1644 edition, such as Hoogstraeten and Vermeer.

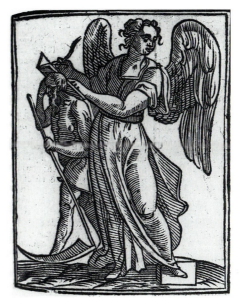

36. *Historia*, woodcut from Dirck Pietersz. Pers, *Iconologia*, 1644, p. 200, 8.1 x 5.7 cm, Bryn Mawr College, Pennsylvania.

37. *Historia*, woodcut from Cesare Ripa, *Iconologia*, Venice, 1645, p. 269, Bryn Mawr College, Pennsylvania.

On the level of content, however, there are many differences, most notably among the users of Ripa's reference work. There are even significant differences among the respective entries in Ripa's work. Ripa is the source for Hoogstraeten's print, *Clio de Historyschryfster*. In the first of two entries in Ripa on Clio we find a description of the attributes Thucydides, trumpet, laurel wreath, and child with torch that Hoogstraeten adopts. Ripa treats all the Muses under "M" in two entries with nine subdivisions in each. By keeping them together in nines, he preserves the tradition of their inseparability. Ripa names Clio the foremost among her sisters, as Hoogstraeten will do after him, thereby altering a tradition according to which Calliope is ranked highest. He devotes a paragraph to each of the Muses and then describes specific examples of their representation in painting and on coins in two art collections. This notion of providing examples as proof of their definition is rare in the *Iconologia* and its use here may have to do with the conceptual difference of the Muses from concepts such as Historia, as if reference to specific representations performed the function of rationalizing symbolism. Ripa, unlike Hoogstraeten, is keenly aware that he is dealing with mythology and not with rational concepts.

Ripa's second entry on Clio is brief.[91] "Clio, Eere-Roem" (Honor-Glory) is said to be a young woman crowned with a laurel wreath, holding a trumpet in her right hand and a volume of Thucydides in her left. The child with torch is not mentioned. Next follows an etymological explication of Clio's name as signifying glory, praise,

and celebration. Then comes an iconographical account of the attributes, which leaves out the trumpet but relates the volume of Thucydides to the latter's attribution of the domain of history to Clio, and makes the laurel wreath a sign for posterity by virtue of its evergreen nature. Such explicability of the figure points toward allegory, but neither of these explications gives even the slightest indication of mapping out a domain for the Muse, of prescribing or circumscribing her "services" to the writer of history. The entry ends by asserting that Clio is the Muse who sings in praise of things past and present. Overall, in Ripa's entries on the Muses it is clear that he takes them as a given, not as something he is empowered to define. Except for the child with torch in the first entry on Clio there are no contradictory variants between the first and second entry, whereas contradictory variants in the definition of other concepts in the text are quite common.

As we shall see, Ripa thought of four possibilities for the concept of Faith, to which Pers added two more in 1644. To put the matter pointedly, with respect to the Muses, the step from Ripa to Hoogstraeten is that from mythology and symbol to allegory, a step externally attributable to the different dates and the different types of books in which the muses appear. As Hoogstraeten lifts Clio into the present to make her serve his explicit purposes, he authorizes her, and in this Hegelian sense she becomes allegorical. In both Ripa's and Hoogstraeten's representations Clio retains her agency in the way Burckhardt believed Baroque and ancient representations of the Muses did: they were "higher beings in whom the deeper joy of the spirit has come alive" ("höhere Wesen, in welchen die Beglückung des Geistes lebendig geworden"). But whereas Ripa's Clio sings in praise "of things present and past," Hoogstraeten's Clio teaches about painting as a mode of writing history; she has a temper or passion; she can be asked beforehand about her preferences, and in general about decorum in history painting, and she is affiliated explicitly with Mars and implicitly with Fortuna. In other words, as she is put to use she becomes demythologized, a process that will eventually lead to Stuck's modern allegory of History as a prophetess of either doom or progress.

Vermeer's *The Art of Painting* stands chronologically between the Pers edition of Ripa and Hoogstraeten. Besides Burckhardt, we should also remember Benjamin's critique of allegory. By juxtaposing allegory and symbol, not just in a structural and antithetical sense but also in a historical sense, Benjamin grasped in allegory the loss of symbol. In turning to Vermeer's Clio, then, we are confronted with a range of possibilities, not only a range of particularities. Is Clio here meant as a mythological figure or as an allegorical person? Is Clio, the Muse who sings in praise of past and present, being invoked or remembered? Does Vermeer's rendering allow for such a distinction? How should we interpret the fact that Clio will be portrayed by herself in the easel painting, abstracted from the bourgeois interior that serves as a studio? What are the relationships of model to costume, costume to its reference, and of all of these to the surroundings and to the anonymous painter? Do these multiple relationships preserve or diminish the mythological notion of Clio? How does their rendering in paint compare to Hoogstraeten's use of Clio? And, finally, how do the scene and its players relate to Vermeer and to the title the painting evidently had in the Vermeer household, *The Art of Painting*? Some of these questions have been asked before, but they have been answered in a different context than the one estab-

lished here, that of concepts and theories of allegory. In this context they relate to the basic issues of authorship and authority in Vermeer's allegorical paintings.

The Art of Painting

I shall begin with a description of Vermeer's *The Art of Painting* (Pl. VII).[92] When I last visited the Kunsthistorisches Museum, the painting was exhibited on an easel, perhaps in order to suggest a symmetry or analogy between Vermeer and the depicted painter. In the provisional gallery for the Dutch masters of the seventeenth century it looked darker than I had remembered, responding to the dim lighting just as it would respond to the glare of floodlights. This external condition of its exhibition drew my attention to the way in which the painting distinguishes most subtly between kinds of diffuse shadows, so that all the things represented – objects, figures, "empty" spaces – touch each other lightly, as independent and yet interrelated phenomena. Throughout the painting lighter and darker areas exist next to one another, except for the area where the female figure stands nearest to the implied, unseen source of natural light on the left. The painting's strong local colors are not dominated by this subdued chiaroscuro. The light shape of the easel's apex, for example, overlaps the darker map while shifting to a darker silhouette against the marble floor. The picture on the easel overlaps the transition from map to wall, while the easel's lower crossbar covers the transition between wall and floor. Thus, the easel provides a coloristic continuity between these different planes by subtle adjustment to its surroundings. The same may also be said of these surroundings themselves, for an anteriority of one motif to another cannot be discerned. The resulting simultaneity is characteristic of Vermeer's manner of painting and contrasts sharply with that of the depicted painter, who suspends his work for an indefinitely prolonged moment to contemplate the model. The borderline between wall and floor is only visible next to the woman, where it suggests a bright abyss. There pictorial space recedes more than elsewhere in the room. This is a coloristic as well as a compositional effect of the horizon's visibility, and also of the orthogonals, which merge near the woman at an imaginary point behind the table.

These details might go unnoticed were it not for some emphatic relationships, such as that between the corner of the woman's mantle and the mask on the table, which it circumscribes. The drapery thus delimits an interval, which stresses that mask and mantle are the mold of one another, and subdues the color contrast between the former's gypsum white and the latter's blue. This interval may also contribute to our acceptance of the woman as in costume and as it were masked, both by her function as model and then by her role as Muse. A natural light entering the room unspectacularly collects on and around her. There is no indication whatsoever of the time of day, season, or weather. But this light does not appear as something external. Thus, here, too, is no anteriority of the pictorial world to its illumination. Together they represent an extended mood or situation. Some shadows lightly ground this situation: the shadow cast by the cloth on the table onto the sketchbook; the shadows cast by the warps in the map onto it, which give it a morphological appearance comparable to that of a landscape; the painter's shadow onto his canvas; the woman's short shadow cast onto wall and floor; the stool's shadow cast onto

the same. If there is a discernible anteriority in Vermeer's *The Art of Painting*, it is that of its appearance, of its representation, to its subject. Thus the real challenge, when writing on allegory in Vermeer's work, consists in finding out what representation and subject have to do with each other and of avoiding too quick a mediation between the two. Such a mediation might erase the viewing experience of the anteriority of the one to the other; it might deny a certain distance between either of them and a given viewer, and claim uncritically the perfect presence of this Vermeer painting. Vermeer's *The Art of Painting* implies the possibility and even the practice of giving form and color a voice within a specific relation to the authoritative voice of the allegorical subject.

The pictorial world of *The Art of Painting* unfolds primarily on the basis of internal dual correspondences. It unfolds, as it were, between two empty chairs, between the painter and the model as muse, between the two halves of the map to the left and right of its prominent central crease, between the model and her props, her face and the mask, between the allegorical person and her attributes, and so on. Any relationship between a beholder and the depicted figures implies these multiple dualisms and adds others to them. The painter is placed so as to balance pictorial reality for a beholder standing centrally before *The Art of Painting*. His stool and feet are planted confidently on black tiles, his main bodily axis continuing the main crease in the map, his gesture paralleling both. His contour follows the diagonals of the floor's pattern and recession to the right as well as to the left background. Even the top of his easel orders a piece of this world as it "holds" the Zuider Zee on the map in its place. Formally speaking, he is a successfully integrating figure, subtly controlling his surroundings; it will be seen, however, that in terms of subject matter he is not. There are several such ambiguities or plain dichotomies in *The Art of Painting*.

To look at the Vermeer is to be guided by a rhythm of dualisms, consisting of the above correspondences but also of odd pairings: two chairs, curtain and map, book and book, cloth on the table and mantle draping the woman, her costume and his costume. But none of these is finite, as each element is engaged in various correspondences across this pictorial reality. Can any of these be grasped iconographically? May colors, for example, be seen to establish order? I think not; even the painter's red stockings and the red end of his mahlstick, while striking as a reference to an additional limb grounding him in the world, do not provide a point of departure other than an apparent irony – its effect of isolating the painter coloristically from the rest of *The Art of Painting*. Color or hue, is ambiguous here, as in other of Vermeer's works. Its subtlety suggests puzzling similarities, most notably the one between the woman's facial tint and the something on the table, perhaps a piece of paper but really an indeterminate object. Both have an air of preciousness because of their luminous hue, both are without graspable identity. Like Proust's "little patch of yellow wall" in *View of Delft*, Bergotte's "butterfly" beyond reach, they are a challenge, an invitation and to the beholder and a warning. Because they are paired visually, they seem to imply a meaningful link whose meaning is withheld from the viewer. Here, recognizability or lack thereof has nothing to do with the use of optical effects as a representational means, a technique familiar from other of Vermeer's works. Nor is it a matter of painterly object definition through quasiphotographic focus and touch. There is little so-called *pointillé* here: a few highlights (on

the left corner of the stool, on the buttons on the upholstered chairs), some blur (in the chandelier, areas of the map, and on the tapestry curtain). The ambiguity has also to do with Vermeer's use of color in a volumetrically undefined woman's face and an indeterminate object on the table. A survey of descriptions of the painting reveals how remarkably little scholars agree on what, on Panofsky's preiconographic level, is to be seen in the table still life. Their silence about the small object in question has to do with its formal and coloristic abstraction from its immediate surroundings, an abstraction itself attributable to the dual, versatile structure of pictorial reality in *The Art of Painting*.

The painting's most dramatic motif is the curtain that appears just to have been lifted by an unknown hand to reveal the calm scene. It is no dumbshow, however, neither privileging the figures over their surroundings nor presupposing those surroundings as their stage: figures and objects belong together, appearing in equal measure resistant to interpretation and yet in a perplexing manner self-evident. The curtain is seen from the reverse side, as if the beholder's space were actually the fictional space revealed to the figures in the painting, who pay no attention to it. This playful reversal of curtain, stage, and audience brings to mind Velázquez's *Las Meninas*. This analogy endows the map with a mirrorlike quality, whereby the undivided Netherlands become the doubled, mirrored, authoritative beholders of Vermeer's interior. The map's historical anteriority to the scene in front of it, however, characterizes this audience as belated, thus compounding the modern beholder's interpretive confusion or sense of inadequacy. At the same time, this structure remains contingent on a sovereign, anonymous individual lifting the curtain, who might all too quickly be identified with Vermeer himself.

What does the curtain actually do in the painting? While it provides an ample view of the painter at work or pausing at work, it barely reveals the model. There is a playful threat that the curtain might fall at any moment. Were this to happen, the painter would still be seen but not the model. Then, indeed, one might perceive the painter as depicted in a moment of reflection or inspiration, comparable to Vermeer's *Geographer* of c. 1668–9.[93] Through these suggestions the curtain provides some access to the painting's temporality. This temporality is characterized by the tension between an impending sudden moment (the curtain's fall) that pertains to the beholder and a suspended scene that is separate from the beholder's chronological time of looking, contemplating, taking notes, moving in front of the painting, integrating what is seen with what was read, etc. That it is the model and the muse Clio whom the curtain mainly reveals, and not the painter, enhances the beholder's sense of her special status. It also separates the painter's work in progress from the model. If we did not see her we might vaguely determine his subject to be a wreathed female figure. As the thought of a model for Clio would not enter this perception, one might be even more surprised that the painter starts from the top, with the laurel wreath, after having sketched in a light underdrawing. Such practice resonates with irony.[94] There is something strange about Vermeer's painter's manner of imitation. However important its iconographical meaning, it cannot be practical to paint the wreath first. Painted first, it surely complicates the process of painting the rest. There is a suggestion that the wreath comes first because it has priority in the painter's mind. The painter's shortcomings then lie in his confounding the practical aspects of represen-

tation with its signifying aspects, as well as with its personal or emotional aspects. This immoderate zeal may lead observers to smile at his slim chance of gaining praise from posterity. His imitation is an immediate and naive rendering, a copy of the wreath on the model's head. This looks rather improvised and oversized, the sort of wreath one might wear for pastoral games or competitions in singing and kissing, not the wreath of Clio, especially when it is compared to the rigidly wrought, Caesarian headgear of Hoogstraeten's Clio (Fig. 35).[95] Moreover, the wreath on the canvas equals the wreath on the model's head in size, thereby either defying all laws of perspectival diminution or suggesting that the painter actually enlarges the motif he isolates and copies. What he paints in his zeal is the wreath of his own ambition, the wreath in his mind's eye.

This sequence of observations and reflections on the depicted painter's practice further enhances the experience of a distance (itself reflected upon by Vermeer) between representation as a painterly practice, as a practice of beholding, as the rendering of a specific subject matter, and as a personal commitment. One of the chief differences between *The Art of Painting* and *Allegory of Faith* thus comes into view. Because of the painter's presence in the former, the strange and unfinished canvas on his easel appears to be about art and notions of imitation as such, whereas Jordaens's *Christ on the Cross*, as cited by Vermeer in *Allegory of Faith* (Pl. VIII), appears as a finished painting within the painting, without a fictive author.

After each exploration of Vermeer's *The Art of Painting*, one returns to the anonymous painter as the one motif balancing its pictorial world. But this balance becomes questionable as soon as one changes either one's imaginary or one's actual position in front of the Vermeer. Such a change is possible without any distortion of one's perception of the image. Svetlana Alpers has pointed out the panoramic quality of seventeenth-century landscape painting, which allows for several viewpoints.[96] It seems to me that this observation applies to some extent to this Vermeer painting as well, inasmuch as the low focal point and the diagonally laid floor tiles allow and even encourage the beholder's imaginary as well as physical mobility in front of the work. Standing in the middle, I imagine the content of the room depicted in *The Art of Painting* as if seen from the right, with the eyes of the painter; this, as we saw, leads to a rather limited understanding of the art of painting. But if I take the painter's viewpoint and stand, as it were, behind him, his situation within his surroundings, his former balancing, or controlling position in it, unravels. Seen from this angle, the model as muse begins to look small and far away, as if she were about to leave the room in the direction of the light source; she becomes an ephemeral appearance hardly within the painter's grasp. As the painter, in turn, appears to make a greater effort to capture her on the canvas, his attitude becomes unbalanced and his work no longer self-aggrandizing. The room looks huge, the things in it forlorn, and the model as muse loses her connection with the objects on the table. The painter's confident zeal of a minute earlier has turned into an almost futile, pitiable effort. Like the table, with its studio props, he looks set aside, left behind. Seen this way, Vermeer's *The Art of Painting* may rightly be called *The Artist in His Studio*, and is to some extent comparable to his other portraits of male professionals, such as *The Geographer*, who – in contrast to the painter – exercises control over his domain from every angle.[97]

If, on the other hand, I ignore both the painter's viewpoint as imagined when standing at center and his actual viewpoint from the right and move instead to the left, near the curtain, then I am confronted with a steep, almost vertical perspective. It is supported by the same floor pattern that earlier permitted the oblique view from the right, from the painter's angle. Now everything in the room moves closer together, and now the woman is clearly the focus of its material world, a world she seems to have the power to withdraw from the painter, as he looks at her from the right. When seen from the left, she appears to assist in Vermeer's achievement of a pictorial harmony, an achievement impossible for and withheld from the painter, who has become a peripheral motif, off to the right. Now *The Art of Painting* reminds one of Vermeer's genre paintings representing a single woman in a room. Moving back to a viewing position roughly congruent with the central axis of the image, I realize that this neutral or habitual central viewpoint merges the two others just probed. They are merged in the memory in a conscious effort that Gottfried Boehm has called "erinnerndes Sehen," mnemonic seeing. By this he means primarily a visual memory not of several images and motifs but of the process of making sense of one image through a gradual mnemonic integration of the successive moments of its visual exploration by the beholder. "Mnemonic seeing" thus results in a visual literacy of artistic forms, differing very little from Hildebrand's interpretation of the *Erinnerungsbild*, or "image of memory," and "Fernbild," or distant image, but differing rather strongly from the conceptual, social memory of imagery as understood by Warburg. This distinction is important, for in coining the term "mnemonic seeing" Boehm's interest is in the abstract, or formal, and noniconographic aspects of the work of art.

In Vermeer's painting mnemonic seeing refers to the fact that there is no objective, conceptualized central axis. The motifs closest to defining the center are the rather misleading chandelier, which does not focus any of the work's levels, and the prominent crease in the map on the wall, which symmetrically orders its warps and material tensions. But otherwise, the center of Vermeer's pictorial space is empty, a rather difficult constitutive blank, to use Kemp's term, an emptiness that must be crossed often by the beholder in any attempt to link the other motifs and objects with one another. Vermeer's painting appears to ask the viewer to supply for it what the crease does for the map's two halves. If this is so, the earlier speculation about the Netherlands as the mirrored audience is further modified. The Netherlands is less a collective entity than a particularized audience, individuated by the crease as much as by the three viewpoints described above, all of which remain within the perimeters of the map.

As the exercise of assuming different viewpoints suggests, at some point this individuation requires a determination of the relationship between painter and model. Vermeer denies to both his own viewpoint, central but empty and therefore variable and versatile. The painter's limited understanding is presented in a wreath, a smile, and a copy of the wreath. But is there a smile on that enigmatic face? Is the painter a self-deluding fool? Is he the only one?

I noted earlier how much in *The Art of Painting* seems unreadable, less because of the optical diffusion of its iconography than because of the versatile dual relationships of objects, colors, and figures in addition to the general unreadability of

faces in Vermeer's art. The book on the table, for instance, reminds one of the way the Bible stands as a link between Christ and Mary in Jan Steen's *Christ in the House of Mary and Martha*.[98] In Vermeer's picture it is hard to tell whether the book links or divides what is to either side of it in the manner of the map's central crease, which stresses the partition of the Netherlands even in its representation of the united provinces.[99] The mask is ambiguous, neither comic nor tragic, nor an effigy, as if further to enhance the unreadability of the woman's facial expression. The sketchbook linking model and painter shows nothing in particular and might just as well be understood to separate them, like the pieces of white cloth, bonnets, and sheet music that separate couples in Vermeer's *The Girl with the Wine Glass*, *The Glass of Wine*, and *Girl Interrupted at Her Music* (Pls. I and III, Fig. 16). And the unidentified object on the table, while in certain ways analogous to the woman's face, is so abstract that it reminds a reader of Proust of the abstractly inviting and promising little patch of yellow wall. The curtain, too, is ambiguous in its own way and scholars are divided regarding its function, whereas they do not doubt that the model is dressed as Clio.[100] This observation returns us to the question of authority in allegorical representation, even in this serene Vermeer painting, with its facile shifts in genre, its variable, subtle, dual relationships, and its unreadable shapes and colors.

How does Vermeer adapt (Pers's) Ripa's second entry on Clio? On the one hand, he certainly follows its general guidelines in his rendering of the allegorical person's youth as well as of the attributes of trumpet, book, and laurel wreath. One might more accurately say that Vermeer makes his painter follow Ripa's guidelines, since it must have been, the latter who asked the model to dress up as Clio and to pose in this particular way near a source of natural light. Furthermore, a classicizing blue mantle is draped over the model's contemporary dress and, unlike other women in Vermeer's art, she wears no earrings. That her head and headgear formally echo the shapes of some of the cartouches in the map the painter may not perceive from his own viewpoint as clearly as does Vermeer's privileged mobile beholder, whose freedom of reference greatly exceeds that of the painter. It is only on this privileged level that Clio and the Netherlands become directly related in the way first suggested by Sedlmayr: Clio praises the Netherlands through painting and because of painting. Whenever these two levels are not distinguished, the logic of the painting and of Vermeer's recourse to allegory becomes questionable. Swillens, for example, emphasizes what he perceives to be the model's feeling of awkwardness in her role:

> She is clearly a model.... She holds the trumpet in an awkward and helpless way thereby showing that she does not know how to handle such an instrument, which Vermeer appears not to have known either, and holding the heavy book clearly costs her some effort. She stands motionless, her glance fixed on the table, on which nothing can be discerned which could hold her attention.[101]

From this one might conclude that the author does not consider allegory to be appropriate for real women, although not in the sense that, ironically, might find feminist approval today, in which allegory is understood as a false projection of ideals onto women.[102] The main issue here is that Swillens sees the model's supposed

awkwardness and weakness as an extension of Vermeer's ignorance. Taking the allegorical concept to be Fama, not Clio, Swillens expects the model to be active, to blow or simulate blowing the trumpet, not to be still and distracted. But quite apart from this shift from Clio to Fama, such expectations are at odds with Ripa.[103] Against Swillens's objections it may be said, for example, that it is of no importance whether an allegorical person is physically strong enough to carry her attributes or not. On the other hand, according to Ripa, an allegorical person is meant to coordinate her attributes through gesture, dress, and general composure. Vermeer's model may indeed be said to lack the last of these basic qualities. But then the muse Clio, although included by Ripa and Pers, is not a concept but a mythological figure, whose status differs from that of Honor or Temperance or Fame. In order to understand the importance of this difference we only need to remember that Hoogstraeten unproblematically calls Clio History ("Historyschryfster," "Historykunde"), but Ripa does not propose this, nor does Vermeer. Vermeer's challenge lies in the fact that the model's subjectivity, her youth in combination with her distraction from her role (presumably indicated by her downcast eyes), does not lend subjectivity to the concept of History as an allegorical person. Rather, she lends it to the mythological Clio, but in such a way as to assert a subject quite separate from her enactment of the Muse. The role is exposed as a detachable shell, but perhaps not exclusively that of the young woman enacting it. I propose that this exposure may, through irony, both reinstate the mythological identity of Clio and enhance the function of the young woman as model.

Vermeer modifies the explicitly transitory play between renowned artist and well-known model (e.g., Rubens–Hélène) through the anonymity of his figures. These particularities have often led critics to the rash conclusion that no allegory is intended by Vermeer. Hurley inverts Swillens's view when she writes: "By presenting the woman in the picture as a *model* of Clio, rather than as Clio herself, Vermeer . . . forc[es] the viewers to take cognizance of their conceptual role in the act of viewing."[104] Although this conclusion may be said to apply to all art by Vermeer, since all his paintings appear to force their viewers into self-reflection, the specific location of its basis in this particular painting is somewhat problematic: What would "Clio herself" have to look like, if not like Vermeer's figure? Did Vermeer have any choice between "Clio herself" and the figure he represented? Are not the naturalized allegorical and mythological figures of Rubens the unnamed models for such an alternative? And if so, should the question of Baroque allegory not be raised on a broader basis? It is useful to distinguish between Vermeer's general lesson (to take cognizance of the beholder's conceptual role), which could also be drawn from the earlier analyzes of his works in this study, and the one specifically presented in *The Art of Painting*, which concerns the futility of its painter's direct and unmediated imitation of Clio. This distinction helps Vermeer's beholder to see so clearly the model's negative association of Clio and map, her distraction from her role by objects on the table, her distancing smile, her elliptical mediation.

"Clio herself" as a mythological presence in the style of Rubens is out of the question in Vermeer's interior. It will be remembered that in his genre painting *The Girl with the Wine Glass* Vermeer introduced Temperance in the form of a vivid representation in the stained-glass window, that is, in the form of an artifact. We shall

see that in his *Allegory of Faith* Christ is introduced through the citation of a painting by Jordaens. But to accept Vermeer's realism or classicism (unity of action, site, and time) is not the same as to claim that the representation of "Clio herself" is not intended here. As Vermeer permits the woman to assert her identity as model he also suggests that Clio refuses the kind of servitude implied by Hoogstraeten's rhetoric.

In order for Clio to praise the painter, so Hoogstraeten implies, the painter must depict the right topic in the right way. At the same time, the very availability of such topics – heroic epic, mythology, ancient history, biblical scenes – through tradition presupposes Clio's approval. But the painter in Vermeer's *The Art of Painting*, by taking "Clio herself" to be his paradigm in the most literal sense of imitation, affirms nothing but his own error. When Gowing writes of Vermeer's Clio that "even the lovely object of attention disowns it" he probably means the woman modeling as Clio.[105] But if we relate this observation to what has just been said about Vermeer's erring painter, it assumes a different meaning. Both "Clio herself" and the woman disown the painter. But may we transfer this observation to the Muse? Who is Vermeer's "Clio herself" that it is possible for him to make her withhold inspiration and praise, to let her act against her role? If Vermeer's Clio is an ironical counterpart Hoogstraeten's Clio, then this may be interpreted to mean that Vermeer considered the Dutch viewing audience, as well as himself, to lack a praiseworthy past and present. In that case Clio, even as she is invoked, will withhold praise and inspiration. This interpretation draws on Benjamin's concept of the essential negativity of allegory, of its impending self-annihilation through a built-in criticism. Here, in *The Art of Painting*, this negativity regards the impossibility of Clio's allegorical presence. To be sure, Benjamin nowhere suggests that this negativity could be represented in such a bright image as the one offered here by Vermeer, apparently with no sign of evil, mourning, or melancholy.

If we associate allegory with ambiguity in this way, then what appears to be a sovereign rationalization of allegory on Vermeer's part may instead be a tension not already mastered by Vermeer but instead sovereignly exposed. Why is there no Benjaminian sense of loss in the painting? Perhaps it is because allegory's negation, its self-annihilation, is only a possibility, a possibility indefinitely delayed rather than anticipated, because of the depicted painter's naivety.[106] It is this naivety which relieves Vermeer's work of what might otherwise be a burdening insight. If Hoogstraeten allowed fortune to shape history, to depose one man from a praiseworthy position in its record and raise up another to it, Vermeer refuses to conceive of any such course here. He puts naivety in the place of both insight and fortune. The misguided painter at his easel does not consider history and Clio to be something other than the world in which he lives, even as that world does not enter his painting. The canvas is unfinished, but its future success seems doubtful, not because it betrays his own or Vermeer's explicit commitment to antiallegorical realism, but on the contrary, because in beginning with the wreath he already claims the praise he wishes to receive.

Vermeer displays his own mastery in showing a scene in which a painter does not master a problem Vermeer himself perceives and implies. In this sense he is served by the woman who models as Clio with the peculiar success of making "Clio herself" turn her back to the painter, who himself turns his back to the beholder.

Suggesting a deeper understanding of the matter, Vermeer underscores Clio's denial of inspiration by carefully scattering a whole range of references through the room: the painter's so called "Burgundian," slightly outdated costume;[107] the dated map, suggesting an intact Habsburg empire and a united Netherlands;[108] the heraldic double eagles of the Habsburgs in the chandelier;[109] the mask that may or may not be a specific effigy;[110] the creases and warps in the map indicative of an aging process.[111] Vermeer gives no privilege to any one of these clues, to any one element or moment in history. By rendering all the details of the interior from which the painter isolates his portrait of Clio and by dignifying the model in a way overlooked or abstracted from by the painter, Vermeer avoids what his painter is incapable of avoiding: a positive image of "Clio herself." The one temporal moment privileged by Vermeer is the moment in which the curtain is lifted to reveal what is to be seen here, a moment that coincides with the painter's suspension of his work. Few signs of actual painterly practice are disernible and this reminds us that the and this reminds us that the contrast between the anonymous, naive painter and the ironical Vermeer is a contrast that may be called self-serving after all. While perhaps he did not so freely choose his notions of allegory, of Clio, and of history, it is peculiar that ultimately Vermeer's dialectically implied muse is entirely in accord with him, both of them smiling at the naive painter copying the model.

Finally, another aspect of "Clio" comes into view. Although the painter isolates the wreath from the very complex circumstances and relationships of objects and figures, these relationships are emphasized by Vermeer through the model's presence. It is because and only because of her position and her costume that the map is often read as a historical map, the chandelier as related to the Habsburgs, and so forth. It is in this sense that "Clio herself," even in her absence, appears to guide Vermeer's *The Art of Painting*. The functional versatility of the female figure lies specifically in her identity as the artist's model who subtly refuses to do her work and thereby incidentally undermines the authority associated with the subject of her assignment, the subject of the muse Clio. She thus exposes the authority of allegory as such to critical and playful reflection. Her refusal to act her role well and the negativity of Clio's presence (her presence as absence) are inextricably related and realized through the woman's downcast eyes, the ambiguity of her pose and expression, the pastoral appearance of her wreath, the luminosity of the atmosphere enveloping her, the light colors used for her drapery, and so forth. It is the elusive nature of Vermeer's women and of their material surroundings, perceived by so many, that appears to arrest Vermeer's paintings in a notion of presence and their contents in a state of simultaneity with their beholders. Here, in *The Art of Painting*, this presence weakens the authority of allegory and the iconicity of objects as displayed historical clues. This characteristic of *The Art of Painting* is integral to Vermeer's mastery of the self-imposed task of relating the art of painting to allegory, history, and mythology. It is, at the same time, a general characteristic of his oeuvre that happens to play out differently in the different genres of history/allegory, genre, cityscape, portrait.

I have interpreted *The Art of Painting* in terms of an ironical and ambiguous serenity of play with possible identities, a play that touches upon Benjamin's concept of allegory's essential negativity, but delays the impact of this negativity upon

the future by interpolating the naive painter. Vermeer, in closely following Ripa's or Pers's guidelines for the mythological identity of Clio, retains this identity together with the allegorical appropriation of Clio for the painter's profession; his oscillation between these two uses may be seen as a deeply ironical analogue to Hoogstraeten's later appropriation.

To a considerable extent, this interpretation reflects my understanding of Vermeer's use of style as a voice by which he creates a distance between appearance and subject matter, wherein the first is anterior to the second. Distance and primacy of appearance apply to figures, objects, and their relationships among themselves and one another. It is clear that the relationship between the voice of style, form, and color and the authoritative voice of allegory is epitomized in the female figure's triple identity: the woman as model as muse and as Muse/Clio. It is also clear that these three identities are themselves dependent on her elusive appearance and on the beholder's varying viewpoints before the painting. Although integrated and functional in Vermeer's painting, this elusiveness and these varying viewpoints remain difficult to grasp.

This difficulty leads me to explore a different approach to the question of allegorical authority in Vermeer's *The Art of Painting*. It may be instructive to view his personal style as a source of conflict with himself: as a conflict that uncovers, without expressly setting out to do so, aspects of the structure of allegory addressed later by Winckelmann, Hegel, and Benjamin as inauthenticity and negativity. Because *The Art of Painting* so conspicuously and masterfully avoids any specific location in time, thereby delaying the completion of allegory's negation or ruination in Benjamin's sense, I have chosen to turn for comparison to the one Baroque topos of history concerned with all the tenses, past, present and future, and their relation: *Veritas filia Temporis*.

<div align="right">

Chapter 11

</div>

Veritas Filia Temporis

In his 1916 essay "Das Problem der historischen Zeit," the sociologist and philosopher Georg Simmel concludes:

> The realism of [the writing of] history does not consist in the *contents of life*, which it would copy as it really was, but rather in this, that history's inevitable difference from life [*Anders-seinalsdas Leben*] must somehow correspond to its motivational forces, to the laws of this life.[112]

Such laws of motivation, or such structure, could not have been envisioned by Hoogstraeten, who instead emphasized the power of fortune over the course of history, while assuming, as it were, a stable canon of its most important topics and proposing to teach art students how to secure fame. In contrast to Hoogstraeten's account of a defined past, unstable present, and hopeful future, in Vermeer's *The Art of Painting* the suspension of any social or professional practice in a prolonged moment of presence may be seen to refer to "Clio herself" as well as to history's "inevitable difference from life." What should we make of Vermeer's way of framing the subject of history, and perhaps specifically Netherlandish history, in such an open manner? I will answer this question by situating Vermeer's *The Art of Painting* among seventeenth-century images of *Veritas filia Temporis*. To do this, it will be useful to study the temporal structure of some of the examples discussed by Fritz Saxl in his classic account of the topos.[113]

Time, Providence, Evidence, Truth

The topos *Veritas filia Temporis* – literally, "Truth the daughter of Time," but more freely used "truth brought to light by time" – is often considered atemporal, even when it is applied to historical truth. For some artists, notably Rubens and Poussin,

Veritas filia Temporis provided a useful frame for the account of history, capable of standing abstractly on its own but also applicable to specific periods of time, sometimes even specific events. If in Rubens's art it relates to either sacred or secular history and their respective truths, which he does not claim to be one and the same, in Poussin it refers to both at once.

Simmel distinguishes between these two histories in his essay on the metaphysics of death. He seems to refer to *Veritas filia Temporis* when he writes that "Death lets life fade away in order that the timeless nature of its contents be set free."[114] The Christian model of salvation history, he maintains, is that of a perpetual revocation of death within and in the course of life through the projected judgment and prolongation of each lived moment beyond death. According to this model, *Vanitas*, the transience of everything earthly and worldly, really means Christian immortality. The other, secular model of historical time interprets death as integral to a finite existence stretched out between birth and death.[115] These two models might be said to correspond to the two baroque topoi of temporality, the medieval *memento mori* and the Horatian *carpe diem*. In his 1916 book on Rembrandt Simmel combined the two models to gain an understanding of what struck him as the dignity of Rembrandt's representation of old age and lived experience, of "gewordenes Leben."[116] It is this understanding that makes him favor Rembrandt's representation of old age and what is called *Altersstil* in an artist.[117] In this book, as in the two essays on historical time and death, Simmel determines that both fate and the historical event are primarily a structure and only secondarily a fact or deed. With his two models of historical time in mind, let us turn to specific seventeenth-century representations of *Veritas filia Temporis*.

Although fate might appear to be antithetical to this topos, Rubens included a representation of both at the beginning and the end, respectively, of his Medici Cycle. In Baroque tragedy, the notion of divine providence sometimes relates to that of fate, to which the ruler him- or herself is subject, as well as to the goodness of his or her rule. Thus, both topoi, the seizure of the moment and the fatefulness of history, are represented in Baroque images of *Veritas filia Temporis*. In either case, as we shall see, the phrase refers to an account of history abstracted and distinguished from concrete events, as if to confirm Simmel's much later definition of the historical record as an "inevitable difference from life itself." This may mean different things in different examples. When Bernini, according to Chantelou's journal of his travels in France of 1665, struggled with the technical difficulties of representing Truth uplifted by Time in stone, he finally had to accept the necessary support structure for his *Verità* – support understood in both the material and in the metaphorical senses:

> His design is to represent him [Time] carrying her [Truth] through the air, and to show by the same means the effects of time which ruins and in the end consumes all things; . . . in his model he has made columns, obelisques, mausolea, and . . . these things which seem overthrown and destroyed by Time are also those which sustain him in the air and without which he could not be there – "unless he had wings," he added, laughing.[118]

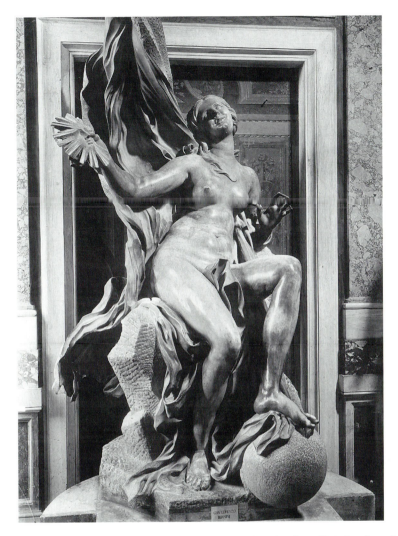

38. Gianlorenzo Bernini, *Verità*, 1646–52, marble, 3.30 cm (with pedestal), Galleria Borghese, Rome.

Bernini may have laughed not only about the inefficacy of Time's stone wings but also at the dialectics of Time's ruinous support structure. In the end, he omitted the figure of Time (Fig. 38). Winner has suggested that Bernini's difficulties with this project stemmed also from the double root of the topos *Veritas filia Temporis* in the Christian and classical traditions. The classical tradition refers to Psalm 85: "Faithfulness will spring up from the ground / And righteousness will look down from the sky."[119]

Borrowing from the iconography of Christ in Limbo, the figure of Truth is often represented as emerging from a cave, but the figure of Divine Justice is rare and mostly replaced by Father Time, who raises Truth from the earth and rescues her from the threat of Envy, Calumny, Discord, and Ignorance. Sometimes Time raises Truth above himself, seeming to deliver her from himself. Whenever the topos is illustrated "in

response to the demands of some specific, genuine human situation,"[120] the "earth" of the psalm is used to refer to the events and Truth to their record as history.[121]

Van den Vondel

One of the most instructive uses of *Veritas filia Temporis* and thematic treatments of time in the Netherlands occurs in Joost van den Vondel's tragedy of 1654, *Lucifer*, where heaven itself becomes the arena of history and its laws, and its structure the subject of history.[122] Once man is created, time enters heaven as a disturbing problem. Lucifer is confused and no longer able to distinguish eternity from worldly temporality. He fears that through the creation of man and the plan to raise him to heaven God will abolish the hierarchy of heaven and perhaps himself, his own absolute power. Already some of the higher angels envy man for his temporality and for Eve. Gabriel, God's spokesman in heaven, announces with involuntary irony: "Time shall divulge the cause" (Act II: 190; 497: "de tijd wil d'oorzaak leren"). Navigating around the word "time," he demands:

> Now learn
> We gradually, with modest reverence,
> God's wisdom to approach. And this to us
> Reveals, by slow degrees, the light of truth
> And knowledge, . . .

This must refer to Psalm 85 and divine justice, but strangely enough, Gabriel adds an appeal to reason:

> . . . and requires that, on his watch,
> Each shall submit himself to reason's rule.
> (Act II: 267–71; 556–9)

When Lucifer and the Luciferians begin their rebellion, they give their interpretation of reason: "Naturally each is shielded by his Rights," which may also be read as "Nature made each defender of his Rights" (Act III: 458; 1148: "Naturlijk is elk beschermet van zijn Recht").[123] Such rights were originally granted by God and valid in an eternal order, but now they are threatened, apparently merely temporal and therefore temporary. They can only be defended against God by recourse to nature, which, associated with time, is distinct from its creator. Just before his lengthy self-justification to an imploring archangel Raphael, Lucifer also speaks of "necessity," calling it his "law," a law separate from that of divine justice (Act IV: 128–30; 1431ff.). By now, Lucifer has somewhat clarified his notions of time and of eternity, claiming his "rights" against Raphael in the name of both:

> The scepters, crowns, and splendors that to us
> The Godhead from his bosom gave, for time
> And for eternity ["Voor eeuwig, en altijd"]!
> (Act IV: 247–9; 1524–6)

He also anticipates, however, that "Heaven shall bury us" (Act IV: 245; 1523) in some abyss. Finally, in a tragic monologue expressing his feelings of guilt, regret, and despair ("my blasphemy / And wickedness," Act IV: 402f.; 1648), Lucifer recognizes how closely time and *Vanitas* are related, that they do not threaten but rather reveal eternity and its order, and that none but he has empowered time to destroy eternity, resulting only in his own destruction:

> What remedy?
> What best to do amid this hopelessness?
> The time brooks no delay. One moment's time
> Is not enough, if time it may be called,
> This brevity 'twixt bliss and endless doom.
> But 'tis too late. No cleansing for my stain
> Is here. All hope is past. What remedy?
> (Act IV: 404-10; 1650-55)

He fights and loses the battle against God and then takes revenge by temporally delaying humankind's ascension. This he does through the Fall, that is, by using time, the only power left to him, to force mankind into history. It is remarkable that van den Vondel has Lucifer dwell so emphatically on the problem of time, making his sin of pride and his individual actions appear a secondary effect of this problem.

In van den Vondel's *Lucifer*, the Christian tradition of *Veritas filia Temporis* is clearly bound to Roman Catholicism. Time is ultimately incapable of undoing God's divine providence for humanity's salvation. But time entails evil, and its threat is so real that it must be fought even in heaven.

Rubens

Two decades earlier, Rubens had used the topos *Veritas filia Temporis* in his religious allegory *The Victory of Truth over Heresy*, which is part of the tapestry series *The Triumph of the Eucharist* (1625–8) made for the Infanta Isabella of Habsburg, governor of the Netherlands. In the modello (Fig. 39) Rubens groups Luther and Calvin together with other evil powers struggling in darkness at Truth's feet, while Truth herself is raised from the ground by Time and points upward to a scroll inscribed "Hoc est corpus meum."[124] Unlike van den Vondel's *Lucifer*, Rubens's *The Victory of Truth over Heresy* requires the service of Time to secure the reign of eternal – that is, Roman Catholic – Truth. In *Lucifer*, time is never personified; though subject to divine providence, it is also disquietingly independent, a decisive "brevity 'twixt bliss and endless doom." In Rubens, however, Time is the one force able to separate heretical historical personages and Roman Catholic dogma, although this means that he is left behind by the latter.

In his series *The Life of Marie de' Medici* (1622–5) Rubens included *Veritas filia Temporis* as a historical allegory adapted to the dispute over the events defining the struggle for power between Marie de' Medici and Louis XIII. The structure of *The Triumph of Truth* from that series is an inversion of *The Victory of Truth*, for here the heavenly realm of Truth is historical and the earth is unspecific (Fig. 40).[125] The paintings preceding it suggest that a temporary discord between Marie de'

39. Peter Paul Rubens, *The Victory of Truth over Heresy*, from *The Triumph of the Eucharist*, modello, 1625–8, oil on panel, 86 x 91 cm, enlarged above and below, originally 64.5 x 91 cm, Museo del Prado, Madrid.

Medici and Louis XIII has been completely overcome by the time of the cycle's completion. Marie and Louis's concord is represented at the top of *The Triumph of Truth*, above Truth, in the image of a harmonious couple, Louis kneeling opposite the seated Marie, in the clouds. They hold up the wreath of concord with the flaming heart of friendship, unity, and mutual dedication, their image and position comparable to a motif seen in an earlier painting, from the cycle *The Meeting of Marie de' Medici and Henri IV at Lyons* (no. 9 in this series). There, the enthroned couple are Jupiter and Juno, the divinities who bestow approval on the event from above. In *The Triumph of Truth* it is Time who lends Truth to the claim of concord. Therefore, it is this claim and not Truth that is triumphant here. Yet because of Truth's sensuality, "the allegorical group entirely prevails over the 'real' personages at the top."[126] In such a conception of history, the anticipated future revelation confirms a fabrication of the past that appears sanctified from the outset by the ruling powers' supposed consent. The illusion is manifold: the image suggests the identity of the

40. Peter Paul Rubens, *The Triumph of Truth*, from *The Life of Marie de' Medici*, 1622–5, oil on canvas, 394 x 150 cm, Musée du Louvre, Paris.

past, present, and future of Marie's biography with their reception; it further obscures what Norbert Elias has described as the funneling of past and future through a never disinterested present of social practice.[127] It also assumes that the control of this monumental cycle over the record of history extends into an indefinite future and can be secured for posterity. These illusions would be impossible without the artist's awareness of their desirability and of his task as an illusionist who plays with history and time, to his own advantage. But Rubens must obscure the presence of his insights. At least, this is what he himself suggests in a letter of May 13, 1625 to his friend Nicolas-Claude Fabri de Peiresc, describing the wedding ceremonies of Henrietta, Marie's older daughter, to Charles I of England, which doubled as a ceremony for the opening of the Luxembourg Palace Gallery:

> His Majesty showed complete satisfaction with our pictures, from the reports of all who were present, particularly M. de St. Ambroise. He served as interpreter of the subjects, changing or concealing the true meaning with great skill.[128]

The point here is not to distinguish "false" allegory from "true" history, but to focus on the functions of allegory. Rubens's control over his version of history is limited, a limitation analogous to the limits of Marie's control over the course of events and their interpretation. It is hard to say if Rubens, given free reign, would have represented historical truth by other means than allegory, or if in some other context than the commissioned series he would have told Marie de' Medici's story from another point of view than that of his own concern and irritation over the dynamics of royal patronage.[129] But even as one refrains from such a judgment of Rubens's own claims, one may analyze the process of allegorical dissimulation.

The presence of critical reflection in dissimulation becomes evident when one compares Rubens's *The Triumph of Truth* with *The Full Reconciliation (with the Son after the Death of the Connétable)* (Fig. 41), which immediately precedes it.[130] Their structure is similar, as if to suggest a certain analogy: just as Louis lifts up Marie in the one image, so Time raises Truth in the other. But the analogy contains a division as well as a contraction. In *The Triumph of Truth*, the couple have a double: Time and Truth are the living concepts abstracted from them only to serve as their sponsors; so Louis and Marie become citizens of heaven. On the other hand, Marie, amplified in the *Full Reconciliation* by the female allegories of Caritas (or Fecunditas Augustae), Providence (Royal Foresight), and avenging Justice (Iustitia Divina), has only one corresponding figure, Truth, in the later painting. This leaves Louis with few powers attributable to him, as he ages from the earlier to the later work and is there doubled by Time.[131] Unless Louis is simply to be considered weak (a suggestion that would weaken Marie in turn, and seems undesirable), this can only mean that powerful Time will be on his side, implying thereby Marie's mortality and advanced age and Louis's ability to rule without her influence, an implication present in Rubens's series from the very beginning in the image of the three Fates. Truth becomes an image of Marie, but her ambiguous "apotheosis" removes her directly from history, as is the case earlier with Henry IV in *The Apotheosis of Henry IV and the Proclamation of the Regency* (no. 13 in the series). Thus Rubens works through-

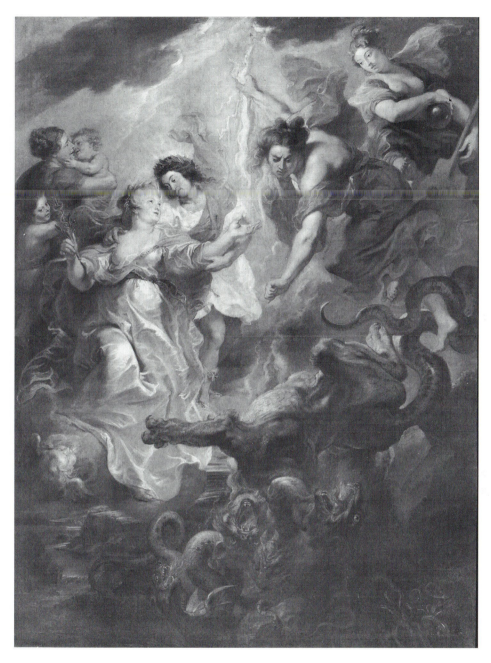

41. Peter Paul Rubens, *The Full Reconciliation (with the Son after the Death of the Connétable)*, from *The Life of Marie de' Medici*, 1622–5, oil on canvas, 394 x 295 cm, Musée du Louvre, Paris.

out the series with two concepts of Time, one mythological, the other a rational factor of history. This dual practice implies critical reflection, it also dissimulates that reflection.

André Félibien understood or wanted to understand Rubens' intentions in *The Triumph of Truth* as an act of homage: "The painter probably wished to mark in this way the perfect and sincere union of Their Majesties." The 1710 album of engravings after *The Life of Marie de' Medici* includes the following similar description:

> The painter, desiring it to be understood that the misunderstanding, which had grown up between Louis XIII and Marie de' Medici, his mother, had come about only through false reports, he represented in this picture Time who uncovers Truth while the King and the Queen, who had been taken unawares by the malice of men, become reconciled before heaven.[132]

This description makes use of the analogy, suggested by Rubens himself, between the cycle's last two paintings (before the final *The Queen Triumphant*, no. 24) in conflating the detailed allegory of *The Full Reconciliation* with the relative abstraction of *The Triumph of Truth*. Either commentator safeguards decorum in his own interest by locating the decorous version of events in Rubens's wishes and desires. Since, however, it is quite conceivable that the royal "misunderstanding" was welcomed and exploited by others, it appears that all parties involved – patron, intermediaries, artist, commentators – practice dissimulation while also proposing something they consider a worthy record of history.

The darkness of Rubens's *The Triumph of Truth* is striking. Truth is never quite lifted out of it, though illuminated from above. This darkness is barely differentiated as a location. Rocks are discernible in the lower left corner, but there are no personifications of evil. Rubens here returns to the earlier, Renaissance iconography of *Veritas filia Temporis*, relying on the iconography of Christ in Limbo, where Truth emerges "from the ground," as in Psalm 85 ("Veritas de terra orta est"). Perhaps meaning to make a joke of a kind unpopular today, Saxl points out that Time looks as if he were having difficulty in lifting up the somewhat stout Truth.[133] This difficulty and its solution through chiaroscuro may also be taken as an irony in Rubens's style analogous to the irony in Bernini's ruinous support structure for his *Verità*. Relevant to both observations is Heinrich Theissing's discussion of baroque chiaroscuro in relation to time. Accepting a Baroque "conflict with time," the tendency to emphasize its destructive over its constructive power – Rubens's dark earth, or Bernini's ruins – he suggests that chiaroscuro painting represents a temporal hovering between the two powers.[134]

But in Rubens's *The Triumph of Truth* there remains something of a vacuum or a cleft, in that as Time's constructive power neither counterweighs nor revokes his destructive power, as it does in Bernini's design for his *Verità*. To the simplicity of the earth below correspond "Their Majesties" above, thus indicating "the demands of some specific, genuine human situation."[135] Here Time has effectively replaced Divine Justice, unless one considers the entire series to constitute the specific demand for divine justice, a demand whose fulfillment remains an open question. For one

can imagine Truth passing the royal couple on her way upward to the light that illuminates her from an invisible source above.

In the 1603 Rome edition of Ripa's *Iconologia*, one reads in the first of three entries on "Verità": "A most beautiful nude woman holds. . .under her right foot a globe of the world." Ripa then moves from the classical locus to "the truth of the Christian faith" and ends by explaining: "The world under [her] foot denotes that she is superior to all the things of the world, &. . .is something divine. . .is a citizen of heaven."[136] This definition is clearly represented by Bernini's sculpture.[137]

In Pers's corresponding entry one reads that "under her right foot she is to have a celestial globe." Despite this change from "globo del mondo" to "Hemelsche globe," Pers retains the final paragraph, with a slight adjustment in his translation, particularly of "cosa divina" as "geestlijcke saecke": "The world under her foot means that she is higher and worthier than all the goods of the world, whereby she is something spiritual."[138] Whether intentionally or by negligence, Pers removes Truth even further from the earth by taking literally Ripa's reference to Menander's epithet of Truth as a citizen of heaven ("een Burgerinne van den Hemel"). He christianizes the reference by changing Ripa's "among the gods" ("tra' Dei") to "next to God" ("neffens God"). Both entries are illustrated very similarly with a woodcut (Figs. 42 and 43) representing naked Truth. She steps upon a globe with indeterminate land masses, gazes up to the radiating sun she holds in her right hand, and displays in her left an open book, which refers to the truth of things to be found in books. A palm frond refers to the inevitability of truth because "just as the palm tree does not give way to any pressure, so Truth does not give way to any adversity."[139] The other entries on "Verità," or "Waerheyt," repeat the attribute of light and add the hour-

42. *Veritas*, woodcut from Cesare Ripa, *Iconologia*, Rome, 1603, 12.5 x 8.5 cm, p. 500, Bryn Mawr College, Pennsylvania.

43. *Veritas*, woodcut from Dirck Pietersz. Pers, *Iconologia*, Amsterdam, 1644, 8.2 x 5.8 cm, p. 589, Bryn Mawr College, Pennsylvania.

glass of Time and the balance of Justice. There is only a single reference in which Truth is "also called a daughter of Time." To this Ripa and Pers add, with varying elaborations, that "in the Greek language she has the significance of something that is always evident and that cannot remain hidden."[140] This last addition binds the topos *Veritas filia Temporis* once again to the classical tradition. Neither the prevalence of Truth *over* the world (in the Christian sense) nor *in* the world (in the Greek sense) is represented in Rubens's *The Triumph of Truth* but rather a mixture of both, ambiguously serving the same historical demand.

Poussin

It has been said that the temporality of Poussin's art, of his classicism, is often that of a moment of dwelling on and persistence in the represented idea.[141] How, then, does his depiction of *Veritas filia Temporis* deal with several tenses? How does his *Time and Truth Destroying Envy and Discord* of 1641 (Fig. 44) compare to Rubens's ambiguous chiaroscuro rendering of the same topos?[142] It does not belong to a different concept of the power of allegorical art, but rather to a different concept of time in relation to space. Poussin does not offer an anticipated future evidence of the past in any precise historical or political sense. Indeed, he offers a present in which Time and Truth, illuminated from above, rise freely in the air, leaving Discord and Envy behind. Time is intent on lifting Truth up, while she raises her hands and face toward the unseen source of light. Discord gazes up after them, while Envy, supporting his head with his right hand, laments their departure and his powerlessness. Conceived as a ceiling painting, Poussin's image constructs an illusionistic *di sotto in su* pictorial space. Envy and Discord are closer to the beholder; they are seated on the architectural crest framing the illusionistic opening of the ceiling in Cardinal Richelieu's library for which it was originally painted. Behind them, the rocks of the earth are visible. Time and Truth appear to be rising from the space between these rocks, past the figures of Discord and Envy. These crouching figures blend in well with the rock formations behind them, with which they are closely associated in both form and color. The light toward which Time and Truth are moving ever so slowly falls on Discord and Envy but also falls past them, presumably into Richelieu's library. No darkness can be seen or inferred, so that the library could not to be mistaken for an abyss. The strongest shadows are cast by Discord and Envy. The solemn gestures of Truth, the coloristic luminosity of the sky and of the figures whose hierarchy it enhances through gradations of value, and the literalness of naked Truth (with which Gustav Klimt would shock his Viennese audience 250 years later) – all these characteristics contribute ultimately to honoring the location of the painting. Truth, it appears, was never concealed on or by the earth; she has always been evident, even before she was lifted up to her rightful place "among the Gods," or "next to God," as Pers has it.

Poussin subtly mediates the Christian and classical traditions of the topos, thereby paying homage to his patron, dignifying the cardinal and his library. This mediation is borne out by Poussin's inclusion of the attributes of Time described in Ripa's *Iconologia*, which are significantly absent from Rubens's *The Triumph of Truth*. Somewhat above Truth, a putto balances two objects, the sickle for Time the Destroyer and the snake biting its tail for Eternity. The putto's balancing gesture and elevated position

44. Nicolas Poussin, *Time and Truth Destroying Envy and Discord*, 1641, oil on canvas, diameter 297 cm, Musée du Louvre, Paris.

in the allegorical configuration may be related to the divine justice of Psalm 85. The attributes thus designated to be equal make Time's simultaneously constructive and destructive agency a counterpart to eternity. The sickle may be related further to Time and Truth's victory over Envy and Discord and the snake of eternity may be related to the self-evidence of Truth at all times. Poussin offers the interpretation that Richelieu, from his library, is capable of perceiving Truth despite the presence of Envy and Discord, and thus is untouched by them. They are no more than a minor disagreeable obstacle, to be watched carefully; but he can always see past them. This spatial and temporal continuity from the implied viewing space to Truth and her destination is one important difference between Poussin's painting and both of Rubens' paintings, *The Triumph of Truth* (Fig. 40) and *The Victory of Truth over Heresy* (Fig. 39). Rubens's *The Triumph of Truth* resolves its tensions when seen in relation to the rest of the cycle, whereas Poussin's *Time and Truth Destroying Envy and Discord* appears as an autonomous allegorical representation, independent of other images and applicable only to a reality outside of the work of art, a reality merely suggested through its spatial construction. Thus Poussin's painting appears to achieve what theorists of alle-

gory from Winckelmann to Benjamin (with the exception of Burckhardt), considered impossible: a complete and autonomous allegory. But it is precisely because of these theories that Poussin's subtle construction of allegorical authority can be understood as such. Allegory's authority is "borrowed," according to Hegel, but that borrowing is hardly discernible here. The reason for this is that it is a double borrowing: first, from an unseen, absolute divine light and second, from the unseen Richelieu. The first is represented in terms of spatial construction, light, and color; the second is implied as the imaginary mirror of the first by the same spatial construction. The two lenders of authority sustain each other. Inasmuch as Time functions as the editor of history, possibly Richelieu's history, in the service of Truth, it is clear that the version of history Poussin offers originates from Richelieu's library, honoring the cardinal without dishonoring Truth. There may be an element of this technique in Rubens's *The Triumph of Truth*, because of the suggested correspondence of Truth to Marie de' Medici (or even their conflation) and because Time may be seen to accompany Louis in the end. But by representing Truth as seen from a certain perspective, Poussin maintains a distance not implied by Rubens, a distance that may or may not be critical.

"Cold Justness" and "Divine Justice"

The significant comparison is less of Poussin's to Rubens's tactics with regard to their patrons; both were skilled in identifying and preserving their interests and integrity. Rather, let us examine how Vermeer's *The Art of Painting* compares to these paintings by artists of whom Vermeer certainly knew and with whom he had in common both Ripa's *Iconologia* – in Pers's translation – and, more generally, a consciousness of the problem of historical representation. Significant, too, of course, is what he did not have in common with them, namely, the public Roman Catholic environment and the patronage of court aristocracy. This, however, can also be said of van den Vondel, whose conversion to Roman Catholicism has been thought to inform his forceful treatment of the theme of rebellion. At the heart of our inquiry here is this question: Does Vermeer's painting have the autonomy only suggested and simulated in Rubens and Poussin's paintings? And can Vermeer's autonomy be interpreted as the freedom to suspend history? The model and "Clio herself"; the painter with his eagerly pursued, limited goal, the painterly style of representation that seems to assert itself against the authoritative voice of allegory – these things are determined by Vermeer alone, or so it seems: that may indeed be the most powerful illusion sustained by *The Art of Painting*.

In view of Schama's strong argument for the Dutch burghers' concerted effort and success in building up a certain cultural self-image, outside of which it would be difficult for an artist to work; and in view of Montias's account of the social ambitions evident in Vermeer's family history and epitomized by the artist himself, it is not conceivable that Vermeer was autonomous in the above sense.[143] More probably his solution is not quite as far from those of Poussin and Rubens as it might seem. The fact that for various practical reasons, and possibly out of conviction, he had converted to Roman Catholicism, a denomination without a powerful institution behind it in the northern Netherlands, does not necessarily speak against this assumption. Vermeer's style and his avoidance of privileging any particular one of

the historical clues he provides in *The Art of Painting* may be too easily abstracted as a conscious refusal to conform.

It has been suggested that the position of "Clio" in front of the map associates her with Philips Angel's identification of Pictura with both the shielded Minerva and the unassailable Dutch Maid in the enclosed Dutch garden represented in the frontispiece to his *Lof der Schilder-konst* of 1642.[144] This association casts an ironical shadow on the paradigm of the Dutch maid as well as on Vermeer's "Clio," if one considers the pastoral wreath on "Clio's" head, her lowered gaze and unreadable face, and also her erotic appeal in the eyes of quite a few scholars. However, this association is not the only one possible. Hedinger has convincingly argued that the paradigm of the Dutch maid is used by Dutch genre painters when they combine a map of the province of Holland with a domestic scene that focuses on the role of women in the house. She also suggests that maps of the seventeen provinces are used as a foil for domestic frictions.[145] This second possibility may be extended to include the painting at hand. Again, it is instructive to think of these interpretations in the actual experience of viewing *The Art of Painting* and the different points of view implied by it. The ironically deflected comparison of Vermeer's "Clio" with the Dutch maid, and also with Pictura–Minerva is possible only from the beholder's primary and conventional central viewpoint, but from neither the painter's point of view to the right nor the point of view suggested by the anonymous figure to the left, who lifts the curtain. From the painter's viewpoint "Clio" seems to exit the garden of the Dutch Republic. From the curtain's viewpoint, the woman who is also a model appears detached from the map, turning her back to it and associating herself more closely with the objects and with the representational, fanciful curtain between the beholder and herself. On the one hand, she emphasizes the genrelike, commonplace aspect of her work as model, a commonplace that may be repetitive and lacking in any consciousness of history. On the other, she marks the contrast between the map's dated facts and the curtain's unknown subject.

The primary illusion of irony is self-conscious sovereignty. It is in this sense that seventeenth-century dissimulation may be called a form of irony.[146] Clearly, the multiple viewpoints and clues and the double level of representation in Vermeer's *The Art of Painting* relate to a consciousness on his part of possibilities and choice. But this consciousness, even when it is called ironic, may just as well be an expression of indecisiveness, of a feeling of uneasiness in the absence of the kinds of public authority Rubens and Poussin had to deal with and could reflect upon; a feeling of uneasiness in the vacuum of Dutch Protestant tolerance in the arts and in the face of a self-regulating art market of specialization, competition, and bourgeois patronage. That this range of possibilities hinges on their construction through perspective links Vermeer with Poussin; that these possibilities refer to concrete facets of history links him, albeit rather remotely, with Rubens. Theissing, referring to Elias and Spinner, discusses the standardization of space and perspective in Renaissance painting as a standardization of pictorial time.[147] Both Poussin and Vermeer achieved a temporal precision through the subtle, thematic use of perspective and optics, but did so with very different results. For Poussin this implies a gesturing toward a self-conscious and perhaps critical distance from his representation; for Vermeer it permits at once the avoidance and the possibility of representing history in painting.

There is no reason to suppose that Rubens, Poussin, or Vermeer could conceive of representing history and its truth directly. But evidently Rubens succeeded in representing his patron's and her advisor's will as his own "wish," and Poussin detached himself from his representation. Vermeer succeeds, to a considerable degree, in imbuing suspension, stillness, and even precious inertia with a sense of knowing deliberateness, as is attested to by the scholarship on *The Art of Painting* and other works, including the very ironical interpretations of Proust and Vaudoyer (stemming from their literal identification of Vermeer with the painter), who say that the creator of this painter painting "Clio" did not care about posterity.

Let us assume for a moment that in fact he did not care about posterity. The reasons for this are not to be found in the sense of futility presented in Hoogstraeten's frontispiece for book 9, "Urania," where Urania's shield, with a *Vanitas* still life, protects the art student–beholder from a too-eager identification with the painter who climbs the ladder to the stars, and from a foolish, worldly ambition (Fig. 34). The reasons must be sought elsewhere. This painter cannot see beyond what is currently before him. From his angle in *The Art of Painting*, the model almost seems to exit the room, moving away from the map and its contents, the seventeen provinces. Even from a central viewpoint, the unity of the Netherlands in the map is not an unambiguous analogue to the painter and the model. The dualism of painter and model prevails, as does that of the northern provinces and of Flanders, before which the two figures approximately stand and sit, respectively. It prevails in part because of the many other dualisms in *The Art of Painting*, described earlier.

While Vermeer's remarkable painterly unity allows for several viewpoints, it may also be said to be incapable of a single viewpoint. The emptiness of the central axis regards "Clio herself." In Rubens's *The Full Reconciliation* the allegorical figures succeed in reinstating Marie de' Medici almost to the point of making Louis the beneficiary of her providential return, rather than his leading her back into the company of royal virtues. And in *The Triumph of Truth* the central axis is everything: its allegorical figures make the Queen Dowager accept the kneeling Louis's petition for unity, so that in his 1626 description of the series Mathieu de Morgues could speak lapidarily of "two hearts reduced to one."[148] In both paintings Marie de' Medici appears to dominate and her position triumphs as Truth – as long as one does not consider the ambiguous role of Time – precisely because the progress of history toward the better is "dislocated" (Burckhardt) from the historical figures into the allegorical figures. These do not appear to act in the name of Marie and Louis, but rather in the name of yet another authority, who lends them their subjectivity (Hegel) and who imposes on them "the task of their role" (Burckhardt). It comes as no surprise that the figure at the very top of *The Full Reconciliation* has been called France, an abstracted national identity, although she bears no resemblance to that figure as represented in several other paintings in the Medici Cycle.[149] This identification expresses the beholder's wish to give a name to that ultimate authority who represents a secular concept of state.[150] The "[p]erfect unity between the King and Her Majesty" (de Morgues) occurs under the aegis of this abstract authority. In *The Triumph of Truth*, Time may be seen to bond with Louis in this sense, as his striking attire and sudden maturity may indicate.

By comparison, even if Vermeer's "Clio" is associated with the map in the manner of the Dutch Maid, when seen from a central viewpoint, she has already left

the "Hollandse Tuin" for Flanders. And from the painter's point of view she seems to have left the latter as well. A copy of the actual prototype of Vermeer's map is extant; studying it, one discovers that the cartouches near its left edge are placed on the border with France, and between them we can read the inscription GAL-LIA.[151] To be sure, these letters themselves cannot be seen in Vermeer's painting. Here as elsewhere, when "reproducing" a map, globe, or painting, he prefers ambiguity to legibility. And yet, as from the painter's perspective the model figuratively crosses the border to France, she brings to mind the several French invasions of the Netherlands during the late seventeenth and early eighteenth centuries, under Louis XIV; the first of these (1672–8) effected the end of Vermeer's career, according to his widow, Catherina Bolnes. Following this line of thought we may recall Napoleon's "reunification" of the Netherlands as the Batavian Republic in 1795; of its transformation into first a French, then a Nassau–Orange monarchy, dissolved in 1831, and so forth. This is to say that in its subtle indecisiveness *The Art of Painting* brings more readily to mind the history of the Netherlands after Vermeer than that of his own time. This is the history eclipsed in many modern accounts of the golden age, which is decidedly *not* the thematic focus of Vermeer's painting.

But whereas Rubens links Time's agency in *The Triumph of Truth* with Louis's growing maturity, Vermeer, in this and most of his paintings represents youth. The incomplete picture on the easel may be seen to suggest formally to the beholder the task of ordering the historical clues provided by Vermeer. Its relative emptiness corresponds to the relative emptiness of *The Art of Painting*'s central axis. These clues do not lead to a specific version of history to be remembered, and in the end, the beholder may well be distracted by the observation of traces time leaves on objects. These traces appear either as a visible aging process – the cracks and creases in the map – or simply through the evidence of disuse – the abandoned studio props on the table. Some of these props are impossible to identify with certainty. In this sense they are lost to the beholder's effort to order the historical clues. The United Provinces on the wall do not correspond directly to any invoked authority other than a spatially and temporally dispersed, individuated audience.

"It is therefore rightly said of allegory that it is frosty and cold," observes Hegel echoing, perhaps coincidentally, a reference that recurs in early monographs on Vermeer to the "coldness" of his art. It is at least striking that "coldness" was so often attributed to the artist whose allegories have been understood as antiallegories. Commenting on Vermeer as a truth-teller and on his modernity, Philip Hale, for example, speaks of his "coldly exquisite sense of the right thing for the right place," of "this cold quality of rightness to the full," entailing "something of the hatred" for "those who are right."[152] The "cold quality of rightness" in Vermeer stands over against the invocation of Divine Justice in Rubens and the balance of self-evident Truth implied in Poussin. Believing that "[n]o amount of good work is forgiven if it is cold," Hale suggests that "Houbraken, the gossiping old Vasari of Holland," omitted Vermeer from his record of Dutch painters because "[p]erhaps the men had quarrelled." For a "reputation is made because one man, in print, says another man is good; or nowadays, when he says he himself is good, as did Whistler."[153] Hale's idea that art history doles out punishments presupposes that the notion of Clio, the muse of history, is completely rationalized, and reveals a considerable distrust of art critics.

According to Hale, Houbraken judged that Vermeer somehow did not deserve to be remembered in a book that, quite unusually, included female painters as well as male, not only in its text but even in its title.[154] This would seem to suggest that all painters were included.

Vermeer took unusual care in the representation of objects, both in their relationships among themselves and to the figures they surround. This care extends to these figures themselves, mainly women, though also a few men. This feature of his style invokes a different kind of history in which things, their appearance, and their relationships, come to represent social experiences. We saw this first when examining Vermeer's genre paintings and now can see it in *The Art of Painting*. The painter in it is portrayed as a pedant, who depicts "Clio" and fame as a thing, a disorderly, pastoral laurel wreath. If "Clio" appears about to exit to the left, or to be hidden by a curtain lifted only momentarily, this carefully represented wreath may be all that remains of her, a still life. That things have a history of which they speak, if considered as representational, is an insight of twentieth-century art criticism, following from research on the representational functions of emblems and objects in still-life painting. As we have seen, it is also an insight anticipated in the art of nineteenth-century France. Vermeer's interior in *The Art of Painting* may well speak of social status and social ambition, as Montias and others have noted, in deemphasizing the painting's allegorical mode. But more important is that it speaks of a shift in the concept of history, a shift away from human agency and toward representation, observation, contemplation, reflection. The painter's model may neither have lost nor avoided "the game of staring" – as Gowing has it – but may instead prefer to look over the objects on the table. As studio props, these things bear possible meanings, but it is not clear that they are only the possibilities of historical subject matter. If this is already the case with the mask and the upright book, still life objects open to existential as much as historical reflection, it is certainly true of the undefinable luminous object on the table, aligned with the model's unreadable, luminous face. Huyghe has suggested that the unreadability of faces in Vermeer's art relates to their being represented as pearllike objects, precious, suggestive, indeterminate.[155] Much scholarship on Vermeer expresses delight in this unreadability, which it takes to be a space of interpretive freedom. It is apparently useless to resist this invitation. But I believe it is also wrong to historicize it as Vermeer's intentional resistance against allegory.

Chapter 12

Vermeer's *Allegory of Faith*

"Vermeer made only one mistake, the painting traditionally known as the *Allegory of Faith*. This painting is an impressive tour de force, beautifully painted, with a fascinating iconography, but as a work of art it is a failure."[156] This judgment by Arthur Wheelock summarizes a widely held opinion about Vermeer's *Allegory of Faith* (Pl. VIII). During a recent visit to New York such an opinion was given spontaneous expression by one of my students – a declared admirer of the aesthetic quality of all other Vermeer paintings: "Okay, here is your typical fat lady. . . ." Her description was interrupted by the laughter of onlookers, one of whom asked: "Someone you know?" Both description and interruption point to one of the central problems in the recent history of the painting's reception, namely, the problem of perceiving the allegorical figure as an individual. This perception, its implications and consequences, are the subject of this chapter.

Critics as diverse as Swillens, Berger, de Jongh, Snow and Montias have given Vermeer's painting serious consideration, treating it as a strange pictorial fusion of Ripa's representations of the New Testament and Catholic faith, and seeing it as a failed work of art. In their view, the painting's failure is double.[157] A close reading of these authors reveals how the painting was and still is considered offensive and challenging in a double sense: first, because it violates an ideal of "Dutchness" established in part by the seventeenth century and in part by its nineteenth- and twentieth-century historians; second, because it appears to challenge certain conventional assumptions about allegory, as well as traditional concepts of allegorical representation, such as the mutual exclusion of allegory and art examined in the previous chapters.[158]

For me, the considerable challenge lies in interpreting art and allegory – or even art as allegory in Vermeer's *Allegory of Faith* – in the ways used for *The Art of Painting*. If we start from the broadest commonality that both paintings are not first art and then also allegory, or first allegory and then also art, but allegorical representations, then it should be possible to arrive at an account of Vermeer's *Allegory of Faith* as a work of art about allegory, not one for or against it.

To do so, let us investigate some facets of the noted and notable offensiveness of *Allegory of Faith*, by reclaiming the instructive and difficult relationships between Vermeer's painting and some supposedly unproblematic Roman Catholic representations of allegories and triumphs. Emphasis will again be on the various concepts of allegory that may be brought to bear upon Vermeer's painting, as well as be seen at work in it. I shall, furthermore, relate these to Vermeer's device of the picture within the picture and to the differences between his use of the device and Rubens's use of it.[159]

To begin with, the rejection of or interpretative impatience with Vermeer's *Allegory of Faith* is linked to the experience of the concreteness and foreignness of this painting in general and of the represented woman in particular. The figure of the woman is not self-contained; she creates no havenlike chamber out of her surroundings. On the contrary, she seems to disappoint the expectations of nourishment that Vermeer's women promise, according to Gowing's, Snow's, and Pops's monographs. Pops, for example, explains how such expectations are prompted by the Marian, motherly, "good" Roman Catholic properties of the single woman in paintings such as Vermeer's *The Milkmaid*, or *Woman in Blue Reading a Letter*, an interpretation he justifies in part by appealing to Vermeer's own documented Roman Catholicism.[160] Such an interpretation, however, is challenged by *Allegory of Faith*, the one painting by Vermeer with an outright Roman Catholic subject. It is ironical that a figure of Faith should be the one to shatter these hopes for and belief in a world of womanly wholeness and in the goodness of Vermeer's women, to ruin them in the process of allegorical unfolding. Not surprisingly, it is Pops once again who expresses his dismay most strongly when he discovers "pollution, not desecration," and "a lesson for lovers in the anxiety of Faith's wild turning." In the end he calls the painting a "nightmare of anxiety,"[161] in his rejection underlining unwittingly what Benjamin considered the "evil" side of the utterly subjective, negatively self-asserting, melancholic interpretation of allegory.

Let us first return to allegory as discussed within a context of offense, remorse, and persistence.[162] In *The Origin of German Tragic Drama*, Benjamin initiated the reconsideration of the Baroque concept of allegory and its temporality in precisely such a context.[163] He emphasized, for instance, the relationship between cultural retrospect, mourning, ruin, and allegory, and drew attention to the basis of the classicist prejudices against allegorical and emblematic images.[164] Against the prejudice that allegory might better be written out than pictured, a prejudice that informed even Winckelmann's reinstatement of allegory, the 1766 *Versuch einer Allegorie*,[165] Benjamin argues that the Baroque period held on fiercely to the allegorical configuration as a subjective manifestation of inherited beliefs, behavioral commandments, and ethical concepts, both classical and Christian. Through this existential positioning of allegory in the Baroque period, by inserting the allegorical image into the process of an all-encompassing natural history of decay,[166] Benjamin accounts for the disappearance, disintegration, and foreignness of the past and of symbolic art, as well as for the negativity of allegory. "Natural history" is the positive formulation of the doubly negative judgment Benjamin had inherited from Winckelmann and Hegel, namely, that the allegorical image is both arbitrary and cold, because lacking in subjective consciousness and agency. These qualities may only be borrowed and, indeed, *must* be borrowed for there to be allegory. "Natural history" is Benjamin's term for describing

natural decay in relationship to chronological, rationalized, secular time, in contrast to either Christian history of salvation or mythological Time, the destroyer who delivers Truth. But, as we saw in the course of interpreting *The Art of Painting*, the negativity of allegory may yield a celebratory representation of the world of things, even when it is born from crisis, the very lack of a centering idea.

If we assume, as many have, that Vermeer's *Allegory of Faith* inhabits a space somewhere between Dutch Protestant and Flemish Catholic history painting, it is useful to study the discourse on allegory by examining examples from both areas in their relation to one another and in their representation of time. Both Catholic and Protestant images take the Triumph of Faith as their subject, a theme represented also in Vermeer's *Allegory of Faith*. Thus we may elucidate some of the ways in which Vermeer's *Allegory of Faith* has given particular offense to those viewers who welcomed the negativity of allegory in his *Art of Painting* to the degree of overlooking it.

Triumphs of Faith

The loss emphasized by Benjamin as essential to allegory in Vermeer's time formed from early on a key part of the discussion of secularization and subjectivity in Dutch art, particularly in the Hegelian discussion of it. Rubens scholarship has sometimes been informed by similar perceptions. In Otto van Veen's series of paintings called *The Triumph of the Catholic Church*, dated 1610–20, two aspects of the work have been criticized by its earliest commentator, the Viennese Franz Martin Haberditzl, in 1908: first, the inscriptions of concepts next to the respective figures, which name them; second, the parchment labels with Latin explication of the represented triumph attached to each painting.[167] These inscriptions and labels are said to render the series "lifeless" and reveal the artist's "lame imagination." In contrast, Rubens, van Veen's pupil, always "dissolves the addition of figure and symbol in action, which more than any explanatory text enlightens us as to what is at stake."[168] To illustrate these judgments one may contrast Rubens's tapestry modello *Triumph of Faith* from the *Triumph of the Eucharist* series of 1625–8 and van Veen's *Triumph of Faith*, the sixth and final painting in his series (Figs. 45 and 46).[169] In order to understand these judgments a closer study of van Veen's series is necessary. Here, I will focus on the *Triumph of Faith*.

Van Veen's series of six paintings represents a triumph in the Petrarchan tradition, extending from right to left. In each painting a triumphal car is drawn by a team of four horses through a wide-open, scenic landscape, led by allegorical figures and followed by historical and biblical figures, accompanied – in four of the six paintings – by angels and putti who populate the air and the clouds, holding banners with inscriptions. The allegorical figures themselves hold scrolls, books, and tablets with inscriptions. Although these objects are attributes, their inscriptions are disproportionately large and thus appear to address and inform the viewer directly. In addition, all six paintings are furnished with pieces of parchment with lengthy inscriptions, by now mostly illegible, pasted along the bottom edge. On the triumphal cars in the first four paintings we see representations of Roman Catholic doctrine, or tradition, in the form of figures engaged in dispute, as may be inferred from their rhetorical gestures, the attention they focus on each other's faces, and the

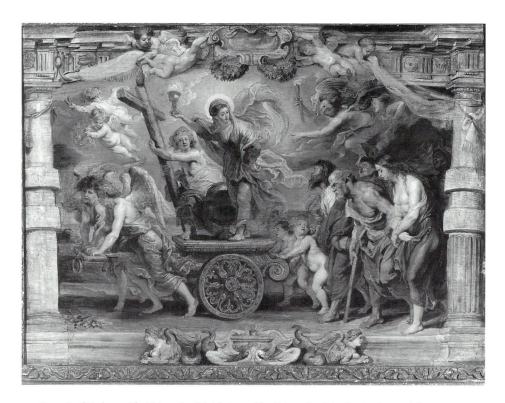

45. Peter Paul Rubens, *The Triumph of Faith*, from *The Triumph of the Eucharist*, modello, 1625–8, oil on panel, 63.5 x 89.5 cm, the Mr. and Mrs. Emile Tournay-Solvay Bequest, Koninklijke Musea voor Schone Kunsten van België / Musées Royaux des Beaux-Arts de Belgique, Brussels.

inscribed objects they point to. In the last two paintings, dispute is replaced by biblical *exempla*, which are subordinated to and centered upon texts and their didactic presentation. A continuity among the paintings is achieved through the uniform depiction of the triumph in the foreground and of the landscape, as well as through the recurrence of allegorical persons. The triumphal procession, however, does not continue from frame to frame in the manner of certain early Netherlandish altarpieces, where figures or drapery might be split between two panels, as, for example, in Rogier van der Weyden's *Crucifixion* (Philadelphia Museum of Art). Instead, certain figures are cropped by the paintings' vertical borders. The current hanging of von Veen's paintings arranges them according to a perceived order of doctrine.[170]

In the sixth and final painting, the *Triumph of Faith*, the figure of Faith, dressed in blue and purple, carries a bare wooden cross over her right shoulder, while holding a tablet inscribed *consubstantialis* in her right hand. This refers to the central article of the Nicene Creed of A.D. 325 (Nicaeum Symbolum), shared in the Reformation period by Roman Catholicism, Lutheranism, and Calvinism alike, that Christ is essentially of one substance with God the Father. She is seated centrally on the triumphal car, turned toward the beholder, rather than in the direction of the procession.[171] She is flanked by several interlocked *exempla*, one of which, on her right, is the scene of Abraham's Sacrifice, frozen in the climactic moment of divine intervention. Lying flat upon his stomach on a cloud and apparently accompanying the tri-

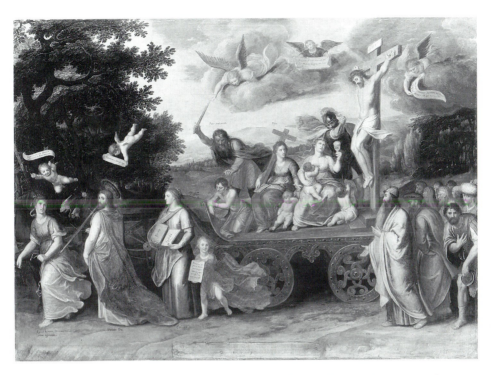

46. Otto van Veen, *Triumph of Faith*, from *The Triumph of the Catholic Church*, 1610–20, oil on panel, 76 x 106 cm, Bayrische Staatsgemäldesammlungen, Schloß, Bamberg.

umphal car in this way, the rescuing angel touches Abraham's poised sword with the tip of his finger. This scene is captioned "The Father is to be trusted" ("pater credentium"), referring to both Isaac's filial trust in his father and Abraham's trust in his god. From Faith's mouth issue the words "For you I live" ("Per te vivo"), as she raises her eyes to the life-size Christ on the cross to her left, thus giving the New Testament exemplum priority over that of the Old Testament. The cross stands on a pedestal at the rear of the car, so that Christ oversees its passengers. Faith points to the group of figures between them, a seated woman with two infants at her feet, nursing a third, and holding up a chalice with the host, while she looks up less confidently to Christ on the cross. The chalice is an attribute of Faith; the children are an attribute of Charity. The woman's mixed identity is clarified by the figure standing behind and between her and Christ. A soldier with raised sword or dagger, he is an antithetical motif to Abraham, a reference to the Massacre of the Innocents. The two infants on the ground react to his threat, one of them crying, the other gesturing at the soldier. In this way the woman is identified as a Christian virtue, and at the same time as a character from the New Testament, and thus as a figure of salvation history.[172] The crowd following the car is not captioned, but seems to include a converted soldier as well as Mary and John. The setting for this final image is a partially wooded scenery with a village in the distance whose church spire points up, as it were, to Abraham's raised sword. Van Veen's series may be characterized as Roman Catholic, yet it is nonconfrontational by comparison to Rubens's *Triumph of the*

Eucharist tapestry series. Van Veen's identification of Faith by the cross she bears and the inscription *consubstantialis*, as well as the fact that she does not herself hold the chalice of holy communion, may be seen as gestures of moderation within the triumph. One might think of van Veen's series as standing in the Erasmian tradition of Christian humanism. The contrast between his series and Rubens's "vital" and "naturalistic" series lies, then, in their different receptions of the Renaissance as well as in their different responses to the issues of Reformation and Counter Reformation. The link between these two basically different approaches is established by the stylistic and rhetorical means the artists use to represent allegories of doctrine.

First made and then revoked by Winckelmann (*Reflections on the Imitation of Greek Works in Painting and Sculpture*, 1755; *Versuch einer Allegorie*, 1766), and then renewed by Burckhardt, the argument that in Rubens's art allegory is transcended by its, or his, vitality overlooks the fact that this vitalization is itself a form of secularization, however much its content may claim the contrary.[173] To locate Rubens's commitment in this process is difficult, as in a certain sense the commitment remains its invisible agent. One account might be that Rubens's professional detachment leads him to exploit his own talents in the fulfillment of an accepted commission. I will return to this possibility later. In van Veen's series such a possibility seems remote, since the triumph of doctrine appears to represent itself with moderation. It is only in certain ambiguities in the relationship of the triumphal procession to the natural setting and of its parts to the whole that the question of subjective conflict arises. It does so most notably in the detail of the cloud keeping up with the procession, so that the angel lying on top of it may eternally fulfill his role of intercepting Abraham's sacrifice of Isaac. Not at all ironical but involuntarily comical, van Veen's subjection of nature to allegory appears surprisingly unreflective, compared to the thoughtfulness of his representation of doctrine.

Marked by regret, distress, or praise, the arguments for Rubens and against van Veen conflate their own classicist concept of allegory, in which the allegorical figure should herself be the origin and agent of the concept she represents, with the specific rhetoric and content of these artists' allegorical triumphs. Vermeer's *Allegory of Faith* does not sustain such a narrative dissolution of allegory.[174] Neither a series of images, nor labeled, nor presenting an event unified by a vital force, Vermeer's allegory is a single image surprisingly close to Ripa's notion of a visual definition instigating a series of separate thoughts and reflections upon Faith, not intended to move the beholder toward immediate imitation. An understanding of the disparate nature of Vermeer's image is aided by Benjamin's account of Baroque allegory as essentially negative and as a mnemonic ruin.

It has been shown that one principle of Ripa's textual and graphic representations of concepts is that the allegorical figure is herself not meant to be an example of what she represents and refers to.[175] However, we have seen that Ripa himself deviates from this principle when, for example, he treats of the largely mythological Muses who are said to have an essential relation to what they represent.[176] But when dealing with strict concepts in Ripa, one must realize that the inherent contradiction of alternative attributes and the burden of bearing those attributes render the allegorical figure a mere structural coordinator of attributes and not the origin of the allegorized concept. We have seen that Benjamin's notion of allegory as personi-

fication (as in Dürer's *Melencolia I*) links these two functions in an emphasis on the melancholic disjunction of figure and objects, and on allegory as mnemonic ruin, as well as groundless critique. In Ripa's *Iconologia*, however, concepts are rarely simple personifications, but often contradictory or bizarre configurations meant to instigate a series of alternative thoughts, not one encompassing and immediate imitation. In his *Allegory of Faith* Vermeer has used Ripa's complex and alternative representations of Faith in ways that Benjamin's account helps us to understand.

Vermeer's Borrowing of Jordaens's *Christ on the Cross*

The basic differences between van Veen and Rubens's works and Vermeer's painting are evident in any attempt to account for the representations of the *Christ on the Cross* by Rubens and Rembrandt and their students. The minimalized drama of this subject is introduced by Vermeer in his *Allegory of Faith* in the form of a rather complicated borrowing of Jacob Jordaens's *Christ on the Cross* as a picture within the picture. Jordaens, one of the most important pupils of Rubens, converted to Calvinism and executed commissions for the Dutch court and the city of Amsterdam. While demonstrating an unusual Flemish connection in his citation, Vermeer favors the exemplum of the motionless Crucifixion over the dramatic one of Abraham's sacrifice. Both scenes are suggested by Ripa as biblical references within a representation of Faith: both are references to the practice of faith. That is to say, they are exactly what the female allegorical figure of Faith herself is not: examples to imitate.

Vermeer's borrowing includes aspects from three of Jordaens's four very similar versions of the subject, painted between 1617 and 1625.[177] It is usually assumed that Vermeer quoted Jordaens's *Christ on the Cross* (Fig. 47) in a private collection in Antwerp.[178] It is a painting that Vermeer may perhaps have once owned, but even if he did there is no reason to assume its faithful transposition into his *Allegory of Faith*.[179] I should like to begin the analysis of Vermeer's reference by investigating further those elements of the iconographic tradition manifested in Jordaens's painting of which Vermeer could have been aware.

The Christ figure introduced in Rubens's Antwerp *Raising of the Cross* is a type that one might call the hanging Christ, his eyes turned up and his arms reaching heavenward.[180] Through Rubens's adaptation of the Laocoön for his rendering of this type, Christ appears to be accepting, if not longing for death: while his soul is devoted to suffering, his body is idealized.[181] He differs from another type, seen in Rubens's *Coup de Lance*, who suffers proudly, his physical strength and youth seeming to triumph over the Crucifixion even as it happens.[182] Only the head is bent in humility and fatigue. Rubens's *Coup de Lance* of 1620 is considered the primary source for Jordaens's several versions of the *Christ on the Cross*. Jordaens's Christ, with lowered head, is shown in a three-quarter view, so that from the beholder's perspective the foreshortened cross introduces a mediation of the two types described above. It does so in a manner not found in any of Rubens's paintings and engages the viewer's attention in the painting and a related print (Fig. 48) through the figure of John. John's pointing gestures mediate between the viewer and the crucified Christ, who is set apart, turned elsewhere, a solitary figure regardless of the many large surrounding figures. Jordaens omits the thieves as well as the action that gave

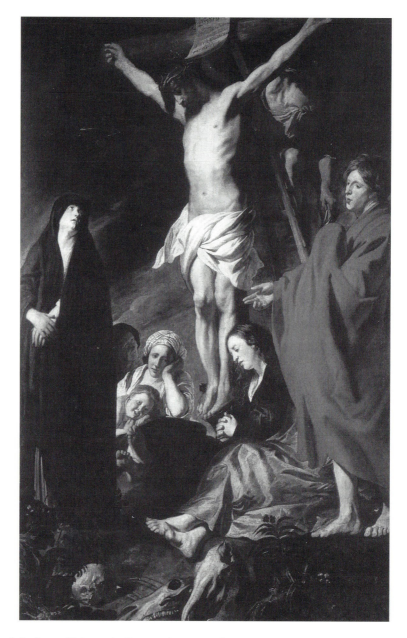

47. Jacob Jordaens, *Christ on the Cross*, early 1620s, oil on canvas, 310 x 197 cm, private collection, Antwerp.

Rubens's painting its title, thus moving the image closer to an *Andachtsbild*, or devotional image.[183] Jordaens's two versions of *Christ on the Cross* fit neither the art-historiographic scheme of Rembrandt's interiority nor that of Rubens's vitality. What does this paradigm mean for Vermeer's painting?

Jordaens's body of Christ is strongly illuminated by Caravaggesque lighting, that is, by a nearby yet unidentified source of light; but the lock of hair hanging on

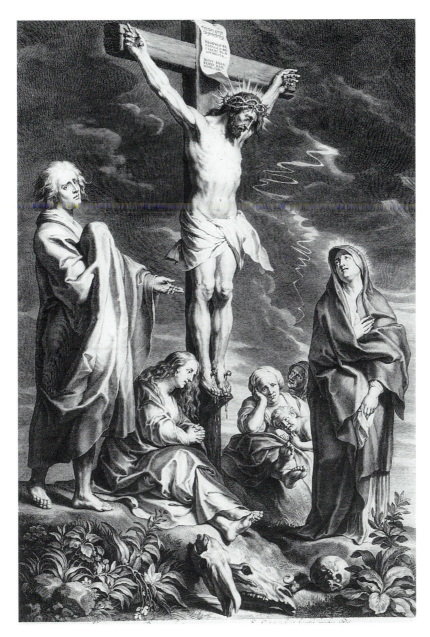

48. Schelte Adams Bolswert after Jacob Jordaens, *Christ on the Cross*, engraving, 61 x 42 cm, Stedelijk Prentenkabinet, Antwerp.

his forehead casts a strong shadow over his eyes. Vermeer, in his borrowing, obliterates the distinctions between the two types of Christ even further as, in conformity with his general tendency to flatten shapes, he turns Jordaens's Crucifixion, with the single exception of the head of Christ, into a distorted frontal view. The facial features, completely withdrawn and submerged in shadow, now appear as a dark silhouette against his strongly lit body and the cross. These changes strongly qualify

Vermeer's allegorical figure and configuration, enhance the tensions within that configuration, and emphasize the difficulty of the commemorative function of allegory in Vermeer's painting. The remoteness of Christ is remarkable. Similarly, the crucifix on the altar next to Vermeer's allegorical figure appears unfocused, a cipher for a Christ turned away from the entire scene. A brief glance again at van Veen's *Triumph of Faith* reveals that in his "lifeless" image, the allegorial figures of Faith and Charity are as real or unreal as their references, Abraham's sacrifice and the Crucifixion.

What Vermeer omits in his borrowing of Jordaens's painting is the Magdalene and the figure on a ladder behind the cross. Vermeer further reduces the action, thus enhancing certain of the composition's characteristics. John's two significant pointing gestures, to the crucified Christ with his right hand and to his mourning breast with his left, are emphasized by Vermeer, while Faith's gesture of placing her hand on her breast occupies the same axis. A third pointing gesture can be found in John's turning toward the beholder, as if to invite participation or recognition. Thus Vermeer neither conflates the realities of viewer, Faith's setting, and the quoted Jordaens, nor does he naturalize them as parts of one world. Instead, he presents them as coordinates in a very refined artifice.

This coordination is spatial as well as temporal. One might say that it is entirely in keeping with allegory's affirmative rather than its speculative role. Yet, as we saw earlier with Rubens's *The Life of Marie de' Medici*, this presumably assigned affirmative role left room for ambiguity and alternative possibilities. In Vermeer's *Allegory of Faith* the double gesture of pointing by Faith and by John serves to suggest and acknowledge the chronological anteriority of the borrowed Jordaens to the allegorical figure. But on another level of temporality, the reference object of pointing, the Christ on the cross, is very remote and withdrawn from Faith's field of reference. Faith and John's affect can only be intimated from their gestures, while the remote Christ appears beyond reach. Indeed, the very origin of their affect is beyond reach. This compositional structure and the painterly realization of withdrawal bring to mind Benjamin's emphasis on the specific temporality of allegory and mourning. There, as here, representational attention moves slowly from object to object, from attribute to attribute in an attempt to regain an intimation of the once presumably whole and now fractured concept of faith. The slow, attentive motion from object to object, from reference to reference, reflected and coordinated by the allegorical figure of Faith, is not only suggested by Vermeer but also enacted by him in the process of their carefully rendered, detailed representation. Only if one thinks of Faith as the originator of what is to be seen in this painting might one accept the association of it or her with "wild turning," as Pops phrased it.

Another tension within Vermeer's allegorical configuration results from the contrast between the clarity and reality of object references and the indirectness and remoteness of figure references. The figure of Faith can assimilate a painting that hangs behind her only formally, a fact that is emphasized by her appeal to the glass sphere suspended from the ceiling. Compared not only to Rubens but also to the Dutch tradition of Rembrandt and Steen – the temporal and spatial fusion of biblical narrative and seventeenth-century locality, personages, costume, and custom into one image – Vermeer's choice here is an antithetical one. It is the choice of a specific

coordination based on temporal sequence and spatial separation of primary and secondary image in order to convey a sense of phenomenal distance as referential distance. The appeal to the sphere is what opens up this configuration toward something either outside of it or reflected in it, but in either case something distant in both the phenomenal and referential senses. I shall return to this motif shortly.

The absence of Jordaens's original Magdalene in Vermeer's Jordaens – because Faith has, so to speak, taken her place – suggests a renaming of the figures seen in the borrowed painting. Vermeer uses the device of spatial and figurative replacement in Vermeer's *Woman Holding a Balance* (1664) (Fig. 49), a use that has led to art-historical controversy about whether the woman, standing in front of the Mannerist *Last Judgment*, covers or replaces the figure of the archangel Michael. This discussion gained momentum once it became known that the scales are actually empty.[184] Should one supplement this figure as present but unseen? Did Mannerist paintings such as the generic one paraphrased by Vermeer even include Michael? And what do these possibilities consequently suggest to the interpreter as the aesthetic, moral, or critical judge of the woman and the painting?[185] In this controversy the woman is often taken as a subject with a real identity, as a pregnant woman, and at the same time as the originator of her own stance and its meaning.[186]

One of several significant differences between the two paintings, *Woman Holding a Balance* and *Allegory of Faith*, lies in the nature of the imitative gesture. In the first painting the woman is actually steadying a balance, a momentarily suspended action appearing as an extension of her self-absorption, the content of which may be understood as some form of emulation of the Mannerist picture's subject. *Allegory of Faith* depicts a very different kind of emulation. The figure's gesture refers to John referring to Christ referring to a remote God, and perhaps more immediately to a solitary death. Apart from the fact that this open sequence of references is paralleled by other sequences within the painting, the merely formal, rhetorical nature of the reference qualifies the "replacement" of the Magdalene by Faith as formal.

Within Jordaens's two images of *Christ on the Cross* (Figs. 47 and 48) the nameless, brightly illuminated figure seated on the ground between Mary and the crucified Christ – perhaps Jordaens's adaptation of Rubens's motif of women and children as spectators of the crucifixion – emulates the mourning Magdalene. In the Vermeer, this nameless woman suggests a viewing axis between the viewer's eye and Jordaens's image. In Vermeer's citation she is prominently placed, at the vanishing point of the linear perspective used in the *Allegory of Faith*. Significantly, this direct axis and the Caravaggesque extension of her body into extra-pictorial space connect her to Vermeer's allegorical figure of Faith. Her feet seem to touch Faith's right knee, and their elbows seem to touch, as if to emphasize their gestures' different functions: mourning and melancholy in the one, formal assertion of faith in the other; affect and consciousness in the one, subjective emptiness and rhetorical coordination in the other, and so forth. These two antithetical elements are not equally balanced; rather, the visually dark Jordaens painting appears as a physical weight bearing down upon the figure of Faith.

Earlier, I discussed the motif of the returned gaze in genre painting as a self-reflective and critical dimension of the work of art as much as of spectatorship. In Vermeer's *Allegory of Faith*, however, the motif is used differently. Alfred Neumeyer

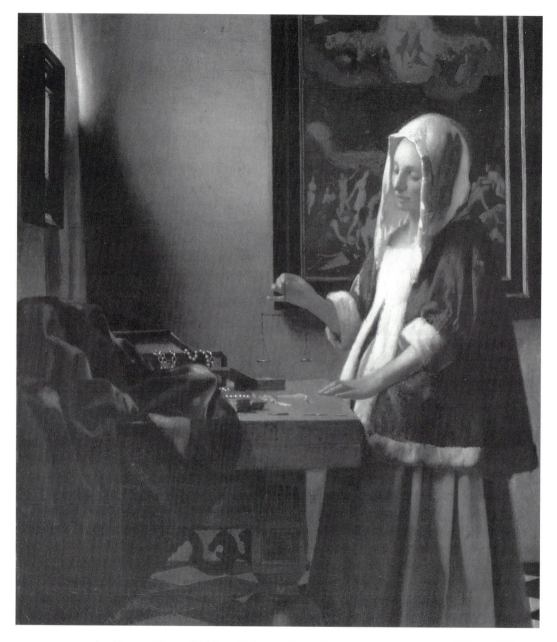

49. Jan Vermeer, *Woman Holding a Balance*, 1662–4, oil on canvas, 42.5 x 38.1 cm, Widener Collection, National Gallery of Art, Washington, D.C.

writes, concerning eye contact between viewer and represented figure: "The represented action is visibly bound up with our perception and that means that it is completed here and now in the moment where we perceive but are also perceived. . . . In that the subject-object relation is aesthetically thematized, the way is opened for an exchange of realities."[187] Like *The Art of Painting*, *Allegory of Faith* involves several realities, not just two. It is worth noting, for example, that Vermeer has adjusted the

proportions of the Jordaens to those of his own painting, an adjustment that opens these two realities more easily to a third outside of the painting. So far, we have looked at the Jordaens within the Vermeer primarily in its relationship to the allegorical figure. Faith's surroundings need to be investigated further in order to understand how it is possible that the Jordaens appears to comment antithetically on Vermeer's primary image, or even to bypass the very image in which it is cited in the mourning woman's search for eye contact with the beholder. Again, this is not only a matter of juxtaposing pictorial spaces within one image, but also one of juxtaposing pictorial times or temporalities within one image. Even in its position as the older painting, as it were, the Jordaens appears more communicative than the Vermeer, acknowledging the beholder through the mourning woman's direct appeal and Christ's direct withdrawal.

This juxtaposition in Vermeer's *Allegory of Faith* emphasizes the remoteness of Christ at the expense of hope for future salvation. Furthermore, it also exposes the vulnerability of allegory's rationality, and of its instrumental character in Hegel's understanding as a disguised grammatical borrowing of authority, subjective consciousness, and agency. While the reference point, the Jordaens, appears as that absolute authority, it also exposes reference as such as an open sequence of pointing gestures (Faith – John – Christ –). The particular irony of Vermeer's image resides in the simultaneity of these gestures whose primary effect is to arouse doubt in, rather than hope for salvation. Some of the conditions necessary for this doubt have already been named, such as the sequence of references and the privileging of an incidental figure in the Jordaens as the new Magdalene. There are others: John's own gesture of mourning is on one axis with Faith's waxen left hand, which languidly and passively serves as a nearly detached pointer to the apple of original sin on the marble floor below. The pattern of that floor refers us further to the crushed snake, which has its assigned place below the globe and Faith's as well as Mary's feet. Traditionally, John the Disciple holds a chalice with a snake as his attribute. In Vermeer's interior, saint and attribute are depicted separately. Conversely, the attribute of the chalice is shared by John and Faith. There are other separations and doublings of motifs, such as the Crucifixion and the crucifix on the table, or the crown of thorns on the open book nearby. These things multiply and particularize the beholder's possibilities of allegorical remembrance. The double function of the Jordaens as reminder and as devotional image and its specific supplementation by motifs "scattered" throughout *Allegory of Faith* suggest that an effort is being made at retrieval that results primarily in its objects' diffusion. But in whose name does it take place? This question necessitates a close study of Vermeer's use of his primary reference text, Ripa's *Iconologia*.

Contexts of Faith

Faith, it has been observed, is seated awkwardly, even indecorously, in order to triumph over the enormous globe.[188] This might also be said about Bernini's *Verità* (Fig. 38). He himself pointed out that the sculptor must establish the sculpture's structure according to allegory's coordination of its components. Faith's awkward pose is formally inscribed in a tilted triangle marked by spherical objects: globe,

apple, and glass sphere. This pose itself should be meaningless to her, for her function is representation, not communication of self, let alone a sense of feminine comfort and harmony.[189] Yet her physical presence, so emphasized by Vermeer, suggests otherwise. This visible tension of the image requires an explanation.

Pers's Ripa

Swillens was the first to point out that Vermeer's painting combines Ripa's representations of the New Testament and of Catholic faith. But the entries in Ripa are not limited to these two. The 1603 Rome edition of the *Iconologia* lists two different versions of "Fede Christiana" and two different versions of "Fede Cattolica."[190] The entries in the Rome edition match nos. 5, 6, 4, and 1 of the 1644 Amsterdam Dutch edition of Ripa's *Iconologia*, generally assumed to have been Vermeer's source for his painting.[191] The Dutch edition expands the Italian model by two more entries on the subject of faith.[192] The four entries consistent with the Italian edition include minor changes, of which perhaps one, if any at all, could be called a Protestant adjustment.[193] If Vermeer referred to Pers's edition of Ripa's *Iconologia*, then one needs to take into account all six entries and their slightly contradictory relationship to one another. One instance is entry 3, with its explication of the figure's decolleté: "She is bare around her shoulders and breast, because the Evangelical sermons must not show off ornate phrases, nor riddles and ambiguous arguments, but must be clear."[194] Thus, the décolleté of the figure of Faith in Vermeer's allegory, which has prompted some viewers to assume a lack of decorum or perhaps a historiated portrait, might instead be seen as a reference to the clarity and simplicity of true faith. The irony of such a literal visual translation of Pers's suggested detail – that its indecorousness seems to override its assigned signification of virtue – is difficult to locate: is it, as Berger suggests, Vermeer's concession of the necessary failure of the image? Or should it be acknowledged as a later reaction on to Ripa's concept of allegory?

Of the six passages in Pers, four prescribe white dress for the allegorical figure, one blue and carmine, and one dark dress but bare shoulders. Again, Vermeer combines prescriptions, or rather, he draws loosely upon all six entries.[195] He appears to take seriously the implications of using white, which is referred to in Pers's entry 4 as a color and yet purified of colors, a light that demonstratively denounces any impurity or contamination. He refers to black as darkness and as representing the contrary of everything denoted by white. Vermeer's use of white and black, light and shadow in his *Allegory of Faith* may be related to Ripa's and Pers's color iconography here and elsewhere in the *Iconologia*.[196] The interior, seen as bourgeois by numerous scholars, not only serves this iconography of color but also develops it.

The allegorical configuration is lit by a source of light coming from the upper left and entering pictorial space on the level of the curtain, appearing on either side of it. The figure's white satin dress reflects this light in a slightly muted manner equal to the appearance of the open book. More light appears on her bare shoulders, neck, and face, and on her pearl necklace. A strong reflection of light is noticeable on the globe of the earth, the apple, the chalice, the crucifix, and, above all, on the glass sphere. It is the glass sphere that reflects the incoming light most purely, separating it from other reflections of colored objects seen on its underside. In Max Eisler's view

this is a "marvel of that Dutch particularity...capable of representing in the indefinite detail the mirror image and the precipitation [Niederschlag] of absolute space."[197] Here Eisler makes use of Hegel's concepts of appearance and color magic, offering instead of these terms the metaphor of representation as precipitation, the world contained and reflected in Vermeer's glass sphere as in a puddle. Otherwise the room is quite dark. Accordingly, black and white play a different role here from the one they have in *A Lady at the Virginals with a Gentleman* (Fig. 17) or in *The Art of Painting* (Pl. VII), where they frame the primaries and tertiaries. Instead they are the two colors (or noncolors) toward which all the others tend, bringing to mind Pers's entry no. 3, the representation of "Fede Christiana Catholica," which emphasizes an overall darkness or overcastness (*duyster, gedeckt*). Usually when Vermeer depicts a marble floor of black-and-white tiles, black tiles dominate. They are placed in diagonally arranged Greek crosses composed of five tiles and separated by single white tiles. This can be seen in *A Lady at the Virginals with a Gentleman*, *The Love Letter*, and *The Art of Painting*.[198] In *The Art of Painting*, all objects of weight and volume stand on black tiles: the artist's feet, his stool, the woman. This is also the case in *Allegory of Faith*, but with the interesting difference that here the white tiles form Greek crosses and the black tiles are single. Thus these black tiles, which are shown without marbling in unrelieved blackness, appear as islands of reference for the objects associated with evil and original sin: the cornerstone strikes the snake on a black tile; the apple lies on a black tile, yet just at the border so that its green-yellow silhouette stands out against the white tile. One might even say, as Pers has it, that the apple is denounced by the purity of the white marble, which, nevertheless, is not perfectly white or pure. Similarly, the snake's tail and the trickle of blood from its mouth are on white tiles and directed so that they cross the pattern of the gray marbling of the white tiles.[199] In short, in *Allegory of Faith* there is a notable spilling-over of symbols of evil from the black to the predominant white tiles, whose whiteness is itself overwhelmed and invaded by disorderly gray veins, significantly stressing a tendency toward darkness. Thus Snow, when speaking of a "deadening effect," a "closed, leaden atmosphere," and when noting the "presence of a materialistic, object-ridden culture" in *Allegory of Faith*, overlooks the peculiar dialectic built into the painting's iconography as well as its compositional and coloristic appearance.[200] The little light able to enter the room falls diagonally on the piece of leather wall covering at right, and not on the Jordaens, though a black shadow is cast by its frame onto the already dark wall. The Jordaens therefore must be understood as visible because of its dim self-illuminating colors in Christ, John, and the mourning woman and because of its own fictional source of light. Light and white are precious and spare in this *Allegory of Faith*, and the theme of impurity transmitted by the predominance of darkness is subtly in accordance with the temporal and spatial remoteness of the Jordaens and with the sense of doubt it transmits to its surroundings.

Allegorical Order and Disorder

As one steps back, as it were, to remark these details and effects of pictorial language turned allegorical, one may ask again about their relationship to the issue of the painting's offensiveness. This issue has in part to do with what is perceived as the

work's compositional order or, rather, as its disorder. It is useful, therefore, to examine this aspect of Vermeer's *Allegory of Faith*, not just on the level of formal analysis but once again in relation to concepts of allegory.

De Jongh, one of the few authors not to take offense at it, explains Faith's pose iconographically when he cites several examples of Jesuit prints that depict Divine Love triumphing over the earth and turning upward toward a sphere that symbolizes heaven, not unlike Ripa's *Veritas* (Figs. 42 and 43). This, together with biographical details, prompts him to interpret Vermeer's painting as a work commissioned by the Jesuits of Delft, an interpretation accepted by many, but not all.[201] Vermeer's specific choices as well as the allegorical figure's pose can be further illustrated and determined by comparison of *Allegory of Faith* with Rubens's treatments of the theme of religious triumph.

In *The Triumph of Faith* (Fig. 45), Rubens presents a standing Faith who holds the chalice with host up high, while an angel, seated next to her on the triumphal car, embraces the bare cross. The very large globe between them is, proportionally speaking, as large as the globe in Vermeer's painting.[202] In Rubens's *Triumph of the Church* from the Eucharist series the allegorical figure bears a monstrance, while the globe is demonstratively placed before the "tapestry within the tapestry," where it is girdled by the snake of eternity biting its tail and crowned by an oak wreath. Rubens's Faith and Church never literally triumph *over* the earth.[203] At the same time, one may not want to go so far as to say that they triumph *within* the world, inasmuch as the triumph and the globe belong to two different levels of the image. The device of the "tapestry within the tapestry" is a gesture of framing and separation that makes Rubens's series as non-narrative as van Veen's.[204]

In Rubens's oil sketch *Christ Triumphant over Sin and Death* (c. 1628–30) for the lost altarpiece for the Carmelites in Antwerp (Fig. 50), the resurrected Christ himself triumphs over the earth, evil, and death, crushing a skeleton and the snake under the globe. He holds up the chalice with host in triumph. Except for his stigmata, no reference is made to the Crucifixion. Doubtless this adaptation of the Apollo Belvedere is the resurrected Christ. Rubens's emphasis on axiality, weightlessness, and balance contrasts with the characteristic avoidance of central axiality in Vermeer's painting. There, balance of composition means something completely different, at once enhancing the relative materiality of Vermeer's allegorical configuration and depending on it. We cannot conceive of the Jordaens painting and the chalice as planted on and triumphant over the globe and the snake, as we do in Rubens's *Christ Triumphant over Sin and Death*. As I have pointed out in my discussion of the use of black and white and shadow and light in the painting, Vermeer's sharp rendering of surfaces and their texture, his suggestion of relative weight and materiality isolate the allegorical references and attributes primarily as specific objects while at the same time insisting on their meaningfulness. In Rubens's painting, on the other hand, everything and everyone appears to be of the same substance, whatever it may be. In Vermeer, the Crucifixion, globe, snake, apple do not follow the law of unquestionable order that at once rules, brings about, and transcends Rubens's oil sketch. Even Vermeer's small crucifix and the pattern of the leather backdrop – which at first glance may appear to glorify and uplift the cross from the mensa – are not entirely symmetrical, as a close look confirms.[205] Thus, Vermeer simultaneously emphasizes both aspects of the concept of allegory as defined by Hegel: on the one

50. Peter Paul Rubens, *Christ Triumphant over Sin and Death*, c. 1628–30, oil on panel, 71.1 x 48.3 cm, The Metropolitan Museum of Art, New York.

hand, the absolute authority borrowed by the allegorical configuration in each of its details and references and, on the other, the grammatical subject of the allegorical person. Rubens's oil sketch, in contrast, does only the first, "hiding" from us this fact of borrowing by the obvious display of Christ's authoritative presence. This presence, however, is borrowed here in support of the Antwerp Carmelites' claim to the direct descent of their order from the saints who witness Christ in this image. This descent was a matter of dispute at the time.[206]

In Vermeer's painting, the real subject, borrower, and speaker is the artist, who declares himself uneasily entangled and conflicted in simultaneously accepting alle-

gory's strategy of borrowing and exposing the vulnerability of its claim to authority. In Rubens's painting, in contrast, the artist's unmistakable painterly style in no way disturbs or calls into question the authority of its image. As we have seen, in Vermeer's *Allegory of Faith* nothing is self-referential, including the Jordaens on the wall, but everything is interdependent by virtue of a structure that is neither a purely metaphorical order nor a merely existential disorder.[207]

It would be naive to believe that *Allegory of Faith* fails entirely where *The Art of Painting* entirely succeeds, that is, in showing the world as a "realm of immanent value".[208] On the contrary, by refusing to show it as such, *Allegory of Faith* succeeds in supplementing *The Art of Painting*. At the least the former severely calls into question the latter's aesthetic illusion, or, more precisely, the aesthetic illusion many modern critics perceive in it. For that reason, the motifs of the curtain and the glass sphere to which Faith formally appeals require further attention. For they, like the withdrawn Christ on the cross, refer to something outside of the allegorical configuration, even on the level of their relative materiality. In *The Art of Painting* the map of the Netherlands seemed to face its citizens; whom, or what, does Vermeer's Jordaens seem to face?

Whereas Rubens's pictorial spaces are not accessible, Vermeer's space is the sort that might be entered, though many beholders would apparently rather not. This dis-invitation is a very important aspect of Vermeer's *Allegory of Faith*. It is as if the disorder of his allegory were a prerequisite for a possible – indeed, necessary – relationship of the viewer to it. The offense in Vermeer's *Allegory of Faith* does not only lie in the concreteness of an image of disparity, of clustered disorder configured by an allegorical person, of self-conscious reference. It also lies in the fact that, in contrast to the examples of Rubens, this allegorical configuration is already given a place in the viewer's world, a world that, if one accepts the painting's conceptual exchange of realities, may be said to be similarly leaden, oppressive, deadening.

In order to recognize the degree of discomfort this exchange affords, it is instructive to compare briefly the room and the distribution of curtain, objects, and figure in Vermeer's *Allegory of Faith* to his *Lady Writing a Letter with Her Maid* (c. 1670–2, collection Alfred Beit, National Gallery of Ireland, Dublin).[209] Again, the beholder is not directly addressed by Vermeer's figures through eye contact. Instead, the maid, who incidentally bears a remarkable resemblance to the model for Faith, seems to observe something or someone outside the window, whom we do not see. This imaginary expansion of pictorial space is an analogue to the seated woman writing a letter to someone who is not the viewer but whom the viewer is encouraged to imagine her- or himself to be. A second chair is provided that permits witnessing in an inappropriate, intrusive manner. The chair stands in the middle of what the modern beholder will consider a social taboo zone, an area bearing signs of privacy, such as the crumpled letter and broken piece of red sealing wax on the floor.[210] One's engagement in the representation, the possible identification with either the letters' authors, or the wish to sit at the table imply a violation of etiquette, a pondering of the private versus the public realm. But this taboo makes entering the picture all the more enticing, whereas such an enticement is completely lacking in *Allegory of Faith*. Someone might very well wish to pick up the letter from the floor, but who would wish to pick up the apple or snake?

51. David II Teniers, *The Archducal Gallery*, 1651, oil on canvas, 96 x 129 cm, Koninklijke Musea voor Schone Kunsten van België / Musées Royaux des Beaux-Arts de Belgique, Brussels.

In Vermeer's *The Art of Painting* and *Allegory of Faith* the exchange of realities means admission to the depth of chair and curtain, no further. But in *The Art of Painting*, while the reverse side of the tapestry curtain is turned to us, some of the front side is also folded over toward our space, so that we are admitted to witness the scene. This playful device extends the aesthetic illusion to the beholder's space, an extraordinarily pleasant experience, even after one discovers the multiple viewpoints discussed in the previous chapters. But is there any such pleasure in witnessing what is at play in *Allegory of Faith*? The answer seems to be no.

The front of the curtain faces the beholder. Its one-sided revelatory function refers both to the custom of protecting paintings with curtains and to theater. In David Teniers's *Paintings Gallery* of c. 1650, Archduke Leopold Wilhelm's version of Raphael's *St. Margaret* is presented propped up in the middle of the room, on special display but with a piece of cloth casually draped over one corner. Raphael's painting is also seen in *The Archducal Gallery* of 1651 (Fig. 51), where it is the only painting with a protective curtain on a rod pulled to the side.[211] In both cases the Raphael painting is staged as something precious while at the same time a potential withdrawal of the painting is implied. Vermeer's curtain does not even slightly overlap

the Jordaens, its primary association being with the Vermeer, not with the painting in the painting.

Vermeer's Jordaens and the tapestry curtain of a courtly or chivalric subject matter, itself historically past, are the two borders of pictorial space parallel to the picture plane and to the painting's vertical, material borders. If we try further to characterize Vermeer's cubic pictorial space in this painting, we realize how openly the border planes are defined. Back wall and floor are reserved as fictional supports for the allegorical configuration. To the left and right continuous space is suggested, characterized to the left by a profane object, to the right by a sacred arrangement. As Jantzen has shown with regard to Vermeer's similarly composed *The Art of Painting*, such a definition of cubic pictorial space conveys a sense of violence: "In the short distance from viewer to the back wall of the room space is, as it were, driven asunder."[212] So, we might add, are its relative secular or sacred aspects and the signified institutions of court and church bordering on this interior. What allows us to call it a bourgeois interior at all? Very few motifs indeed: the chair, the floor, the ceiling, the identifiable globe, and the glass sphere. The Jordaens painting focuses both the room we behold and our viewing space as an adjacent or even continuous interior, since Vermeer's room, given its unknown dimensions, can always be imagined as a continuation of that of the beholder. While this device clearly modifies assumptions about Dutch interior as private space, the reflecting sphere alone relates to an exterior world beyond this shared interior, a world to which the allegorical figure appears to turn and which is withheld from the implied human presence before the painting. Religion in Vermeer's *Allegory of Faith* may be hidden within or withdrawn from the allegorical configuration. To his modern beholders this would not be so disquieting, if what has conventionally been declared a bourgeois interior were more clearly defined as such. Strangely oscillating between place of worship and domestic interior, it not only calls into question the aesthetic illusion and the positive artistic self-consciousness seen by many in *The Art of Painting*, but also the bourgeois world apparently celebrated in Vermeer's genre paintings depicting women reading, writing, receiving letters, playing music, handling vessels with near-ritualistic care. In *Allegory of Faith* the indeterminate bourgeois interior lives off the reflective sphere by which it is also connected to the allegorical configuration. Vermeer's Jordaens, as we have seen, withdraws its content. What is the sphere's redeeming purpose?

For an entirely secular comparison we may turn to Hendrik van der Burch's *A Dutch Interior* (Fig. 52), which is especially evocative.[213] The relationship between a woman's fur-lined jacket and the transient spaces to the left is more likely to capture our imagination than the setting's juxtaposition with the sumptuous still life on the wall, in the manner of Abraham van Beyeren. The motif of the jacket appears like an example for Walter Benjamin's explanation of the word, object, or gesture as a fragment, that is, as something at once sadly and promisingly incomplete:

> But has the counterpart of this temporal removal ever been investigated, the shock with which we come across a gesture or a word as we suddenly find in our house a forgotten glove or reticule? And just as they cause us to surmise a stranger who has been there, there are words and gestures from which we infer that invisible stranger, the future who left them in our keeping.[214]

52. Hendrik van der Burch, *A Dutch Interior*, mid-17th century, oil on canvas, 43.5 x 36.5 cm, Staatliche Museen zu Berlin, Preußischer Kulturbesitz, Gemäldegalerie.

From a Benjaminian viewpoint, the sphere in Vermeer's *Allegory of Faith* cannot be considered such a romantic fragment, with a double character of promise and challenge, but as a fragment of a doomed world. It admits neither the romantic viewer implied in Benjamin's text nor the promising personal symbol. This would amount to giving privilege to the blue ribbon from which the sphere is suspended, sign of domestic adornment, over all other objects in the room. And, indeed, there seems to be a discreet longing for just that in the modern reception of Vermeer's image. Snow, an emphatically modern viewer of Vermeer, notes that the sphere with its ribbon is the one object in Vermeer's painting that exposes the materiality of the others. Surprisingly, he then interprets it as a symbol of vanity – not *Vanitas*, but very concretely the vanity of Faith, whom he takes for the sitter in a historiated portrait.[215] Taking up Snow's observation, I should like to suggest that the sphere with its ribbon is the one motif in this painting that we could easily imagine in one of Vermeer's genre paintings. Placed in *Allegory of Faith*, it is reminiscent of these other Vermeers, yet represents them ironically, taking on the meaning of hope and salva-

tion within the allegorical configuration. Is the sphere, then, comparable after all to Benjamin's romantic fragment? Does Vermeer's *Allegory of Faith* contain both the allegorically configured, isolated object and the romantic fragment? If so, how can they share the same location?

Spheres of Virtue

In Dutch painting such spheres are either part of the furnishing of a bourgeois interior in genre painting, as in de Hooch's *Music Party with Five Figures* (Fig. 14) or they are part of an arrangement of objects in *Vanitas* still lifes.[216] Only in the graphic arts and in emblem books does one encounter the very complex contextuality of the motif. In his iconographic study on the motifs of the cube and the sphere and their relationship to one another, Peter-Klaus Schuster investigates the association of both negative and positive meanings with the stability of the cube and the instability of the sphere.[217] For the Renaissance and Baroque periods he determines three basic binary positions represented in images of virtue or of vice: first, the Platonic Christian position, which values instability and mobility above stability and immobility; second, liberal, humanistic, conciliatory thinking wherein they are equal; and third, the stoic Christian position, which values stability and constancy over instability.[218] Accordingly, the cube as well as the sphere can be considered as *Tugendsitz*, as the site – literally, seat – of virtue.[219] How does Schuster's account, here somewhat schematically reduced, pertain to Vermeer's painting, particularly to the function of Faith's awkward pose, her triumph over the globe, and her appeal to the glass sphere?[220] In Vermeer's painting we do not see that Faith is seated on a cube or any kind of stable seat. Thus, her unstable pose excludes the possibility that a *Tugendsitz* might offer a polar contrast to the globe.

None of Schuster's positions seems to fit Vermeer's image: each is partially implied by it and yet contradicted by other aspects. This suggests two interpretive possibilities. First, in Hegel's terms, Faith as the merely grammatical subject of the allegorical configuration cannot bring about the balance or synthesis of different positions. Of necessity failing to do so, she is formally the victim of her lack of subjective agency, and thus reflects this lack back onto the artist. This may further explain why critics speak of the painting not only as if it offended them, but as if they felt betrayed by the artist. Second, it is possible that the Jordaens painting is a substitute for the cube as *Tugendsitz*, serving as a rectangular shape that focuses and anchors the allegorical configuration as well as the beholder's position in its field. Seen this way, however, the Jordaens appears overburdened with functions and tasks from which Vermeer, in his peculiar rendering of his cited paradigm, allows it to withdraw at the same time that the female mourner *in* the Jordaens, with her direct gaze, reflects the task of understanding back onto the beholder. These two interpretive possibilities resemble one another in one respect: in both it is the glass sphere that becomes the ultimate motif to which all – Faith, artist, beholder – appeal. At the same time, it comes to stand for the painting's empty, or absent, subjectivity. As suggested by the vagueness of the visible reflection, this remains open, oscillation between reflection and appeal both temporally and interpretively.[221]

The one Dutch image familiar to me in which the glass sphere appears in a secular allegorical context, is Samuel van Hoogstraeten's frontispiece to book 5,

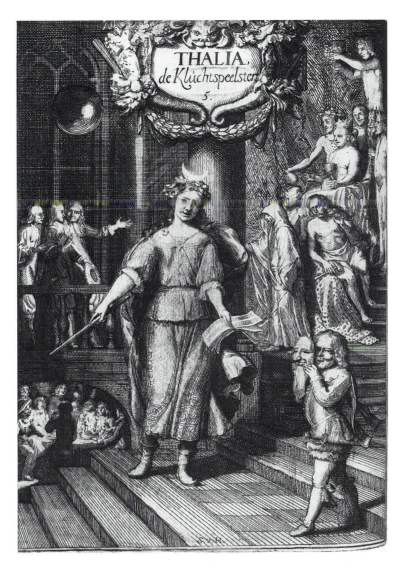

53. Samuel van Hoogstraeten, frontispiece to *Thalia*, from *Inleyding*, book 5, 1678, facing p. 273, engraving, 15.6 x 11.5 cm, private collection.

"Thalia, de Kluchtspeelster," of his *Inleyding* of 1678, the book on the art of pleasing order or composition (Fig. 53).[222] There the sphere hangs down from nowhere specifically, implictly from the theater's ceiling, next to the title cartouche and to Thalia, and above the surprised artists, three young men who look with pleasure at the costumed comedians and actors descending the stairs from a space on the right that is radiant with light. This light is reflected in the glass sphere. In the center and foreground of the image stands Thalia. She wears a crescent moon in her hair, as if in a constellation with the reflecting sphere. A young boy, or jester, standing near her, holds her comic mask before his face, peeking out from behind it toward the viewer. In the vault below, a group of men and women are gathered around a table, several

of them bearing brightly shining candles. Metaphors of light are also used in the poem accompanying the print, where the mask is said to relate to the *schikkunst* of antiquity. This is a term with several meanings, referring either to the art of ordering in the sense of decorum and propriety, or to the art of enjoyment, that is, comedy.[223] The artists are said to gaze themselves "dumb and blind" and Thalia herself is called "changeable like the moon." The sphere is not mentioned in this text, but it appears to sum up and represent the theme of pleasurable and deceptive illusion. Its ambiguity is relieved by the literal context of the theatrical sphere of suspense, mockery, and humor provided by Hoogstraeten, a context completely absent from Vermeer's image. The double meaning of *schik* is maintained also in the rules and lessons put forth in book 5, "Thalia," and printed in the margins, such as "The artist's freedom must not be abused."[224] The enjoyment of comedy and farce is based on rules that prevent abuse. Release from rules is not to be found in art but in the artist's relaxation (*uitspanning*) from it, so Hoogstraeten suggests in chapters eight and nine of "Thalia." *Uitspanning*, literally the release of work animals from their yoke, points to the character of art as work, even though Hoogstraeten uses the metaphor of the world as theater.[225]

The theatrical aspect of Vermeer's *Allegory of Faith* is rather different. By including the ambiguous and illusionistic glass sphere as the motif of hope to which all turn, Vermeer himself withdraws authority from his allegory of the central Christian virtue. To this extent he breaks the rules of allegory and makes room thereby for the modern scorn of this Faith, "your typical fat lady." Once this utter lack of respect is seen to correspond to the apparent lack of authority, a shift in the concept of allegory comes into view as well. The abusive epithets inspired by this shift come surprisingly close to Benjamin's partially Marxist revision of his concept of Baroque allegory in his later work on allegory, prostitution, and commodity in Baudelaire. This includes the following statements:

> The devaluation of the world of things in allegory is exceeded within
> the world of things itself through the commodity.
> [T]he prostitute is the incarnated allegory.[226]

While the discussion of Vermeer's art in the modern context seems to work well with many of his paintings, in the case of *Allegory of Faith* it effects a graphic devaluation in a tacit move from allegory to commodification. And so Ludwig Goldscheider, who was hardly thinking of Baudelaire, could write of Vermeer's Faith: "This personification of Faith is a fat, female figure with large feet and hands, and a head like an Easter egg; she is tightly swathed in her silk Sunday-best dress, blue and white and very shiny. Her attitude is almost indecent. Jan Steen's *Drunken Woman* has exactly the same pose."[227] The illusion here, of course, is that Faith, now endowed with an immoral subjectivity, has turned herself into a commodity, thereby surprising the beholder into thinking of him- or herself as the offended virtue.

How can I summarize the historical address being made to the modern viewer from within Vermeer's painting? It is not only that Vermeer's *Allegory of Faith* stands between Roman Catholicism and Protestantism in its references, iconography, composition, concreteness, and in the materiality of its allegorical disorder.

More than that, it is an image of the seventeenth century offensive to twentieth-century viewers because it represents the single woman as a figure defying any comfortable secular or emotional identification on the part of her implied viewers. Viewing Vermeer's *Allegory of Faith* is painful because the event witnessed is the devaluation of allegorical authority as the threshold between the pastness of religion and the future of idealized secular woman. As Christ is withdrawn the sphere helps some beholders to escape back to their splendidly secular Vermeer. But here lies a threat to the legitimacy of that view of Vermeer. It is, as it were, spoiled by *Allegory of Faith*. In this respect the painting could hardly be more different from *The Art of Painting* or even *Woman Holding a Balance* (Fig. 49), though structurally, in spite of their differences in mood, or tone, the three paintings have something very important in common. In each the negativity of allegory is represented as an actual withdrawal within the painting: Clio, Christ, and Divine Justice withdraw themselves in these works, leaving behind a vacuum of authority that continues to challenge their beholders.

Epilogue

In general, reflectiveness does not see sight, but only the mirrored or dissected eye; and the reflection does not reflect itself. If we were completely aware of ourselves, then we would be our own creators, unlimited.

JEAN PAUL, 1812[1]

I invite the reader to consider with me Ferdinand Georg Waldmüller's *Portrait of a Cartographer and His Wife* of 1824 (Fig. 54).[2] This double portrait stands in the Dutch tradition of merging portraiture with genre.[3] The couple is represented in an interior, perhaps the husband's study. He is seated at his desk and appears meditative, apparently looking at nothing in particular. He holds a pen in his right hand in a writing position, resting his left on the arm of his chair. His wife stands near him in a supportive role. She has laid her left hand on her husband's shoulder and is about to place flowers in a vase on his desk with her right. Their heads are turned toward each other, but their eyes do not meet. It is almost as if they had turned one another into an *Erinnerungsbild*, an image of memory, but one requiring neither modification nor verification. The couple are middle-aged, and according to this painting their roles in marriage have long been settled; we are looking at routine. So far we might say that Waldmüller, perhaps the most successful painter of the nineteenth-century bourgeoisie in Austria and Germany, has made appropriate and wise use of his knowledge of seventeenth-century Dutch painting. This knowledge is rooted in several copies he made in the 1820s of works by Vroom, Ruisdael, Potter, and others. None of these paintings, however, is a double portrait.[4]

Yet Waldmüller goes beyond evoking the paradigmatic golden age of painting and middle-class comfort by including two paintings within his picture, both examples of Christian iconography. These may be seen as Waldmüller's attempt to mediate the couple's Roman Catholic religion with the generally Protestant paradigm chosen for the composition. The couple's denomination is also indicated by the large cross set with jewels the wife wears as a pendant. Significantly, the paintings cited

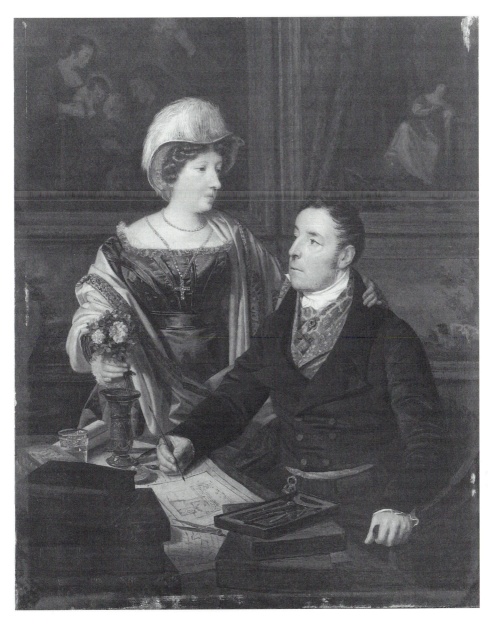

54. Ferdinand Georg Waldmüller, *Portrait of a Cartographer and His Wife*, 1824, oil on panel, 40.9 x 32.6 cm, Federal Republic of Germany, on permanent loan to Westfälisches Landesmuseum für Kunst- und Kulturgeschichte, Münster.

here differ from those seen in family portraits of the period, such as Carl Julius Milde's *Pastor Rautenberg and His Family* (Fig. 5), in that they are not reproductions after Raphael,[5] but rather what appears to be a van Dyck Holy Family Greeted by John the Baptist and Elizabeth on the left and what very clearly is Vermeer's *Allegory of Faith* on the right.[6] What does Waldmüller's work offer in light of my examination of the painterly modes of idyll and allegory?

The first impulse might be to see the juxtaposition of solemn marital idyll and Vermeer's unauthoritative allegory as counterproductive. If Waldmüller's intention was to represent the couple's exemplary religiosity while manifesting his own admiration for the Vermeer, this negative judgment might be correct. But it is probably more instructive to leave the artist's unknown intentions aside and to analyze the juxtaposition with due differentiation between the two individuals making up the couple. Formally speaking, Faith's diagonal, excentric pose contrasts strongly with the carefully balanced order established in the configured couple. Interpreting these, we might see a contrast between Faith's necessarily external, allegorical affect and the couple's inner calm. This contrast reflects not so much on Faith as on the couple, so that what at first appeared as inner calm, composure, and tenderness now appears as a necessity, an involuntary and slightly gloomy interiority far removed from Hegel's subjective freedom. Moreover, the contrast between the cited painting and the painting in which it is cited reflects differently on each of the depicted individuals.

The contrast highlights the husband's profession as cartographer, his scientific attention to the world, and Faith's triumph over a terrestrial globe, a globe to whose detailed cartography – unseen in Waldmüller's citation – others have drawn attention.[7] The man turns his back to the Vermeer, postponing his contempt for the world until retirement, so to speak. The humor in this goes almost unnoticed because of the woman's stance, which is not one of polarity but of ambiguity. A woman presenting flowers to a man is a convention of erotic imagery and familiar from Venetian Renaissance portraiture of courtesans, as well as from historiated portraits such as Rembrandt's Saskia van Uylenburgh or Rubens's Hélène Fourment as Flora. But the cartographer's wife is hardly a seducer. The vase and the proper dress, severe hairstyle and bonnet render the woman's gesture a very remote echo of the erotic meaning it once had in art, and possibly in this couple's lives. That meaning is translated here into a decorous marital affection. The routine of the couple's lives is just benignly broken by the woman's offering of flowers, a gesture without significant consequences. The role of subdued nurturing assigned to the woman places her between the man and the pictures on the wall, whose Christian subjects commend her as guardian of the couple's spiritual well-being. Her virtues are the theological virtues of Love and Faith, signified by the Holy Family, John the Baptist, and St. Elizabeth and by Vermeer's *Allegory of Faith*.

Yet missing from Waldmüller's favorable exposition of these people's characters is any representation the third theological virtue, Hope – a putative, absent third painting. I see two possible interpretations of this omission. One is directly negative: Hope is literally missing. The other possibility is not significantly more cheerful: Waldmüller does not provide an explicit pictorial reference to Hope, because the couple represent this virtue implicitly through the exemplarity of their marital life. But such an allegorical reading of their well-appointed idyll makes us wonder just how they are exemplary. Once again we are left with the image of settled routine and responsibilities. To these no inner motive corresponds at the moment of their depiction, as only befits an allegorical representation. The allegorical image of affectionate routine refers at most to a past, not a present hope. Here it becomes crucial that the wall decorations are not explicit reproductions of old masterpieces, but seem to be these masterpieces themselves. Print reproductions might have pointed to a later, modern time's

renewed interest in these works as well as to a certain distance from them. And that would correspond to an actual fashion in nineteenth-century bourgeois interiors, as seen in Milde's *Pastor Rautenberg and His Family* (Fig. 5). By rendering the couple as the owners of the Holy Family and the Vermeer, Waldmüller not only shows them to be wealthy but binds them to the past as to a burdensome heritage of exemplars.[8] The quoted Vermeer only enhances this burden, inasmuch as Faith's allegorical reference to the Crucifixion lends none of the reassurance that the Holy Family does.

This is a disturbed idyll, the disturbance occurring not directly through the beholder's presence, which is entirely ignored by the couple, but through the quoted Vermeer on the one hand and through the complete absence of an implied larger world on the other. Cartography is not a social but a geographic implication of the world. A Vermeerian device, the barrier created by a stack of books and boxes with instruments piled up in the foreground on the man's desk, effects an additional separation between the couple and the beholder. If husband and wife were looking at each other, their isolation might work as a reflection of their shared life and inner virtues; but since they are not, this isolation appears complete, inflecting the entire image with a sense of gloom or loneliness. In a way, the social world is replaced by the historical paintings on the wall. While Vermeer's *Allegory of Faith* directly enhances the atmosphere of loneliness, the cordial and sociable encounter of the Holy Family, John the Baptist, and Elizabeth does so by contrast.

Seen in this way, the painting stands out in Waldmüller's oeuvre which is often referred to as sentimental. A little sentimentality might have relieved this allegory of marital life of its glumness.[9] By avoiding sentimentality, for whatever reason, and by his choice of the Vermeer, Waldmüller renders an instructive image of some of the differences between the paradigmatic golden age of seventeenth-century Dutch painting and the early nineteenth century as the present in which this wishful paradigm takes hold. But then, according to the premise of this study, the relation of reception and interpretation is never completely explained, so that these differences may be looked at by the twentieth-century viewer as gaps to fill by reflecting on the experience of distance from both these bourgeois centuries. This reflection might take many forms: it could include critical attention to or aversion to the gender roles ascribed to the couple in Waldmüller's portrait; awareness of a much increased secularization and hence inability to perceive the reproduced Vermeer and (presumed) van Dyck as naive devotional references; realization that it would be difficult now to think of any objects as generally significant attributes in portraiture; a revised viewer expectation toward portraiture as something more expressive of the artist's relationship to the sitter; and, finally, the acknowledgment that such a paradigm of a more directly expressive, seemingly more honest portraiture entails yet another desire. This is the wish for a transcendence of the sitters' as much as the beholder's entrenchment in conventions and in things.

And with that we may think of the glass sphere in *Allegory of Faith* and of other Vermeer paintings studied here, the sphere and the paintings not cited by Waldmüller, which make of this entrenchment a temporary appearance suggestive of other possibilities.

Notes

Unless otherwise indicated, all translations are my own.

Introduction

1. Goethe, "Dresdner Galerie," 1794, in Goethe 1954: 101.

2. Aragon and Cocteau 1982: 77, translation altered.

3. Riegl 1982: 22f.

4. *The Procuress* is cited in Blankert 1978 as cat. no. 3, and in Wheelock 1995 as cat. no. A4. All Vermeer paintings will be identified in notes by Blankert's and Wheelock's cataloogue numbers, thus referring to the detailed entries of Blankert's catalogue raisonné and to Wheelock's convincing chronology, recently established on the basis of his analysis of Vermeer's technique or painting. Blankert published a slightly revised catalogue as part of Aillaud et al. 1988. This publication will be mentioned only where Blankert's two catalogues differ.

5. Thanks go to David Cast for drawing my attention to Pasmore's work and Bruce Laughton's account of it (Laughton 1986: 217f.). The author has kindly expanded his understanding of it in a letter; and Julian Agnew allowed me to study it to understand what Laughton refers to as its Euston Road School green. For *The Lacemaker*, see Blankert 1978: cat. 26; wheelock 1995, cat. no. A29.

6. George Deem has kindly allowed me to study this work and include its reproduction here. For other of his Vermeers and their discussion, see Sager 1973: 27; exhib. cat. Indianapolis 1974; Kultermann 1977, passim; and exhib. cat. Roslyn Harbor, Nassau County, 1994; Anderson 1995: 69ff.

7. See Gowing 1952; Zbegniew Herbert, "Letter," in Herbert 1991: 146-50; Gayford 1993.

8. For accounts of Jost's film, see Canby 1992; Jost 1992; Hoberman 1992. For a comparison of narrative technique and gesture in film and in seventeenth-century Dutch genre painting, see Hollander 1989.

9. Kaysen 1993; see also Cheever's review of the book (1993).

10. Riegl 1982 and "Der moderne Denkmalkultus, sein Wesen, seine Entstehung," in Riegl 1929: 144-94.

11. It is interesting to note that the sociologist and philosopher Georg Simmel, in his *Philosophie des Geldes* of 1900, makes very similar, but more critical observations about a then current cult of history and its objects, or monuments. See Simmel (1900) 1958, section on "Distanz:" 536-55.

12. See W. Kemp 1988; W. Kemp 1983, chapter 1, "Zur Methode," 10-40; both titles with further references. The second, "Zur Methode," provides a brief account of the lineage of Hagedorn - Diderot - Hegel - Riegl that is also important to my study. The notion of "constitutive blanks" is worked out in Kemp's "Ellipsen, Analepsen, Gleichzeitigkeiten. Schwierige Aufgaben für die Bilderzählung," in W. Kemp 1989, 62-88; and in his article, "Death at Work: A Case Study of Constitutive Blanks in Nineteenth-Century Painting," 1985.

13. I am referring most directly to Gottfried Boehm's "Mnemosyne. Zur Kategorie des erinnernden Sehens," and Hans-Georg Gadamer's "Über das Lesen von Bauten und Bildern," both in Boehm et al. 1985. Gadamer's essay corresponds closely to section two of his "The Relevance of the Beautiful." See Gadamer 1988A: 22-31. More broadly, I also refer to Heinrich Theissing's *Die Zeit im Bild* (1987); a collection of essays published on the occasion of an exhibition of the same title, *Zeit, Die vierte Dimension in der Kunst* (1985); and Bernard Lamblin's comprehensive *Peinture et temps* (1983, 1987). Important to my study — as they were to these authors — are sociological, art theoretical, and philosophical investigations of the phenomenon of time; namely, Georg Simmel's essay "Das Problem der historischen Zeit" (1916) and his book *Rembrandt: Ein kunstphilosophischer Versuch* (1916); Martin Heidegger's *Sein und Zeit* (1927); Hans Robert Jauss' *Zeit und Erinnerung in Marcel Prousts "A la recherche du temps perdu.": Ein Beitrag zur Theorie des Romans* (1954); Gadamer's *Wahrheit und Methode* (1960); and Norbert Elias' *Über die Zeit* (1984). All of these will be cited in due course.

14. Jaeger 1981: 156f. and 168f. Jaeger refers to a pamphlet published on the occasion of Hitler's birthday, April 20, 1945, which gives an outline of the museum project. Its frontispiece was a color reproduction of Vermeer's *The Art of Painting*. See also Grosshans 1983: 91f.

Part I

1. Alewyn 1985: 30f.; Heckmann 1986: 103-8. See also Meijers 1992.

2. Adorno 1992: 34.

3. Adorno 1986: passim; for example, 57-60.

4. Adorno 1974: 240.

5. Hinz 1974: 61–74; Hinz 1980; see also Hinz 1979.

6. Lorenz 1985; Norman 1987; Himmelheber 1989; exhib. cat. New York, 1994.

7. It may be argued, however, that such rigidity is not entirely original to the 1920s. According to Richard Hamann and Jost Hermand, late nineteenth-century genre painting and group portraiture shows a decisive *Versachlichung* of the "insufferable" hominess and anecdotal aspects of the Munich and Düsseldorf schools of genre painting from the 1830s through the 1860s. See Hamann and Hermand 1959, vol. 2: 21f.

8. The caption's subtitle quotes Göring's statement: "Iron has always made an empire strong, butter and lard have at most made a people fat."

This photomontage first appeared in the journal *AIZ* 51, on December 19, 1935; it was adapted by Heartfield for a revue put on for the Free German League in London in the summer of 1939. See *Photomontages* 1977: 130. On this image and others by Heartfield containing the barbaric ax with an engraved or otherwise applied swastika, see Evans 1992: 332f.; "Göring the Executioner of the Third Reich," 154f.; "The Difference," 196f.; "Protect the Saar from the Executioner's Ax," 262f: "Free Plebiscite on the Saar," 288f.; "They judge the people, as long as the people do not judge them," 354f.

9. It is quite striking that such depictions of the family at home often show only one grandparent, the widowed grandmother, as if to depict the loss of men's lives in the previous world war. It seems to me that in his photomontage Heartfield demonstrates his familiarity with this type of painting, many examples of which can be seen in Hinz 1974.

10. Goethe, "Dresdner Galerie," 1794, in Goethe 1954: 91–108.

11. Hinz refers to a 1973 interview in the German weekly *Die Zeit* with Wissel and other prominent Nazi-sponsored artists, in which they take the position "daß eine nationalsozialistische Malerei nie existiert habe, weil Künstler vermöge der ihnen eigenen Subjektivität – unabhängig von den umgebenden Verhältnissen – immer nur 'Kunst', nie aber pure Dienstleistungen produzierten" (*Zeitmagazin* 21, May 18, 1973: 15). Wissel insists on the autonomy of art in order to prove its apolitical essence. Wissel's painting was included in the exhibition, *The Romantic Spirit in German Art, 1790–1990* (London, Hayward Gallery) as representative of official Third Reich art (exhib. cat. London 1994a, cat. no. 197).

12. Unless the irony of such practice is itself consumed by death, as is the case in Tom Stoppard's 1994 play *Arcadia*.

13. Sedlmayr 1951; Badt 1961.

14. Bätschmann 1984: 26.

15. For a detailed investigation of both authors' principles, see von Mengden 1984, passim, and Zaunschirm, 1993: 41–65.

16. Badt 1961: 119–21: "Verklärung des Alltäglichen"; "Erleben[s] eines zeitlosen Glücks."

17. Badt 1961: 111f.

18. See Adams 1971: 120-3.

19. On Sedlmayr's antimodernism, see Schneider 1990.

20. Sedlmayr 1951: 175: "Der erste Bildsinn ist der 'wörtliche', 'realistische' (Vermeer malt ein

Modell), der zweite der allegorische (die Malkunst der Ruhm Hollands), der dritte der spirituelle und zeitfreie."

21. Sedlmayr 1951: 174.

22. Ibid.

23. For an account of Badt's writings, see Gosebruch 1959: v–viii; and von Mengden 1984.

24. An involuntary irony of Sedlmayr's definition of the real is that in identifying the anonymous painter in the picture with Vermeer, he replicates the French tradition from Thoré to Proust of fictionalizing Vermeer, the tradition I will analyze in Part II of this book.

25. Badt 1961: 121.

26. These issues are further complicated by the fact that both Badt and Sedlmayr make detailed reference to Alois Riegl. See Badt, "Alois Riegl," 1960, in Badt 1983: 27–67. This chapter is a thorough critique of Riegl's concept of space and implicitly of all art-historical studies that have subsequently used it. Sedlmayr is singled out as the most consistent follower of Riegl. Badt criticizes Sedlmayr's use of Riegl's term *Kunstwollen*, or artistic volition, for the cultural will of a people, as well as his use of "space" as a structural principle of art. Riegl was reproached directly for his concept of space by E. H. Gombrich in a letter of June 15, 1960 to Adrian Stokes; see R. Read 1993: 505, 508f., 516, 530f.

27. G. F. W. Hegel, *Vorlesungen über die Aesthetik. Werke in 20 Bänden*, 1983, vols. 13, 14, and 15; G. W. F. Hegel, *Aesthetics: Lectures on Fine Arts*, translated by T. M. Knox, 2 vols., 1975 (pagination consecutive in vol. 2). Hereafter, both works will be cited in text and notes as "H.," followed by volume and page number, and "K." followed by page number. I have sometimes altered quotations from Knox's translation to provide a more literal sense of Hegel's phrasing. On Hotho and the status of the text, see Gethmann-Siefert 1983 and 1984.

28. See Knabe 1972, in particular the chapters on *intérêt* and on *illusion*, 330–8, and 299–304. On the question of German–French mutual influence, see W. Becker 1971.

29. See H., 13: 77; K.: 845; and Diderot 1984. This edition includes a glossary of art terms used by Diderot, among them *magie* and descriptive adjectives like *vigoureux*, which we find still used with a certain sense of binding meaning in the French art critics of the nineteenth century. Goethe's translation is of Diderot's first two essays, on drawing and design and on color, which he published with an interpolated commentary in

Propyläen in 1799. See Goethe, "Diderots Versuch über die Malerei," in Goethe 1954: 201–53; especially on *Zauberei* in the harmony of colors: 240. See also Goethe's "Transparentgemälde" of 1820, where he speaks of "das Zauberische in den Werken der großen Niederländer aus späterer Zeit"; Goethe 1954: 861f. The first German translation of Diderot's *Essais* is Diderot, *Versuche über die Mahlerey*, "übersetzt von Carl Friedrich Crammer, dt. Buchdrucker und Buchhändler zu Paris" (Riga, 1779). Of course, Germans also read Diderot in French. August Wilhelm Schlegel offers a very interesting example of a writer hinting that he knows Diderot's terminology and yet rejects it in search of a more personal and expressive language for the description of paintings; this is in his fictive art-critical conversation among three friends in the Dresden Gemäldegalerie, called "Die Gemählde," of 1798. See Schlegel 1828, vol. 2: 145–252.

30. See Knabe 1972, chapters "couleur/coloris," 129–40; "clair-obscur," 116–22; "illusion," 299–304; as well as Antoine-Joseph Pernéty, *Dictionnaire portatif de peinture, sculpture et gravure*, 1757 (reprint 1972): "clair/obscure," 61–4; "couleur," 109–14.

31. Goethe 1949: 169–72. This passage from Goethe's novel has been quoted in Fried 1980: 171–3. That in the eighteenth century ter Borch's art was identified by his ability to depict satin can also be seen Joshua Reynolds's travel account, *Journey to Flanders and Holland*, of 1781. See Alpers 1983: xvii. On Goethe's use of "dem herrlichen Kupferstich unseres Wille" (Goethe, *Wahlverwandtschaften*) and the epistemological function of the tableau vivant in nineteenth-century Germany, see Miller 1972.

32. Wille served as an adviser to private collectors and played an important role in the revival of both French and German interest in seventeenth-century Dutch painting, as well as in German attention to contemporary French painting. See Becker 1971: 20–2, with extensive bibliography, 119f., 377f.; Boeckl 1947; exhib. cat. British Museum, 1994b: no. 29.

33. Hagedorn 1762, chapter 29, "Gesellschaftsgemählde"; quotations: 408–13.

34. Hagedorn 1762, chapter 48, "Von den Mittelfarben überhaupt": 679.

35. "Magic" is "a word used metaphorically for painting to express the great art of representing the objects with much truth, so that they produce an illusion, to the point of enabling one to say, for example, that these flesh tones, this arm, this body

is fleshy. . . . This *magic* does not depend on the chosen colors themselves, but on their distribution, according to the artist's understanding of chiaroscuro. If it is well handled, it results in a seductive charm which attracts the beholders, arrests them with satisfaction and prompts them to admiration and astonishment," Pernéty 1972: 396f.

36. Demetz 1963. This view can still be found in Fischel c. 1900–5: xxvii, where he writes that ter Borch's paintings are much more elegant and distinguished than the society they represent. Analogously, even the most merciless accounts of nineteenth-century German and Austrian genre painting tend to exempt Ferdinand Georg Waldmüller from their polemics on the basis of his extraordinary technical achievement. On Waldmüller, see Grimschitz 1957; also Pevsner 1973: 235: "combining the sugary taste of his time with a surprising Pre-Impressionism."

37. For Kemp, as for Hegel, the function of the implied beholder is both structural and historical. See W. Kemp 1983 and 1988. For a very brief account of Kemp's work in relation to Hegel and Riegl, see Iversen 1993: 136ff.

38. Börsch-Supan 1971, vol. 2, *1826–1850*. On Hegel's critique, see Gethmann-Siefert 1984.

39. See, for example, Börsch-Supan 1971, cat. no. 252: "Eine Spielergesellschaft nach Honthorst," and no. 253: "Eine alte Frau nach Ostade," both by Heinrich Julius of c. 1827–8 (the exhibition was a biannual event).

40. I. Wirth 1990: 36–43.

41. Börsch-Supan 1971, cat. nos. 364–8; no. 365. On Pistorius, see also *Allgemeine Deutsche Biographie*, vol. 26: 196f.; Bötticher 1891-1901, vol. 2: 280. On the generally increased interest in seventeenth-century Dutch painting at that time, see Stemmrich 1983; Wyss 1984; Carasso 1992; Grijzenhout 1992; Meijer 1992.

42. I. Wirth 1990: 232–47; Rave 1949(?): 17.

43. Thus far, I have been unable to trace this unnamed work. I have, however, found a variation of Hegel's argument in early twentieth-century accounts of such nineteenth-century genre paintings as the "Hosemannsche Trunkenbolde" and comparable attempts by Johann Peter Hasenclever, Franz von Defregger, Rudolf Jordan, Adolf Schrödter, and Ludwig Knaus to imitate Ostade, Teniers, Steen, and Brouwer. The most critical of these accounts are Gurlitt 1900: 242–54; Schmidt 1923: 16, 27f., 94, 129–62; and Beenken 1944: 316–436. See also Pevsner 1973: 190–242.

44. See I. Becker 1983: 50, cat. no. 7. Theodor Hosemann, *The Caretaker as Father*, 1847, printed from colored pen- and -ink drawing, signed 1846, frontispiece to issue no. 2 of Anton Johann Gross-Hoffinger, *Wien wie es ist*, 4 issues, Leipzig: Ignaz Jackowitz, 1847.

45. Waagen 1851: 267f., cat. no. 791.

46. See also H. 13: 222; K.: 169. Hegel specifically targets the painters of the Düsseldorf Academy. On this art, see Ricker-Immel, 1979. On Hegel's attitude toward such contemporary painting, see also Busch 1985: 22, 109f., 170ff. It must be noted that Hegel was no less critical of contemporary history painting that took its subject matter from literature (Shakespeare, Tasso, Goethe). See H. 15: 91–4; K.: 856–8, where he reviews the 1828 art exhibition in Berlin.

47. See Pöggeler 1956, Rodi 1983.

48. Perhaps Jean Paul's bizarre metaphorical mode – which Hegel calls "kunterbuntes Durcheinanderwürfeln" (Knox's "most disorderly" is literally Hegel's "most colorful jumbling into confusion") – provides a contrast to sincere color magic.

49. Knabe 1972: 380; chapter on "naïveté/naïf," 381–4, quotation 384: "le naïf sera tout voisin du sublime."

50. Jean Paul 1980, 253–7: "Die Tiefe als die umgekehrte Höhe (altitudo)"; "weder die Erhabenheit der Gestalten der italienischen Form, noch die komische oder auch ernste Vertiefung der entgegengesetzten niederländischen annimmt"; "nur aber spreche nicht der Dichter, sondern der Character das Komische aus." A partial translation of Jean Paul's *Vorschule* is included in Wheeler 1984: 162–201.

51. Friedrich Theodor Vischer, in his *Aesthetics* of 1847–57, elaborated an aesthetic of the comical as the inverted sublime, crediting Jean Paul with most of its ideas, including the humorous contempt of the world (*humoristische Weltverachtung*). But for Vischer, writing after 1848, this position of a merely ideal subjective freedom had become a problematic deception, an "appeasement," "consisting of the perception that everything is ultimately common existence and yet the idea is present there too." Vischer demanded a real counterpart to this illusion in art. In the end, he himself came to doubt Jean Paul's notion of *echtdeutsche*[n] *Humor*, typically German humor, a humor of *Hausväterlichkeit*, of hominess. Vischer thereby anticipates Nietzsche's judgment of Jean Paul as "a good, comfortable human being, and yet a disaster, a disaster in housecoat." See Vischer 1975: 374; Jean Paul 1980, paragraph 34; Nietzsche 1983: 919.

52. Jean Paul 1980: 257–62. "Epische Darstellung des *Vollglücks* in der *Beschränkung*."

53. This term was coined by Jens Tismar and applied by him to several authors. On Jean Paul, see Tismar 1973: 7–42; Böschenstein-Schäfer 1977: 34, 120–3. More recently, the term has been used for Biedemeier painting; see exhib. cat. Munich, 1987.

54. Jean Paul 1982, vol. 3: 737: "eigene Vorneigung zum Häuslichen, zum Stilleben, zum geistigen Nestmachen."

55. Jean Paul 1980: 125: "Der Humor, als das umgekehrte Erhabene, vernichtet nicht das Einzelne, sondern das Endliche durch den Kontrast mit der Idee." It is important to see that Jean Paul links humor and its annihilating power with both folly and insanity, with *Torheit* and *Tollheit*. His novels *Titan* and *Siebenkäs* each include one high-strung character who represents this kind of humor. These characters are humane, incorruptible, impulsive, critical, solitary, and, as a consequence, self-destructive. But his novels also include characters who naively aspire to the highest achievements and moral standards without recognizing the comical aspects of their sublime aspirations. These two types of characters both represent insanity and folly as well as comical inversions of the sublime.

56. Iversen 1993: 43–6. See also Olin 1992: chapter 8, "The Ethics of Attention," 155–69; Olin 1989, passim; Sauerländer 1977, passim.

57. See Riegl 1931 and 1989. For an excellent account of this work, see Iversen 1993: 91–123; and for her comparison of Riegl's book with more recent accounts of spectatorship, ibid: 124–47.

58. The new affectedness of art is expressive, not rhetorical. It is a kind of selfish emotionality. If it had been rhetorical it might, by virtue of the accompanying rationalization of feeling or of the passions, have opened art up to an active, critical viewer participation, as seen in French classicism.

59. Thoré 1906; Hofstede de Groot 1905, 1907; Hofstede de Groot 1907–28. This last work appeared in English in several volumes beginning in 1908; this version is cited here as Hofstede de Groot and Valentiner 1976. It is interesting to note that the earlier book was published in different formats, including a de luxe edition (*Prachtausgabe*) in double folio (Amsterdam: 1907 in German and Dutch, 1909 in English). This suggests an audience of bibliophiles interested in Vermeer or of admirers of the artist who wished to treasure him in such a visibly concrete manner. The history of this first publication is somewhat complicated. According

to *Kayser's Vollständiges Bücherlexikon 1903–1906* (vol. 34: 969) and the *Gesamtverzeichnis des deutschsprachigen Schrifttums 1700–1910* (vol. 150: 502), it was published in four parts in double folio format. It consists of thirty-seven pages of text and thirty-nine single-sheet heliographic reproductions. Part 1 appeared in Leipzig in 1905, Parts 2–4 in 1907 and 1908 in Leipzig and Amsterdam (an obviously mixed copy is in the Boston Public Library). A supplement of three more plates was published in Leipzig in 1908. Zeitler and Prina clearly had access to Hofstede de Groot's catalogue in 1905–6 when preparing their edition of Thoré's monograph. For the verification of these details I thank Susan Dackerman and Peter Sander, who helped me to track them down.

60. De Vries 1948 lists many of these short articles in his bibliography and oeuvre catalogue.

61. Friedländer 1926: 37f.

62. The first examples of this approach are Herbert Rudolph's famous article, "'Vanitas': Die Bedeutung mittelalterlicher und humanistischer Bildinhalte der niederländischen Malerei des XVII. Jahrhunderts," of 1938, and Ernst Friedrich von Monroy's posthumously published dissertation of 1940, *Embleme und Emblembücher in den Niederlanden 1560–1630: Eine Geschichte der Wandlungen ihres Illustrationsstils* (1964), which includes a study of *rederijker* chamber emblems in paintings as well as thoughts on emblematic meaning in still life and landscape painting. For a comprehensive summary of this history, see Bialostocki 1984: 421–38.

63. See, for example, Bode 1883: vii: "obgleich feuilletonistisch gehalten"; and Thoré 1911. The editors of this edition of Thoré's Salon critiques, Schmarsow and Klemm, characterize them in the preface as "[l]eicht lesbar, immer anregend, und auch in spielender Form ernstlich durchdacht, ja selbst in heiterer Ironie noch gesinnungstüchtig" (viii). Volume 3 includes an elaborate exposition of Thoré's writings by Klemm, "Thoré-Bürger als Kunstkritiker," 231–302. The preface had already been used in a 1908 edition by Schmarsow and Klemm of *W. Bürger's Kunstkritik*.

64. Thoré 1866: 298: "En ce temps-là, nous regardions tous la peinture pour le plaisîr des yeux et pour en écrire de belles descriptions."

65. Paul Prina, the translator employed by Julius Zeitler, not only translated Thoré's essays on Vermeer, but also Edmond and Jules de Goncourt's *La Femme au dix-huitième siècle* as *Die Frau im 18. Jahrhundert*, with sixty pages of annotations (1905–7).

66. Thoré 1866: 300, 310; Thoré 1906: 7, 22.

67. See Diderot 1984, glossary; Knabe 1972: 359–64.

68. Thoré 1866: 460, 320; Thoré 1906: 54, 37.

69. Compare Waagen 1862: 180; Thoré 1866: 327; Thoré 1906: 47.

70. Thoré 1866: 326; Thoré 1906: 45.

71. Thoré 1906: 83. Justi's praise of Thoré's *aperçus* and *geflügelten Worte* culminates in the claim that "seine Feuilletonaphorismen sind zuverlässiger als manche gelehrten Bücher."

72. Valentiner 1932: 324.

73. Max J. Friedländer, "Vom Wesen der Genremalerei und dem Entstehen der Bildgattungen," in Friedländer 1947: 191–286; especially 242-4. The quotations are my translation from the original German edition. See also Friedländer 1965: 154-218; especially 193.

74. Brieger 1922: 129f.

75. Bode 1909–11: 56f.; and Bode 1883: vi, where he praises Thoré's work in general as paradigmatic historical scholarship and a foundation for "die kritische Bildexegese."

76. Friedländer 1965: 185f. On Bode, see Beyrodt 1990 exhib. cat. Berlin 1995, and Ditzen 1995, passim, for information about publications as well as conferences and exhibitions organized in honor of Wilhelm von Bode on the occasion of his 150th birthday. Bode and Hofstede de Groot also worked together and co-authored a six-volume monograph on Rembrandt (Paris: Sedelmeyer, 1897–1906). It was Henry Havard who in his *Van der Meer de Delft* of 1883 first suggested Leonaert Bramer as Vermeer's teacher.

77. Interestingly, André Malraux writes in *The Voices of Silence*: "He seems to disindividualize his models. . . , the result being that they are not types but, rather, highly sensitive abstractions in the manner of certain Greek *Korés*" (1990: 476). For a brief critical account of Malraux on Vermeer, see Maurice Merleau-Ponty 1969: 98–101.

78. Bloch 1962: 256, and Bloch 1990: 234f. *Erbschaft dieser Zeit*, or *Heritage of our Times*, includes a long text of 1935 by the same title as well as other essays on the appropriation of Expressionism by the political extremes of both left and right. The statements on Hausenstein are made in the essay "Der Expressionismus, jetzt erblickt", or "Expressionism, Seen Now" from 1937. Bloch credits Hausenstein with turning the public's mind and taste against Expressionism after World War I, thus preparing the way for Hitler's suppression of this art. This judgment must be weighed against the complex evidence of Hausenstein's writings and adoption of an expressionistic style, most obvious perhaps in his 1919 book on Grünewald's *Isenheim Altarpiece*, where it serves a nationalistic account of the art work. For a general orientation on Hausenstein, see exhib. cat. Marbach, 1967.

79. Reifenberg 1924. Reifenberg (1892–1970), an art historian and essayist, worked for the *Frankfurter Zeitung* in several capacities between 1924 and 1943, when it was closed by the Nazis: as art critic, as political correspondent in Paris, and as editor. Later, he was one of the editors of the *Frankfurter Allgemeine Zeitung*.

80. Hausenstein 1926: 308. The supposedly Grecian Vermeer has recently been psychoanalyzed by Edward Snow (1979, 1994), with reference to Nietzsche's Greece. Snow starts out with an extended both critical and personal account of Vermeer's *Girl with a Pearl Earring* and the dual analysis of response and painting.

81. Hausenstein was evidently convinced of the correctness of this ambivalence in Vermeer's art and character. He repeats part of it in his *Kunstgeschichte* of 1927: 304, 317f.

82. With regard to Vermeer, this re-creation is of a rather mixed nature, including perhaps what Theodor Heuss once called Hausenstein's "indiscretion against himself." See Theodor Heuss, in a letter to Elly Knapp, of August 8, 1907, from Paris (exhib. cat. Marbach, 1967: 37).

Hausenstein's essay is an homage to Julius Meier-Graefe. See Hausenstein, "Der Kunstschriftsteller," *Kunstblatt*, ed. Paul Westheim, 1917, quoted in exhib. cat. Marbach 1967: 45. See also Manheim 1990.

83. For this understanding of the term *genre*, see Stechow and Comer 1975–6; and for the effort to coordinate the phenomenon with classical art theory, Raupp 1983; L. de Vries 1991.

84. The following quotations are taken from the two sections on Vermeer and on genre painting in the nineteenth and twentieth centuries, respectively. Friedländer 1947: 240-4, 277–86; Friedländer 1965: 193–6 and 222–9.

85. Friedländer 1947: 240; Friedländer 1965: 192.

86. Riegl 1982: 22.

87. This and all of the following citations are from Würtenberger 1937: 80–90. The term *Gesellschaftsbild* was taken up by writers on nineteenth-century German genre painting imitating the Dutch painters; e.g., Beenken 1944: 319f.

88. Sutton 1980b, cat. no. 29.

89. Sutton 1980b, cat. no. 109.

90. Blankert 1978, cat. no. 17; Wheelock

1995, cat. A21 and pp. 113–19.

91. See Blankert 1978: cat. nos. 11 and 8; Wheelock 1995: cat. nos. A11 and A10.

92. This information was provided by the Herzog Anton Ulrich-Museum, Brunswick.

93. Waagen 1862, vol. 2: 110: "ein Mädchen auf einem Stuhl und zwei Männer."

94. Hofstede de Groot and Valentiner 1976: 599, cat. no. 38; Hofstede de Groot 1905, 1907: 34, cat. no. 26. The title *La Coquette* appears to originate with the oeuvre catalogues published by Théophile Thoré and Henry Havard.

95. Blankert 1978, cat. no. 16; Wheelock 1995, cat. no. A14 and pp. 85–95. Hofstede de Groot calls *The Music Lesson* by this name in his monograph (1905, 1907: 33, cat. no. 17) and *A Lady at the Virginals and a Gentleman* in his catalogue raisonné (1976: 594, no. 28). *Girl Interrupted at Her Music* is called *The Voice Lesson* [*Die Gesangstunde*] (1905, 1907: 33, cat. no. 18) and *A Gentleman and a Young Lady* (1976: 594, no. 27), respectively. For an account of eroticism in Vermeer's musical subjects, see de Mirimonde 1961. Blankert considers *Girl Interrupted at Her Music* to be a copy (1978, cat. no. B2; Aillaud et al. 1988, cat. no. b2, "the ruin of a Vermeer"). Wheelock 1995 accepts the work as cat. no. A13. In Hofstede de Groot's catalogue (1976, cat. no. 27), the painting is identified as *A Gentleman and a Lady*, in Prina's edition of Thoré's articles it is called *The Voice Lesson* [*Die Gesangstunde*] (Thoré 1906, cat. no. 10). The work's provenance can be traced back to 1810, and Hofstede de Groot published it as a Vermeer in 1899.

96. Friedländer 1947: 242; Friedländer 1965: 194.

97. For a comparison with Mondrian see Seuphor and Berckelaers 1957: 69; H. L. C. Jaffé 1970: 46; H. Read 1969: 91; Bryson 1983: 120.

98. This term was coined by Herbert Read in his essay "The Serene Art of Vermeer," in H. Read 1969: 87ff.

99. Thoré 1906: 77. Prina's revised short catalogue includes Thoré's descriptions of Vermeer's paintings, such as this one from vol. 2 of his *Musées de la Hollande* of 1859, 1860.

100. For *A Girl Asleep*, see Blankert 1978, cat. no. 4; Wheelock 1995, cat. no. A5 and pp. 39–48.

101. Exhib. cat. Brunswick 1978: 164–8; exhib. cat. Philadelphia 1984: 338f. In its focus on motifs, not on representation, emblematic research has often created interpretive problems or even impasses for itself. However, the main founder and

representative of this kind of iconographic research, Eddie de Jongh, addressed this problem himself, in his study, "Pearls of Virtue and Pearls of Vice" (1975–6); see also exhib. cat. Auckland, 1982: 27–37.

102. Snow 1979: 48ff.

103. Thoré 1906: 77. See also Schneider 1994: 33, where these elements are recombined to turn the girl into an adulterous wife.

104. See, for example, the prominent motif of the footwarmer, in Roemer Visscher and in paintings by Miense Molenaer, Leyster, and Steen.

105. See Maser 1971: emblem no. 149.

106. See Henkel and Schöne 1967: columns 1561f.; as well as Frossati-Okeyama 1992. Seth (1980) identifies the allegorical figure in Vermeer's stained-glass window exclusively with Heinrich Aldegrever's *Invidia*, from the series of virtues and vices of 1522 and 1549. He relates its meaning to the man seated at the table, so as to read him as a jealous, rejected lover. For the series, see Strauss 1980: cat. nos. 111 (397), 125 (401).

107. Here I disagree with Bauer, who believes that with this emblematic image the artist not only meant but was successfully able "to limit and fix the interpretation" of his work (Bauer 1988: 216).

108. Gowing 1952: 117.

109. Thoré 1866: 460; Thoré 1906: 56. Prina here uses the word "Kokette": "und die mit ihrem Galan scherzende Kokette in Braunschweig! Das ist das Leben selbst."

110. Plietzsch 1939: 26.

111. See Klessmann, in exhib. cat. Brunswick 1978: 165.

112. Klessmann, in exhib cat. Brunswick 1978: 166.

113. Hofstede de Groot 1905, 1907: 33, cat. no. 25.

114. Fischel c. 1900–5: 109.

115. On these titles, see Ruurs, "Documents," in Blankert 1878, cat. no. 8, "The Glass of Wine"; Hofstede de Groot and Valentiner 1976: cat. no. 37; Bode 1909–11: 61, "such pictures as 'The Party,' in the Brunswick Gallery, the similar representation at the Bürger sale (1892)"; Swillens 1950: 73, *Young Woman Drinking with Gentleman*, as opposed to the Brunswick painting, *Young Woman with Wine-glass and Two Cavaliers*; E. J. van Straaten 1977: 56–9, *Het Glas Wijn*.

116. Wheelock 1988: 70, 68.

117. See Geraert ter Borch, *Drinking Woman and Sleeping Soldier*, c. 1658–9, Gudlaugson 1959: cat. nos. 110 (*Paternal Admonition*) and 146. Ter Borch's oeuvre contains two more representations

of a woman drinking by herself; see cat. nos. 125, 190. Wheelock (1988: 68, 20) compares Vermeer's *The Glass of Wine* with de Hooch's *A Dutch Courtyard*, a painting rather different in mood. The figures in the latter work take obvious pleasure in their social gathering and the woman standing at the table appears to participate deliberately in the men's drinking. The outdoor setting, the open gateway, and the child nearby further exclude any sense of coercion from the scene. See *Two Soldiers Smoking and a Woman Drinking in a Courtyard*, c.1658–60, National Gallery, Washington, D. C., and *A Man Smoking and a Woman Drinking in a Courtyard*, c. 1658–60, Mauritshuis, The Hague, in Sutton 1980b, cat. nos. 35A and 35B, figs. 34–8. In the second version the figure of the man offering to refill the woman's glass is overpainted. The pitcher simply stands by itself on the table; the second pipe simply lies there as well. These objects may but do not necessarily relate to the woman. Interestingly, she does not look more coerced in 35A than in 35B. Scenes with men emptying glasses are abundant in Dutch genre painting, but draw no specific attention from art critics.

118. Spicer 1992, passim.

119. Würtenberger 1937: 88f.: "Die zur Seite gelegten Gegenstände zeigen das frühere Tun des Paares an und haben mehr pathetisches Leben als das völlig erstarrte Weintrinken. . . . Allerdings ging bei einer solchen Schöpfung die Verwirklichung des Begriffes des Geselligen verloren."

120. Here Würtenberger seems to develop an observation made by Riegl in his essay on Ruisdael, namely, that objects – not only subjects – can gaze at the beholder. See Olin 1992: 160f., Riegl 1929, passim.

121. Würtenberger 1937: 89f. Compare the Vermeer to de Hooch's *Three Figures at a Table and a Couple at a Harpsichord* (c. 1675–7), Sutton 1980b, no. 118, fig. 121. Of this work Friedländer might say that it looks as if naturally "come about, not made" (Friedländer 1947: 234).

122. Würtenberger 1937: 94. Friedländer, in contrast, discusses Steen between the sections on de Hooch and Vermeer.

123. Benjamin 1983, vol. 1 (*Gesammelte Schiften*, vol. 5, Part 1): 59. In keeping with his insight, Würtenberger later wrote an article on "Das Maleratelier als Kultraum im 19. Jahrhundert" (1961).

124. Aragon and Cocteau 1982: 77.

125. Except of course on the level of making a presumably timeless Vermeer a pawn of cultural politics. I am referring to Jan van Meegeren's production of Vermeers, to their classification as a national cultural treasure in the Netherlands, and to Nazi appropriations of that treasure, especially, Göring's purchase of the forged Vermeer, *Woman Taken in Adultery*. Abraham Bredius published the discovery of Vermeer's *The Disciples of Emmaus* in the *Burlington Magazine* in November 1937: 211. By the end of December the painting was acquired, through the Rembrandt-Vereniging and other contributions for the Museum Boymans in Rotterdam. Bredius and A. B. de Vries further celebrated the work in their articles of 1938. In 1945 when van Meegeren claimed authorship of his forgeries, the "new" Vermeers and their promotion by Dutch art historians in the late 1930s was questioned. All of this happened only because the sale of a "Vermeer," van Meegeren's *Woman Taken in Adultery*, to Göring was investigated in the 1940s as an act of collaboration with Nazi Germany. See Coremans 1949.

126. Lamblin 1987, chapter 6, "La Peinture du genre," 461–567, especially 491–500 on Vermeer and de Hooch; the quotation is taken in part from an essay by René Huyghe (1948: 105), 496.

127. Letter to Theodor Heuss of March 9, 1906; see exhib. cat Marbach, 1967: 33.

128. Hausenstein 1923: 168–70.

129. Blankert excludes the work from Vermeer's oeuvre. See Blankert 1978, cat. no. B4, and Aillaud et al. 1988: 187, cat. no. B4. Wheelock 1995 includes *Young Girl with a Flute* in his catalogue as "attributed to Johannes Vermeer," cat. no. A36; see also Wheelock 1988; 126; then he thought that the work is "not by the master himself."

130. One of the first references to this cliché can be found in Georg Forster's *Ansichten vom Niederrhein* of 1790. Praising the civil freedom and prosperity he finds in Amsterdam, he rejects the characterization of the Dutch as phlegmatic, proposing instead to think of Dutch prudence and pragmatism as Republican virtues, *Republikanertugend*. See Forster 1965: 100–12.

Part II

1. Stokes 1965: 17.

2. See Blankert 1978, cat. no. 10, Wheelock 1995, cat. no. A12.

3. Gowing 1952: 129.

4. Heppner 1937–8: 69f: Thoré's first encounter was in 1842, his "steekbrief" for information on Vermeer was published in 1859, and the three articles, i.e. the monograph, "Van der Meer de Delft" in 1866.

5. An analogous study could be written on

Rembrandt, Giorgione, or Leonardo. See Hüttinger 1977.

6. Reference is to Carrier 1987. As far as I can see, Carrier focuses on successive rhetorical models of academic and critical writing from Walter Pater to Arthur Danto, without taking into consideration other genres of writing about art.

7. Eisler 1916; Hildebrand (1st ed. 1893) 1918; Hildebrand 1909; Jantzen (1911) 1951; this concept was first developed in Jantzen's book *Das niederländische Architekturbild* of 1910. For references on Benjamin, see Part III of this study.

8. Liedtke 1979: 273.

9. On the subject of the cityscape, see Manke 1963; Donahue 1964; Wagner 1971; Links 1972; exhib. cat. Amsterdam 1975; Liedtke 1976; exhib. cat. Amsterdam 1977; L. de Vries 1977; Brown 1978; Liedtke 1979; Sutton 1980a and 1980b; Liedtke 1982; Schloss 1982; exhib. cat. Rotterdam, 1991; Lawrence 1991. On the relationship of cityscape and mapmaking, see Alpers 1983; Hedinger 1986; Woodward 1987, each with further bibliography.

10. Exhib. cat. Amsterdam 1977: 15.

11. Exhib. cat. Amsterdam 1977: 18.

12. Ibid. James goes on to interpret the Dutch identity of art and scenery as a charming quaintness, partly comical and lacking spirituality.

13. Seymour 1964; Fink 1971; Wheelock 1977b.

14. For a recommendation to this effect by Jean Leurechon in his *Recréation mathematique* (1626), see Wheelock 1977a: 95.

15. On such issues, see Lambert 1971: 179–234; with regard to Delft, exhib. cat. Delft 1982, part 3.1, essays VI. 4A and 4B by J. D. van Dam and R. A. Leeuw on the Delft pottery and tile industry; 135–52.

16. In contrast to Gombrich's approach, it has been argued that the "revolution" of experimental science resulted in a rationalization of space and time as something abstracted from experience and, in fact, nonempirical. See Elias 1992a: 83–92; Elias 1992b: 107–15. On some consequences of this for art, see Theissing 1987: 186ff.

17. Baudelaire 1991: 370–3; 371.

18. For a general introduction, see Koumans 1930; Murris 1925; Chu 1974.

19. For related reading, see Lowe 1991, in response to Edward Said, chapters 2, "Travel Narratives and Orientalism: Montagu and Montesquieu," and 3, "Orient as Woman, Orient as Sentimentalism: Flaubert."

20. Van Winter 1965.

21. On Baudelaire's response to travel and the visual arts, see Coven 1993: especially 148ff.

22. See Koumans 1930: 15–40 for several references to land reclamation and artificial waterways as Chinese or Venetian.

23. Verlaine 1960.

24. Here I am interested in modes of perception and reception, regardless of how exaggerated and fantasized the "oriental" aspects of Holland may be in these texts. For factual accounts of the Netherlands and the Far East, see van Raay 1989, with further bibliography.

25. Havard's bibliography includes *La Hollande pittoresque, le coeur du pays* (1878b), translated as *The Heart of Holland* (1880); *Histoire de la faience de Delft* (1878a); *L'Art et les artistes hollandais* (1878–81); *Michiel van Mierevelt et son gendre* (1894); *La Céramique hollandaise* (1909); as well as the translation of a Dutch exhibition catalogue as *Objets d'art et de curiosité tirés des grandes collections hollandaises* (1873).

26. He also organized the exhibition of sculpture and painting at the 1889 Exposition Universelle in Paris. See *La Grande Encyclopédie*, vol. 19: 941; and Trenard 1989.

27. Havard 1876b: 320; translation slightly changed. This work was also translated into German as *Eine malerische Reise nach den toten Städten der Zuyder See* (1882).

28. For an account of French travel guides as well as Diderot's brief reference to Broek and Zaandam, see Bakker 1986: 15–24; quotations 20f.

29. Schopenhauer 1923: 30f. *Baedeker's Belgium and Holland* of 1894, written by Karl Baedeker himself, praises the extensive railway system which, by 1892, ran for 1,756 miles, and the good access to all places worth seeing (xxvi); he mentions Broek in passing as "a village known for its almost exaggerated cleanliness" (351).

30. Nerval 1961: 837f. In one version of "Les Délices de la Hollande", in his *Notes de voyage*, he emphasizes the travel experience of the railway, while describing in another that of viewing Dordrecht from a steamboat. See Nerval 1961: 867–77, and 1467f.

31. Du Camp's Dutch travel accounts were published in the *Revue de Paris* in 1857, prior to their appearance in book form as *En Hollande, Lettres à un ami, suivies des catalogues des musées de Rotterdam, La Haye et Amsterdam* (1859). I am quoting from the revised edition (1868: 73). Particularly striking is the order of subject matter in this book. Accounts of oriental taste, collections, and ethnicity are coupled with subjects of nature, nat-

ural history, and curiosity cabinets of natural artifacts. See the table of contents: "Curiosités et puérilités – Japoneries – Le Bois," or: "Sirènes, Fossiles, Oiseaux, Oeufs, Tarets. – Panthéon hindon. – Japoneries," and even: "Jardin zoologique. – Les Juifs" (1868: 388).

32. Zielonka 1985.

33. There are certainly political aspects to the orientalizing of the Netherlands in French travel literature. One such aspect, which can not be pursued here but should be mentioned, is the topic of religious tolerance and the prominence of the Jewish population in Amsterdam, to which all travel accounts I have studied give attention, but in ways differing considerably from one another. Esquiros is unusual in devoting one of his longest chapters to an analysis of "Les Juifs en Hollande," emphasizing origin, class, education, wealth, and occupation. He ends with an international survey of the status of Jews in society, from which France is conspicuously absent, and an appeal to progressive thinking. See Esquiros 1859, vol. 2: 145–226.

34. Esquiros 1859, vol. 1: 116, 119.

35. Havard, *Amsterdam et Venise* (1876a). A rather different comparison of the two cities is Burke 1974.

36. Léopold Flameng (1831–1911) and Léon Gaucherel (1816–86) were very successful printmakers who specialized in book illustration and in reproduction prints of old and modern masters for the *Gazette des Beaux-Arts* and other publications on art and architecture. Henry Havard published a monograph on Flameng in 1904. See H. V. 1916; on Gaucherel, L. B. 1920.

37. See specifically Bakker 1986: 25–32. Monet painted twenty-four views of Zaandam and sixteen views of Amsterdam during his time in Holland. See D. Wildenstein 1974–91, vol. 1: cat. nos. 170ff. For the comparison with Far Eastern art, see van de Wetering 1986; Joosten 1986.

38. Havard 1888: 18: "Le *Sphinx*, comme il aimait à appeler Vermeer, a livré son secret." He also rejects Thoré's claim that Vermeer was a pupil of Rembrandt's, suspecting Thoré of a misplaced upgrading of Vermeer as Rembrandt's equal (22).

39. See Diderot 1984: 288; and Pernéty 1972: 554f.

40. Du Camp 1868: 39f. While emphasizing the real historical connections between the Netherlands and the Far East, du Camp also takes pleasure in orientalizing his travel observations on the Netherlands. See 73ff., 98ff., and his accounts of Zaandam and Broek, 165ff. The first reminds him of Constantinople (170), the second he calls a

"fantaisie la plus cocasse que jamais Chinois ivre d'opium ait pu rêver" (172).

41. Thoré 1866: 463.

42. This claim was made even more emphatically in Estaunié's *Impressions de Hollande* (1893): "Il y a de l'orientalisme dans l'âme hollandaise, un orientalisme inavoué et qui, pareil à tous les instincts hors de route, est le germe de ses grandeurs." See Koumans 1930: 57.

43. It is this subjectivity to which Monge draws attention in this comparison between Fromentin and Proust. See Monge 1961, passim.

44. On Fromentin the painter, see H. V. 1916; Beaume 1913; Rosenthal 1982, chapters 5 and 6; for the comparative study of his four major publications, the African journals *Un Eté dans le Sahara* and *Une Année dans le Sahel*, the novel *Dominique*, and *Les Maîtres d'autrefois*, see A. Evans 1964. On Fromentin the art critic, see Auzas 1984: 3–16.

45. Thoré 1911, vol. 3, passages from Thoré's Salons of 1861–6: 116–21, translated from Thoré 1870; Salon de 1861, chapter 3: 116; Salon de 1863, chapter 2: 385; Salon de 1865, chapter 3: 215; Salon de 1866, chapter 3: 311. Fromentin also appears to have sold his works immediately upon their exhibiton. See Sterling and Adhémar, 1959, vol. 2: 31f.

46. Fromentin 1938: 54–7.

47. Rosenthal suggests a link between the popularity of Dutch genre painting and French orientalist painting in nineteenth-century France (1982: 94, 97). It is also in keeping with Fromentin's view of the monochromy of Dutch no-subject painting that his own orientalist paintings use a reduced color scheme that has been compared to that of Corot. Thus Fromentin uses two paradigms, oriental monochromy and 'Indian' colorism.

48. Fromentin 1938: 30f. Fromentin earlier evoked Rembrandt's etching *The Three Trees* as the true image of "la vie de voyage" (2f.).

49. On Thoré, see Klemm 1911; Marguery 1925; Heppner 1937–8; Blum 1946: 1–76; Thuillier 1960; Jowell 1977.

50. Jowell 1977: 243–54.

51. Marguery 1925: 242ff., 295, 298.

52. Schmarsow and Klemm, in their preface to Thoré 1911, vol. 1: vii. They continue: "so ist er auch unter diesem Namen bei uns eingebürgert, und soll es bleiben, wie er gewollt." This view of Thoré as an enlightened art critic and citizen is elaborated upon in Klemm's "Thoré-Bürger als Kunstkritiker," ibid.

53. *Revue de Paris*, October 4, 1857. See du Camp 1868: 39.

54. See also Thoré 1866: 463 and 569, cat. no. 51.

55. Thoré 1858–60, vol. 1: 273, footnote 1, quotes Gautier: "Van Meer peint au premier coup avec une force, une justesse et une intimité de ton incroyable. . . . La magie du diorama est atteinte sans artifice" (*Moniteur*, June 1858). See also Snell 1982: 220f., 256.

56. He also calls Rembrandt's *Nightwatch* an "espèce de sphinx" (vol. 1: 38).

57. Blanc 1861, section on "Jean Ver Meer ou Van der Meer de Delft," 2; section on "Pierre de Hooch ou de Hooghe," 6. The *Girl Reading a Letter at an Open Window* is reproduced as an engraving (7), with the slight alteration of hair added to the woman's "Chinese", i.e. shaved forehead (the term is Thoré's).

58. Thoré 1866: 297, 298, 316, 323.

59. Gowing makes a similar connection, identifying the "ideal orient" with the "immemorial world of femininity" in Vermeer's art (1952: 54).

60. Montias 1988: 190ff.

61. See also the discussion of these characteristics in Part III, "Cold Justness versus Divine Justice."

62. Szondi 1980: 267–512, especially 274–9, 443, 450–2, 463–72.

63. Reference is to Hegel 1983, vol. 13, particularly "Vom Symbolischen überhaupt," 393–407, "Die eigentliche Symbolik," 448–66. In T. M. Knox's translation (Hegel 1975), these sections are called "The Symbolic in General," and "Symbolism Proper," 303–22, 347–61.

64. H., 14: 150; K.: 526, in the section called "The Details of the External Appearance as Accidental."

65. Szondi demonstrates that for Hegel the dialectical identity of the symbolic and the real involves the possibility of complete negation and is representable only in symbolic and romantic poetry. See Szondi 1980: 380ff.

66. Again, one must not lose sight of the differences at work within this comparison. In the realm of "symbolism proper" the Egyptians had "in Apis [the bull] a vision of God himself" ("in Apis die Anschauung des Göttlichen selber"; H., 13: 407; K.: 313). In contrast, the Dutch had in their paintings the metaphorical representation of the human and worldly as *Schein*, appearance.

67. Gadamer 1965: 94; 1988b: 88.

68. Gadamer 1965: 76; 1988b: 72.

69. Timmers 1942: 52.

70. Not surprisingly, one rarely finds references to contemporary accounts of any of the countries or arts invoked, such as Fraissenet 1857, or to the important seventeenth-century source of Engelbert Kaempfer's account of Japan and Dutch-Japanese relations. (Kaempfer 1906).

71. Hegel himself perceives the possibility of loss on the beholder's part when he declares the necessity that Dutch painting of "vulgarity" (*gemeine Natur*) be in small format (H., 13: 224f.; K.: 171).

72. Huyghe 1936: 7-15; Monnin-Hornung 1951; Macchia 1960; Meyers 1973; Stierle 1985; Magill 1987; Theroux 1988; Collier 1989 (published originally in Italy, 1986). On Paul Helleu, one of Proust's presumed models for his fictional painter Elstir, see Quinell 1983; Grioni 1993a; Grioni 1993b; as well as Liedtke 1990: 38: Helleu went with the Boston collector Isabella Stewart Gardner to Drouot's December 5, 1892 auction, to purchase one of Thoré's Vermeers, *The Concert*.

73. Johnson 1980, chapter 3, "Proust and the Metaphor of Painting," 147–91; Borowitz 1982; Borowitz 1983. The one study that appears to balance these two orientations in scholarship is Chernowitz 1945.

74. "Valéry Proust Museum," in Adorno 1992, 173–86; especially 180.

75. Adhémar 1966.

76. Misme 1921: 271.

77. Misme 1921: 276.

78. Vaudoyer 1968: 81–96. For a complete translation into English, see Arasse 1994, appendix 1, 87–97. Vaudoyer's brief introductory paragraph, containing information about the show, is omitted in the 1968 edition of the French text.

79. Vaudoyer 1968; 187–95.

80. Vaudoyer 1968: 189.

81. While this is not my topic, it is useful to be aware of a complex political side to the writings discussed here. Orientalism in Europe in this exhibition really means orientalism in France, and this exhibition was mounted and Vaudoyer's review article written at a time of crisis in French colonial politics in Morocco, a crisis that also severly strained French–German relations. See Poidevin and Bariéty 1982: 225–53.

82. Vaudoyer 1911: 90.

83. Rosenthal mentions van Mour and Liotard briefly (1982: 16ff.). On all three of them, see Boppe 1911. Interestingly, Vaudoyer does not mention at all that Favray was foremost a painter of Christian iconography and portraits for the Knights of Malta. And he takes great pleasure in

presenting Liotard's colorful life as an artist-adventurer in Turkish costume. For a more recent account of Liotard, see Grijzenhout 1985.

84. Vaudoyer 1911: 100f.

85. See Cuzin 1988: 330, cat. no. 362; G. Wildenstein 1960: cat. no. 339, fig. 147.

86. Quite representative of this focus on light and on the colors blue and yellow in Vermeer's oeuvre at the turn of the century is *Vermeer of Delft*, vol. 5 in the popular *Masters in Art. A Series of Illustrated Monographs* (1904), which includes excerpts on this from texts by Thoré (1866), Carl Leucke (1878), Abraham Bredius (1890), Arsène Alexandre (1894), Frederick Wedmore (1888), John C. van Dyke (1895), Alfred Woltmann and Karl Woermann (1887–8), Alfred Peltzer (1903).

87. Vaudoyer 1968: 92. Accidental or not, the layout of the large color plates in Schneider 1994 makes use of exactly these three colors, in addition to white and black, to frame the Vermeers.

88. Hale 1913: 9, 17–28, 110ff.

89. Hale 1913: 73. The metaphoric quality of the Far East in these accounts has been ignored in a recent attempt to argue Vermeer's conscious, if not intended, imitation of Javanese Buddhist sculpture and the theme of nothingness (Larsen 1985).

90. The study of Proust I found most helpful, regardless of the fact that it nowhere treats the subject of visual art, is Hans Robert Jauss, *Zeit und Erinnerung in Marcel Prousts "A la recherche du temps perdu": Ein Beitrag zur Theorie des Romans* (1955).

91. The primary edition of the novel used in this study is Marcel Proust, *A la recherche du temps perdu*, ed. Jean-Yves Tadié et al. (1987). However, I shall quote the novel from its 1982 English edition; page references for quotations and paraphrases follow each in parentheses, citing both the English and French editions. Where necessary, I shall refer to differences between the two, since the 1987 edition presents a rather different text from earlier French editions, the original as well as that of 1954, which together formed the basis for Moncrieff's original translation and its revision. I shall also make use of the variations of certain phrases and passages, as given in Tadié's appendices.

92. Proust 1976: 102.

93. The steeple is, indeed, an important motif in the novel. For an excellent interpretation of it, see Jauss 1955, chapter 2, "Das Doppelspiel von erinnerndem und erinnertem Ich," especially 76ff.

94. Proust 1976: 103; (spelling and punctuation as in the original text).

95. See Stierle "Proust, Giotto und das Imag-

inäre," in Boehm 1985: 236ff. on this.

96. Thus, the recurrent motif of Giotto's allegorical figures and personifications of vices and virtues in the Arena Chapel in Padua contains two possible identities, first, as allegorical figures who are indifferent toward the signs and attributes they bear, and second, as physiognomic and body types, whose truth and reality depends on that indifference and who have "doubles" in Marcel's life, such as the pregnant kitchen maid in Combray, whom Swann likens to Giotto's Charity (Proust 1982, vol. 1: 87ff.; 1987, vol. 1: 79ff.). On the Giotto allegories see also Jauss 1955: 152ff., Collier 1989: 64ff, and Stierle, in Boehm 1985, passim.

97. Johnson 1980: 166ff.

98. See Jauss 1955: 128, with reference to Proust 1982, vol. 3: 260; 1987: vol. 3: 762: "The only true voyage of discovery, the only really rejuvenating experience, would be not to visit strange lands but to possess other eyes, to see the universe through the eyes of another, of a hundred others."

99. Proust 1933, vol. 4, part 2, 86–8: "Lettres à Jean-Louis Vaudoyer," nos. 38, of May 2, 1921, and 39, 1921.

100. Vaudoyer 1968: 94f. In Adhémar's reprint, the second passage appears twice, the first time accidentally added to a description of the *The Lacemaker*. See Adhémar 1966: 298. Unwittingly, this misprinting brings out the significance of Vaudoyer's statement, though in Bryson's sense of Vermeer as an artist painting himself out of the picture, or in Snow's, of an incognito sojourn within the female model.

101. Vaudoyer 1968, 95: "cette double allégorie," i.e., the artist and the model.

102. Meyers, and similarly Theroux and Macchia. A broader approach is taken by Chernowitz, Monnin-Hornung, and Johnson.

103. Here the new edition by Tadié presents a text to which Moncrieff's translation no longer corresponds accurately. In both variants (1987, vol. 1: 215 and 1204), Proust speaks of small, even dancing personages discernible in that illuminated distance.

104. Proust avails himself here of the repeated shift in ascriptions from Maes to Vermeer and back that occurred in Vermeer connoisseurship of the 1880s and 1890s. See Blankert 1978: cat. no. 2.

105. Proust 1987, vol. 1: 1243f.: there are two variations on this travel plan, listing in one of them London and thus suggesting a different group of Vermeer paintings to be visited.

106. Vanzype 1908: 84.

107. Shattuck dismisses Bergotte's death scene as the ironized death of a fetishist, an aesthetic idolater (1974: 86). In this he shares the view of Monnin-Hornung 1951: 39ff.

108. First Painter and, following him, Chernowitz, Theroux, and Meyers have made much of Proust's drawing upon personal experience of the painting on exhibit at the Jeu de Paume in 1921. See Painter 1978, vol. 1: 307; vol. 2: 320. Proust asked Vaudoyer in a letter: "Voulez-vous y conduire le mort que je suis et qui s'appuiera sur votre bras?" Afterward, he expressed his gratitude with a citation from Vaudoyer's article in *L'Opinion* of May 14, 1921, referring to "ce Ver Meer où les pignons des maisons 'sont comme de précieux objets chinois'". In another letter he appears to allude to the Bergotte scene, writing to Vaudoyer: "J'ai beaucoup parlé avec Gide et un peu avec tout le monde de vos merveilleux articles sur Ver Meer." See Proust 1933, vol. 4, no. 42, 1922, and no. 40, 1921 (90, 88).

109. Briefly referred to by Borowitz 1983: 76. Johnson sees Ruskin as Proust's primary reference for his use of "the metaphor of painting" in the novel, and points out the "pèlerinage Ruskinienne" in Proust's *En mémoire des églises assassinées* (1980: 151).

110. "Rembrandt." In Proust, 1971: 659–64.

111. I have discussed Reifenberg in connection with Hausenstein in the second chapter of Part I of this book. See Reifenberg 1924: 10.

112. National Gallery of Art, Washington, D.C. Blankert 1978: 164, cat. no. 20, quotation after an auction catalogue of 1808, Wheelock 1995, cat. no. A22.

113. R., D. 1992: 132f.

114. See Collier 1989, in particular chapters 6 and 7.

115. Proust, "Chardin et Rembrandt" (first published in *Le Figaro littéraire*, March 27, 1954), in Proust 1971: 372–82, especially 372–4.

116. Proust 1971: 376.

117. Proust, "Regrets, Reveries, Changing Skies." In Proust 1948, 113–71, no. 18: 150f.; translation of Proust, "Les Regrets, rêveries, couleurs du temps." In Proust 1924: 173–240, no. 18: 215f.

118. Proust, "Notes" to *Contre Sainte-Beuve*, arranged by the editors. In Proust 1971, 303–12; quotation 304.

119. The complete footnote reads as follows: "Ce qu'il y a dans un tableau d'un peintre ne peut pas le nourir, ni dans un livre d'un auteur non plus, et dans un second tableau du peintre, un second livre de l'auteur. Mais si dans le second tableau ou le second livre, il aperçoit quelque chose qui n'est pas dans le second et dans le premier, mais qui en quelque sorte est entre les deux, dans une sorte de tableau idéal, qu'il voit en matière spirituelle se modeler hors de tableau, il a reçu sa nourriture et recommence à exister et à être heureux. . . .S'il découvre entre deux tableaux de Ver Meer . . ." Here he breaks off.

120. Vaudoyer 1968: 87.

121. Vanzype 1908; in the following I will focus on 3–13, 60–5. De Rudder 1914. The other volumes in this series were devoted to early Netherlandish painting, with the exception of a monograph on ter Borch. Vaudoyer makes reference to Vanzype in his essays on Vermeer.

122. See van Gehren 1992; and Thomas 1992: 133–59. The latter bases his interpretation of *The Art of Painting* on the fantasy that the woman might be the baker's daughter.

123. Norman Bryson holds this view to the extent that he presents Vermeer's art as the turning point in an ideology of a conscious Western obliteration of the process of production in cultural self-representation, an ideology to be broken up only by certain genres of nineteenth-century art. See Bryson 1983: 111–17.

124. Eisler 1916: 243. See also Eisler 1923.

125. On Vermeer's social advancement, as artist and citizen, from the lower middle class of artisans, to which his immediate ancestors belonged, to the upper middle class of office-holding burghers and merchants, see Montias 1988, passim.

126. Pops 1984: 48. Wheelock and Kaldenbach 1982, who call the painting glorious and haunting (9), explain the effect through a technical analysis of the painting. See also Wheelock 1995: 73–83.

127. Proust 1982, vol. 1: 238; 1987, vol. 1: 215. It is possible that Proust drew on de Rudder's 1914 monograph on de Hooch here. De Rudder places great emphasis on the quality of illumination, addressing it throughout his text and even including a separate chapter, "Un artisan de lumière" (79–89). Before de Rudder, it was Charles Blanc who, in 1861, enthusiastically described the effects of two sources of light in de Hooch's paintings and who attributed to the illuminated window and door frame in the background the effect of a promise. See Blanc, "Pierre de Hooch ou de Hooghe." In Blanc 1861: 6. For a sampling of remarks on this characteristic of de Hooch's interiors by authors writing at the turn of the century,

see *Pieter de Hooch* 1902, which includes excerpts from articles by Arsène Alexandre, Walter Armstrong, Roger Peyre, Richard Muther, Charles Eastlake, and others.

128. Eisler 1916: 243. Accordingly, Eisler considers the drawing in the Städelsches Kunstinstitut, Frankfurt, a purposeful study of the site by Vermeer, whereas Blankert views it as an anonymous drawing made afterward and only possibly related to Vermeer's painting (Blankert 1978: 158). Eisler's notion of mirroring is linked to Riegl and specifically to what Olin calls Riegl's "ethics of attention." Olin 1992: 155–89.

129. See Proust 1987, III: 1740: In his notes on the death scene, Tadié identifies a primary "yellow patch" near the drawbridge on the painting's extreme right edge, but then observes accurately that there are several such patches signifying walls.

130. Eisler 1916: 238f. "beides Varianten des Freiraumes, aus dem sich der Innenraum Vermeers fortlaufend nähren sollte." The notion that these two paintings form a pair in many beholders' minds appears to continue to this day. When the Mauritshuis undertook their cleaning and restoration in 1994, it was decided not to withdraw the paintings from view but instead to let the public watch the entire restoration process of both, treated side by side, through a glass partition in the gallery. Wadum et al. 1994: 4f.

131. Claudel,"Introduction à la peinture hollandaise." In Claudel 1964: 11–95. Compare Claudel 1950; Killiam 1987.

132. For an analysis of the importance and function of color in Proust's novel, see Pasco 1969.

133. Eisler 1916: 249. For more recent accounts of Vermeer's use of color and hue, see Wheelock 1995, passim; and Hofmann 1980; Dittmann 1987, "Helldunkel und Farbe: Die Malerei des 17. Jahrhunderts," 195-249; as well as Matile 1979, chapter "Zur Entwicklung der Künstlerfarbenlehre im 17. Jahrhundert," 39-57. As for the modern afterlife of seventeenth-century color theory and praxis, see Thürlemann und Bürgi 1988. A brief account in English is Parkhurst 1972; the primary reference work on color in seventeenth-century painting, including that of Vermeer, is now Gage 1993, chapter 9; his example of a Vermeer is a detail of *The Art of Painting* showing the model or muse.

134. Since Eisler largely disregards color, he treats the chiaroscuro of the *Girl* as if she were not a painterly representation but a sculpture, a positive space in the vastness of negative space, with the consequence that he classicizes the painting. In

keeping with this tendency, Eisler does not distinguish between the historical positions of beholding and representing, whose seeming identity in Dutch art baffled French writers, but which Proust integrates into one determined and structured temporality of viewing and viewed.

135. See exhib. cat. Delft 1982, cat. nos. 211, 213–16.

136. Wheelock and Kaldenbach 1982; Wheelock, in Bock 1987.

137. Eisler 1916: 249: "Im leuchtenden Spiegel des Vergänglichen ist ein Gedanke des Ewigen gefangen."

138. Eisler 1916: 245.

139. Eisler 1916: 252: "Wir sind auf einer Stufe des Malerweges, auf der die Stube den Künstler schon ganz gefangen genommen hat und er nur dieses *einen* Ausdrucks fähig ist. Stube und Gasse sind eins geworden in der Gesinnung des Meisters, die Träger einer frohen Stimmung unbehelligten, auf sich gestellten Heimgefühls." Blankert 1978, cat. no. 9, dates *The Little Street*, like *View of Delft*, 1661; Wheelock 1995, cat. no. A7. Eisler considers *The Little Street* slightly later. On this painting, see also Alpatov 1974.

140. See Jantzen (1911) 1951. Jantzen (1881–1967) began his teaching career in Freiburg in 1916; in 1931 he moved to the University of Frankfurt am Main and in 1935 to Munich, where he remained.

141. The English translation is not reliable. Some of the most important passages are abridged or plainly omitted, and some of the terminology is mistranslated. I will refer to the translation, but will change and add to it where necessary. *Fernbild*, for instance, is wrongly translated as "visual projection." See Hildebrand 1918: 17; Hildebrand 1909: 31.

142. See Sattler 1962: 410–12. Certain aspects of Wölfflin's *Principles of Art History* of 1915 are indebted to Hildebrand. See Meier 1990: 67f.

143. Hildebrand 1918: 76: "schieben wir hinter den Tatbestand der Erscheinung gleichsam eine Vergangenheit oder eine Zukunft oder eine dauerhafte Wirkung." See Hildebrand 1909: 101.

144. "Wirkungsform" is literally "form of effect", and translates best as "perceptual form." Hildebrand's concepts are explained in chapter 2, "Form und Wirkung," which is almost unrecognizably abridged in the English translation. See Hildebrand 1918: 16–28; Hildebrand 1909: 36–46. On the "Lektüre" or "reading" of forms, see Hildebrand 1918: 75; Hildebrand 1909: 31.

145. The perception of the newborn child he

calls the "Höhepunkt des Positivismus gegenüber der Erscheinung." See Hildebrand 1918: 26; Hildebrand 1909: 44.

146. Hildebrand 1918: 8.

147. Hildebrand 1918: xiiif.: "Die Einsicht in einen Zusammenhang dieser Art ist umso notwendiger, als die technische Entwicklung und die Fabrikarbeit der heutigen Zeit dazu geführt haben, *das Gefühl für die Art des Entstehens überhaupt* zu schwächen und das Produkt nur an sich, nicht aber als Ausdruck und Niederschlag einer bestimmten geistigen Tätigkeit aufzufassen."(My emphasis, C. H.) Hildebrand 1909: 15.

148. On the single man painted out by Vermeer, see Wadum et al. 1994: 32f.

Part III

1. Walter Benjamin mentions this as significant to his own work in one of his letters from Capri of 1924. See Benjamin 1978, no. 134 to Gershom Scholem, vol. 1: 348.

2. Proust 1982, I: 86–8; Proust 1987, I: 79–82.

3. Proust 1982, III: 367; Proust 1987, III: 862.

4. Proust 1982, III: 390: "But no, Albertine was for me not at all a work of art. I knew what it meant to admire a woman in an artistic fashion, having known Swann." Proust 1987, III: 885.

5. "Zum Bilde Prousts," In Benjamin 1980, vol. 2, part 1: 310–24, quotation 324: "so tiefe Komplizität mit Weltlauf und Dasein." For an English translation, see "The Image of Proust," In Benjamin 1969: 201–16, quotation 215, translation altered.

6. *Ursprung des deutschen Trauerspiels.* In Benjamin 1980, vol. 1, part 1: 203–430. English translation, Benjamin 1985. As a reader of Proust, Benjamin may have contrasted his own earlier critique of allegory and subjectivity, as well as his search for critical procedures and a possible agreement with others on these, with the utter solitude of Proust's "solution." But he may also have seen a link between that solitude and his own disappointment in the reception of his *Ursprung.* Apart from failing in its immediate purpose, to serve as Benjamin's habilitation thesis and allow him to join the faculty of a university as a Germanist, it also did not receive the hoped-for response among those whom he considered like-minded scholars. On this, see Brodersen, in Bredekamp 1991; van Reijen 1992: 17–31. On affinities between Warburg and Benjamin, see Kemp 1985; Kany 1987; J. Bekker, in van Reijen 1992, 64–89.

7. Burckhardt 1919; von Monroy 1964.

8. Warnke, in Garber 1991: 1222; Haus, in Garber 1991, especially 1327ff., quotation 1331.

9. Or, as Warnke recently put it, "the relationship between aesthetic forms and political interests." Warnke, in Garber 1991: 1214.

10. Benjamin 1978, vol. 1: 309–13 and 353ff.; nos. 122 and 126 of 1923 to Florens Christian Rang, and no. 136 of 1924 to Gershom Scholem.

11. Benjamin 1978, vol. 1: 354. Benjamin discusses this problem in his introduction to *Origins.* On the critique of such "hysteria" and its very concrete political meaning, see Nutz, Raabe, and Voßkamp, all in Garber 1991.

12. Hausenstein 1921: 42–4, Benjamin 1980, vol. 1: 413, n. 18.

13. Hofstede de Groot and Valentiner 1976: 580.

14. Kahr 1978: 291–5.

15. Blankert 1978, cat. nos. 19 and 29; Wheelock 1995, cat. nos. A24, A34.

16. Montias 1988: 202.

17. Echoing Hofstede de Groot, Plietzsch (1939: 32) concludes that essentially "lagen solche Allegorien dem der übersinnlichen Sphäre abgewandten Meister überhaupt nicht." See also Huyghe 1973: 182: "À la symbolique, qui émanait de son art comme une vision, il substitue, par une régression, l'allégorie."

18. This contrasts with her interpretation of emblematic and allegorical content in Vermeer's *Girl Asleep.* See Kahr 1972. Svetlana Alpers expressly argues for a distinction within emblem literature, thus accepting a "realistic," nonallegorical, descriptive type, existing on the periphery of Dutch painting as an "art of describing." For the interpretation of Vermeer, however, she considers it irrelevant. See Alpers 1983: 229–33.

19. On this publication as a key example of late nineteenth-century historicism, see Hess 1975, especially 566ff.

20. Karl Weiß 1882.

21. Ilg 1872. Other early considerations of the work are Appell 1888–9; Lang 1890; and Poppelreuther 1904. Warburg, of course, referred to the work in his dissertation on Botticelli of 1891. See Wuttke 1980: 11–63.

22. And yet a few years after Weiß's review of Ilg's volumes it introduced the rebus and other types of picture puzzles for the reader's entertainment at the end of each issue, providing the solution in the following issue. See for example, *Die Gartenlaube* 1890, no. 9, 292: "Hieroglyphenrätsel," and no. 27, 868: "Weihnachtshieroglyphen." These picture puzzles consist of self-referential pictographs of everyday objects, such as tools, cloth-

ing items, body parts, domestic animals, and sometimes, as in the Baroque rebus of Stefano della Bella, individual letters between pictographs. Functioning phonetically and thus only in the original language, these picture puzzles were meant for the general reader of *Die Gartenlaube*. Arrival at the solution, in general proverbial or sententious, was less a matter of reflection than of patience.

23. Gerlach 1882–5, "Vorwort," vol. 3:i.

24. Gerlach 1882–5, vol. 3: ii.

25. Gerlach 1882–5, vol. 1, preface to the entire publication, page i. Emphasis in the original.

26. Gerlach 1882–5, vol. 1: ii: "In fact, in the cultural life of nations allegorical concepts occur only late in art, mythology, and poetry, the vigorous youth of a nation creates exclusively strong figures full of real life, powerful gods, strong heroes. . . . When later symbolizing and allegorizing became an outgrown fashion, . . . when the pedantic spirit of a latter day immersed itself in the most subtle speculations in this area and, viewing allegory as the highest triumph of art, wanted to realize everything possible and impossible in always similar personifications – then, of course, much that was stale, mindless, and affected came about."

27. Gerlach 1882–5, vol. 1: ii.

28. Interestingly, Ilg comes quite close to Proust's account of Giotto's Virtues and Vices and of his "impression of actual movement, literally real activity, that the gestures of Charity and Envy had given me." Proust 1982, vol. 3: 663; Proust 1987, vol. 4: 227.

29. Of these "modern allegories" Ilg writes that they "are a certainly inferior but an unavoidable substitute for the creations of faith and of the decayed ideals of immediate-naive feelings. There can be no doubt as to what kind of an era we live in today . . . [T]his publication intends to provide inspiration. It is . . . not a pattern book of ancient allegories, but the continuation of allegorizing activity in a new spirit, taking its starting point now here, now there, just as it pleased the individual artist." Gerlach 1882–5, vol. 1: 2, preface to *Allegorien*.

30. Gerlach 1882–5, vol. 1: 3: "The topical content of our publication is self-explanatory and allows easy recognition. The artistic creations in these plates speak clearly – they would fail to meet the true essence of allegory [i.e., successful rhetoric], if they could not do so, if they were incomprehensible without commentary."

31. Gerlach 1882–5, vol. 1: 5 of the commentary (plate 1).

32. Gerlach 1882–5, vol. 1: 17 of the commentary (plate 55a).

33. Stuck (1863–1928) shares this typological concept of allegory with other fatalists of his generation, such as Max Klinger (1857-1920). Klinger sculpted a *Cassandra* (1886–95, Museum der bildenden Künste, Leipzig), who may be read as History. This Cassandra has a visionary facial expression and the blind gaze of the seer; she grips her left hand firmly with her right, a captive of her prophecy. See exhib. cat. Frankfurt am Main 1992: 113, 283f., cat. no 46.

34. Through the individuation of History one is inclined to see these similarly, so that the "demon of destruction" simply looks too old and weak to do any harm and the "genius of creative progress" has yet to grow up.

35. This problem is heightened where classical mythology and ancient history serve as an alternate referenced origin to Christian symbolism and typology. At one point, Daly specifically examines how in emblems dominated by allegory ("allegorical variants") objects or motifs are cut off from their typological and symbolic meaning, which up to this point might be taken as their original meaning. See Daly 1979: especially 35–46, 95f.

36. Often this is also the case in the *Reyen*, a special kind of interlude, of seventeenth-century drama. Lohenstein's *Kleopatra*, for example, includes the Judgment of Paris (act two) as an analogue to the drama's action. Scholars are divided as to the structural role of the *Reyen*. Benjamin, significantly, saw in it the allegorical framework of the action; others have seen it as an interruption of the action. In a certain sense this debate regards the question of anteriority, which I consider to be important as well for the interpretation of Baroque allegorical painting. On the *Reyen* and its comparability to the emblem, see Steinhagen 1977: 207–13.

37. "Strenge Kunstwissenschaft," Benjamin 1980, vol. 3: 363–9, 369–74; the essay is a review article on the occasion of the first volume of *Kunstwissenschaftliche Forschungen* (1931) which includes Sedlmayr's essay, "Zu einer strengen Kunstwissenschaft." This article is still very impressive in its demand of a place for theory in scholarship on art and in its critical range. For a translation see Benjamin 1988. See also Dilly 1988: 15–17, 77–92. Dilly uses the title of his chapter "Kunstgeschichte auf neuen Wegen," as a partly ironical reference: like Benjamin's "Strenge Kunstwissenschaft," it originates with Sedlmayr.

38. Benjamin 1980, vol. 3: 372, similarly in

the first version: 366.

39. On the other hand, he soon became interested in the alternative to the "sobriety" and "rigor" of scholarship presented by the "intoxication" of Surrealism and Dada and by their notions of allegory, hieroglyph, picture puzzle, and "fabulous realms of beauty." See Benjamin's essay, "Der Surrealismus: Die letzte Momentaufnahme der europäischen Intelligenz" (1929). In Benjamin 1980, vol. 2, part 1, 295–310; Benjamin 1986, 177–92.

40. For comprehensive bibliographies on the subject, see Mende 1971: 246–50; for a state-of-research account, Schuster 1982.

41. Jäger, in Garber 1991; Steiner in van Reijen 1992.

42. Benjamin 1980, vol 1, part 1: 237; Benjamin 1985: 53–6.

43. Both passages, Benjamin 1980, vol. 1, part 1: 342f., Benjamin 1985: 166, translation altered.

44. Benjamin 1980, vol. 1, part 1: 360–2; Benjamin 1985: 185–7. Literary criticism of the Baroque has tried to do justice to the significance of Benjamin's work; see, for example, Walter Haug, ed., *Formen und Funktionen der Allegorie*, (1979). In the study of the visual arts Benjamin's work has been received almost exclusively by scholars interested in modernism; those working on seventeenth-century art have largely ignored his writings. One exception is Sibylle Penkert (1978), who discusses emblematics in express opposition to Benjamin.

45. Benjamin 1980, vol. 1, part 1: 362f.; Benjamin 1985: 187.

46. Benjamin 1980, vol. 1, part 1: 357; Benjamin 1985: 181f., translation altered.

47. Interestingly, Jacob Burckhardt refers to the relationship of allegory and ruin in his essay "Die Allegorie in den Künsten," in Burckhardt 1919, by way of citing hearsay: "'die Allegorie sei eine besondere Liebhaberei verfallender Kunstepochen'"(376).

48. Benjamin 1980, vol. 1, part 1: 407, 406; Benjamin 1985: 233.

49. Benjamin 1980, vol. 1, part 1: 407; Benjamin 1985: 233.

50. Benjamin 1978, vol. 2: 523, letter no. 201, to Max Rychner, March 7, 1931.

51. See chapter "Von der Allegorie überhaupt," "Ein jedes allegorisches Zeichen und Bild soll die unterscheidenden Eigenschaften der bedeutenden Sache in sich enthalten, und je einfacher dasselbe ist, desto begreiflicher wird es, so wie ein einfaches Vergrößerungsglas deutlicher als ein

zusammengesetztes die Sachen vorstellt." in Winckelmann 1960: 178–96, quotations 178, 194. This is an abridged edition. For the complete text, see Winckelmann 1825, vol. 9, *Versuch einer Allegorie, besonders für die Kunst (1766)*, quotations 61f., paragraph 61f., and 20, paragraph 20. Very short translated excerpts from the *Versuch* are provided in Winckelmann 1972: 145–52.

52. Winckelmann (1825: 57–62, paragraphs 56–8) outlines his criteria for the renewal of allegory in his own times and for the future: simplicity (*Einfalt*), clarity (*Deutlichkeit*), and grace (*Lieblichkeit*). On the subject of simplicity he adds that it regards "the invention of an image that is as little as possible a sign" ("Entwerfung eines Bildes welches so wenig Zeichen als möglich ist").

53. Winckelmann 1825, 50–6, paragraphs 47–55; Winckelmann 1960: 191.

54. Winckelmann 1825, 40ff., paragraphs 35f.; Winckelmann 1960: 185.

55. Winckelmann 1825, 62f., paragraph 62, Winckelmann 1960: 194.

56. See exhib. cat. Los Angeles 1988, cat. no. 47, 278–80, reference to a 1633 description of the painting's iconography, including "roots that allude to the practice of self-mortification and fasting."

57. See Ettlinger 1978: pls. 110–28, pl. 127 for *Theologia*; and Ortolani 1948: 223f.: "Ma più fu concepita una Teologia, come Diana che si fa Endimione ad un astro de tre volti!" See also Ettlinger 1953: 261–5.

58. Winckelmann 1987: 32f.

59. Hegel 1983, vol. 13: 486–546; Knox 1975: 378–426. Here again I shall refer in the text to these sources in parentheses as H., vol. 13 and K., respectively.

60. The true symbol is an unself-conscious symbol, conscious only of being a symbol. For Hegel, its quintessential example, as we saw in Part II, is the Egyptian sphinx.

61. The topos of allegory's coldness was even used in Wackenroder and Tieck's *Phantasien über die Kunst* of 1799 to characterize Michelangelo's art in contrast to Raphael's: "In allen Kunstwerken Michael Angelos ist das Streben zur Allegorie, dieses kalte, große Ideal. . .anzutreffen" (Wackenroder 1977: 33).

62. Benjamin 1980, vol. 1, part 1: 406; Benjamin 1985: 233, translation altered; from Sigmund von Birken, *Die fried-erfreute Teutonie*, Nuremberg, 1652: 114.

63. Benjamin's own demand for critical distance becomes drawn into his perception of criti-

cism as an outgrowth of melancholy and as a contemplation of loss. It may well be that in the final analysis Hegel's definition of allegory leads to similar conclusions with respect to specific works of art, yet it is also to be expected that critical distance reaches beyond such conclusions and permits an insightful historical critique, which Benjamin thought insufficient.

64. See Haus, in Garber 1991.

65. Shiff 1992: 91; see Benjamin 1985: 178.

66. Benjamin explored this opposition in his writings on photography and mechanical reproduction, where he understands allegory politically. When he now addresses allegory in Marxist terms he implicitly continues Hegel's discourse on allegory's "grammatical subject" and borrowed authenticity.

67. Benjamin's concern about the frequently perceived affinity of Expressionism and Baroque art was – unbeknownst to either of them – partly shared by Ernst Friedrich von Monroy who included modernity in general. Von Monroy presupposed the historicity of style in emblems and considered what he saw as a gradual conflation of emblem and genre to be a change within emblems, rather than a result of their application in a new context. In this view, emblematics were secularized by 1630 in the graphic oeuvre of Rembrandt, through "die reine Vergegenwärtigung, das reine Jetzt und Hier" and the "völlige Sinnentleerung" of emblems. Von Monroy later reassessed these conclusions, still liking his findings regarding stylistic and conceptual change in emblems, but no longer believing in their self-annihilation during that process of change. Von Monroy's insistence on emblems as a visual and factual but nonoptical episteme at work in Dutch painting aligns optical seeing and modernity as obstacles to scholarship (von Monroy 1964: 64, 111–112).

68. Burckhardt 1919, "Wir werden fortan 'Abstracta' und 'allegorische Figur' als gleichbedeutend gebrauchen" (374).

69. Burckhardt 1919: 382f., 387. See Euripides 1956: 338–40, lines 843–73. On Burckhardt's interpretations of Rubens, see Maurer 1951.

70. Burckhardt 1898: 227 and 237; also Burckhardt 1950, on the *Allegory of the Thirty Years War*, here called *Outbreak of War*: 14, 42, 48, 113; and on the Medici Cycle: 114–19. *The Presentation of the Portrait* is no. 6 in the series.

71. Burckhardt 1919: 383f.

72. Mandowsky 1934: 6–13.

73. Jochen Becker, introduction to Ripa 1971: ix. He continues: "And we find that the allegory of

Fortitude is traditionally provided with the column as an attribute." See also Frossati-Okeyama 1992, synopsis of Ripa 1603: 164f., Ripa 1644: 81.

74. And yet it is Winckelmann who objected to Ripa's "vernünftelnder Subjektivität," as Becker put it recently. See J. Becker, in van Reijen 1992: 66.

75. Werner 1977: 19.

76. Interpretations of Vermeer's *The Art of Painting* include Swillens 1950: 99–102; Sedlmayr 1951; Gowing 1952; de Tolnay 1953; Gowing 1954; van Gelder 1958; Badt 1961; Snow 1979: 96–116; Nefzger 1980; Alpers 1983: 119–68; and in response to her interpretation, Grafton and Kaufmann 1985; Bryson 1983: 111–17, where Vermeer's painting is chosen as the book's dust cover illustration and thus declared to epitomize its thesis; Pops 1984: 61–8; von Mengden 1984; Hedinger 1986: 105–20; Hubschmitt 1987; Asemissen 1988; Hurley 1989; Braider 1989, now included in Braider 1993: 174–98; Thomas 1992: 133–59; Snow 1994: 119ff.; Arasse 1994: 40–58; Wheelock 1995: 129–39.

77. This problem has most recently been addressed by Daniel Arasse. His 1989 article, "Le Lieu Vermeer", was anonymously reviewed under the interpretive title "Selbstbespiegelung der Bilder" ("Self-mirrorring of the Images") in the *Frankfurter Allgemeine Zeitung* (May 31, 1989) and welcomed as a structural and phenomenological analysis of Vermeer's paintings. The reviewer suggests an ahistoricity with which Arasse, if I understand his argument correctly, would disagree. Drawing on Louis Marin's "theory of enunciation," Arasse explicitly states that "la structure Vermeer" (Merleau-Ponty) has a specific location and "le lieu Vermeer" is situated within history, even though this location remains inaccessible to the beholder. The emphasis on history is even stronger in Arasse's earlier *L'Ambition de Vermeer* of 1988 (translated as *Vermeer: Faith in Painting*, 1994), an interpretation of Vermeer's art of painting as a delegation of knowledge to the act of painting, understood as the representation of phenomena, the pure presence of things, and as a very particular, individualized form of Roman Catholic religious practice in a Protestant cultural environment. See Arasse 1994; especially chapters 4, "The Art of Painting," 40–58, and 6, "Vermeer's Religion," 76–86.

78. Bätschmann 1984, paragraph 30, "Die Arbeit und das Werk," 84–7, quotation 84.

79. Schug 1985–6; on Vermeer: 152f.

80. E.g. Kahr, Swillens. Few (e.g., Dittmann

1977), agree with Badt's claim that this or any painting has a determined beginning, middle, and end, prescribing through this structure the process of beholding and of interpretation. Such a claim is to be distinguished from the more general assumption that there is historically a strong sense of order in Baroque art and social structure, first argued comprehensively by Norbert Elias (1979; Elias 1983).

81. E.g., Rubens's *Judgment of Paris*, 1638–9 (Madrid, Museo del Prado) with Hélène Fourment as Venus.

82. Otto 1971: 38f. For representations of the Muses in different artistic media, see Reid and Rohmann 1993, vol. 2: 671-90.

83. Hoogstraeten 1978. On Hoogstraeten, see Sumowski 1983, vol. 2; Brusati 1984.

84. Brusati points out that in this as well as in the previous title page Hoogstraeten himself lays claim to fame by representing the imperial medal he had received during his stay in Vienna, 1651–5 (1984: 257f.).

85. Angel, 1969: 25.

86. Hoogstraeten 1978: 85.

87. Hoogstraeten 1978: 68: "Hier is d'Historykunde op 's werelts top geklommen, / Zy voert het Heldenboek, en Famaes veldbazuin, / Waer door verstaen wordt, Hoe 't Geval somtijts in puin / Begroef, en doofde die voorheen als fakkels glommen."

88. Hoogstraeten 1978: 69: "Leer ons nu, welk de heerlijkste dingen in de konst zijn, en welke men, om van u met roem en glory uitgetrompet te worden, zal aenslaen. Sla ons het heldenboek van uwen (1) [Thucydides] schrijver, en de Godlijke vaerzen van uwen (2) [Homerus] Poëet open, en wijs ons aen, wat de voornaemste deelen in een Historie zijn. . . . [D]eel ons, om yder ding zijn behoorlijke grootsheit, door byvoegselen en zinnebeelden, te geeven, de drift van uwen geest meede!"

89. See Bloch 1936; 257f.; de Mirimonde 1964; exhib. cat. Hamburg 1993, especially Gregor Weber's essay; Kaufmann 1993: 89; see also Pigler 1956, vol. 2, *Profane Darstellungen*, entries for "Musen," "Apoll und die Musen," "Parnass," "Minerva unter den Musen"; Raupp 1978.

90. Ripa 1970: 218: "memoria delle cose passate." This edition does not include a woodcut, though the 1645 Venice edition does; Ripa 1971: 200f.

91. Ripa 1970: 346–51; Ripa 1971: 337–8. There are no significant differences between the Rome 1603 and the Amsterdam 1644 editions. The latter switches the order of the two entries in the former. Thus in the Rome 1603 edition, the "puttino" is mentioned last, not first. There is, however, no indication that either Ripa or Pers meant the order of alternate entries to be understood as a ranking.

92. This is the name used in the museum. The collection catalogue *Kunsthistorisches Museum Wien, Verzeichnis der Gemälde* (1973: 195) refers to it as *Die Malkunst* and elucidates: "das Mädchen posiert als Klio, die Muse der Geschichte."

93. Blankert 1978, cat. no. 24; Wheelock 1995, cat. no. A28.

94. It brings to mind, for example, Philipp Otto Runge's rebellion against the standard training technique at the Copenhagen Academy, in which art students were required to draw plaster casts of Greek sculpture, working from the head down, rather than being encouraged to imitate in a free and genuine way.

95. On the Dutch pastoral see Kettering 1983; with reference to Vermeer, see Goodman-Soellner 1989. Huyghe (1973: 174ff.) emphasizes the Venetian element in Vermeer's *Diana and Her Companions* and other early works and relates the prominent theme of music in Vermeer's oeuvre to it. See also de Mirimonde 1961. On Vermeer's *Diana*, see Blankert 1978, cat. no. 2; Hofmann 1980; Wheelock 1995, 29–37, cat. no. A3. Early in the nineteenth century Roeland van Eijnden and Adriaan van der Willigen (reprint 1979: 166) called Vermeer "den TITIAAN der *moderne* Schilders van de Hollandsche School."

96. Alpers 1983: 142ff.

97. On these male figures, see Hauser 1981; Foucart 1983; Edwards 1986; Elovsson 1991.

98. Kirschenbaum 1977, cat. addendum 6, fig. 128. For this motif, see also cat. 17, fig. 73: *Esther before Ahasuerus*, and cat. no. 44, fig. 39: *The Child Jesus in the Temple*. In Steen's paintings the upright Bible stands demonstratively on the floor. This Protestant sign has been sublimated by Pieter de Bloot in his *Christ in the House of Mary and Martha* (1637, Schloß Vaduz, collection of the Prince of Liechtenstein), where he places the upright Bible on a table near the three protagonists. See exhib. cat. Zurich 1987, cat. no. 20.

99. Welu (1975, 1978) first discussed this map and its possible meanings in detail, including its "updating"; others have followed him, particularly Hedinger, who attributes intended political meaning to the maps in many Dutch paintings of interiors, including those of Vermeer (1986: 107). On the seventeen provinces, see ibid: 34–7; 63–70.

100. The curtain plays an important role in Sedlmayr's (1951) perception of a nostalgia on Vermeer's part for a Roman Catholic world of art patronage and in Alpers's notion of painting, or picturing, as self-conscious description (1983); Braider (1989) considers it the curtain of allegory; for Wheelock (1988) and Pops (1984) it enhances the theatricality of the scene; de Tolnay (1953) takes it to be the indicator and threshold of vision and dream; and Raupp sees in it a barrier to the realm of allegory. Raupp (1984: 326) sees a theatricality that serves the glorification of history painting. Interestingly, he interprets the motif of the artist looking over his shoulder as an *Ideenschau* (201). Could it also refer to Ripa's *Historia*, who looks over her shoulder? For an interpretation of the curtain in Dutch painting, see also W. Kemp 1986 and 1988.

101. Swillens 1950: 100.

102. The most powerful argument of this kind has been made by Linda Nochlin in her in partially Benjaminian interpretation of Courbet's *The Painter's Studio*. See Nochlin 1988.

103. This shift is understandable, since a number of Ripa's *imagini*, or *uytbeeldinghen* are quite close. Pers's subtitle for "Clio" is "Eere, Roem," "Honor, Glory." His Historia looks over her shoulder, as does Vermeer's Clio. Pegasus is a motif in many representations of the concert of the Muses (see exhib. cat. Hamburg 1993), such as Aegidius Sadeler's engraving of c. 1590 after Hans van Aachen of 1560, after Joris Hoefnagel; Caesar Boetus van Everdingen's *The Four Muses*, c. 1648–50, The Hague, Huis ten Bosch, where it is a life-size motif in the middle ground behind the muses. It is the companion of Pers's "Fama Chiara, Heldere Fama" (Ripa 1971: 161), the entry following "Fama Buona. Een goed Gerucht of Naem," taken by Swillens to be Vermeer's primary reference.

104. Hurley 1989: 351.

105. Gowing 1952: 45.

106. Gowing revised his earlier interpretation in his essay of 1954. There, the "lovely object of attention" no longer disowns it; instead, she and the painter engage in a game between male artist and female model, "the game of staring" each other down: "Looking is in fact a real attacking; it is to devour, as we say, with one's eyes." The painter is the winner – a rather violent Vermeer, according to Gowing; the woman the loser, casting down her eyes: "In one act he devours what he sees and makes it his own," but then he disowns her, keeping his distance in order to represent what he now owns. Gowing relishes Vermeer's "play."

See Gowing 1954: 88f. Snow's variant of this interpretation is: "If it strikes us that the act of painting is only a pretext for the relationship it creates between the painter and the model, it seems equally clear that the painter's subject (allegorical, female) is only a pretext for the act of painting. . . . [T]he man is finally free to look, and the woman to openly constitute herself as an object of his gaze." See Snow 1979: 98, 106.

107. First mentioned by van Gelder 1958: 8 and repeated ever since. In fact, this kind of waistcoat, though not always black, can be seen in a number of seventeenth-century paintings. See exhib. cat. Philadelphia 1984, cat. no. 28, 29, 37, 77, 85, 86, 125. The earliest of these examples is dated 1630, the latest 1676. Vermeer himself uses the slitted black waistcoat in his *Procuress*. The one difference between the waistcoat there and the "Burgundian" type seen in *The Art of Painting* is the length of the slits in the sleeves.

108. Pops 1984: 64; Sedlmayr 1951: 174f.

109. See Pops 1984: 64; and Eiche 1982: 208f.

110. Pops 1984: 64; Snow 1994: 94, 123; Schneider 1994: 84.

111. See Hedinger 1986 for a detailed description of each of these clues. Her research resulted in the important discovery that the inclusion of such a crease, or of comparable compositional means that emphasize the division of the formerly united Netherlands can be found in other artists' works as well (54f., 116f.).

112. Simmel 1957: 58; see 43–58.

113. Saxl 1936: 197–222. For more pictorial examples, see Pigler 1956: 504ff.; and for related scholarship, see Wittkower 1977, chapters 6 and 7.

114. Simmel, "Zur Metaphysik des Todes," (1910) in Simmel 1957: 35; see 29–36. For a connection between Benjamin and Simmel's notions of ruin, see Turner, in van Reijen 1992.

115. Heidegger refers to Simmel's two essays in *Sein und Zeit* (1986), paragraph 50, p. 249, n. 1, and paragraph 80, p. 418, n. 1.

116. Simmel 1985. Panofsky (1973) found this interpretation convincing.

117. Simmel's concept of the *Augenblick*, or moment, differs from Heidegger's. Although Simmel also discusses "history" and "time" as two separate phenomena, he does not understand the moment as an awareness and seizure of possibilities. For Simmel, individual self-assertion is always very concrete and limited, whereas Heidegger's concept of the moment corresponds rather to Simmel's notions of fate and of the historical event. For these, see Simmel's "Das Problem der hi-

storischen Zeit" and "Das Problem des Schick-sals," in Simmel 1957: 9–16. On artistic "old-age style," see Rosand 1987.

118. Quoted in Winner 1966: 393, from Chantelou 1930: 131.

119. Quoted from *The Holy Bible: Revised Standard Version*, 1973: 522. Saxl's most literal example of this tradition is Palma il Giovane's *Justice and Truth* (Saxl 1936, fig. 10), in which Time is not represented at all. Truth and Justice and their correlates, Peace and Concord, referred to in the inscription under the globe, are understood as eternal, not temporal.

120. Saxl 1936: 220.

121. In Saxl's account, a balanced realignment of both the origin and the destination of Truth occurs in Picart's 1707 engraving in honor of Descartes (Saxl 1936, fig. 12). There, Time fights Ignorance while Truth, ignoring this battle, looks intently on her light. Descartes and other philosophers simply wait for the end of the battle, when they will be able to turn directly to Truth, undisturbed by Time and history. See Mason Rinaldi 1984.

122. Joost van den Vondel, *Lucifer: Treurspel*, intro. and ed. Lievens Rens (1979). In the following I shall quote from it as well as from *Vondel's Lucifer*, translated by Leonard Charles van Noppen (1898). The Dutch edition numbers the lines from beginning to end, the English translation numbers them anew in each act. I will give in parentheses first the English and then the Dutch numbering. On van den Vondel and the visual arts, see Slive 1953: 67–82.

123. The second is van Noppen's choice.

124. See Saxl 1936: 212; de Poorter 1978, vol. 1: 377–84, cat. nos. 17, 17a–c; vol. 2, pls. 203ff.; Scribner 1982, chapter 4, "The Victories," 55–64.

125. For accounts and documentation of these events, see Thuillier and Foucart 1970; Saward 1982; an der Heiden 1984; and Millen and Wolf 1989. The numbering of paintings in the series differs in these publications, depending on whether *Marie de' Medici as Bellona (The Queen Triumphant)* is seen as no. 3 (an der Heiden, in keeping with von Simson and Großmann) in the series or as no. 24 (Millen and Wolf, in keeping with Thuillier and Foucart). Here I shall use the second option. *The Triumph of Truth* is no. 23.

126. Millen and Wolf 1989: 220. They conclude from this: "In consequence the latter become not the central subject but, conversely, the illustration of an allegory". Marie de' Medici "now" (January 29–February 2, 1622) felt "secure":

"Time, she must have thought, had at last unveiled the truth" (222, 223).

127. Elias 1992a: 44–51; Elias 1992b: 74–80.

128. Rubens 1991: 107-110, quotation 109.

129. For an account of this and other aspects of Rubens's rhetoric, see Warnke 1965. Thuillier and Foucart believe that Rubens's pictorial language of historical allegory was outdated virtually upon completion of the series; see chapter "A Formula without Posterity," (1970: 39ff.).

130. No. 22 in the series. For a detailed account of this painting and the changes its title and its iconography underwent, see Millen and Wolf (1989: 205–20), who call it *The Return of the Mother to Her Son*. See also Saward 1982: 174–82; an der Heiden 1984: 43ff.; Thuillier and Foucart 1970: 91f., and pertinent primary sources, in the section "A Documentary History of the Gallery through the Completetion of the Paintings," 92–132.

131. Millen and Wolf see a change of status from "Louis-Apollo" to "Caesar Triumphator" (1989: 221).

132. Thuillier and Foucart 1970: 92.

133. Saxl 1936: 211.

134. Theissing 1987: 219ff.; see also Spinner 1971.

135. Saxl 1936: 220.

136. Ripa 1970: 499–501: "Una bellissima donna ignuda, tiene. . . .sotto al destro piede il globo del mondo;" and "Il mondo sotto il piè, denota, che ella è superiore à tutte le cose del mondo, & . . .è cosa divina [&]. . .è cittadina del cielo."

137. This is Winner's interpretation of the globe beneath Truth's right foot in Bernini's sculpture, with reference to Ripa (Winner 1966: 403).

138. Ripa 1971: 589f.: "onder de rechter voet salse een Hemelsche globe hebben," and "De Wereld onder haer voet, bediet, dat zy hooger en waerdiger is, als alle de goederen des Werrelds, overmits zy een geestlijcke saecke is."

139. Ripa 1971: 590.

140. Ripa 1971: 590: "en daerom isse oock een Dochter van den Tijd genaemt; en in de Griexsche taele, heeftse de beteyckenisse van een saecke, die altijd openbaer is, en niet kan verborgen blijven." Ripa 1970: 501 ibid: "& però è dimandata figliuola del tempo, & in lingua Greca hà il significato di cosa, che non stà occulta."

141. Philippot, in Baudson 1985: 144. This moment of dwelling may also signify melancholy. Compare Bätschmann 1982, chapter 4, "Präsenz–Absenz," 53–70; and Braider 1993: 241,

333ff. See also Carrier 1991; Bätschmann, in Winner 1992. These authors invoke Panofsky's interpretation of Poussin's two versions of *Et in Arcadia Ego* (Panofsky 1970, chapter 7).

142. Wright 1985, cat. no. 120.

143. Schama 1988; Montias 1988.

144. Grafton and Kaufmann 1985: 263–5. On the Dutch Maid and the "Hollandse Tuin," see Schama 1988: 69ff., figs. 23–7, with further references.

145. Hedinger 1986: 63–93.

146. On the concept and practice of *dissimulatio*, see Warnke 1985: 53–8.

147. Theissing 1987: 185ff. See also Schöne 1989; similarly, Spinner 1971.

148. For Mathieu de Morgues's description, see Thuillier and Foucart 1970: 124ff.; it includes this and the following quotation. This sense of historical facticity is frequently reproduced in the midst of a critical account by the use of the word "now," e.g., Saward 1982: 181: "[S]he is thus deified within her lifetime, having now gained the authority of the gods;" see also Millen and Wolf 1989: 222.

149. Felibien (Thuillier and Foucart 1970: 91) calls her Hope seated on the globe of France! An der Heiden (1984: 45) calls her Francia.

150. Hoffmann-Curtius 1993 helped me to think through the functions of Rubens's two paintings.

151. The clearest reproduction of the map in the Bibliothèque Nationale, Paris, is in Welu 1978: 10, fig. 2. Welu's interpretation of the figure's placement links her with the engraving of the court in The Hague behind her. Of course, like the letters GAL-LIA, this image cannot be seen in Vermeer's painting.

152. Hale 1913: 12, 20, 28.

153. Hale 1913: 29, 63f.

154. Arnold Houbraken, *De Groote Schouburgh der Nederlantsche Konstschilders en Schilderessen*, 3 vols., Amsterdam, 1718–21 (reprint 1888). Hale's suspicion of a personal enmity between Houbraken and Vermeer is perhaps derived from a curious fact in Houbraken's section on Carel Fabritius. There Houbraken quotes Arnold Bon's poem on Fabritius from Bleijswick's *Beschrijvinge der Stad Delft* of 1667, but he omits the last line that identifies the phoenix rising from the ashes of Fabritius as "Vermeer, die meesterlijck betrad zijn pade." See Hofstede de Groot 1893: 361, with reference to Houbraken 1718–21, vol. 3: 337.

155. Huyghe 1936: 14.

156. Wheelock 1988: 118.

157. In studies of Vermeer, *Allegory of Faith* is often mentioned only in passing. For longer discussions of the work, see Barnouw 1914; Swillens 1950: 96ff.; Claudel 1964: 36; Berger 1972: 244–52; de Jongh 1975–6; Snow 1979: 110ff.; Pops 1984: 71ff.; Marval 1988; Montias 1988: 189, 202, n. 94; Arasse 1994: 76–86.

158. Braider's is the most recent attempt to interpret Vermeer's *The Art of Painting* as ironic, and to denounce allegory as "a totalitarian art." Braider contrasts *The Art of Painting* with *Allegory of Faith* as follows. "And yet we must not lose sight of the fact that the art celebrated in this way [i.e., "ironic self-reflexiveness of the painter's *cogito*"] remains profoundly anti-allegorical: a realist art given, as such, to dealing in concrete particulars as opposed to the summative abstractions of allegory. This explains why Vermeer's other allegory, the *Allegory of the Faith*, is so very bad" (Braider 1989: 181).

159. On the subject of the picture within the picture, see exhib. cat. Hartford 1949; K. A. Wirth, 1958; Stechow 1960; Chastel 1967; Warnke 1968; Gállego 1974; Georgel and LoCaq 1983; Filipzcak 1987. Specific interpretations of the motif and concept include Müller Hofstede 1984; Coppens 1986; and, with regard to Vermeer, Mirimonde 1961; Seth 1980; Goodman-Soellner 1989.

160. On the latter, see Blankert 1978, cat. no. 14; Pops 1979: 63ff. On Roman Catholicism in Delft, see Montias 1988: 173ff.; Jacobs, in exhib. cat. Delft 1982, with further bibliographic references.

161. Pops 1979: 71ff., 95.

162. For general comments, see Held 1937.

163. Benjamin 1980, vol. 1, part 1, chapter "Allegorie und Trauerspiel": 336–409, on Romanticism, 336–65; Benjamin 1985: 159–235, especially 159–89.

164. Benjamin 1980, vol. 1, part 1: 390ff.; Benjamin 1985: 215ff.

165. On this problem see also Fischer 1990, especially 247-56.

166. Benjamin 1980, vol. 1, part 1: 353ff.; Benjamin 1985: 171ff.

167. Haberditzl 1908: 226ff., Baudouin 1977: 47–63. Van Puyvelde (1971: 15, 151) presents van Veen as an untalented, increasingly burdensome court artist. His and Haberditzl's view of van Veen as painter contrast strongly to the account of van Veen as humanist in Müller Hofstede 1957; and Gerard-Nelissen 1971.

168. Haberditzl 1908: 227.

169. On Rubens' modello for *Triumph of Faith* or *Triumph of Catholic Faith*, Royal Museum of Fine Arts, Brussels, see Held 1980, cat. no. 102.

170. It is not clear in which order van Veen intended the series to be hung. The order proposed by Haberditzl in 1908 is not congruent with the order proposed by the current hanging and inventory numbers of the Bayrische Staatsgemäldesammlungen. Furthermore, if one orders the series so that the landscape continues virtually without breach, the sequence of paintings differs from both of these.

171. The horses are led, from left to right, by "Human Reason, understanding divine revelation" ("Ratio humana, divinam revelationem agnoscens") above whom a putto announces "it illuminates every man who comes into this world" ("Illuminat omnem hominem venientem in hunc mundum"). Human Reason looks back over her shoulder – a classical motif in the iconography of the procession (cf. the Ara Pacis Augustae) – to the haloed figure of Christ, captioned "Word of the Lord" ("Verbum Dei"). From his mouth issues a sword and above him a putto admonishes the viewer to "study scripture" ("Scrutamini scripturas"). He in turn looks over his right shoulder at crowned Ecclesia, who carries scrolls with both hands before her inscribed "sermon" and "letter" ("sermo," "epistola"). An angel accompanies her on foot, smiling at the beholder and bearing the admonition, "In vain he calls God his father who does not acknowledge the Church as his mother" ("Frustra appellat Deum patrem, qui / non agnoscit ecclesiam matre[m]").

172. Above these figures we may read, to the left, "God so loved the world that / he gave his only begotten son" ("Sic Deus delexit mundum ut/ filium suam unigenitum daret"), and to the right, "Here no one has greater love. / He gave God his soul for [the sake of] his enemies" ("Majorem caritem hic nemo habet. / Deo donat animam sua[m] pro inimicis suis").

173. De Poorter 1978, vol. 1: 321, see also 204 and 209. For the tapestry at the Convent of the Descalzas Reales in Madrid, see de Poorter, pl. 149, for the modello, see Held 1980, cat. no. 106, pl. 109. A similar understanding of the relationship between Rubens and the Counter Reformation as a wholehearted mutual embrace is argued in Glen 1977. In his catalogue entry for Rubens's oil sketch for the lost altarpiece for the Carmelites in Antwerp, Held suggests that it is at once an example of the artist's brilliance and, as a commissioned

work, "a job like any other" (1980, cat. no. 392, pl. 383, color pl. 19; quotation vol. 1: 530).

174. This narrative dissolution of allegory happens already in the sixteenth century. An interesting example is G. B. Zelotti's frescoes in Palladio's Villa Emo, among them an allegory of sculpture. Here Sculpture is a woman artist, on her knees, hard at work, turning her back to us. See Favero 1972, pl. 83. In the North, this possibility is rejected by the classicist Gerard de Lairesse in his *Groot Schilderboek* of 1707, in which he recommends the use of Ripa's *Iconologia* in such a way that his *imagini* are either added figures whose attributes enhance the clarity of a history through their presence, or as the only figures and thereby the main agents of a depicted history. See Timmers 1942: 51f.

175. See Werner 1977: 13, 19f.

176. See the earlier discussion of Ripa in light of other theories of allegory. Burckhardt went so far as to reject any public claim for the allegorical image in the nineteenth century as vulgar hypocrisy, though, significantly, he exempted the allegorically decorated fountain from his assault. This links Burckhardt to the Romantics' efforts to retrieve mythology through natural allegory, as well as to Benjamin's emphasis on the subjectivity of allegory. On Winckelmann's distinction between "abstract" and "concrete" allegories and their potential reference to action, see Fischer 1990: 254ff.

177. I wish to thank Nora da Poorter, of the Historische Musea Rubenianum, Antwerp for answering my questions about this work. The other three versions are *Christ on the Cross with Madonna and John* (an engraving by Schelte A. Bolswert after Jordaens, here Fig. 48, M. Jaffé 1968–9, cat. no. 294); *Christ on the Cross with Madonna and John the Baptist* c. 1617, Antwerp, St. Paul's Church (d'Hulst 1982, pl. 45); *Christ on the Cross*, early 1620s, Rennes, Musée des Beaux-Arts (d'Hulst 1982, pl. 58).

178. It is identified as Vermeer's reference by Blankert 1978: 169; Swillens 1950: 97, and de Tolnay 1953: 269.

179. See Montias 1988: 340f., appendix B, doc. 364. The inventory of movable goods in Vermeer's house made on February 24, 1676 includes "a large painting representing Christ on the Cross" in the "interior kitchen," and a second one in the "basement room." Nora de Poorter believes that the painting Vermeer uses in *Allegory of Faith* is yet another version by Jordaens. See exhib. cat. Antwerp 1993, p. 112.

180. See Warnke 1980: 39–50. Martin (1969: 40) interprets Christ's upturned gaze as motivated by the lost panel of God the Father above it. Glen (1977: 39), in contrast to Riegl, views the emotional women on the left wing as identification figures for the beholder, rather than the mounted officer on the right wing. Jordaens' oeuvre includes a late *Christ on the Cross* (c. 1660, Bordeaux, St. Andrew's Cathedral; see d'Hulst 1982: 262, pl. 227), who is an extreme realization of the hanging Christ. His suffering is solitary, although he is presented in the midst of a dense group of figures. This type of the solitary, vertically hanging Christ was called *Jansenisten-kruis* by Jordaens' contemporaries, as it was taken to refer to the Jansenist teaching that the promise of redemption referred to the chosen few, not to all Catholics. See Knipping 1940, vol. 2: 265f. The matter may have been important to Vermeer, as the split of the clergy in Delft into Jansenists and Jesuits was crucial for the Roman Catholic. Vermeer's emphasis on Christ's withdrawal in his Jordaens can be seen in this context.

181. For a discussion of Rubens's several versions of the solitary *Dead Christ on the Cross*, see Glen 1977, chapter 3; Hubala 1967.

182. On the iconography of the Crucifixion, see Knipping 1940, vol. 1: 222, 280ff.; vol. 2: 265ff.; Thoby 1959; Marrow 1979: 164ff., 189, 198. On the development of the two types of iconography, the voluntary sacrifice and the violent sacrifice of Christ, as well as their fusion, see Koseloff 1934: 34–58, 85–105. On the theological reasons for the post-Reformation emphasis on Christ's death, see Elze 1966: 148ff.

183. A link between Rubens's and Jordaens's painting can be seen in Rubens's drawing of *Christ Crucified with the Two Thieves* (1614/16, London, British Museum), which includes the types of a resolute Madonna and a mourning and gesturing John varied by Jordaens in his four versions. Freedberg 1984: cat. no. 35, pl. 117.

184. Blankert 1978, cat. no. 15 and Wheelock 1995, cat. no. A16. In his later catalogue, Blankert changed the title from *Woman Weighing Gold* to *Woman Holding a Balance*. (Blankert, in Aillaud et al. 1988, cat. no. 15.)

185. Salomon 1983, based in part on Harbison 1976. See also Gaskell 1984; Snow 1979, "Epilogue," and Wheelock 1995: 97–103.

186. It might be useful to relate the interpretation of the woman as allegorical figure and as subjective consciousness to a distinction between divine justice and human justice, as well as to holy justice, justice as a philosophical virtue, and justice as a political virtue. On these distinctions, see Pleister and Schild 1988, chapter 2 by Schild: 86–171; Ripa 1970: 187–9. Pers follows Ripa closely in this, only presenting his entries in another sequence and deemphasizing the color gold, so prominent in Ripa's entries (Ripa 1971: 432f.). Ripa's suggestion was perhaps taken up by Vermeer in his *Woman Holding a Balance*, notably in the motif of the curtain and the color of the light illuminating the woman, as well as some details in his pictorial space. One might also say that Vermeer followed Ripa's suggestion that the allegorical figure be beautiful, a suggestion also followed by Samuel van Hoogstraeten, whose *Triumph of Truth and Justice* (1670 Finspong Castlem, Sweden) depicts Justice as a full-length, standing classical nude. See Sumowski 1983, vol. 2, cat. no. 830.

187. Neumeyer 1964: 45, 83.

188. De Jongh 1975–6: 78ff. The comparison with David Teniers's *Faith*, as suggested by de Jongh, underscores the sense of tension in Vermeer's painting.

189. Berger (1972: 245f.) suggests that Vermeer's painting is an allegorical or historiated portrait and that, as a "real" woman posing as allegorical figure in a Dutch townhouse interior, Faith is most uncomfortable and justifiedly so.

190. Ripa 1970: 149–51.

191. Swillens 1950: 97; Blankert 1978: 169.

192. Ripa 1971: 147–50. Pers lists: 1) "Fede Catholica. Catholick of algemeen Geloof"; 2) "Fede. Geloof"; 3) "Fede Christiana Catholica"; 4) "Fede Catholica. Catholick of algemeen Geloof"; 5) "Fede Christiana. Het Christelicke Geloof"; 6) "Fede Christiana. 't Christen Geloof." For a synopsis of different editions of Ripa's *Iconologia*, see Frossati-Okeyama 1992: 86f.

193. Pers gives an abridged version of Ripa's reference to light in early Roman Catholic ceremony: "Dies *Augustinus* seght: *Blindheyt is Ongelovigheyt, en Verlichting is 't Gelove.* Waeromme oock by de oude H. Godesdiensten het licht ontsteken wort." The passage in Ripa 1603 is not only more evocative of ceremony but mentions sacrifice as its correlate: "dicendo S. Agostino sopra S. Giovanni al capitolo nono: *Cecitas est infidelitas, & illuminatio fides*, però per antica ceremonia nel sacrificio della Messa, & in altri atti Ecclesiastici, si vede l'uso de' lumi, & delle torcie accese, del che diffusamente tratta Stefano Durante, de ritib. Eccl. lib. 1. cap. 10" (Ripa 1970: 151). But Pers's entries on Faith cannot generally

be called a transformation into Dutch idiom and Protestant cultural needs. He retains, for instance, the passage on faith and works in entry 5(1), the two mentions, in entries 5(1) and 1(4), of Faith alone being pointless in view of the law. Only entry 6(2) emphasizes the sense of hearing over that of seeing by reference to two Pauline letters (Ripa 1971: 149). It should be noted that de Jongh refers Teniers's painting of *Faith* back to this passage, while otherwise linking it closely to Vermeer's painting which he interprets as expressly Jesuit. Entries 2 and 4(3) are the ones quoted by Swillens and Blankert as Vermeer's sources.

194. Ripa 1971: 148: "Zy is totte schouderen en borst toe, bloot, om dat de Evangelische Predicatien niet met cierlijcke woorden moeten opgepronkt werden, noch met raedsels en dobbelsinnige teedenen, maer moeten klaer zijn."

195. This, apparently, did not bother the seventeenth-century audience. See Blankert 1978, cat. no. 29, where he quotes the 1699 and 1718 auction catalogues as stating: "Een zittende Vrouw met meer betekenisse" and "Een zittende Vrouw, met meerder betekenisse," respectively.

196. Ripa's *Iconologia* includes an elaborate iconography of color that has not received due attention. On black and white specifically, see Frossati-Okeyama 1992: columns 329f., 599-602.

197. Eisler 1916: 276.

198. On *The Love Letter* (c. 1670-2, Rijksmuseum Amsterdam), see Blankert 1978, cat. no. 22, Wheelock 1995, cat. no. A31.

199. These gray veins are not all laid in the same direction as they are in *A Lady at the Virginals with a Gentleman*, where they take on a watery quality and the force of a subtle tide. Pops (1984: 74) writes of "seascapes by implication"; Gowing (1952: 59) of Chinese calligraphy.

200. Snow 1979: 110–12.

201. De Jongh 1975–6: 74f., with reference to Knipping; taken up by Wheelock 1988: 118; Braider 1989: 175; Arasse 1994: chapter 6. De Jongh's interpretation is disputed by Montias, who considers Vermeer's painting too austere for a Jesuit commission. Montias 1988: 202, n. 94.

202. Van Veen, in the second painting of his series, *The Triumph of the Catholic Church*, shows Faith seated securely on a large globe of the earth. See Knipping 1940, vol. 1: 71ff., pl. 47.

203. In several title pages designed by Rubens for publications on church history the triumphant Church appears at the top center, partly merged with the figures of Faith and Divine Love, as in the title page for Mudszaert's *De Kerckelycke Historie*

(Antwerp, 1622). See de Poorter 1978, vol. 2, pl. 88, and Judson and van de Velde 1978, cat. no. 49, pls. 166–71. This figure's personal attributes are the cross and the mitre, while the globe is placed next to her, a phoenix perched triumphantly upon it, so that globe and phoenix refer both to her and, to the right of the cartouche, to Successio Papalis.

204. On some of the problems posed by the double illusion or fictionality of a tapestry within a tapestry, see Scribner 1982: 125ff.; de Poorter 1978, vol. 1: 171ff. and 184ff., with further bibliography.

205. The same piece of leather appears, turned on its side, in Vermeer's *The Love Letter*; see Montias 1988: 191 and document nos. 340, 364.

206. Rubens includes the figure of St. Cyril, partriarch of Alexandria, as a Carmelite. He may well have known that Cesare Baronio rejected this genealogical claim by the Carmelites in his *Annales Ecclesiastici*, printed in Antwerp in 1596–7 by Plantin, who tempered Baronio's argument through editing. Rubens's use of this book's frontispiece for his design of the frontispiece for Mudszaert's *De Kerckelycke Historie* of 1622 suggests some familiarity with its content. Rubens had occasion to reflect upon Baronio's Counter Reformation thinking when he worked on the altarpiece for S. Maria in Vallicella in the Chiesa Nuova in Rome in 1606–8. See Warnke 1968; P. Jean de la Croix 1969; Baudouin 1983; Freedberg 1984, cat. nos. 17, 17a. For the frontispiece for Mudszaert, see Judson and van de Velde 1978, cat. nos. 49, 49a, pls. 166–8; for the title page for Baronio's *Annales Ecclesiastici*, pl. 170.

207. Jordaens's oeuvre includes a *Triumph of the Eucharist* (1630, National Gallery of Ireland, Dublin). Here the Christ child as Salvator Mundi sits astride a globe, which is tightly girdled by a snake. Other objects held by the child or surrounding him in an allegorical manner are also attributes of Fathers of the Church, who are gathered around him.

208. Snow 1979: 110–12.

209. Blankert 1978, cat. no. 27; Wheelock 1995, cat. no. A32, and pp. 157–62

210. On the topic of letter writing, see Alpers 1983: 192ff.

211. Filipczak (1987: 181) draws attention to the practice of display in the room, but she does not interpret the curtains. On their function in Dutch paintings, see W. Kemp 1988. As for the recognizability and relative "correctness" of displayed paintings and their consideration as a form of reproduction, see Georgel and LoCaq 1983: 164ff.

For Raphael's *St. Margaret*, see *Kunsthistorisches Museum Wien* 1973, pl. 26, c. 1520, inv. 171; for the history of Archduke Leopold Wilhelm's collection, ibid., xff.; also Garas 1967: 59, on the Raphael. A second version of the painting is in the Louvre.

212. Jantzen 1910: 47: "Auf der kurzen Strecke vom Beschauer bis zur Rückwand des Zimmers ist der Raum förmlich auseinandergetrieben."

213. Sutton 1980b.

214. Benjamin, *A Berlin Chronicle* (1932). In Benjamin 1986, 3–60, quotation 59; Benjamin 1970: 120f.

215. Snow 1979: 112, and n. 29.

216. De Jongh (1975–6: 80) calls the globe over which Teniers's Faith is triumphant a "glass globe symbolizing the despicable world." For *Vanitas* still lifes with such spheres by Jan Davidsz. de Heem (c. 1625–9, private collection, Bremen) and Jacques de Gheyn II (1603, Metropolitan Museum, New York), see exhib. cat. Münster 1979–80, cat. nos. 116, 112. See also Simon Luttichuys, *Allegory of the Arts* (1646, Muzeum Narodowe, Gdansk) in exhib. cat. Washington 1989: 114–16, cat. no. 23; and van Straten 1992, fig. 3. See also entries "sphère," and "sphère transparente," in Tervarent 1958, columns 358–63. Müller (1953: 172) includes the ribbon in the meaning of *vanitas* on the basis of the German colloquial expression "an einem Faden hängen." This association suggests that we think of the suspended sphere as a reference to Fortuna and the Fates. See also the anonymous print titled *Concerning Contempt of the World* of c. 1550–60, in which such a sphere, hanging from the upper gum of the "porcine Mouth of Hell," is clearly labeled "mundus." See Tanis and Horst 1993, cat. no. 6 (Tanis). For examples of the sphere as domestic furnishing in de Hooch's work, see Sutton 1980b, cat. no. 95, pl. 98: *A Man Playing the Lute and a Woman Singing* (c. 1670, location unknown).

217. Schuster 1988; with extensive bibliography.

218. Schuster 1988: 428–32, 439.

219. For the second position he cites an emblematic image, *Mobile fit fixum*, from Otto van Veen's *Emblemata sive Symbola* of 1614. My earlier discussion of van Veen's series, *The Triumph of the Catholic Church*, shows it to be in keeping with this placement. Schuster 1988: 428f., fig. 3, "Ausdruck eines humanistischen Ausgleichs- und Mäßigkeitsstrebens."

220. Her pose is not unique, it is rather similar to Eternity's pose in Samuel van Hoogstraeten's *Time and Eternity* (c. 1665–75, location unknown,

Sumowski 1983, vol. 2, cat. no. 832). It seems to me that formally both may be traced back to Adam Elsheimer's awkwardly seated figure in his *The Realm of Juno* (lost, known through Wenceslaus Hollar's engraving of 1646), in which Juno, though presented with the gestures, insignia, and general posture of a commanding figure, looks at the same time heavy and limp, and leans to one side. For Elsheimer's image, see Andrews 1977: 151f., cat. no. 22; Krämer 1973: 156. Andrews suggests that Rembrandt knew Hollar's print and based his own *Juno* (Metropolitan Museum, New York) on it. See also Schwartz 1991: 314.

221. A very different type of representation is discussed in Brusati 1990–1. Her examples include spheres reflecting clearly and unmistakably the artist at the easel before the painting. This is a closed model of reflexivity, closed both in itself and to the beholder.

222. Hoogstraeten 1978: 172f. The only genre scene known to me, in which a sphere hanging from the ceiling might have allegorical meaning, is Jan Steen's *Brothel Scene* (c. 1668–70, Szépmüvészeti, Museum, Budapest). See exhib. cat. Frankfurt 1993, cat. no. 77.

223. See Sewel and Buys 1766; Sterkenburg 1975.

224. Hoogstraeten 1978: 182.

225. It is also invoked in book 7, "Melpomene, de Treurdichtster."

226. See Steinhagen, in Haug 1979, quotations from Benjamin's "Zentralpark" and from his manuscript (Benjamin 1980, vol. 1, part 2: 660; vol. 1, part 3: 1151).

227. Goldscheider 1967: 27. He adds with satisfaction that the painting's admirer Paul Claudel is "a lone voice." Harry Berger, having quoted this passage, (1972: 246f.) takes up its tone when he describes "her admiring gasp", declaring that "she is clearly trying to make the most of it" and that the "globe is big as a beachball."

Epilogue

1. Cited Wheeler 1984: 169, trans. of Jean Paul 1980: 60, paragraph 13: "Überhaupt sieht die Besonnenheit nicht das Sehen, sondern nur das abgespiegelte oder zergliederte Auge; und das Spiegeln spiegelt sich nicht. Wären wir unserer ganz bewußt, so wären wir unsere Schöpfer und schrankenlos."

2. Grimschitz 1957: cat. no. 129; Schröder 1990: 16, cat. no. 10; Westhoff-Krummacher 1975: 170, inv. no. 8237.

3. On portraiture and genre, see Riegl 1931;

Smith 1987; and Raupp 1984. For the nineteenth century, see Lorenz 1985, chapter 5, "Familiengenre," 201–25.

4. See Grimschitz 1957, cat. nos. 76, 106, 107, 124, 127, 136, 154. For comparison see de Jongh, in exhib. cat. Haarlem, 1986. For Waldmüller's innovations in genrelike family portraiture, see Lorenz 1985: 216ff., Schröder 1990: 16.

5. On such wall decorations, see Lorenz 1985: 141, n. 75.

6. The painting on the left iconographically and compositionally resembles the Holy Family as painted by Rubens (c. 1616–18, Potsdam, Schloss Sanssouci; and 1626–7, Paris, Musée du Louvre), but stylistically – the dressed John the Baptist with shiny curls, the subdued, less sensuous Mary, the elderly, white-haired Joseph – it points to van Dyck, although I have not been able to identify the work. Grimschitz made one copy of a van Dyck painting (Grimschitz 1957, cat. no. 72).

7. Welu 1975: 541–3. The titles of two book publications of Austrian maps are clearly legible in Waldmüller's work. Westhoff-Krummacher 1975: 170.

8. One possibility here is that these unknown people are indeed the owners of the two paintings. Willem van de Watering (in Blankert 1978: 170) takes the portrait as evidence for the location of Vermeer's *Allegory of Faith* in a Viennese private collection. That Waldmüller had access to such collections may be concluded not only from the many portraits of aristocrats he painted in this period but also from the fact that in 1823–4 he made copies of two paintings by Ruisdael and Potter, which Grimschitz identifies as paintings in the Czernin Collection (Grimschitz 1957, cat. nos. 123 and 125). Vermeer's *The Art of Painting* had been in that collection since 1813, albeit identified as by Pieter de Hooch (see Blankert 1978: 163).

9. Schröder (1990: 16) goes so far as to suggest that this couple have nothing more to say to each other.

References

Adams, Hazard, ed. *Critical Theory since Plato.* New York: Harcourt Brace Jovanovich, 1971.

Adhémar, Hélène. "La Vision de Vermeer par Proust, à travers Vaudoyer." *Gazette des Beaux-Arts* 68 (1966), 291–302.

Adorno, Theodor W. *Minima Moralia: Reflections from a Damaged Life.* Trans. Edmund Jephcott. London: New Left Books, 1974.

———. *Aesthetic Theory.* Trans. C. Lenhardt. London and New York: Routledge & Kegan Paul, 1986.

———. *Prisms.* Trans. Samuel and Shierry Weber. Cambridge, Mass.: MIT Press, 1992.

Aillaud, Gilles, John Michael Montias, and Albert Blankert. *Vermeer.* New York: Rizzoli, 1988.

Allgemeine Deutsche Biographie. Königliche Akademie der Wissenschaften, Leipzig: Duncker & Humblot, 1888.

Alpatov, Mikail. "Die *Straße in Delft* von Jan Vermeer." In *Studien zur Geschichte der westeuropäischen Kunst* 142–4, 193–203. Cologne: DuMont, 1974.

Alpers, Svetlana. *The Art of Describing: Dutch Art in the Seventeenth Century.* Chicago: University of Chicago Press, 1983.

Anderson, Rae. "The Artist's Studio as a Space of Creativity." *Canadian Review of Art Education. Revue canadienne d'éduction artistique* 22: 1 (1995) 56–80, 1995.

Andrews, Keith. *Adam Elsheimer: Paintings, Drawings, Prints.* New York: Rizzoli, 1977.

Angel, Philips. *Lof der Schilderkonst.* (Leiden: Willem Christiaens, 1642). Reprint, Utrecht: Davaco, 1969.

Anonymous. "Selbstbespiegelung der Bilder." *Frankfurter Allgemeine Zeitung*, May 31, 1989.

Appell, J. W. *The dream of Poliphilus: Facsimiles of one hundred and sixty-eight woodcuts in the "Hypnerotomachia Poliphili" Venice 1499.* London: W. Griggs, 1888-89.

Aragon, Louis, and Jean Cocteau. *Conversations on the Dresden Gallery.* Trans. Francis Scarfe, foreword by Joseph Mashek. New York: Holmes & Meier, 1982.

Arasse, Daniel. "Le Lieu Vermeer." *La Part de l'oeil* 5:5 (1989), 7–29.

———. *Vermeer: Faith in Painting.* Princeton: Princeton University Press, 1994.

Armstrong, Walter. "Johannes Vermeer, of Delft." *The Portfolio* 22 (1891), 23–7.

Asemissen, Hermann Ulrich. *Jan Vermeer. Die Malkunst: Aspekte eines Berufsbildes.* Frankfurt: Fischer, 1988.

Auzas, Pierre-Marie. "La Peinture hollandaise vue par Fromentin et par Claudel." *Bulletin de la Societé Paul Claudel* 93–6 (1984), 3–16.

B., L. "Gaucherel, Léon." *Thieme-Becker Künstler-Lexikon* vol. 13, 258–9. Leipzig: E. A. Seemann, 1920.

Badt, Kurt. *"Modell und Maler" von Vermeer, Probleme der Interpretation: Eine Streitschrift gegen Hans Sedlmayr.* Cologne: DuMont 1961.

———. *Raumphantasien und Raumillusionen.* Cologne: DuMont, 1983.

Baedeker, Karl. *Baedeker's Belgium and Holland.* Leipzig: Baedeker, 1894.

Bakker, Boudewijn. "Monet as a Tourist." In exhib. cat. Amsterdam 1986, 15–35.

Barnouw, A. J. "Vermeer's zoogenaamd Novum Testamentum." *Oud Holland* 34 (1914), 50–4.

Bätschmann, Oskar. *Dialektik der Malerei von Nicolas Poussin.* Zürich: Schweizerisches Institut für Kunstwissenschaft, and Munich: Prestel, 1982.

———. *Einführung in die kunstgeschichtliche Hermeneutik: Die Auslegung von Bildern.* Darmstadt: Wissenschaftliche Buchgesellschaft, 1984.

———. *Nicolas Poussin: Dialects of Painting.* Trans. Marko Daniel. London: Reaktion, 1990.

———. "De Lumine Et Colore: Der Maler Nicolas Poussin in seinen Bildern." In Winner 1992, 463–83.

Baudelaire, Charles. *The Flowers of Evil and Paris Spleen.* Trans. William H. Crosby. Brockport, N.Y.: BOA, 1991.

Baudouin, Frans. *Pietro Pauolo Rubens* Trans. E. Callender. New York: Abrams, 1977.

———. "Het hoogaltaar in de kerk der Geschoeide Karmelieten te Antwerpen, ontworpen door Rubens." In *Essays in Northern European Art Presented to Egbert Haverkamp-Begemann on His Sixtieth Birthday*, 27–32. Soest and Doornspijk: Davaco, 1983.

Baudson, Michel, ed. *Zeit: die vierte Dimension in der Kunst.* Weinheim: VCH, 1985.

Bauer, Linda Freeman. "Seventeenth-Century Naturalism and the Emblematic Interpretation of Paintings." *Emblematica* 3:2 (1988), 209–28.

Beaume, George. *Fromentin.* New York: Frederick A. Sokes, 1913.

Becker, Ingeborg. *Theodor Hosemann: Illustrator–Graphiker–Maler des Biedermeier.* (Exhib. cat. Berlin) Wiesbaden: Reichert, 1983.

Becker, Jochen. "Ursprung so wie Zerstörung: Sinnbild und Sinngebung bei Warburg und Benjamin." In van Reijen 1992, 64–89.

Becker, Wolfgang. *Paris und die deutsche Malerei 1750–1840. Studien zur Kunst des 19. Jahrhunderts.* Vol. 10. Munich: Prestel, 1971.

Beenken, Hermann. *Das neunzehnte Jahrhundert in der deutschen Kunst: Aufgaben und Gehalte, Versuch einer Rechenschaft.* Munich: Bruckmann, 1944.

Belting, Hans, Heinrich Dilly, Wolfgang Kemp, and Willibald Sauerländer, eds. *Kunstgeschichte: Eine Einführung.* Berlin: Dietrich Reimer, 1988.

Benjamin, Walter. *Illuminations.* Ed. Hannah Arendt, trans. Harry Zohn. New York: Schocken, 1969.

———. *Berliner Chronik.* Ed. Gershom Scholem. Frankfurt am Main: Suhrkamp, 1970.

———. *Briefe.* Ed. Gershom Scholem and Theodor W. Adorno, 2 vols. Frankfurt am Main: Suhrkamp, 1978.

———. *Gesammelte Schriften.* Ed. Rolf Tiedemann and Hermann Schweppenhäuser. 4 vols. (12 parts). Frankfurt am Main: Suhrkamp, 1980.

———. *Das Passagenwerk.* Vol. 5 (2 parts) of *Gesammelte Schriften.*

———. *The Origin of German Tragic Drama.* Trans. John Osborne. London: New Left Books, (1977) 1985.

———. *Reflections.* Ed. Peter Demetz, trans. Edmund Jephcott. New York: Schocken, (1978) 1986.

———. "Rigorous Study of Art." Trans. Thomas Y. Levin, *October* 47 (1988), 84–90.

Berchet, Jean-Claude, ed. *Le Voyage en Orient: Anthologie des Voyageurs François dans le Levant au XIX^e Siècle.* Paris: Robert Laffont, 1985.

Berger, Harry. "Conspicuous Exclusions in Vermeer: An Essay in Renaissance Pastoral." *Yale French Studies* 47 (1972), 243–65.

Beyrodt, Wolfgang. "Wilhelm von Bode 1845–1929." In Dilly 1990, 19–34.

Bialostocki, Jan. "Einfache Nachahmung der Natur oder symbolische Weltschau: Zu den Deutungsproblemen der holländischen Malerei des 17. Jahrhunderts." *Zeitschrift für Kunstgeschichte* 47 (1984), 421–38.

Bientjes, J. *Holland und der Holländer im Urteil deutscher Reisender 1400–1800.* Groningen: J. B. Wolters, 1967.

Blanc, Charles. *École hollandaise*, 2 vols. *Histoire des peintres des toutes les écoles* (1848–76). Vol. 8. Paris: Jules Renouard, 1861.

Blankert, Albert. *Vermeer de Delft: Complete Edition of the Paintings.* Oxford: Phaidon, 1978.

Bloch, Ernst. *Erbschaft dieser Zeit.* Frankfurt am Main: Suhrkamp, 1962. Eng. ed. *Heritage*

of our Times. Trans. Neville and Stephen Plaice. Berkeley and Los Angeles: University of California Press, 1990.

Bloch, Vitale. "Pro Caesar Boetius van Everdingen." *Oud Holland* 53 (1936), 256–62.

Blum, André. *Vermeer et Thoré-Bürger*. Geneva: Editions du Mont-Blanc, 1946.

Bock, Henning, and Thomas W. Gaethgens, eds. *Holländische Genremalerei im siebzehnten Jahrhundert*. Berlin: Gebrüder Mann, 1987.

Boeckl, W. "Johann Georg Wille." *Thieme-Becker Künstler-Lexikon*. Vol. 36, 11–12. Leipzig: E. A. Seemann, 1947.

Bode, Wilhelm. *Studien zur Geschichte der holländischen Malerei*. Braunschweig: Friedrich Vieweg, 1883.

———. *Great Masters of Dutch and Flemish Painting*. Trans. Margaret L. Clarke. New York: Scribner's & Sons, 1909-11.

Boehm, Gottfried, Karlheinz Stierle, and Gundolf Winter, eds. *Modernität und Tradition: Festschrift für Max Imdahl zum 60. Geburtstag*. Munich: Wilhelm Fink, 1985.

———. "Mnemosyne: Zur Kategorie des erinnernden Sehens." In Boehm 1985, 37–57.

Boppe, A. *Les Peintres de Bosphore au 18ᵉ Siècle*, Paris: Hachette, 1911.

Borowitz, Helen. "The Watteau and Chardin of Marcel Proust." *The Bulletin of the Cleveland Museum of Art* 69 (1982), 18–35.

———. "The Rembrandt and Monet of Marcel Proust." *The Bulletin of the Cleveland Museum of Art* 70 (1983), 73–95.

Börsch-Supan, Helmut, ed. *Die Kataloge der Berliner Akademie-Ausstellungen 1786-1850*. 2 vols. *Quellen und Schriften zur bildenden Kunst*. Vol. 4: Berlin: Hesseling, 1971.

Böschenstein-Schäfer, Renate. *Idylle*. 2d. rev. ed. Stuttgart: Metzler, 1977.

Bötticher, Friedrich von. *Malerwerke des 19. Jahrhunderts*. 2 vols. Leipzig: Schmidt & Günther, 1891–1901.

Braider, Christopher. "The Denuded Muse: The Unmasking of Point of View in the Cartesian *Cogito* and Vermeer's *The Art of Painting*." *Poetics Today* 10 (1989), 173–203.

———. *Refiguring the Real: Picture and Modernity in Word and Image 1400–1700*. Princeton: Princeton University Press, 1993.

Bredekamp, Horst, et al. *Aby Warburg: Akten des Internationalen Symposions Hamburg 1990*. Weinheim: VCH, 1991.

Bredius, Abraham. "Nog een woord over Vermeer's Emmausgangers." *Oud Holland* 55 (1938), 97–9.

Brieger, Lothar. *Das Genrebild: Die Entwicklung der bürgerlichen Malerei*. Munich: Delphin, 1922.

Brodersen, Momme. "'Wenn Ihnen die Arbeit des Interesses wert erscheint. . . .' Walter Benjamin und das Warburg-Institut: Einige Dokumente." In Bredekamp 1991, 87–94.

Brown, Christopher. *Dutch Townscape Painting. Themes and Painters in the National Gallery* vol. 10. London 1978.

———. *Images of a Golden Past: Dutch Genre Painting in the Seventeenth Century*. New York: Abbeville, 1984.

Bruckner, D. J. R. "A Hands on History of Art. *The Art Pack*, by Christopher Frayling, Helen Frayling and Ron van der Meer. New York, Alfred A Knopf." *The New York Times Book Review*, September 6, 1992.

Brusati, Celeste. The Nature and Status of Pictorial Representation in the Art and Theoretical Writing of Samuel van Hoogstraten. Ph.D. diss. University of California Berkeley, 1984.

———. "Stilled Lives: Self-Portraiture and Self-Reflection in Seventeenth-Century Netherlandish Still-Life Painting." *Simiolus* 20 (1990–1), 167–82.

Bryson, Norman. *Vision and Painting: The Logic of the Gaze*. New Haven and London: Yale University Press, 1983.

Burckhardt, Jacob. *Erinnerungen aus Rubens*. Basel: C. F. Lendorff, 1898.

———. *Vorträge 1844–87*. Ed. Emil Dürr. Basel: Benno Schwabe, 1919.

———. *Recollections of Rubens*. Ed. Horst Gerson, trans. Mary Hottinger. London: Phaidon, 1950.

Bürger, William. See Thoré, Théophile.

Bürgi, Bernhard. "Der Mut, die Reinheit der Mittel wiederzufinden." In Bürgi 1988, 29–89.

———. ed. *Rot–Gelb–Blau: Die Primärfarben in der Kunst des 20. Jahrhunderts*. Stuttgart and Teufen: Hatje and Niggli, 1988.

Burke, Peter. *Venice and Amsterdam: A Study in Seventeenth-century Elites*. London: Temple Smith, 1974.

Busch, Werner. *Die notwendige Arabeske: Wirklichkeitsaneignung und Stilisierung in der deutschen Kunst des 19. Jahrhunderts*. Berlin: Gebrüder Mann, 1985.

Camp, Maxime du. *En Hollande: Lettres à un*

ami, suivies des catalogues des musées de Rotterdam, La Haye et Amsterdam. 1857, 1859. Rev. ed. Paris: Michel Lévy Frères, 1868.

Canby, Vincent. "Obsession with Art and Money: All the Vermeers in New York." *The New York Times,* May 1, 1992.

Carasso, Dedalo. "Duitse en franse denkers over de zeventiende-eeuwse Nederlandse schilderkunst, 1775-1860." In Grijzenhout 1992, 161-92.

Carrier, David. *Art Writing.* Amherst: University of Massachusetts Press, 1987.

———. "Poussin's Self-Portraits." *Word & Image* 7:2 (1991), 127–48.

Chantelou, Paul Fréart de. *Journal du voyage en France du Cavalier Bernin.* Intro. G. Charensol. Paris: Stock, 1930.

Chastel, André. "Le tableau dans le tableau." In *Stil und Überlieferung in der Kunst des Abendlandes: Akten des Internationalen Kongresses für Kunstgeschichte Bonn* 3 Vols. Vol. 1, 15–29. Berlin: Gebrüder Mann, 1967.

Cheever, Susan. "A Designated Crazy: *Girl, Interrupted,* by Susanna Kaysen." *The New York Times Book Review,* June 20, 1993, 1, 24f.

Chernowitz, Maurice E. *Proust and Painting.* New York: International University Press, 1945.

Chu, Petra ten-Doesschate. *French Realism and the Dutch Masters: The Influence of Dutch Seventeenth-Century Painting on the Development of French Painting between 1830 and 1870.* Utrecht: Hantjens Dekker & Gumbert, 1974.

Claudel, Paul. *L'Oeil écoute.* Paris: Gallimard, 1964. Eng. ed. *The Eye Listens.* Trans. Elsie Pell. New York: Philosophical Library, 1950.

Collier, Peter. *Proust and Venice.* New York: Cambridge University Press, 1989.

Coppens, Chris. "Spanish Drawings as a Model for a Baroque Book of Devotions with Etchings by Romeyn de Hooghe." *Rutgers Review* 7 (1986), 63-74.

Coremans, P. B. *Van Meegeren's Faked Vermeers and de Hooghs: A Scientific Examination.* Trans. A. Hardy and C. M. Hutt. Amsterdam: J. M. Meulenhoff, 1949.

Coven, Jeffrey. *Baudelaire's Voyages: The Poet and his Painters.* Exhib. cat. Huntington, N.Y., Toronto, and London: Bulfinch Press,
1993.

Cuzin, Jean Pierre. *Jean-Honoré Fragonard: Life and Work. Complete Catalogue of the Oil Paintings.* New York: Abrams, 1988.

Daly, Peter M. *Emblem Theory: Recent German Contributions. Wolfenbütteler Forschungen.* Vol. 9. Nendeln, Liechtenstein: KTO Press, 1979.

Demetz, Peter. "Defenses of Dutch Painting and the Theory of Realism." *Comparative Literature* 15:2 (1963), 97–115.

Diderot, Denis. *Versuche über die Mahlerey.* Trans. Carl Friedrich Crammer. Riga, 1779.

———. *Essais sur la peinture. Salons de 1759, 1761, 1763.* Ed. Gita May and Jacques Chouillet. Paris: Hermann Editeurs des sciences et des arts, 1984.

Didi-Huberman, George. "L'Art de ne pas décrire: Une aporie du détail chez Vermeer." *La Part de l'oeil* 2 (1986), 103–19.

Dilly, Heinrich. *Deutsche Kunsthistoriker 1933–1945.* Berlin: Deutscher Kunstverlag, 1988.

———, ed. *Altmeister moderner Kunstgeschichte.* Berlin: Dietrich Reimer, 1990.

Dittmann, Lorenz. "Über das Verhältnis von Zeitstruktur und Farbgestaltung in den Werken der Malerei." In *Festschrift für Wolfgang Braunfels,* 93–109. Ed. F. Peil and Jörg Traeger. Tübingen: Wasmuth, 1977.

———. *Farbgestaltung und Farbtheorie in der abendländischen Malerei: Eine Einführung.* Darmstadt: Wissenschaftliche Buchgesellschaft, 1987.

Ditzen, Lore. "Der Weg zur Weltspitze. Die Berliner Mussem erinnern an ihren 'General' Wilhelm von Bode." *Süddeutsche Zeitung,* no. 129, December 16, 1995.

Donahue, Susan. "Daniel Vosmaer." *Vassar College of Undergraduate Studies* 19 (1964), 18–27.

Edwards, Jo-Lynn, "La Curieuse histoire de l'*Astronome* de Vermeer et de son pendant au XVIIIᵉ siècle." *Revue du Louvre et des Musées de la France* 36:3 (1986), 197–201.

Eiche, Sabine. "*The Artist in His Studio* by Vermeer Is about a Chandelier." *Gazette des Beaux-Arts* 99 (1982), 203f.

Eijnden, Roeland van, and Adriaan van der Willigen. *Geschiednis der Vaderlandsche Schilderkunst.* (Haarlem, 1816-40). Reprint, Amsterdam: B. M. Israel, 1979.

Eisler, Max. "Der Raum bei Jan Vermeer." *Jahrbuch der Kunsthistorischen Sammlun-*

gen des Allerhöchsten Kaiserhauses Wien 33 (1916), 213–91.

———. *Alt-Delft: Kultur und Kunst*. Amsterdam: Elsevier, and Vienna: Staatsdruckerei, 1923.

Elias, Norbert. *Die höfische Gesellschaft: Untersuchungen zur Soziologie des Königtums und der höfischen Aristokratie*. Darmstadt: Luchterhand, 1979. Eng. ed. *The Court Society*. Trans. Edmund Jephcott. New York: Pantheon, 1983.

———. *Über die Zeit. Arbeiten über die Wissenssoziologie*. Vol. 2. Frankfurt am Main: Suhrkamp, (1984) 1992a. Eng. ed. *Time: An Essay*. Trans. in part Edmund Jephcott. Oxford: Basil Blackwell, 1992b.

Elovsson, Per-Olov. "The Geographer's Heart: A Study of Vermeer's Scientist." *Konsthistorisk Tidskrift* 60 (1991), 17–25.

Elze, Martin. "Das Verständnis der Passion Jesu im ausgehenden Mittelalter und bei Luther." In *Geist und Geschichte der Reformation, Festgabe für Hanns Rückert zum 65. Geburtstag*. Ed. H. Liebing and K. Scholder, 127-51. Berlin: de Gruyter, 1966.

Eschenberg, Barbara. "Darstellung von Sitte und Sittlichkeit–Das Genrebild im Biedermeier." In exhib. cat. Munich, 1987, 169–79.

Esquiros, Alphonse. *La Néerlande et la vie hollandaise*. 2 vols. Paris: Michel Lévy Frères, 1859.

Ettlinger, Luitpold D. "Pollaiuolo's Tomb of Pope Sixtus IV." *Journal of the Warburg and Courtauld Institutes* 16 (1953), 239-74.

———. *Antonio and Piero Pollaiuolo*. Oxford and New York: Phaidon, 1978.

Euripides. *Heracles*. Trans. William Arrowsmith. New York: The Modern Library, 1956.

Evans, Arthur R. *The Literary Art of Eugène Fromentin: A Study in Style and Motif*. Baltimore: The Johns Hopkins University Press, 1964.

Evans, David. *John Heartfield AIZ/VI 1930–38*. Ed. Anna Lundgren. New York: Kent Fine Art, inc., 1992.

Exhib. cat. Amsterdam. *Anamorfosen: Spel met perspectif*. Rijksmuseum, 1975.

Exhib. cat. Amsterdam. *Opkomst en bloei van het Noordnederlandse stadgezicht in de 17de eeuw.* (bilingual!) *The Dutch Cityscape in the Seventeenth Century and Its Sources.* Historisch Museum Amsterdam and Art Gallery of Ontario, Toronto, 1977.

Exhib. cat. Amsterdam. *Monet in Holland*. Rijksmuseum Vincent van Gogh, 1986.

Exhib. cat. Antwerp. *Jacob Jordaens (1593–1678)*. Koninklijk Museum Voor Schone Kunsten, 1993.

Exhib. cat. Auckland. *Still-Life in the Age of Rembrandt*. City Art Gallery, 1982.

Exhib. cat. Berlin. *Berlin zwischen 1789–1848: Facetten einer Epoche*. Akademie der Künste, 1981.

Exhib. cat. Berlin. *Theodor Hosemann: Illustrator–Graphiker–Maler des Biedermeier*. Staatsbibliothek Preußischer Kulturbesitz, 1983.

Exhib. cat. Berlin. *Wilhelm von Bode als Zeitgenasse der Kunst. Zum 150 Geburtstag*. National galerie. Staatliche Museen zu Berlin.

Exhib. cat. Brunswick. *Die Sprache der Bilder*. Herzog Anton Ulrich-Museum, 1978.

Exhib. cat. Cambridge, Mass. *Jacob van Ruisdael*. Fogg Art Center, and Mauritshuis, The Hague, 1981.

Exhib. cat. Delft. *1667 tot 1813*. Vol. 3 (2 parts) *De Stad Delft, cultuur en maatschappij*. Stedelijk Museum Het Prinsenhof, 1982.

Exhib. cat. Dijon. *La Peinture dans la peinture*. Musée des Beaux-Arts, 1983.

Exhib. cat. Düsseldorf. *Die Düsseldorfer Malerschule*. Kunstmuseum Düsseldorf, 1979.

Exhib. cat. Frankfurt am Main. *Max Klinger 1857–1920*. Städelsches Kunstinstitut, 1992.

Exhib. cat. Frankfurt am Main. *Leselust: Niederländische Malerei von Rembrandt bis Vermeer*. Kunsthalle Schirn, 1993.

Exhib. cat. Haarlem. *Portretten van echt en trouw: Huwelijk en gezin in de Nederlandse kunst van de zeventiende eeuw*. Frans Hals Museum, 1986.

Exhib. cat. Hamburg. *Pegasus und die Künste*. Museum für Kunst und Gewerbe, 1993.

Exhib. cat. Hartford. *Pictures within Pictures*. Wadsworth Atheneum, 1949.

Exhib. cat. Indianapolis. *George Deem*. Indianapolis Museum of Art, 1974.

Exhib. cat. London. *The Romantic Spirit in German Art, 1790–1990*. Hayward Gallery, 1994a.

Exhib. cat. London. *German Printmaking in the Age of Goethe*. British Museum, 1994b.

Exhib. cat. Los Angeles. *Guido Reni, 1575–1642*. Los Angeles County Museum of Art, 1988.

Exhib. cat. Mannheim. *Zeit: Die vierte Dimension in der Kunst*. Kunsthalle Mannheim, 1985.

Exhib. cat. Marbach am Neckar. *Wilhelm*

Hausenstein: Wege eines Europäers. Deutsches Literaturarchiv im Schiller-Nationalmuseum, 1967.

Exhib. cat. Munich. *Biedermeiers Glück und Ende, . . . die gestörte Idylle, 1815–1848.* Stadtmuseum, 1987.

Exhib. cat. Münster. *Stilleben in Europa.* Westfälisches Landesmuseum für Kunst und Kulturgeschichte, 1979–80.

Exhib. cat. New York. *Piet Mondrian.* Museum of Modern Art, 1970.

Exhib. cat. New York. *Courbet Reconsidered.* The Brooklyn Museum, 1988.

Exhib. cat. New York. *The Golden Age of Danish Painting.* The Metropolitan Museum of Art, 1994.

Exhib. cat. Paris. *Realismus. Zwischen Revolution und Reaktion 1919-1939.* Centre Georges Pompidou and Berlin, Staatliche Kunsthalle, 1980–1.

Exhib. cat. Paris. *Malcolm Morley.* Centre Georges Pompidou, 1993.

Exhib. cat. Philadelphia. *Masters of Seventeenth-Century Dutch Genre Painting.* Philadelphia Museum of Art, 1984.

Exhib. cat. Roslyn Harbor, Nassau County, N.Y. *Art about Art.* Museum of Art, 1994.

Exhib. cat. Rotterdam. *Perspectives: Saenredam and the Architectural Painters of the Seventeenth Century.* Museum Boymans-van Beuningen, 1991.

Exhib. cat. Rotterdam. *Images of Discord / De Tweedracht Verbeeld: A Graphic Interpretation of the Opening Decades of the Eighty Years' War.* Atlas van Stolk, 1993.

Exhib. cat. The Hague. *Great Dutch Art from America.* Mauritshuis, 1990

Exhib. cat. Washington, D.C. *Still Lifes of the Golden Age: Northern European Paintings from the Heinz Family Collection.* National Gallery of Art, 1989.

Exhib. cat. Zürich. *Im Lichte Hollands: Holländische Malerei des 17. Jahrhunderts aus den Sammlungen des Fürsten von Liechtenstein und aus Schweizer Besitz.* Kunstmuseum, 1987.

Favero, Giampolo Bordignon. *The Villa Emo at Fanzolo.* Trans. Douglas Lewis. *Corpus Palladianum.* Vol. 5. University Park and London: The Pennsylvania State University Press, 1972.

Filipzcak, Zirka Zaremba. *Picturing Art in Antwerp, 1500–1700.* Princeton: Princeton University Press, 1987.

Fink, Daniel E. "Vermeer's Use of the Camera Obscura, a Comparative Study." *Art Bulletin* 53 (1971), 493–505.

Fischel, Oskar. *Die Meisterwerke des Kaiser Friedrich-Museums zu Berlin.* Munich: Hanfstaengl, n. d., c. 1900–5.

Fischer, Bernhard. "Kunstautonomie und Ende der Ikonographie: Zur historischen Problematik von *Allegorie* und *Symbol* in Winckelmanns, Moritz' und Goethes Kunsttheorie." *Deutsche Vierteljahrsschrift für Literatur und Geistesgeschichte* 64:2 (1990), 247–77.

Forster, Georg. *Ansichten vom Niederrhein: Eine Auswahl.* Ed. Ludwig Uhlig. Stuttgart: Reclam, 1965.

Foucart, Jacques. "L'Astronome de Vermeer." *Revue du Louvre et des Musées de France* 33:4 (1983), 280f.

Fraissenet, Edouard. *Le Japon contemporain.* 2 vols. Paris: Hachette, 1857.

Freedberg, David. *The Life of Christ after the Passion. Corpus Rubenianum Ludwig Burchard.* Part 7. London and Philadelphia: Miller Harvey and Heyden, 1984.

Freedberg, David, and Jan de Vries, eds. *Art in History, History in Art: Studies in Seventeenth-Century Dutch Culture.* Chicago: University of Chicago Press, 1991.

Fried, Michael. *Absorption and Theatricality: Painter and Beholder in the Age of Diderot.* Los Angeles and Berkeley: University of California Press, 1980.

Friedländer, Max J. *Die niederländischen Maler des 17. Jahrhunderts. Propyläen Kunstgeschichte.* Vol. 12. Berlin: Propyläen Verlag (1923), 2d. ed., 1926.

———. *Essays über die Landschaftsmalerei und andere Bildgattungen.* The Hague: A.A.M./Stols, 1947. Eng. ed. *Landscape, Portrait, Still-Life: Their Origin and Development.* New York: Schocken, 1965.

Fromentin, Eugène. *Les Maîtres d'autrefois,* Trans. E. von Bodenhausen. Berlin: Bruno Casirrer, 1903. Eng. ed. *The Masters of Past Time. Dutch and Flemish Painting.* Ed. Horst Gerson. Ithaca, N.Y.: Cornell University Press, 1981.

———. *Un Eté dans le Sahara* (1854). Ed. Maxime Revon. Paris: Louis Conard, 1938.

Frossati-Okeyama, Yassu. *The Ripa Index: Personifications and Their Attributes in Five Editions of the Iconologia.* Doornspijk: Davaco, 1992.

Gadamer, Hans-Georg. *Wahrheit und Methode: Grundzüge einer philosophischen Hermeneutik*. Tübingen: J.C.B. Mohr, Carl Siebeck, 1965.

———. *The Relevance of the Beautiful and Other Essays*. Ed. Robert Bernasconi, trans. Nicholas Walker. New York: Cambridge University Press, 1988a.

———. *Truth and Method*. New York: Crossroad, 1988b.

———. "Über das Lesen von Bauten und Bildern." In Boehm 1985, 97–103.

Gage, John. *Color and Culture: Practice and Meaning from Antiquity to Abstraction*. Boston, London and Toronto: Bulfinch Press, 1993.

Gállego, Julián. "Le Tableau à l'intérieur du tableau." *Colóquio Artes* 2d. series 17 (1974), 37–42.

Garas, K. "Die Entstehung der Galerie des Erzherzog Leopold Wilhelm." *Jahrbuch der Kunsthistorischen Sammlungen Wien* 63 (1967), 39–80.

Garber, Klaus, ed. *Europäische Barock-Rezeption* 2 vols. *Wolfenbütteler Arbeiten zur Barockforschung* Vol. 20. Wiesbaden: Harrassowitz, 1991.

Gaskell, Ivan. "Vermeer, Judgement and Truth." *Burlington Magazine* 76 (1984), 557–61.

Gayford, Martin. "The Beautiful and the Good: Iris Murdoch on the Value of Art." *Modern Painters* 6:3 (1993), 50–4.

Gehren, Georg von. "Kunst geht nach Weißbrot. Aus dem Alltag der kinderreichen Familie Vermeer van Delft." *Frankfurter Allgemeine Zeitung*, no. 207, September 5, 1992.

Gelder, Jan Gerrit van. *De Schilderkunst van Jan Vermeer*, ed. J. A. Emmens. Utrecht: Kunsthistorisch Instituut, 1958.

Georgel, Pierre, and Anne-Marie LoCaq. *La Peinture dans la peinture*. Exhib. cat. Dijon, 1983.

Gerard-Nelissen, I. "Otto van Veen's Emblemata Horatiana." *Simiolus* 5 (1971), 20–63.

Gerlach, Martin (ed.). *Allegorien und Embleme: Originalentwürfe von den hervorragendsten modernen Künstlern, sowie Nachbildungen alter Zunftzeichen und moderne Entwürfe von Zunftwappen im Charakter der Renaissance*. Intro. Albert Ilg, 3 vols. Vienna: Gerlach & Schenk, 1882–5.

Gerson, Horst. *Ausbreitung und Nachwirkung der holländischen Malerei des 17. Jahrhunderts* (1942). Reprint, ed. B. W. Meijer.

Amsterdam: B. M. Israel, 1983.

Gethmann-Siefert, Annemarie. "Die Kritik der Düsseldorfer Malerschule bei Hegel und den Hegelianern." In Kurtz, Gerhard, ed. *Düsseldorf in der deutschen Geistesgeschichte*, 263–88. Düsseldorf: Schwann, 1984.

———. "H. G. Hotho: Kunst als Bildungserlebnis und Kunsthistorie in systematischer Absicht–oder die entpolitisierte Version der ästhetischen Erziehung des Menschen." In Pöggeler 1983, 229–61.

Glen, Thomas L. *Rubens and the Counter Reformation: Studies in His Religious Paintings between 1609 and 1620*. New York: Garland, 1977.

Glück, Gustav. *Van Dyck. Klassiker der Kunst in Gesamtausgaben*. Vol. 13. Stuttgart: Deutsche Verlags-Anstalt, 1931.

Goethe, Johann Wolfgang von. *Die Wahlverwandtschaften, die Novellen, die Maximen und Reflexionen. Gedenkausgabe*. Ed. Ernst Beutler. Vol. 9. Zürich: Artemis, 1949.

———. *Schriften zur Kunst. Gedenkausgabe*. Ed. Christian Beutler. Vol. 13. Zürich: Artemis, 1954.

Goldscheider, Ludwig. *Johannes Vermeer*. London: Phaidon, 1967.

Goncourt, Edmond and Jules. *Die Frau im 18. Jahrhundert*. Ed. and trans. Paul Prina, 2 vols. Leipzig: Julius Zeitler, 1905–7.

Goodman-Soellner, Elise. "The Landscape on the Wall of Vermeer." *Konsthistorisk Tidskrift* 58 (1989), 76–87.

Gosebruch, Martin. *Festschrift für Kurt Badt zum siebzigsten Geburtstag: Beiträge aus Kunst- und Geistesgeschichte*. Berlin: de Gruyter, 1959.

Gowing, Lawrence. *Vermeer*. London: Faber & Faber, 1952.

———. "An Artist in His Studio: Reflections on Representation and the Art of Vermeer." *Art News Annual* 23 (1954), 85–96, 184f.

Grafton, Anthony, and Thomas DaCosta Kaufmann. "Holland without Huizinga: Dutch Visual Culture in the Seventeenth Century." *Journal of Interdisciplinary History* 16:2 (1985), 255–65.

Grijzenhout, Frans. *Liotard in Nederland*. Exhib. cat. Utrecht: Centraal Museum te Utrecht, 1985.

Grijzenhout, Frans and Henk van Veen, *De gouden eeuw in perspectief: Het beeld van de nederlandse zeventiende-eeuwse*

schilderkunst in later tijd. Nijmegen: SUN, and Heerlen: OU, 1992.

Grimschitz, Bruno. *Ferdinand Georg Waldmüller.* Salzburg: Galerie Welz, 1957.

Grioni, John S. "The Elegance of Helleu," *Konsthistorisk Tidskrift* 62:2 (1993a), 89–96.

———. "Helleu's Nudes," *Konsthistorisk Tidskrift* 62:3–4 (1993b), 221–6.

Grosshans, Henry. *Hitler and the Artists.* New York and London: Holmes & Meier, 1983.

Gudlaugson, Sturla J. *Geraert ter Borch.* 2 vols. The Hague: Martinus Nijhoff, 1959.

Gurlitt, Cornelius. *Die deutsche Kunst des 19. Jahrhunderts: Ihre Ziele und Taten.* Berlin: Georg Bondi, 1900.

Haberditzl, Franz Martin. "Die Lehrer des Rubens." *Jahrbuch der kunsthistorischen Sammlungen in Wien* 27 (1908), 161–235.

Hagedorn, Christian Ludwig. *Betrachtungen über die Mahlerey.* 2 vols. Leipzig: Wendler, 1762.

Hale, Philip Leslie. *Jan Vermeer of Delft.* Boston: Small, Maynard, 1913.

Hamann, Richard and Jost Hermand. *Naturalismus: Deutsche Kunst und Kultur von der Gründerzeit bis zum Expressionismus.* Berlin: Akademie Verlag, 1959.

Harbison, Craig. *The Last Judgment in Sixteenth Century Northern Europe: A Study in the Relation between Art and Reformation.* New York and London: Garland, 1976.

Haskell, Francis. *Rediscoveries in Art: Some Aspects of Taste, Fashion and Collecting in England and France.* Ithaca, N.Y.: Cornell University Press, 2d. ed., 1980.

Haug, Walter, ed. *Formen und Funktionen der Allegorie. Symposium Wolfenbüttel, 1978.* Special issue of *Deutsche Vierteljahrsschrift für Literatur und Geistesgeschichte.* Stuttgart: Metzler, 1979.

Haus, Andreas. "Leidenschaft und Pathosformel: Auf der Suche nach Bezügen Aby Warburgs zur barocken Affektenlehre." In Garber 1991, 1319–39.

Hausenstein, Wilhelm. *Der nackte Mensch in der Kunst.* Munich: Piper 1911.

———. *Über den Expressionismus in der Malerei: Tribüne der Zeit.* Vol. 1. Ed. Kasimir Edschmid. Berlin: Erich Reiss, 1919.

———. *Vom Geist des Barock.* Munich: Piper, 1921.

———. *Kairouan, oder, Eine Geschichte.* Frankfurt am Main: Kurt Wolff, 3d–5th ed., 1921.

———. *Das Gastgeschenk, Werke und Maler in dreiundzwanzig Erzählungen.* Vienna and Munich: Rikola Verlag, 1923

———. *Rembrandt.* Stuttgart, Berlin and Leipzig: Deutsche Verlags-Anstalt, 1926.

———. *Kunstgeschichte.* Berlin: Deutsche Buchgemeinschaft, 1927.

Hauser, Andreas. "Allegorischer Realismus: Zur Ikono-Logik von Vermeers *Messkünstler.*" *Städel-Jahrbuch* 8 (1981), 186–203.

Havard, Henry. *Objets d'art et de curiosité tirés des grandes collections hollandaises.* Haarlem: J. M. Schalekan, 1873.

———. *Amsterdam et Venise*: ill. by Léopold Flameng and Léon Gaucherel. Paris: E. Plon, 1876a.

———. *La Hollande Pittoresque. Voyage aux villes mortes du Zuiderzée.* Paris. E. Plon, 1875.

———. *The Dead Cities of the Zuyder Zee. A Voyage to the Picturesque Side of Holland.* Trans. Annie Wood, ill. by van Heemskerck, van Beest, Havard. Rev. ed. London: Richard Bentley & Son, 1876b.

———. *Histoire de la faience de Delft.* Paris: E. Plon, 1878a.

———. *La Hollande pittoresque, le coeur du pays.* Paris: E. Plon, 1878b.

———. *The Heart of Holland.* Trans. Cashel Hoey. New York: Harper & Bros., 1880.

———. *L'Art et les artistes hollandais.* 4 vols. Paris: Maison Quantin, 1878-81.

———. *Histoire de la peinture hollandaise.* Paris: Maison Quantin, 1881.

———. *Eine malerische Reise nach den toten Städten der Zuyder See.* Jena: Costenoble, 1882.

———. "Van der Meer de Delft." *Gazette des Beaux-Arts* Période 2, vol. 27 (1883), Part 1, 389–99; Période 2, vol. 28, Part 2, 212–24.

———. *Van der Meer de Delft.* Paris: Librairie de l'Art, 1888.

———. *Michiel van Mierevelt et son gendre.* Paris: Librairie de l'Art, 1894.

———. *Léopold Flameng: Etude biographique et critique.* Paris. 1904.

———. *La Céramique hollandaise.* 2 vols. Amsterdam: Vivat, 1909.

Heckmann, Hermann. *Matthäus Daniel Pöppelmann und die Barockkunst in Dresden.* Stuttgart: Deutsche Verlags-Anstalt, 1986.

Hedinger, Bärbel. *Karten in Bildern: Zur Ikonographie der Wandkarte in holländischen*

Interieurgemälden des 17. Jahrhunderts. Hildesheim, Zürich, and New York: Georg Olms, 1986.

Hegel, G. F. W. *Aesthetics, Lectures on Fine Arts.* Trans. T. M. Knox. 2 vols. Oxford: Clarendon Press, 1975.

———. *Vorlesungen über die Ästhetik. Werke.* Vols. 13, 14, and 15. Frankfurt am Main: Suhrkamp, 1983.

Heidegger, Martin. *Sein und Zeit* (1927). Tübingen: Niemeyer, 1986.

Heiden, Rüdiger an der. *Die Skizzen zum Medici-Zyklus von Peter Paul Rubens in der Alten Pinakothek.* Munich: Hirmer, 1984.

Held, Julius. "Allegorie." *Reallexikon zur Deutschen Kunstgeschichte.* Vol. 1, columns 345–66. Stuttgart: Metzler, 1937.

———. *The Oil Sketches of Peter Paul Rubens: A Critical Catalogue.* 2 vols. Princeton: Princeton University Press, 1980.

Henkel, Arthur, and Albrecht Schöne. *Emblemata: Handbuch zur Sinnbildkunst des 16. und 17. Jahrhunderts.* Stuttgart: Metzler, 1967.

Heppner, A. "Thoré-Bürger en Holland. De ontdekker van Vermeer en zijn liefde voor Neerlands kunst." *Tijdschrift voor Nederlandsche Kunstgeschiednis* 54–5 (1937–8), 17–34, 67–82, 129–94.

Herbert, Zbegniew. *Still-Life with a Bridle: Essays and Apocryphas.* Trans. John and Bogdana Carpenter. Hopewell, N.J.: Ecco Press, 1991.

Hess, Günter. "Allegorie und Historismus: Zum Bildgedächtnis des späten 19. Jahrhunderts." In Hans Fromm et al., eds. *Verbum et Signum: Beiträge zur mediävistischen Bedeutungsforschung, Friedrich Ohly zum 60. Geburtstag überreicht,* 555–91. Munich: W. Fink, 1975.

Hildebrand, Adolf. *Das Problem der Form* (1893). Strasbourg: J. H. Heitz, 1918. Eng. ed. *The Problem of Form.* Trans. Max Meyer and Robert Morris Ogden. New York: G. E. Stechert, 1909.

Himmelheber, Georg. *Biedermeier, 1815–1835: Architecture, Painting, Sculpture, Decorative Arts, Fashion.* Trans. John W. Gabriel. Munich: Prestel, 1989.

Hinz, Berthold. *Die Malerei im deutschen Faschismus: Kunst und Konterrevolution.* Munich: Hanser, 1974.

———. "Malerei im 'Dritten Reich' und ihre antagonistische Provenienz." In exhib. cat.

Paris 1980–1, 120–7.

———. *Art in the Third Reich.* Trans. Robert and Rita Kimber. New York: Pantheon, 1979.

Hoberman, J. "Individualists." *The Village Voice,* 5 May, 1992.

Hoffmann-Curtius, Kathrin. "Ein Paar–Ein Volk: Bilderpolitik zur deutschen Vereinigung 1989/90." *kritische berichte* 21:2 (1993), 77–98.

Hofmann, Walter Jürgen. "Vermeers Dianabild." In Hans Joachim Albrecht et al., eds. *Von Farbe und Farben: Festschrift für Albert Knoepfli zum 70. Geburtstag,* 324–8. Zürich: Manesse, 1980.

Hofstede de Groot, Cornelis. *Quellenstudien zur holländischen Kunstgeschichte: Arnold Houbraken und seine "Groote Schouburgh" kritisch beleuchtet.* The Hague: Martinus Nijhoff, 1893.

———. *Jan Vermeer und Karel Fabritius: Photogravüren nach ihren bekannten Werken mit biographischem und beschreibendem Text.* Leipzig: Hiersemann, 1905–7. 2d. ed. Amsterdam: Scheltema & Holkema, 1907.

———. *Beschreibendes und kritisches Verzeichnis der Werke der hervorragendsten holländischen Maler des XVII. Jahrhunderts, nach dem Muster von John Smith's Catalogue raisonné zusammengestellt.* Esslingen am Neckar: P. Neff, 1907–28.

Hofstede de Groot, Cornelis, and Wilhelm R. Valentiner, *A Catalogue Raisonné of the Works of the Most Eminent Dutch Painters of the Seventeenth Century Based on the Work of John Smith.* Trans. Edward G. Hawke. London (1908-27). Reprint, Cambridge: Somerset House, 1976.

Hollander, Anne. *Moving Pictures.* New York: Knopf, 1989.

Hoogstraeten, Samuel van. *Inleyding tot de Hooge Schoole der Schilderkonst: Anders de zichtbaere werelt, Verdeelt in negen Leerwinkels, yder bestiert door eene der Zanggoddinnen.* (Rotterdam: François van Hoogstraeten, 1678). Reprint, Ann Arbor: University of Michigan Press, 1978.

Houbraken, Arnold. *De Groote Schouburgh der Nederlantsche Kunstschilders en Schilderessen* (Amsterdam 1718-21). Ed. and trans. Alfred von Wurzbach. *Quellenschriften für Kunstgeschichte und Kunsttechnik.* Vol. 14. Vienna: W. Braumüller, 1888.

Hubala, Erich. *Der Münchner Kruzifixus.* Stuttgart: Reclam, 1967.

Hubschmitt, Walter Evan. The Art of Painting: An Iconographic Examination of "De Schilderconst" by Johannes Vermeer of Delft. Ph.D. diss. State University of New York, Binghamton, 1987.

Hulst, Roger Adolf d'. *Jacob Jordaens*. Ithaca, N.Y.: Cornell University Press, 1982.

Hurley, Ann. "'Ut Pictura Poesis': Vermeer's Challenge to Some Renaissance Literary Assumptions." *The Journal of Aesthetics and Art Criticism* 47 (1989), 349–57.

Hüttinger, Eduard. "Leonardo- und Giorgione-Kult: Materialien zu einem Thema des Fin de Siècle." In *Fin de Siècle: Zur Literatur und Kunst der Jahrhundertwende*. Ed. Roger Bauer, 143–69. Frankfurt am Main: Vittorio Klostermann, 1977.

Huyghe, René. "Affinités électives: Vermeer et Proust." *Amour de l'art* 1936, 7–15.

———. "Les thèmes-clefs et l'évolution de l'artiste: Vermeer, Rembrandt, Delacroix." *Eranos* 40 (1973), 158–200.

Ilg, Albert. *Über den kunsthistorischen Wert der Hypnerotomachia Poliphili: Ein Beitrag zur Geschichte der Kunstliteratur der Renaissance*. Vienna: W. Braumüller, 1872.

Iversen, Margaret. *Alois Riegl: Art History and Theory*. Cambridge, Mass. and London: MIT Press, 1993.

Jacobs, Y. H. A. "Katholiek leven binnen Delft, 1650–1813." In exhib. cat. Delft 1982, 78–82.

Jaeger, Charles de. *The Linz File: Hitler's Plunder of Europe's Art*. Exeter: Webb & Bower, 1981.

Jaffé, Hans Ludwig C. *Piet Mondrian*. New York: Abrams, 1970.

Jaffé, Michael. *Jacob Jordaens 1593–1678*. Ottawa, 1968–9.

Jäger, Lorenz. "Die esoterische Form von Benjamins *Ursprung des deutschen Trauerspiels*." In Garber 1991, 143–54.

James, Henry. "In Holland." In *Transatlantic Sketches*, 379–90. Boston: James R. Osgood & Co., 1875.

Jantzen, Hans. *Das niederländische Architekturbild*. Leipzig: Klinckhardt & Biermann, 1910.

———. "Die Raumdarstellung bei kleiner Augendistanz." In *Über den gotischen Kirchenraum*, 41–8. Berlin: Gebrüder Mann, 1951.

Jauss, Hans Robert. *Zeit und Erinnerung in Marcel Prousts "A la recherche du temps perdu": Ein Beitrag zur Theorie des Romans*. Heidelberg: Carl Winter Verlag, 1955.

———. *Ästhetische Erfahrung und literarische Hermeneutik*. Fankfurt am Main: Suhrkamp, 1982.

Jean de la Croix O.C.D., P. "La Glorification de l'Eucharistie de Rubens et les Carmes." *Metropolitan Museum Journal* 2 (1969), 179–95.

Jean Paul. See Richter, Johannes Paul.

Johnson, Lee McKay. *The Metaphor of Painting: Essays on Baudelaire, Ruskin, Proust, and Pater*. Ann Arbor: University of Michigan Research Press, 1980.

Jongh, E. de. "Vermommingen van Vrouw Wereld in de 17de eeuw." In *Album Amicorum J.G. van Gelder*. Ed. J. Bruyn et al., 198–206. The Hague: Martinus Nijhoff, 1973.

———. "Pearls of Virtue and Pearls of Vice." *Simiolus* 8 (1975–6), 69–97.

———. "The Interpretation of Still-Life Paintings: Possibilities and Limits." In exhib. cat. Auckland, 1982, 27–37.

———. *Portretten van echt en trouw, huwelijk en gezin in de Nederlandse kunst van de zeventiende eeuw*. Exhib. cat. Haarlem, 1986.

Joosten, Joop M. "Claude Monet's 'Discovery': Japanese prints given away in Holland as wrapping-paper?" In exhib. cat. Amsterdam 1986, 72–82.

Jost, Jon. *All the Vermeers in New York*. Film, 1992.

———. "Reubens for Lunch, Vermeers for Eternity." *Film Comment* 28 (1992), 80.

Jowell, Frances Suzman. *Thoré-Bürger and the Art of the Past*. New York and London: Garland, 1977.

Judson, J. R. and Carl van de Velde. *Book Illustrations and Title Pages. Corpus Rubenianum Ludwig Burchard*. Part 21, 2 vols. London and Philadelphia: Miller Harvey and Heyden, 1978.

Kaempfer, Engelbert. *The History of Japan, Together with a Description of the Kingdon of Siam (1690–92)*. Trans. J. G. Scheuchzer. Glasgow: J. MacLehose and Sons, 1906.

Kahr, Madlyn Millner. "Vermeer's *Girl Asleep*: A Moral Emblem." *Metropolitan Museum Journal* 6 (1972), 115–32.

———. *Dutch Painting in the Seventeenth Century*. New York: Harper & Row, 1978.

Kany, Roland. *Mnemosyne als Programm: Geschichte, Erinnerung und die Andacht zum Unbedeutenden im Werk von Usener, Warburg und Benjamin.* Tübingen: Niemeyer, 1987.

Kaufmann, Thomas DaCosta. *The Mastery of Nature. Aspects of Art, Science and Humanism in the Renaissance.* Princeton: Princeton University Press, 1993.

Kaysen, Susanna. *Girl, Interrupted.* New York: Random House, 1993.

Kayser, Christi;an Gottlob. *1903–1906 Kayser's Vollständiges Bücher-Lexikon.* Vol. 34. Leipzig: Chr. Herm Tauchnitz, 1908.

Kemp, Martin. *The Science of Art: Optical Themes in Western Art from Bruneleschi to Seurat.* New Haven and London: Yale University Press, 1990.

Kemp, Wolfgang, ed. *Der Anteil des Betrachters: Rezeptionsästhetische Studien zur Malerei des 19. Jahrhunderts.* Munich: Mäander, 1983.

———. "Death at Work: A Case Study of Constitutive Blanks in Nineteenth-Century Painting." *Representations* 10 (1985), 102–23.

———. "Fernbilder: Walter Benjamin und die Kunstwissenschaft." In *Walter Benjamin im Kontext,* ed. Burckhardt Lindner, 2d. expanded ed., 224–57. Königstein im Taunus: Athenäum, 1985.

———. *Rembrandts Die heilige Familie, oder, Die Kunst einen Vorhang zu lüften.* Frankfurt am Main: Fischer, 1986.

———. "Ellipsen, Analepsen, Gleichzeitigkeiten: Schwierige Aufgaben für die Bilderzählung." In Kemp, ed. *Der Text des Bildes: Möglichkeiten und Mittel der eigenständigen Bilderzählung,* 62–88. Munich: Edition Text + Kritik, 1989.

———. "Kunstwerk und Betrachter: Der rezeptionsästhetische Ansatz." In Belting et al. 1988, 240–57.

Kettering, Alison McNeil. *The Dutch Arcadia: Pastoral Art and Its Audience in the Golden Age.* Montclair: Allenheld and Schram, 1983.

Killiam, Marie-Thérèse. *The Art Criticism of Paul Claudel in "L'Oeil écoute."* New York and Bern: Peter Lang, 1987.

Kirschenbaum, Baruch D. *The Religious and Historical Paintings of Jan Steen.* Montclair: Allanheld and Schram, 1977.

Klemm, Bernhard. "Thoré-Bürger als Kunstkritiker." In Thoré 1911, vol. 3, 231–302.

Klessmann, Rüdiger, "Jan Vermeer van Delft, *Das Mädchen mit dem Weinglass.*" In exhib. cat. Brunswick 1978, 164–8.

Knabe, Peter-Eckhard. *Schlüsselbegriffe des kunsttheoretischen Denkens in Frankreich von der Spätklassik bis zum Ende der Aufklärung.* Düsseldorf: L. Schwann, 1972.

Knipping, B. *De Iconografie van de Contra-Reformatie in de Nederlanden.* 2 vols. Hilversum: N. J. Paul Brand, 1940.

Koolhaas, Eveline, and Sandra de Vries. "Terug naar een roemrijk verleden: De zeventiende-eeuwse schilderkunst als voorbeeld voor de negentiende eeuw." In Grijzenhout. 1992, 107–38.

Koseloff, Olga. "Die Ikonographie der Passionsmomente zwischen der Kreuztragung und dem Tode Christi." *Het Gildeboek* 17 (1934), 34–58, 85–105.

Koumans, Marie Madelaine C. *La Hollande et les hollandais aux XIXe siècle vus par les français.* Maastricht: E. en Ch. van Aelst, 1930.

Krämer, Gode. "Das Kompositionsprinzip bei Adam Elsheimer." *Städel-Jahrbuch* NF IV (1973), 145–72.

Kultermann, Udo. "Vermeer, versions modernes." *Connaissance des Arts* 1977, 94–101.

Kunsthistorisches Museum Wien, Verzeichnis der Gemälde. Vienna: Anton Schroll, 1973.

Lambert, Audrey M. *The Making of the Dutch Landscape: An Historical Geography of the Netherlands.* London and New York: Seminar Press, 1971.

Lamblin, Bernard. *Peinture et Temps.* 2d. ed. Paris: Meridiens Kluicksieck, Publications de la Sorbonne, 1987.

Lang, Andrew, ed. *The Strife of Love in a Dream, London 1592.* London: David Nutt, 1890.

Larsen, Erik. "Jan Vermeer van Delft and the Art of Indonesia." *Revue belge d'archéologie et d'histoire de l'art* 54 (1986), 17–27.

Laughton, Bruce. *The Euston Road School: A Study in Objective Painting.* Aldershot: Scolar Press, 1986.

Lawrence, Cynthia. *Gerrit Adriaensz. Berckheyde (1638–98): Haarlem Cityscape Painter.* Doornspijk: Davaco, 1991.

Liedtke, Walter A. "*The View of Delft* by Carel Fabritius." *Burlington Magazine* 118 (1976), 63–73.

———. "Pride in Perspective: The Dutch Townscape." *Connoisseur* 200 (1979), 264–73.

———. *Architectural Painting in Delft.* Doorn-

spijk: Davaco, 1982.

———. "Collectors and Their Ideals." In exhib. cat. The Hague, 1990, 14–59.

Links, Joseph G. *Townscape Painting and Drawing*. New York: Harper & Row, 1972.

Lorenz, Angelika. *Das deutsche Familienbild in der Malerei des 19. Jahrhunderts*. Darmstadt: Wissenschaftliche Buchgesellschaft, 1985.

Lowe, Lisa. *Critical Terrains: French and British Orientalism*. Ithaca, N.Y. and London: Cornell University Press, 1991.

Macchia, Giovanni. "Proust et la peinture." In *Il Paradiso della ragione: Studi letterari sulla Francia*, 417–29. Bari: Laterza, 1960.

Magill, M. "Art et littérature dans la Recherche du Temps Perdu." *Bulletin d'Informations Proustiennes* 1987, 79–88.

Malraux, André. *Voices of Silence*. Trans. Stuart Gilbert. Princeton: Princeton University Press, 1990.

Mandowsky, Erna. *Untersuchungen zur Ikonologie des Cesare Ripa*. Hamburg: H. Proctor, 1934.

Manheim, Ron. "Julius Meier-Graefe 1867–1935: Kunstschriftsteller zwischen Traditionsbewußtsein und Modernität." In Dilly 1990, 95–115.

Manke, Ilse. *Emanuel de Witte, 1617–92*. Amsterdam: Menno Herzberger, 1963.

Marguery, H. "Un Pionnier de la histoire de l'art: Thoré-Bürger." *Gazette des Beaux-Arts* 11 (1925), 229–45, 295–311, 367–80.

Martin, John Rupert. *Rubens: The Antwerp Altarpieces*. New York: Norton, 1969.

Marrow, James. *Passion Iconography in Northern European Art of the Late Middle Ages and Early Renaissance: A Study of the Transformation of Sacred Metaphor into Descriptive Narrative*. Kortrijk: van Ghemmert, 1979.

Marval, Mary. Johannes Vermeer's *Allegory of Faith* Reconsidered. Master's thesis, McGill University. Montreal, 1988.

Maser Edward A. *Baroque and Rococo Pictorial Imagery. The 1758-60 Hertel Edition of Ripa's Iconologia*. New York: Dover, 1971.

Mason Rinaldi, Stefania. *Palma Il Giovane: L'Opera Completa*. Milan: Alfieri, Electa, 1984.

Matile, Heinz. *Die Farbenlehre Philipp Otto Runges: Ein Beitrag zur Geschichte der Künstlerfarbenlehre*. Munich and Mittenwald: Mäander, 1979.

Maurer, Emil. *Jacob Burckhardt und Rubens. Baseler Studien zur Kunstgeschichte. Vol. 7*. Basel: Birkhauser, 1951.

Meier, Nikolaus. "Heinrich Wölfflin." In Dilly 1990, 63–80.

Meijers, Deborah J. "Twee vorstelijke verzamelingen in Duitsland en het beeld van de Nederlandse zeventiende-eeuwse schilderkunst." In Grijzenhout 1992, 193–208.

Mende, Matthias. *Dürer-Bibliographie: Zur 500. Wiederkehr des Geburtstags von Albrecht Dürer, 21. 5. 1971*. Ed. Elisabeth Rücker. Wiesbaden: Harrassowitz, 1971.

Mengden, Lida von. *Vermeers "De Schilderconst" in den Interpretationen von Kurt Badt und Hans Sedlmayr: Probleme der Interpretation*. Bern and Frankfurt am Main: Peter Lang, 1984.

Merleau-Ponty, Maurice. *La Prose du monde*. Ed. Claude Lefort. Paris: Gallimard, 1969.

Meyers, Jeffrey. "Proust and Vermeer." *Art International* 17:5 (1973), 68–71, 97.

Millen, Ronald Forsyth, and Robert Erich Wolf. *Heroic Deeds and Mystic Figures: A New Reading of Rubens' Life of Maria de' Medici*. Princeton: Princeton University Press, 1989.

Miller, Norbert. "Mutmassungen über lebende Bilder: Attitüde und 'tableau vivant' als Anschauungsform des 19. Jahrhunderts." In *Das Triviale in Literatur, Musik und Bildender Kunst*. Ed. Helga de la Motte-Haber. *Studien zur Philosophie und Literatur des 19. Jahrhunderts. Vol. 18*, 106-30. Frankfurt am Main: Vittorio Klostermann, 1972.

Mirimonde, A. P. de. "Les Sujets musicaux chez Vermeer de Delft." *Gazette des Beaux-Arts* 57 (1961), 29–52.

———. "Les Concerts des muses chez les maîtres du Nord." *Gazette des Beaux-Arts* 63 (1964), 129–58.

———. "La Musique dans les allégories de l'amour." *Gazette des Beaux-Arts* 69 (1967), 319–46.

Misme, Clothilde. "L'Exposition hollandaise des Tuileries." *Gazette des Beaux-Arts* 3 (1921), 261–76.

Monge, Jacques. "Un précurseur de Proust: Fromentin et la mémoire affective". *Revue d'historie littéraire de la France* 61: 4, 1961 564–88.

Monnin-Hornung, Juliette. *Proust et la peinture*. Geneva: E. Droz, 1951.

Monroy, Ernst Friedrich von. *Embleme und Emblembücher in den Niederlanden 1560–1630: Eine Geschichte der Wandlungen ihres Illustrationsstils.* Ed. Hans Martin Freiherr von Erffa. Utrecht: Hantjens Dekker & Gumbert, 1964.

Montias, John Michael. *Vermeer and His Milieu: A Web of Social History.* Princeton: Princeton University Press, 1988.

Mulisch, Harry. *Die Entdeckung des Himmels.* Trans. Martina den Hertog-Vogt. Munich: Hanser, 1993.

Müller, Lieselotte. "Bildgeschichtliche Studien zu Stammbuchbildern II: Die Kugel als Vanitassymbol." *Jahrbuch der Hamburger Kunstsammlungen* 2 (1953), 157–77.

Müller Hofstede, Justus. "Zum Werke des Otto van Veen 1590–1600." *Bulletin des Musées Royaux des Beaux-Arts* 6 (1957), 127–74.

———. "*Non Saturatur Oculus Visu.* Zur Allegorie des Gesichts von P. P. Rubens und Jan Bruegel d. Ä." In *Wort und Bild in der niederländischen Kunst und Literatur des 16. und 17. Jahrhunderts.* Ed. H. Vekeman and J. Müller Hofstede, 243-89. Erfstadt: Lukassen Verlag, 1984.

Murris, R. *La Hollande et les hollandais au XVIIe et au XVIIIe siècles vus par les Français.* Paris: Librairie Ançienne Honoré Champion, 1925.

Nefzger, Ulrich. "Erwägungen zu Vermeer: Vom Halt der inneren Welt." In *Festschrift für Wilhelm Messerer zum 60. Geburtstag,* 251–71. Cologne: DuMont, 1980.

Nerval, Gérard de. "Les Fêtes de Hollande". In *Lorely: Souvenirs d'Allemagne. Oeuvres.* Ed. Albert Béguin and Jean Richer, 820–43. Paris: Gallimard, 1961.

———. "Les Délices de la Hollande". In *Notes de Voyage. Oeuvres,* 867–77, 1467f. Paris: Gallimard, 1961.

Nietzsch, Friedrich. *Menschliches, Allzumenschliches. Werke.* Ed. Karl Schlechta, vol. 1. 435–1008. Berlin: Ullstein, 1983.

Neumeyer, Alfred. *Der Blick aus dem Bilde.* Berlin: Gebrüder Mann, 1964.

Nochlin, Linda. "Courbet's Real Allegory: Rereading *The Painter's Studio.*" In Exhib. cat. New York, New York, 1988, 17–41.

Norman, Geraldine. *Biedermeier Painting 1815–1848: Reality Observed in Genre, Portrait and Landscape.* New York: Thames & Hudson, 1987.

Nutz, Maximilian. "Messianische Ortsbestimmung und normative Menschenkunde. Gundolf und die Barockliteratur." In Garber 1991, 653–773.

Olin, Margaret. "Forms of Respect: Alois Riegl's Concept of Attentiveness." *Art Bulletin* 71 (1989), 285–99.

———. *Forms of Representation in Alois Riegl's Theory of Art.* University Park and London: Pennsylvania State University Press, 1992.

Ortolani, Sergio. *Il Pollaiuolo.* Milan: Ulrico Hoepli, 1948.

Otto, Walter F. *Die Musen und der göttliche Ursprung des Singens und Sagens.* (1955, lst. ed.) Darmstadt: Wissenschaftliche Buchgesellschaft, 1971.

Painter, George D. *Marcel Proust: A Biography.* 2 vols. New York: Vintage, 1978.

Panofsky, Erwin. "Rembrandt und das Judentum." Ed. Gerda Panofsky. *Jahrbuch der Hamburger Kunstsammlung* 18 (1973), 75–108.

———. *Meaning in the Visual Arts.* Harmondsworth: Penguin, 1970.

Parkhurst, Charles. "Red-Yellow-Blue: A Color Triad in Seventeenth-Century Painting." *Baltimore Museum of Art Annual* 4 (1972), 35–9, 108–10.

Pasco, Allan Humphrey. *Proust's Colour Vision: A Study of the Use of Colour as a Literary Device in "A la recherche du temps perdu."* Ann Arbor: University of Michigan Research Press, 1969.

Penkert, Sibylle. "Zur Emblemforschung." In S. Penkert, ed. *Emblem und Emblematikrezeption: Vergleichende Studien zur Wirkungsgeschichte vom 16. bis 20. Jahrhundert,* 1–22. Darmstadt: Wissenschaftliche Buchgesellschaft, 1978.

Pernéty, Antoine-Joseph. *Dictionnaire portatif de peinture, sculpture et gravure.* Paris, 1757. Reprint. Geneva: Minkoff, 1972.

Pevsner, Nikolaus. *Academies of Art: Past and Present.* 2d. ed. New York: Da Capo, 1973.

Philippot, Paul. "Anhaltspunkte für eine Geschichte der Zeit in der westlichen Kunst." In Baudson 1985, 127–53.

Photomontages of the Nazi Period: John Heartfield. Munich and New York: Hanser and Universe Books, 1977.

Pieter de Hooch. Masters in Art, A Series of Illustrated Monographs. Vol. 3. Boston: Bates & Guild, 1902.

Pigler, Andor. *Barockthemen: Eine Auswahl von*

Verzeichnissen zur Ikonographie des 17. und 18. Jahrhunderts. 3 vols. Budapest: Verlag der Ungarischen Akademie der Wissenschaften, 1956.

Pleister, Wolfgang and Wolfgang Schild. *Recht und Gerechtigkeit im Spiegel der europäischen Kunst.* Cologne: DuMont, 1988.

Plietzsch, Eduard. *Vermeer van Delft.* Leipzig: K. W. Hiersemann, 1911.

———. *Vermeer van Delft.* Munich: Bruckmann, 1939.

Podro, Michael. *The Critical Historians of Art.* New Haven and London: Yale University Press, 1982.

Pöggeler, Otto. *Hegels Kritik der Romantik.* Bonn: Bouvier, 1956.

Pöggeler, Otto, and Annemarie Gethmann-Siefert, Eds. *Kunsterfahrung und Kulturpolitik im Berlin Hegels.* Hegel-Studien 22, supplement. Bonn: Bouvier, 1983,

Poidevin, Raymond and Jacques Bariéty. *Frankreich und Deutschland. Die Geschichte ihrer Beziehungen 1815–1975.* Munich: C. H. Beck, 1982.

Poorter, Nora de. *The Eucharist Series. Corpus Rubenianum Ludwig Burchard.* Part 2 (2 vols.). London and Philadelphia: Harvey Miller and Heyden, 1978.

Poppelreuther, Josef. *Der anonyme Meister des Poliphilo: Eine Studie zur italienischen Buchillustration und zur Antike in der Kunst des Quattrocento.* Strasbourg: Heitz, 1904.

Pops, Martin. *Vermeer: Consciousness and the Chamber of Being.* Ann Arbor: University of Michigan Research Press, 1984.

Proust, Marcel. *Les Plaisirs et les jours.* Paris: Gallimard, 1924.

———. *Correspondance Génerale.* Ed. Robert Proust and Paul Brach, 5 vols. Paris: Plon, 1933.

———. *Pleasures and Regrets.* Trans. Louise Varese. New York: Crown, 1948.

———. *Contre Sainte-Beuve:* Precédé de *Pastiches et mélanges* et suivi de *Essais et articles.* Ed. Pierre Clarac and Yves Sandre. Paris: Gallimard, 1971.

———. *Le Carnet de 1908. Cahiers Marcel Proust. Nouvelle série* 8. Ed. Philip Kolb. Paris: Gallimard, 1976.

———. *Remembrance of Things Past.* Trans. C. K. Scott Moncrieff, Terence Kilmartin, Andreas Mayor. 3 vols. New York: Vintage, 1982.

———. *A la recherche du temps perdu.* Ed. Jean-Yves Tadié et al. 4 vols. Paris: Gallimard, 1987.

Puyvelde, Leo van. *Flemish Painting: The Age of Rubens and Van Dycke.* London: Weidenfeld and Nicolson, 1971.

Quinell, J. M. "Paul Helleu: A Reevaluation." *Apollo* (1983), 115–17.

R., D., "William Wilson. Allan Stone." *Artforum International* 30:11 (1991), 132f.

Raabe, Paul. "Expressionismus und Barock." In Garber 1991, 675–82.

Raay, Stefan van, ed. *Imitation and Imagination: Japanese Influence on Dutch Art.* Amsterdam: D'ARTS, 1989.

Raupp, Hans-Joachim. "Musik im Atelier: Darstellungen musizierender Künstler in der niederländischen Malerei des 17. Jahrhunderts." *Oud Holland* 92 (1978), 106–29.

———. "Ansätze zu einer Theorie der Genremalerei in den Niederlanden im 17. Jahrhundert." *Zeitschrift für Kunstgeschichte* 43 (1983), 401–18.

———. *Untersuchungen zu Künstlerbildnis und Künstlerdarstellungen in den Niederlanden im 17. Jahrhundert.* Hildesheim, Zürich and New York: Georg Olms, 1984.

Rave, Paul Ortwin. *Deutsche Malerei des 19. Jahrhunderts.* Berlin: Gebrüder Mann, 1949(?).

Read, Herbert. "The serene art of Vermeer." In Read H. *Art and Alienation,* 87ff. New York: Viking, 1969.

Read, Richard. "Art Criticism versus Art History: The Letters and Works of Adrian Stokes and E. H. Gombrich." *Art History* 16 (1993), 499–540.

Reid, Hane Davidson, and Chris Rohmann, Eds. *The Oxford Guide to Classical Mythology in the Arts, 1300–1990s.* 2 vols. Oxford: Oxford University Press, 1993.

Reifenberg, Benno. *Vermeer van Delft.* Munich: Piper, 1924.

Reijen Willem van. "Innerlichkeit oder Begriffsarbeit? Die Barockrezeption W. Benjamins und Th. W. Adornos." In van Reijen 1992, 17–31.

Reijen, Willem van, ed. *Allegorie und Melancholie.* Frankfurt am Main: Suhrkamp, 1992.

Richardson, E. P. "De Witte and the Imaginative Nature of Dutch Art." *Art Quarterly* 1 (1938), 5–16.

Richter, Johannes Paul, *Kleine Vorschule der*

Ästhetik. Werke. Ed. Norbert Miller, vol. 5. Munich: Hanser, 1980.

———. *Selberlebensbeschreibung. Werke in drei Bänden.* Ed. Norbert Miller, vol. 3, 705-54 Munich: Hanser, 1982. Munich: Hanser, 1982.

Ricker-Immel, Ute. "Die Düsseldorfer Genremalerei." In exhib. cat. Düsseldorf 1979, 149-64.

Riegl, Alois. *Gesammelte Aufsätze.* Ed. Karl M. Swoboda, intro. Hans Sedlmayr. Augsburg and Vienna: Bruno Filser Verlag, 1929.

———. *Das holländische Gruppenporträt* In *Jahrbuch der Kunsthistorischen Sammlungen des Allerhöchsten Kaiserhauses Wien* 23 (1902), 71–278. Reprint, ed. Karl M. Swoboda and Ludwig Müntz, 2 vols. Vienna: Österreichische Staatsdruckerei, 1931.

———. "The Modern Cult of Monuments: Its Character and Its Origin" (1903) *Oppositions. A Journal for Ideas and Criticism in Architecutre* 25 (1982), 21–51.

———. "Geertgen tot Sint Jans' Legend of St. John the Baptist." Excerpt from Riegl 1902, 1931, trans. Stephen S. Kayser. In W. Eugene Kleinbauer. *Modern Perspectives in Western Art History,* 124–38. Toronto and Buffalo, N.Y.: University of Toronto Press, 1989.

Ripa, Cesare. *Iconologia overo descrittione di diverse imagini cavate dall' antichità, e di propria inventione.* (Rome, 1603). Reprint, intro. Erna Mandowsky. Hildesheim, Zürich and New York: Georg Olms, 1970.

———. *Iconologia of Uytbeeldinghen des Verstants van Cesare Ripa van Perugien.* Ed. and trans. Dirck Pietersz. Pers. (Amsterdam, 1644). Reprint, intro. Jochen Becker. Soest and Doornspijk: Davaco, 1971.

Rodi, Fithjof. "Die Romantiker in der Sicht Hegels, Hayms und Diltheys." In Pöggeler 1983, 177-97.

Rosand, David, ed. "Editor's Statement: Style and the Aging Artist." *Art Journal* 46:2 (1987), 91-3.

Rosenthal, Donald. *Orientalism: The Near East in French Painting 1800–1880.* Memorial Art Gallery of the University of Rochester, Rochester, N.Y., 1982.

Rubens, Peter Paul. *The Letters of Peter Paul Rubens.* Ed. and trans. Ruth Saunders Magurn. Evanston, Ill.: Northwestern University Press, 1991.

Rudder, Arthur de. *Pieter de Hooch et son Oeuvre. Collection des grands artistes des Pays-Bas.* Vol. 14. Paris and Brussels: G. van Oest, 1914.

Rudolph, Herbert. "'Vanitas': Die Bedeutung mittelalterlicher und humanistischer Bildinhalte der niederländischen Malerei des XVII. Jahrhunderts." In *Festschrift Wilhelm Pinder,* 405–33. Leipzig: E. A. Seemann, 1938.

Sager, Peter. *Neue Formen des Realismus: Kunst zwischen Illusion und Wirklichkeit.* Cologne: DuMont, 1973.

Salomon, Nanette. "Vermeer and the Balance of Destiny." In *Essays in Northern Art Presented to Egbert Haverkamp-Begemann on his Sixtieth Birthday,* 216–21. Doornspijk: Davaco, 1983.

Sattler, Bernhard, ed. *Adolf von Hildebrand und seine Welt: Briefe und Erinnerungen.* Munich: Akademie der schönen Künste and Verlag D. W. Callway, 1962.

Sauerländer, Willibald. "Alois Riegl und die Entstehung der autonomen Kunstgeschichte am Fin de Siècle." In *Fin de Siècle: Zur Literatur und Kunst der Jahrhundertwende.* Ed. Roger Bauer, 125–43. Frankfurt am Main: Vittorio Klostermann, 1977.

Saward, Susan. *The Golden Age of Marie de' Medici.* Ann Arbor: University of Michigan Research Press, 1982.

Saxl, Fritz. "Veritas Filia Temporis." In *Philosophy and History. Essays Presented to Ernst Cassirer.* Ed. Raymond Klibansky and H. J. Paton, 197–222. Oxford: Clarendon Press, 1936.

Schama, Simon. *The Embarrassment of Riches: An Interpretation of Dutch Culture in the Golden Age.* Berkeley: University of California Press, 1988.

Schlegel, August von. *Kritische Schriften.* 2 vols. Berlin: G. Reimer, 1828.

Schloss, Christine Scheeles. *Travel, Trade, and Temptation: The Dutch Italianate Harbour Scene, 1640–1680.* Ann Arbor: University of Michigan Research Press, 1982.

Schmidt, Paul Ferdinand. *Biedermeier-Malerei.* Munich: Delphin, 1923.

Schnaase, Carl. *Niederländische Briefe.* Stuttgart und Tübingen: J. G. Cotta, 1834.

Schneider, Norbert. "Hans Sedlmayr 1896–1984." In Dilly 1990, 267–88.

———. *Vermeer 1632-1675. Veiled Emotions.* Cologne: Benedikt Taschen, 1994.

Schöne, Wolfgang. *Über das Licht in der Malerei.*

(1954). Berlin: Gebrüder Mann, 1989.

Schopenhauer, Arthur. *Reisetagebücher aus den Jahren 1803–1804*. Ed. Charlotte von Gwinner. Leipzig: Brockhaus, 1923.

Schröder, Klaus Albrecht, *Ferdinand Georg Waldmüller*, Munich: Prestel, 1990.

Schug, Albert. " 'Helenen in jedem Weibe'–Helene Fourment und ein besonderer Porträttypus im Spätwerk von Peter Paul Rubens." *Wallraf-Richartz-Jahrbuch* 46 (1985–6), 119–64.

Schuster, Peter-Klaus. "Das Bild der Bilder: Zur Wirkungsgeschichte von Dürers Melancholiekupferstich." *Idea: Jahrbuch der Hamburger Kunsthalle* 1 (1982), 72–134.

———. "Grundbegriffe der Bildersprache?" In *Kunst um 1800 und die Folgen: Festschrift für Werner Hofmann*. Ed. Christian Beutler et al., 425–76. Munich: Prestel, 1988.

Schwartz, Gary. *Rembrandt: His Life, His Paintings*. London: Penguin, 1991.

Scribner, Charles, III. *The Triumph of the Eucharist Tapestries Designed by Rubens*. Ann Arbor: University of Michigan Research Press, 1982.

Sedlmayr, Hans. "Zu einer strengen Kunstwissenschaft," *Kunstwissenschaftliche Forschungen* 1 (1931), 7–32.

———. "Der Ruhm der Malkunst: Jan Vermeer 'de schilderconst.' " In *Festschrift für Hans Jantzen*, 169–77. Berlin: Gebrüder Mann, 1951.

Seth, Lennaert. "Vermeer och van Veens Amorum Emblemata." *Konsthistorisk Tidskrift* 49 (1980), 17–40.

Seuphor, Michel, and F. L. Berckelaers. *Piet Mondrian: Life and Works*. New York: Abrams, 1957.

Sewel, Willem, and Egbert Buys. *Volkomen Woordenboek der Nederduitsche en Engelsche Taalen* 2 vols. Amsterdam: Kornelis de Veer, 1766.

Seymour, Charles. "Dark Chamber and Light-Filled Room: Vermeer and the Camera Obscura." *Art Bulletin* 46 (1964), 323ff.

Shattuck, Roger. *Marcel Proust*. Princeton: Princeton University Press, 1974.

Shiff, Richard. "Handling Shock: On the Representation of Experience in Walter Benjamin's Analogies." *Oxford Art Journal* 15:2 (1992), 88–103.

Simmel, Georg. *Philosophie des Geldes*. (1900). Berlin: Duncker & Humblot, 1958.

———. *Brücke und Tor: Essays des Philosophen zur Geschichte, Kunst und Gesellschaft*. Ed. Michael Landmann and Margarete Susman. Stuttgart: K. F. Köhler Verlag, 1957.

———. *Rembrandt. Ein kunstphilosophischer Versuch*. (1916). Intro. Beat Wyss. Munich: Matthes & Seitz, 1985.

Slive, Seymour. *Rembrandt and His Critics 1630–1730*. The Hague: Martinus Nijhoff, 1953.

———. *Jacob van Ruisdael*. New York: Abbeville Press, 1981.

Smith, David R. "Irony and Civility: Notes on the Convergence of Genre and Portraiture in Seventeenth-Century Dutch Painting." *Art Bulletin* 69 (1987), 407–30.

Snell, Robert. *Théophile Gautier: A Romantic Critic of the Visual Arts*. Oxford: Clarendon Press, 1982.

Snow, Edward. *A Study of Vermeer*. Berkeley: University of California Press, 1979.

———. *A Study of Vermeer*. Rev. ed. Berkeley: University of California Press, 1994.

Spicer, Joaneath. "The Renaissance Elbow." In Jan Bremmer and Herman Roodenburg, eds. *A Cultural History of Gesture*. Intro. Keith Thomas, 84–128. Ithaca, N.Y.: Cornell University Press, 1992.

Spinner, Kaspar H. "Helldunkel und Zeitlichkeit." *Zeitschrift für Kunstgeschichte* 34 (1971), 169–83.

Stechow, Wolfgang. "Landscape paintings in Dutch Seventeenth Century Interiors." *Nederlands Kunsthistorisch Jaarboek* 11 (1960), 165–84.

Stechow, Wolfgang, and Christopher Comer. "The History of the Term Genre." *Allen Memorial Art Museum Bulletin* 33:2 (1975–6), 89–94.

Steiner, Uwe. "Traurige Spiele–Spiel vor Traurigen." In van Reijen 1992, 32–63.

Steinhagen, Harald. *Wirklichkeit und Handeln im barocken Drama. Historisch-ästhetische Studien zum Trauerspiel des Andreas Gryphius*. Tübingen: Niemeyer, 1977.

———. "Zu Walter Benjamins Begriff der Allegorie." In Haug 1979, 666–85.

Stemmrich, Gregor. "C. Schnaase: Rezeption und Transformation Berlinischen Geistes in der kunsthistorischen Forschung." In Pöggeler 1983, 263–82.

Sterkenburg, P. G. J. van. *Een Glossarium van de zevendiende-eeuws Nederlands*. Groningen: H. D. Tjenk Willink, 1975.

Sterling, Charles and Hélène Adhémar. *Musée*

National du Louvre, Peintures: École française, XIX^e siècle. 4 vols. Paris: Éditions des Musées Nationaux, 1959.

Stierle, Karlheinz. "Zwei Hauptstädte des Wissens: Paris und Berlin." In Pöggeler 1983, 83–111.

———. "Proust, Giotto und das Imaginäre." In Boehm 1985, 219-49.

Stokes, Adrian. *The Invitation in Art*. New York: Chilmark Press, Random House, 1965.

Stone-Ferrier, Linda. "Gabriel Metsu's *Vegetable Market*, at Amsterdam: Seventeenth-Century Dutch Market Paintings and Horticulture." *Art Bulletin* 71 (1989), 428–52.

Straaten, Evert J. van. *Johannes Vermeer 1632–75: Een Delfts schilder en de cultuur van zijn tijd*. The Hague: Staatsuitgeverij, 1977.

Straten, Roelof van. "Early Works by Lievens and Rembrandt in Two Unknown Still Lifes." *Artibus et Historiae* 26 (1992), 121–42.

Strauss, Walter L., ed. *Heinrich Aldegrever. The Illustrated Bartsch*. Vol. 16. New York: Abaris, 1980.

Sumowski, Werner. *Gemälde der Rembrandt-Schüler*. 5 vols. Landau: Pfälzische Verlagsanstalt, 1983.

Sutton, Peter C. "Hendrik van der Burch." *Burlington Magazine* 122:2 (1980a), 315–26.

———. *Pieter de Hooch: Complete Edition with a Catalogue Raisonné*. Ithaca, N.Y.: Cornell University Press, 1980b.

Swillens, P. T. A. *Johannes Vermeer. Painter of Delft, 1632–75*. Utrecht and Brussels: Uitgeverij Het Spektrum, 1950.

Szondi, Peter. *Poetik und Geschichtsphilosophie I. Studienausgabe der Vorlesungen*. Vol. 2. Frankfurt am Main: Suhrkamp, 1980.

Tanis, James and Daniel Horst. *Images of Discord: A Graphic Interpretation of the Eighty Years' War*. Bryn Mawr, and Grand Rapids: William B. Eerdmans, 1993.

Tatlock, R. R. "Vermeer's 'Girl with a Flute'." *Burlington Magazine* 39 (1921), 28f., 33.

Tervarent, Guy de. *Attributs et symboles dans l'art profane 1450–1600: Dictionnaire d'un Langage perdu*. Geneva: E. Droz, 1958.

Theissing, Heinrich. *Die Zeit im Bild*. Darmstadt: Wissenschaftliche Buchgesellschaft, 1987.

Theroux, Alexander. "The Sphinx of Delft: The Strange Correspondence between a Dutch Master and His French Disciple." *Art and Antiques* (1988:12) 85–8, 120–4.

Thoby, Paul. *Le Crucifix, des origines au Concile de Trente. Étude iconographique*. Nantes: Bellanger, 1959.

Thomas, Francis-Noël. *The Writer Writing: Philosophical Action in Literature*. Princeton: Princeton University Press, 1992.

Thoré, Théophile (William Bürger). *Musées de la Hollande*. Vol. 1: *Amsterdam et la Haye*. Vol. 2: *Musée van der Hoop, à Amsterdam et Musée de Rotterdam*. Paris: Jules Renouard, 1858, 1860.

———. "Van der Meer de Delft." *Gazette des Beaux-Arts* 21 (1866), 297–330, 458–70, 542–75.

———. *Salons de W. Bürger. 1861–1868*. 2 vols. Paris: Jules Renouard, 1870.

———. *Jan Vermeer van Delft* Ed. and trans. Paul Prina. Leipzig: Julius Zeitler, 1906.

———. *Kunstkritik*. Ed. August Schmarsow and Bernhard Klemm. Leipzig: Klinckhardt & Biermann, 1908.

———. *Französische Kunst im 19. Jahrhundert*. Ed. August Schmarsow and Bernhard Klemm, 3 vols. Leipzig: Klinckhardt & Biermann, 1911.

Thuillier, Jacques, "L'Homme qui retrouva Vermeer." *L'Oeil* 65 (1960), 50-7.

Thuillier, Jacques and Jacques Foucart. *Rubens' "Life of Marie de' Medici."* New York: Abrams, 1970.

Thürlemann, Felix. "Grün—die verstoßene Vierte: Zur Genealogie des modernen Farbpurismus." In Bürgi 1988, 11–28.

Timmers, J. J. M. *Gérard Lairesse*. Amsterdam: H. J. Paris, 1942.

Tismar, Jens. *Gestörte Idyllen: Eine Studie zur Problematik der idyllischen Wunschvorstellungen am Beispiel von Jean Paul, Adalbert Stifter, Robert Walser, Thomas Bernhard*. Munich: Carl Hanser, 1973.

Tolnay, Charles de. "L'Atelier de Vermeer." *Gazette des Beaux-Arts* 41-2 (1953), 165–72.

Trenard, G.L. "Henry Havard." In *Dictionnaire de biographie français*. Vol. 17, 778. Paris: Librairie Letouzey et Ané, 1989.

Turner, Bryan S. "Ruine und Fragment: Anmerkungen zum Barockstil." In van Reijen 1992, 202–23.

Tuve, Rosemond. "Notes on the Virtues and Vices." *Journal of the Warburg and Courtauld Institutes*, 26 (1963), 264-303.

V., H., "Flameng, Léopold," "Fromentin, Eugène." *Thieme-Becker Künstler-Lexikon*. Vol. 12, 69f., 523f. Leipzig: E. A. Seemann,

1916.

Valentiner, Wilhelm R. "Zum 300. Geburtstag Jan Vermeers, Oktober 1932: Vermeer und die Meister der holländischen Genremalerei." *Pantheon* 10 (1932), 305–24.

Vanzype, Gustave. *Vermeer de Delft. Collection des grands artistes des Pays-Bas.* Vol. 4. Paris and Brussels: G. van Oest, 1908.

Vaudoyer, Jean-Louis. "L'Orientalisme en Europe au XVIIIᵉ siècle." *Gazette des Beaux-Arts* 6 (1911), 89–102.

———. *L'Art est délectation.* Intro. René Huyghe. Paris: Hachette, 1968.

Veen, Otto van. *Amorum Emblemata.* (Antwerp, 1607). Reprint, Hildesheim, Zürich and New York: Georg Olms, 1970.

Verlaine, Paul. *Quinze jours en Hollande.* In *Oeuvres Complètes de Paul Verlaine.* Ed. Jacques Boul et al. 2 vols. Vol. 2, 845–906. Paris: Club des Libraires de France, 1960.

Vermeer of Delft. Masters in Art, A Series of Illustrated Monographs. Vol. 5. Boston: Bates & Guild, 1904.

Vischer, Friedrich Theodor. *Ästhetik oder Wissenschaft des Schönen.* Ed. Robert Vischer. 3 vols. (Munich, 1922). Reprint, Hildesheim, Zürich, and New York: Georg Olms, 1975.

Visscher, Roemer. *Sinnepoppen.* (Amsterdam, 1614). Reprint, The Hague: Martinus Nijhoff, 1949.

Vondel, Joost van den. *Lucifer: Treurspel.* Intro. and ed. Lievens Rens. The Hague: Martinus Nijhoff, 1979.

Vondel's Lucifer. Trans. Leonard Charles van Noppen. New York and London: Continental Publishing, 1898.

Voßkamp, Wilhelm. "Deutsche Barockforschung in den Zwanziger Jahren." In Garber 1991, 683–703.

Vries, A. B. de. "Noch einmal Vermeer und Caravaggio." *Pantheon* 22 (1938), 286f.

———. *Jan Vermeer de Delft.* Trans. Louise Servicen. Basel: Holbein, 1948.

Vries, Lyckle de. "The Dutch Cityscape in the 17th Century and Its Sources, Amsterdam and Toronto." *Simiolus* 9:3 (1977), 187–9.

———. "The Changing Face of Realism." In Freedberg and de Vries 1997, 209–44.

Waagen, Gustav Friedrich. *Kunstwerke und Künstler in Deutschland.* 2 vols., Leipzig: Brockhaus, 1843, 1845.

———. *Königliche Museen: Verzeichnis der Gemäldesammlung.* Berlin: Moeser und Kühn, 1851.

———. *Handbuch der deutschen und niederländischen Malerschule.* 2 vols. Stuttgart: Ebner & Seubert, 1862.

Wackenroder, Heinrich, und Wilhelm Tieck. *Phantasien über die Kunst* (1799). Stuttgart: Reclam, 1977.

Wadum, Jørgen, René Hoppenbrouwers, and Luuk Struick van der Loeff. *Vermeer Illuminated. Conservation, Restoration and Research.* The Hague: Mauritshuis, 1994.

Wagner, Helga. *Jan van der Heyden: 1637–1714.* Amsterdam and Haarlem: Scheltema & Holkema, 1971.

Warnke, Martin. *Kommentare zu Rubens.* Berlin: de Gruyter, 1965.

———. "Italienische Bildtabernakel bis zum Frühbarock." *Münchner Jahrbuch der bildenden Kunst* 19 (1968), 61–102.

———. *Peter Paul Rubens: Life and Work.* Trans. D. Pedini Simpson. Woodbury, N.Y.: Barron's, 1980.

———. "Die Entstehung des Barockbegriffs in der Kunstgeschichte." In Garber 1991, 1207–23.

Weber, Gregor J. M. "Poetenhafer, Flugesel und Künstlerparnass in den Niederlanden." In exhib. cat. Hamburg 1993, 71–92.

Weiß, Karl. "Allegorien und Embleme." *Die Gartenlaube* (1882:10), 160f.

Welu, James E. "Vermeer. His Cartographic Sources." *Art Bulletin* 57 (1975), 529–47.

———. "The Map in Vermeer's *The Art of Painting.*" *Imago Mundi* 30 (1978), 9–30.

Werner, Gerlind. *Ripa's Iconologia: Quellen, Methode, Ziel.* Utrecht: Hantjens Dekker & Gumbert, 1977.

Westhoff-Krummacher, Hildegard. *Katalog der Gemälde des 19. Jahrhunderts im Westfälischen Landesmuseum für Kunst und Kulturgeschichte.* Münster, 1975.

Wetering, Ernst van de. "Dutch Reality and Monet's Artistic 'Deceit.'" In exhib. cat. Amsterdam 1986, 49–71.

Wheeler, Kathleen M., ed. *German Aesthetics and Literary Criticism: The Romantic Ironists and Goethe.* Cambridge: Cambridge University Press, 1984.

Wheelock, Arthur K. Jr. "Gerard Houckgheest and Emanuel de Witte: Architectural Painting in Delft around 1650." *Simiolus* 8 (1975–6), 167–85.

———. "Constantijn Huygens and early attitudes towards the camera obscura." *History of*

Photography 1:2 (1977a), 93–103.

————. *Perspective, Optics and Delft Artists around 1650.* New York and London: Garland, 1977b.

————. "Pentimenti in Vermeer's Paintings: Changes in Style and Meaning." In Bock 1987, 385–412.

————. *Vermeer.* 2d. ed. New York: Abrams, 1988.

————. *Vermeer and the Art of Painting.* New Haven and London: Yale University Press, 1995.

Wheelock, Arthur K., Jr., and C. J. Kaldenbach, "Vermeer's *View of Delft* and his Vision of Reality." *Artibus et Historiae* 6 (1982), 9–35.

Wildenstein, Daniel. *Claude Monet: Biographie et catalogue raisonné.* 5 vols. Paris and Lausanne: La Bibliothèque des Arts, 1974–91.

Wildenstein, Georges. *The Paintings of Fragonard.* London: Phaidon, 1960.

Winckelmann, Johann Joachim. *Sämtliche Werke.* Ed. Joseph Eiselein. Donaueschingen: Verlag deutscher Klassiker, 1825.

————. *Kleine Schriften und Briefe.* Weimar: H. Böhlau's Nachfolger, 1960.

————. *Writings on Art.* Ed. David Irwin. London: Phaidon, 1972.

————. *Reflections on the Imitation of Greek Works in Painting and Sculpture.* Bilingual ed., trans. Elfriede Heyer and Roger C. Norton. La Salle, Ill.: Open Court, 1987.

Winner, Matthias. "Bernini's *Verità* (Bausteine zur Vorgeschichte einer *Invenzione*)." In *Munuscula Discipulorum: Hans Kauffmann zum 70. Geburtstag.* Ed. Tilmann Buddensieg and Matthias Winner, 393–413. Berlin: Bruno Hessling, 1966.

————. ed., *Der Künstler über sich in seinem Werk. Internationales Symposium der Bib-* *liotheca Hertziana Rom 1989.* Weinheim: VCH, Acta Humaniora, 1992.

Winter, Pieter Jan van. *De Chinezen van Europa.* Groningen: J. B. Wolters, 1965.

Wirth, Irmgard. *Berliner Malerei im 19. Jahrhundert.* Berlin: Siedler, 1990.

Wirth, K. A., "Einsatzbild." *Reallexikon zur Deutschen Kunstgeschichte.* Vol. 4, columns 1006ff. Stuttgart: Metzler, 1958.

Wittkower, Rudolf. *Allegory and the Migration of Symbols.* Boulder, Colorado: Westview Press, 1977.

Wölfflin, Heinrich. *Principles of Art History.* Trans. Mary Hottinger. New York: Holt & Co., 1932.

Woodward, David, ed. *Art and Cartography: Six Historical Essays.* Chicago: University of Chicago Press, 1987.

Wright, Christopher. *Poussin: Paintings: A Catalogue Raisonné.* New York, Hippocrene Books, 1985.

Würtenberger, Franzsepp. *Das holländische Gesellschaftsbild.* Schramberg im Schwarzwald Gatzer & Hahn, 1937.

Wuttke, Dieter, ed. *Aby Warburg. Ausgewählte Schriften und Würdigungen,* Baden-Baden: Valentin Koerner, 1980.

Zaunschirm, Thomas. *Leitbilder: Denkmodelle der Kunsthistoriker, oder, Von der Tragik, Bilder beschreiben zu müssen.* Klagenfurt: Ritter, 1993.

Zielonka, Anthony. *Alphonse Esquiros (1812–1876): A Study of His Works.* Paris and Geneva: Champion-Slatkine, 1985.

Zijderveld, A. "Cesare Ripa's *Iconologia* in ons land," *Oud Holland* 64 (1949), 113–28, 184–92.

Index